William Blake's

Circle of Destiny

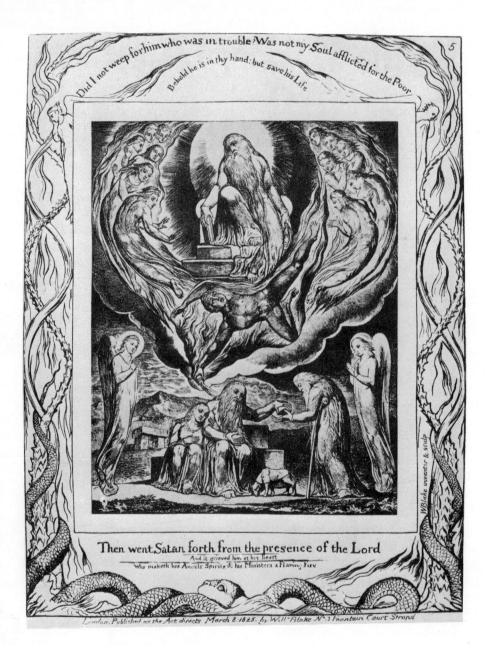

ILLUSTRATIONS OF THE BOOK OF JOB, PLATE V

William Blake's
Circle of Destiny

MILTON O. PERCIVAL

1964
OCTAGON BOOKS, INC.
NEW YORK

Copyright 1938, by Columbia University Press

Reprinted 1964
by special arrangement with Columbia University Press

OCTAGON BOOKS, INC.

175 FIFTH AVENUE
NEW YORK, N. Y. 10010

LIBRARY OF CONGRESS CATALOG CARD NUMBER: 64-24854

Printed in U.S.A. by
NOBLE OFFSET PRINTERS, INC.
NEW YORK 3, N. Y.

To MY WIFE

Preface

THE *Circle of Destiny* is not a study in sources, but a work of interpretation. Its conclusions have been derived almost exclusively from the text of Blake's prophetic writings and from his paintings and drawings. Sources and analogues have been introduced only to support the interpretation and to show that Blake's myth is not the phantasy of a solitary dreamer, but the culmination of a long tradition. In order that the interpretation might not be buried beneath the weight of evidence, only a portion of the material which I might have used in support of my conclusions has actually been utilized.

The study had its inception, seven or eight years ago, in certain surmises about the contraries and the biblical pattern of the *Four Zoas*. As comprehension grew it became increasingly apparent that Blake had pondered the basic philosophical problems more deeply than had been supposed. One might hope, therefore, that the myth was not, as it had seemed, chaotic and arbitrary, but a visionary presentation of a systematic body of thought. The study was therefore extended to include all of the prophetic writings, the illustrations of the Book of Job, and the miscellaneous paintings and drawings. The result was the emergence of a logical and coherent system. What it is, the following pages undertake to tell.

Though few references have been made in the course of the following pages to other students of Blake, it must not be thought that I am unappreciative of their contributions. Yet, in following certain leads to their conclusions, I was pursuing a more or less independent path. Certain publications, admirable in themselves, either have lain outside the path taken in this work or have not contributed, so far as I am aware, to my own interpretation. Nevertheless, two or three specific debts must be noted. To Professor Damon I owe the increased interest

in the prophetic writings which led to this work. And two sets of Messrs. Sloss and Wallis's edition of the prophetic writings, as well as two copies of Mr. Wicksteed's study of the illustrations of the Book of Job, all worn to tatters, are mute testimony to their usefulness.

It gives me pleasure to thank the Hon. Mrs. Stirling of Keir and her son, Mr. William Stirling, for permission to reproduce the painting entitled "Eve Tempted by the Serpent," and Mr. W. Graham Robertson for permission to reproduce "Hecate" and "The Elohim Creating Adam." I wish also to thank Messrs. Ernest Benn, Ltd., for concurring with these permissions. Thanks are due also to certain of my colleagues—Professors A. R. Chandler, H. R. Walley, W. R. Parker, and Dr. Tom B. Haber—for reading and criticizing the manuscript, in whole or in part. My chief debt, which I should be unable to describe, is acknowledged in the Dedication.

M. O. P.

Columbus, Ohio
August 2, 1937

Contents

Illustrations

I

Introduction

. . . I rest not from my great task,
To open the Eternal Worlds, to open the immortal Eyes
Of Man inwards into the Worlds of Thought, into Eternity
Ever expanding in the Bosom of God, the Human Imagination.
Jerusalem, p. 5.

OF THE many ironies which have gathered round the life and work of William Blake, two are pre-eminent. One is that he, the sanest and profoundest thinker among the poets of the romantic generation, was believed to be a madman. The other lies in the supposition that he read but little, that he put his philosophy together, Crusoe-like, from "odds and ends about the house," and that his great want was a "framework of accepted and traditional ideas." The former misconception requires no comment, for it is moribund; but the latter still prevails. Argument would be out of place in these introductory pages. I must content myself with a counter-statement. I predict, then, that when the evidence is in, it will be found that in the use of tradition Blake exceeded Milton and was second, if to anyone, only to Dante. To be sure, a great deal of the Blakean tradition might not be called "accepted." It certainly was not orthodox. But the Blakean heterodoxy was equally traditional with Dante's orthodoxy. The Orphic and Pythagorean tradition, Neoplatonism in the whole of its extent, the Hermetic, kabbalistic, Gnostic, and alchemical writings, Erigena, Paracelsus, Boehme, and Swedenborg—here is a consistent body of tradition extending over nearly twenty-five hundred years. In the light of this tradition, not in the light of Christian orthodoxy, Blake read his Bible, weighing and deciding for himself, formulating a "Bible of Hell"; for he was one in whose veins ran the dissidence of dissent and the protestantism of the Protestant

religion. Anyone who undertakes to do Blake's reading after him will respect his prowess as a reader. Anyone who undertakes to evaluate his evaluations will, unless he is restrained by orthodoxy, respect his power as a thinker. When Blake, in an impetuous moment, referred to himself as a "mental prince," he uttered no more than sober truth.

So great was the impress of older thinking upon Blake's mind that it is difficult to fit him into the framework of his own time. Whether one thinks of that time as the declining Enlightenment or the rising Romantic Movement, he is an incongruous figure. The world of the Enlightenment was for him no less than a world ripe for a Last Judgment. In Blake's vision of the cosmic scheme the temporal wheel had almost come full circle. Nearly six thousand years ago the serpent of Natural Religion, not then recognized for what it was, had lured Albion out of Paradise. But now, at last, in the Natural Religion of the eighteenth century the error stood revealed in all its nakedness and turpitude. The round of error must either renew itself and swing over the long cycle once again, or be cast off, into the outer realm of possibility, to remain there as a memory and a warning. Which course would the cycle take? The Spectre in Blake made him painfully aware of error's power continually to renew. Where Babylon ends, Babylon might begin again. Eternal recurrence might be the pattern, as the Stoics said. But the prophet in him repudiated any such purposeless interpretation of experience. "Time is the mercy of eternity," and its function, cruel and merciful at once, is to shape experience in such a way as to restore the wandering spirit to its source. Firmly persuaded that time had almost fulfilled its function, Blake rejoiced in visions of the Last Judgment and the ending of all things temporal. In the drumbeat of revolution in America and France, which to his forward-looking contemporaries heralded a Utopia to be reached over the road of perfectibility—the perfectibility of the natural man—Blake heard the doom of the natural man and the signal for the descent of the New Jerusalem out of heaven. In the rising Romantic Movement he doubtless found some elements of the coming millennium, yet

his romanticism was different from any other. His primitivism owed more to Swedenborg than to the commoner romantic sources. His belief in progress, if he may be said to have entertained one, was simply in the Ring of Return. He hated Rousseau equally with Voltaire. With Shelley alone among the romantics could he have had any fundamental sympathy, if, indeed, fundamental sympathy could be predicated of one who held the "fatal and accursed" doctrine of the goodness of the natural heart. He was really nearer to Plotinus than to Shelley and nearer to certain Gnostic figures than to Plotinus. He would have been more at home in the Alexandria of the third century than he was in the London of his own time. The mystical thinking, the millennial hopes, the heterodox interpretation of Christ's mission, the spectre of natural religion—in short, nearly all the ingredients of Blake's thinking—were provided then. The manifold systems which went into the making of Blake's system either flourished in that syncretistic time or had their roots there. If Blake is a modern figure, it is because ancient thought can still be made significant.

And certainly Blake is a modern figure, so much so that to relegate him to the ancient world seems like sheer paradox. He has more to say to the present world than any other poet of his time, and more to say about the issues of life than most poets of whatever time. He lived in an era when modern problems were beginning to take shape. He brought to bear upon them a mind capable of original and profound interpretation of the cosmic drama, richly endowed with irony, shrewdness, and common sense, undeceived by the solemn plausibilities of the world, possessed, above all, of keen psychological insight. The solutions which he reached are still cogent. His own age, which he rejected except as it showed signs of regeneration, had the inestimable value of acting as an irritant to his imagination.

> I turn my eyes to the Schools & Universities of Europe,
> And there behold the Loom of Locke, whose Woof rages dire
> Wash'd by the Water-wheels of Newton; black the cloth
> In heavy wreathes folds over every Nation.

Beholding this, he turned his eyes to the past and the future, so

that finally, after long contemplation, he was able to say: "I see the past, present and future existing all at once." The myth corroborates this assertion. It embraces the whole of human life, from the Fall to the Last Judgment.

Blake's outline of the spiritual history of mankind is based upon the Scriptures. The handicap implied by such restriction is not really as great as might be supposed. Everything he knew, he told Crabb Robinson, was in the Bible. Yes, but the Bible can be read in a spiritual sense, and one can find there, with a little ingenuity, whatever one is looking for. Wide reading in philosophy had taught Blake very definitely what to look for, and several of his masters had taught him how to find the most exotic fruit of allegory beneath the plainest leaves. What a feeble obstacle the letter offered when Swedenborg and Boehme and Philo of Alexandria searched their Scriptures, or when the Neo-platonists subjected the ancient classics to new scrutiny! And how Blake bettered the instruction! As the myth unrolls itself, especially in the *Four Zoas*, it weaves into its basically biblical pattern, imagery and ideas from the poetic genius wherever that genius has devoted itself to things divine. The idea may have been suggested by Ovid, one of Blake's favorite authors. The *Metamorphoses* knits into one harmonious whole the myths of the ancient world from chaos and creation to the deification of Julius Caesar. This "sublime and regular plan," as Bishop Warburton called it, he further describes as "a popular history of Providence . . . from the creation to his [Ovid's] own time, through the Egyptian, Phoenician, Greek and Roman histories." Blake's plan, equally sublime and regular, purports to be a history of Providence as it has been manifested through the poetic genius in Egypt, Asia, Europe, and America, extending from the Creation to the Last Judgment.

It is obvious that Blake is one of those who have caught God's secret. Faith in such a secret might be called his birthright; his complete formulation of it does not come until fairly late. In a series of attempts, each more complex than the preceding one, he sought to formulate his faith into a system. The *Gates of Paradise*, which in its first state is early work, swings the cycle

round with amazing rapidity, and yet the gist of the matter is contained in that sequence of sixteen plates. The early prophetic books carry the formulation into the field of myth, but even these were apparently regarded as inadequate, and the *Four Zoas*, which followed immediately upon their completion, recounts the tale with much greater deliberation and complexity. This remains, indeed, the most "sublime and regular" of all the versions. *Jerusalem*, however, tells the story once again from a different point of view, and *Milton*, though one of the most obscure of the prophetic writings, embodies the same doctrine. Turning from the pen to the graver, Blake embodied his own version of the Fall and the Redemption in his illustrations to *Paradise Lost* and *Paradise Regained*. Finally, in the Job illustrations, Job, the individual, passes over the same wheel of experience that Albion, the representative of mankind, had traversed in the *Four Zoas*. All these versions tally. The same key unlocks them all.

In view of all these presentations of the system, it is certainly ironical that Blake should be thought never to have achieved a system but to have lost himself in a maze of his own devising. Doubly ironical if he, whose abhorrence of the indefinite was so great that he made it a cornerstone of his philosophy, whose hero, Los, is forever hammering systems out of the hidden obscurity in which they lurk, who hated nothing so much as a polypus of incoherent roots, had become entangled in such a polypus himself. That he did not become so entangled, that on the contrary he had a system, a system as logical and coherent as any of the metaphysical systems formulated by the poets, the following chapters undertake to prove.

The basic conceptions of the system are ancient and elemental. A supra-mundane and eternal world is assumed. A fall and a return are presupposed. The soul stands sure. These truths are never questioned. Certain other suppositions, less instinctive, more speculative, suppositions deduced long ago from observation of nature's ways, are also adopted into the basic pattern of the metaphysics. For example, the physical world was conceived of in ancient times as resulting from the interac-

tion of two elemental forces, the one active and formative, the other passive and receptive. On the analogy of sex these forces were often imagined as masculine and feminine. On the analogy of vegetation they were regarded as inner and outer; the inner, creative life force being, in the language of the schoolmen, *natura naturans,* the outer, passive creation being *natura naturata.* On the vegetable analogy, again, the two forces were thought of as temporal and eternal. The outer vegetative form decays and dies; the life force persists forever. Thus far, then, the two forces may be contrasted as inner, active, eternal, and masculine; and outer, passive, temporal, and feminine. But the series are not yet complete. In the first is placed, as the summation of all the other members, imagination; which is contrasted in the second both by reason and by selfhood.

Imagination and reason have often been paired, the two representing reason in her more and in her less exalted mood. In this, as in so many other matters, Plotinus states the Blakean position. "No: our reasoning is our own; we ourselves think the thoughts that occupy the understanding—for this is actually the We—but the operation of the Intellectual Principle enters from above." That these two degrees of reason are not only higher and lower, but inner and outer, is also a commonplace of the tradition which Blake inherited. Downward is also outward, as upward is also inward. The contrasting origin of reason and imagination is a fact of everyday experience. Whence comes imagination if not from the innermost recesses of our being, if not from those moments when the mind turns inward upon itself? And what is the seat of reason, if not in the externality, where it checks and reasons and compares? The contrast of inner and outer may, in fact, become the dominating contrast of the opposing series. Inward are the active, the eternal, the masculine, and the imaginative. Outward are the passive, the temporal, the feminine, and the rational. But in these allocations, reason, being placed in the outward series, comes into alliance with the feminine, which gives us pause. However, when we remember that Blake's feminine is a metaphysical feminine, that it is the outward, the natural, and the phe-

nomenal, the difficulty disappears. For it is with the world of feminine phenomena and what may be deduced therefrom that reason is concerned; when it becomes creative and exalted it rises into masculine imagination. The distinction has also the authority of tradition. In the passage just quoted from Plotinus, the discursive reason is associated with the "we ourselves" (the outward, the natural, and hence the feminine) , while imagination enters "from above," or in a variant figure, from within. This alliance of reason with the outward and passive feminine is basic in Blake's system from first to last. In the *Marriage of Heaven and Hell* reason is defined as "the bound or outward circumference of energy," and good is defined as "the passive that obeys reason." In the later prophetic writings reason seeks a static world; its only faith is in demonstration; it is continually in alliance with the outward and passive feminine. But the ideal of good which it proposes is continually challenged by the inner and imaginative masculine.

Imagination—the central virtue—is further paired in the outward series by the self. This antinomy also is in accordance with tradition and with the facts of experience. For the tradition, reference may be made once again to the association in Plotinus of the outward and the "we ourselves." As for experience, how else except by imaginative identification of our own self with another do we conquer our normal selfhood? And in these moments do we feel that we are ourselves, or that we are possessed by some mysterious power not ourselves that makes for brotherhood? It is only this inner power, this "not ourselves," that has the capacity for imagination and self-sacrifice. It alone has the life, the light, the vision. Should the outward and natural self come to entertain the idea that it is anything more than derivative and instrumental, its self-assertion would be utterly without vision—blind, selfish, static. It would be the assertion of which the pebble sings in the *Songs of Experience*:—

> Love seeketh only Self to please,
> To bind another to its delight,
> Joys in another's loss of ease,
> And builds a Hell in Heaven's despite.

The mistake of the fallen world, as we find it in the myth, is a religion and a society founded upon "the selfish virtues of the natural heart."

The two series might be extended further, but the main members are those already mentioned. Their relationship may be summed up thus: At the center is imagination, "the human existence itself," the one reality. It is divine—not ourselves; and it is, of course, eternal. It may also be thought of as inner, active, and masculine. As it manifests itself outwardly, in the world of self and phenomena, it is temporal, passive, rational, and feminine. But since the outward is only a manifestation of the inward, the antinomy is not truly a duality; the two are one. To use a traditional figure they constitute a tree of life, firmly rooted in the inward, active masculine, bearing its fruits in the outward, passive feminine.

But the dual principle is only half the story. It is united with another principle, equally fundamental, which is fourfold. The fourfoldness corresponds to the four eternal senses—the intellectual life, the emotional life, the creative life, and the sensuous life, in which the three prior powers come into harmonious manifestation or embodiment. Physiologically these powers are head, heart, loins, and body. This also is ancient, and as Blake thought, eternal wisdom. A tripartite division of man's powers, corresponding more or less closely to Blake's head, heart, and loins, was a commonplace of ancient psychology. The fourth element, the body, might have been suggested by the *Kabbalah*, by Philo, by Jacob Boehme, or directly by the nature of man himself. However, it is not man alone who is fourfold. The universe, which ought never to be thought of as separate and apart from man, is also fourfold, in all its height and breadth and depth; and the fourfold principle is subject to the twofold principle. Head, heart, loins, and body, in the macrocosm and the microcosm, are inner and outer, active and passive, masculine and feminine.

Had Blake's thinking remained on this analytical and abstract level, his drawings would resemble those elaborate representations which we find among the alchemists and the

Rosicrucians, and his writings would correspond. His greatness consists in his ability to transcend this level. He surveys the past, the present, and the future as a poet, a dramatist, a philosopher, and a psychologist. Hence his dual principle, whose various qualities may be summed up as masculine and feminine, becomes personified in cosmic men and women, acting with a considerable degree of sexual realism, yet always with extraordinary logical and psychological insight into the necessities of the situation from the metaphysical point of view. And his fourfold principle becomes Zoas, personal, living, even demonic. The Zoas invade and control the universe, shaping it into the form and image of a man, shaping every particle in it into human form, evolving Christ, who is the humanity itself. They work, not from the outside, like a deistic God, but from within, like the inward, creative forces which they are. They are the final causes—of the world as it was, as it is, as it is to be. Cosmic history, as well as human history, emanates from them. They are at once man and the universe and God.

These two principles—the twofold and the fourfold—are the warp and woof of Blake's metaphysics. When they function according to the divine plan, they create the life of Eternity, a twofold paradise consisting of a masculine world of creative energy and a feminine world of rational repose. The one is Eden; the other, Beulah. They embody and represent the law of contraries, by which all life is governed. Wherever you look, action and reaction, ebb and flow, energy and repose, will be found in operation. Without these contraries, Blake says, "is no progression." In the masculine contrary alone energy would be exhausted and have no means of recuperation. In the feminine contrary alone life would be a sleep with no awakening. The two together keep the wheel of life in constant motion.

But selfhood intervenes, and both principles attempt to work in accordance with their own, instead of the divine, plan. Head, heart, loins, and body fall from mutual harmony into mutual contraiety, each struggling for dominion. The relation of inner and outer goes into reverse, the outer principle, which is the self, seeking dominion over the inner principle, which is

the divine. The tree of life turns upside down; its roots are "brandished in the heavens"; its fruits depend "in earth beneath." The Fall is the progression into the outward, the passive, the feminine, and the rational.

It will be obvious that this reversal involves man in a complicated misery. In the eternal world the glory of the outer is its service to the inner. In art, in law, in religion, for example, the outward form is willing to be temporal and die before a fresh creative impulse. In the fallen world the religious dogma, the legal code, the artistic form, the social institution, all resist change, asserting their own permanence and sanctity. The eternal imagination, whose joy it is to create ever-changing forms in response to changing needs, is imprisoned within the lineaments of some form created in response to a need now superseded. This attempt to reverse the divine plan, were it successful, would deliver man permanently over to spiritual sleep or even death, but it succeeds only partially and temporarily. The energies may be thwarted or debased or maddened, but they cannot be destroyed. Even the selfhood will in time discover its mistake. Hence, though man lies asleep upon the Rock of Ages, with Life and Death, so to speak, contending over him, the ultimate victory of Life is certain.

The world beneath the stars or beneath the moon—Blake's fallen world—was considered by antiquity to be subject to necessity, a force of which the stars were looked upon as the agents or the symbols. It is to this world of necessity that the temporal cycle is delivered. Blake's myth recalls, in several aspects, the myth in Plato's *Statesman*, where it is said that God from time to time retires to his watchtower and lets the helm of the cosmos go, whereupon the world turns round and revolves in the opposite direction. Not only does Blake's fallen world revolve "in the opposite direction," but the Eternals, in the early prophetic books, retreat when the Fall is imminent, and cut themselves off, to all appearance, from the temporal cycle. Nevertheless, we must not suppose that Blake at any time believed that God abandoned man in his hour of need. Proclus argued that the outer world of necessity, even the severed world

of Plato's myth, was providential and part of the complete order. The necessity, or fate, to which this world is subject is not, he urges, "to be conceived as really external to the souls that undergo it, but as written in them in the form of laws which are realized according to the choices they make." The world of necessity is a kind of karma in which the errors of a previous life are experienced and cast out. Empedocles specifically defined the error. Fate, he said, was "the alteration from unity into plurality according to Discord, and from plurality into unity, according to Friendship." This is one phase of the error which brings Blake's world into subjection to necessity. But this world of necessity and apparent externality is "providential and part of the complete order." If in the early prophetic books Urizen, the eternal priest, falls, Los, the eternal prophet, falls too. He, the eternal prophet, the Poetic Genius, the indwelling divinity, is God becoming "as we are, that we may be as he is." The providential and redemptive aspect of the Fall receives greater emphasis in the later years, but it is always there. The path of experience is always circular. In the *Four Zoas*, the Seven Eyes of God are duly appointed to swing it round.

The path away from Eden and the return thereto have often been imaged in mystical theology as a spiral, descending and ascending; or as a cycle. The Ring of Return is a well-known mystical conception. In Blake's system the revolution embraces two or four stages, according to the depth of fall.

Even on the supernal level there is a rise and fall, a constant interchange of contraries, a wheel of departure and return. The exchange of Eden for Beulah involves descent; but so long as Beulah retains its faith in the values of Eden, the fall is not deep or severe, and the return is easy. But if in Beulah the error deepens and the circuit of return is closed, then the wheel has to swing "downwards and outwards," over a greatly expanded periphery, into the worlds of Ulro and Generation. For the punishment of error in Blake's system as in life itself lies in the bitter experience of error. When man decides, as he does in Beulah, without yet realizing the import of his decision, to live by the outward, the passive, the feminine, the selfish, and the

rational, he must be delivered over into the reality of his dream world in order that he may know it and renounce it. For experience, in Blake's system, is remedial. Error runs its course. The spiritual body, like the natural body, labors to throw off infection and in the end succeeds. The path of experience is therefore circular. When the error which may be described as Nature and Natural Religion becomes formulated in man's mind, the cycle over which it is destined to run takes shape and begins to move. This cycle, which descends from Beulah into Ulro and ascends from Ulro by way of Generation into Beulah, where it joins the supernal cycle, is the Circle of Destiny.

Throughout this study I take the prophetic writings as a single entity. This is possible because they embrace no fundamental inconsistencies. What have been taken as such are in the main owing to defects of interpretation. It is true that there are some differences in emphasis. Little, if anything, is said in the earlier prophetic writings about regeneration as a necessary element in the problem of liberation. The Godwinian doctrine of liberation alone would seem to be sufficient. Several years of bitter experience were to be required before Blake became fully aware of the darker half of the picture—the fact that man must become paradisiacal within before an outer paradise can be secured. "The sensual and the dark rebel in vain." Disillusionment did not cause Blake to turn reactionary, he remained a rebel to the end; but he had to work out more clearly and systematically the relation of rebellion and regeneration. A similar shift takes place in the theme of sex. In the earlier writings sex, while not without its overtones, is in the main direct and stark and bare; and free love is demanded without ado. But as the years pass, and the heydey in the blood grows tame, this demand, though never given up, is only one element in a view of sex that involves the entire cosmos. Other differences, such as the change from the twofold system of the early prophetic books to a fourfold system later, are in the line of direct development. On the whole the later prophetic writings are a logical evolution from the initial tracts.

II

The Characters

The Four Living Creatures, Chariots of Humanity, Divine, Incom-
prehensible,
In beautiful Paradises expand. These are the Four Rivers of Para-
dise
And the Four Faces of Humanity fronting the Four Cardinal Points
Of Heaven, going forward, forward irresistible from Eternity to
Eternity.

Jerusalem, p. 98.

IN A sense there is only one character in the myth. He is Al-
bion, the last of a long line of primordial cosmic figures with
which the Platonizing imagination filled ancient speculation
and which came down along esoteric by-paths through the Mid-
dle Ages and emerged again into the main highway of knowl-
edge in the Grand Man of Swedenborg. There was, for instance,
the Adam Kadmon of the *Kabbalah*, primordial and archetypal,
the image of everything that is above and everything that is
below, the sum of the ten divine emanations and the embodi-
ment, therefore, of all manifestation. There was also the heav-
enly man of Philo, ideal, incorporeal, incorruptible, not yet
sexually divided, pure intelligence—the first of the two Adams
in the Book of Genesis. And there was St. Paul's heavenly man,
the second Adam, the equivalent of Christ, who, though not
pictured in cosmic proportions, remained in his primordial per-
fection, the antithesis of the natural man. In these ideal figures
is man's dream of original perfection, tragically mocked by pres-
ent imperfection. The chasm between the dream and the reality
was bridged in Gnostic mythology by a cosmic man who falls
from his heavenly estate, suffers the dispersion of his members,
becomes entangled in a web of matter, but finally purifies and
unifies himself and reascends.

In all of these reveries Blake found poetic truth, and drew upon them to construct his own cosmic figure, Albion. The conception of the universe as a living being is common enough in ancient speculation. Blake conceived of it in human terms. One morning, as he was walking along the seashore near Felpham, the conception took the form of an ecstatic vision.

> In particles bright
> The jewels of Light
> Distinct shone & clear.
> Amaz'd & in fear
> I each particle gazed,
> Astonish'd, Amazed;
> For each was a Man
> Human-form'd. Swift I ran
> For they beckon'd to me
> Remote by the Sea,
> Saying: "Each grain of Sand,
> "Every Stone on the Land,
> "Each rock & each hill,
> "Each fountain & rill,
> "Each herb & each tree,
> "Mountain, hill, earth & sea,
> "Cloud, Meteor & Star,
> "Are Men seen Afar."

Albion, then, is the symbol, not of mankind merely, but of the manifold universe conceived as having the organic unity of a man. This unity, which Albion enjoyed before the Fall, and which is further indicated by the statement that he "anciently contained in his mighty limbs all things in heaven and earth," is lost when, like the Gnostic man, he descends into the world of matter; but, like the Gnostic man, he gathers together his scattered members and reascends.

Though in *Jerusalem* Blake identifies Albion with England, the universality of the symbol holds. Blake had by that time accepted the conclusions of certain antiquarians of his time that the Druids, the ruins of whose temples could still be seen at Stonehenge, were the ancient patriarchal people. They had scattered and peopled all the nations of the earth.

London cover'd the whole Earth, England encompass'd
　　the Nations,
And all the Nations of the Earth were seen in the Cities
　　of Albion.

Though Albion was the "parent of the Druids," his religion,
unlike theirs, was the religion of antiquity, the Everlasting Gos-
pel, the religion of Jesus, in which all peoples are one.

　　　The fields from Islington to Marybone,
　　To Primrose Hill and Saint John's Wood,
　　　Were builded over with pillars of gold,
　　And there Jerusalem's pillars stood.

And there, presumably, Jerusalem's pillars will stand again. "All
things begin and end in Albion's ancient, Druid, rocky shore."

　　Of the heavenly Albion we are told but little; he has to be
reconstructed almost entirely from his earthly counterpart and
from our knowledge of Eternity. He is a giant figure, his head,
heart, loins, and body identified with the outposts of the uni-
verse. The head of the unfallen cosmic man is in the south, the
loins in the north, the heart in the east, the body in the west.
At first sight these allocations may seem meaningless and ar-
bitrary, but, upon a little reflection, they will appear not
unreasonable, in view of the difficulty of equating the cosmic
man with the cardinal points. That the sun is in the south
is to the inhabitant of the northern hemisphere a matter of
daily experience. At its midday splendor it is also in the zenith.
To the south, then, and the zenith, the head of the cosmic
Albion, his mental sun, is logically assigned, and the loins,
conversely, will be allocated to the north, the nadir. The emo-
tional luminary of the cosmic man—the light of his heart—is
the moon. It may be thought of as having its natural habitation
in the "eastern cave" from which it sets forth nightly on a jour-
ney westward and outward. Since the heart occupies a central
position, the east becomes the center; while the west, where the
journey is completed, becomes the far horizon, the all-inclusive
circumference, the outline—the body. There he stands, then,
the cosmic man, one with himself and one with his universe.
No duality disturbs his unity. The heavenly Albion does not

distinguish between soul and body, between good and evil, between man and nature. Even the sexual duality is transcended; for Albion, like nearly all primal men, is sexless, or rather, bisexual.

Nevertheless, this unity has within it the potentiality of disruption, for it is at once fourfold and dual. That unity should be fourfold is a tradition so ancient and solemn that it carried in Blake's mind a special authority. Ezekiel had seen in vision the Holy Chariot of the Almighty as fourfold. Pythagoras, who learned according to one tradition from the Egyptian priests and according to another from the Druids, had taught that the sacred quaternion was the source of eternal nature. Unity is fourfold in the *Kabbalah*, as witness its four worlds and the four letters of the sacred, ineffable name—the Tetragrammaton. Four is basic in the Tarot cards, in Ptolemy's Gnostic system, in Rosicrucianism, and finally in Blake. The number itself is filled with mysterious potency, since its elements make ten, the complete and perfect number and the parent of all the numbers that follow. But the fourfoldness in Blake is also dual. Each of Albion's four great powers—head, heart, loins, and body—may be divided, as in Ptolemy's system, into masculine and feminine. If to the eight characters thus provided we add Albion himself and his feminine counterpart, we have the number ten, which is the natural expansion of the number four. Setting aside certain considerations which complicate the matter slightly, it is fair to say at this point that these ten are the characters of the myth. Its activities are theirs.

The earthly Albion is, as we should expect, the opposite of the heavenly Albion. He has fallen into an upside-down position indicative of a complicated spiritual confusion. The upside-down position may be purely metaphorical, as it is in Swedenborg, who tells us that the devils in hell are upside down, although they do not know it. However, if Blake believed that the cosmos was really upside down, he had the authority of Aristotle, who argued gravely that the south pole was the true "up" and that the cosmos appeared to be standing on its head. As a result of this fall Albion has become mortal, sexual, dark-

ened, disorganized. His mortal body lies asleep beside the sea of time and space,

> . . . stretch'd like a Corse upon the oozy Rock,
> Wash'd with the tides, Pale, overgrown with weeds,
> Yet mov'd with horrible dreams.

In a variant figure he has been rent (by the demon of duality) into countless multiplicity. His divided powers have been set one against another. Once, like Adam Kadmon, he "contained in his mighty limbs all things in heaven and earth." But now the starry heavens (a symbol of unity in multiplicity) have broken away, and the scattered portions of the cosmos are his *disjecta membra*. Like Osiris, he has been torn to pieces by the Typhon of evil. If Blake read Andrew Ramsay's *Travels of Cyrus*, he found this great myth interpreted as the destruction of the body after its desertion by the spirit. The soul of Osiris forsook the body which is nature, and Typhon tore it apart and dispersed its members. When man ceases to think of nature as spiritual, the universe loses its unity and becomes a multiplicity of incoherent and divided fragments.

A sharer in Albion's fortunes is Jerusalem, the feminine half of the mystical union of contraries which is Albion. Upon her rests the ineffable grace and glory that distinguish others of her line—the kabbalistic Shekinah, the Gnostic Sophia, Dante's Blessed Virgin, the Celestial Virgin of Boehme. She is, like Albion, an inclusive figure, the personification of his spiritual well-being, the result of the harmonious functioning of all his powers. She is designated as the sum of Albion's Emanations, the mother of his little ones, the aggregate of the Daughters of Inspiration, a tent and tabernacle of mutual forgiveness. She exists because in Eternity error is forgiven, nothing condemned. Among the children of Albion her name is "Liberty"—the liberty of regenerated souls.

I know of no other Christianity [writes Blake] and of no other Gospel than the liberty both of body and mind to exercise the divine arts of imagination—imagination, the real and eternal world of which this vegetable universe is but a faint shadow, and in which

we shall live in our eternal or imaginative bodies, when these vege-
table mortal bodies are no more.

Jerusalem is the fruition of this gospel and this liberty.

> In Great Eternity every particular Form gives forth or Emanates
> Its own peculiar Light; & the Form is the Divine Vision,
> And the Light is his Garment. This is Jerusalem in every Man.

The divine image of the unified life of Eden, Jerusalem is
among the first to be affected by the impending Fall. She comes
down in ruins over the entire earth the moment Albion's spir-
itual deterioration begins. In the temporal world Jerusalem's
throne is assumed by Vala, the "shadow" of Jerusalem. As the
shadow of Jerusalem Vala is not the fruition of the divine
vision, but an abstract ideal erected by the "holy reasoning
power." In his unfallen state Albion knows that spiritual well-
being is the result of spontaneous, imaginative living. In his
fallen state he expects it to result from a life that is selfish, skep-
tical, and rational. Under Vala's regency Jerusalem is exiled.
She wanders among "the dark Satanic wheels" which turn the
mills of rational thought, condemned as a harlot for her ac-
ceptance of all the facts of life. She is the Magdalen of the
fallen world, accused by the self-righteous as the "mother of
pity and dishonourable forgiveness."

For the source of the distress into which Albion and Jeru-
salem fall we must look to the four fundamental powers—head,
heart, loins, and body—in terms of which Albion's being is de-
fined. To them Blake gives the name Zoas, a name adapted
from the Greek word for the "living creatures" of Ezekiel,
with whom, as well as with the four beasts of the Apocalypse,
he identifies them. The responsibility of the Zoas for Albion's
distress is shared by their four feminine selves to whom Blake
gives the collective name of Emanations.

The psychological powers personified in the Zoas are in their
unfallen state the four eternal senses, with which esoteric doc-
trine endowed the primal and eternal man. In their primal state
they are flexible, expanding and contracting at will, giving

Albion now a unified world, now a multiple world, as his need
or his volition may direct; for

> . . . contracting our infinite senses
> We behold multitude; or, expanding, we behold as one.

Fallen, they shrink to the level of the five senses and, becoming
fixed, interpret life in terms of the multiple world apparent to
their contracted powers. With the unified world, the mystical
world of the One, as symbolized by the undivided Albion, they
have lost touch. They will not return to it until, having puri-
fied themselves, they become once more expansive. If the nature
of the Zoas remains mysterious, we have only to remember that
Blake has himself declared:

What are the Natures of those Living Creatures the Heavenly
 Father only
Knoweth: No Individual Knoweth, nor Can Know in all Eternity.

The four Zoas, as the divine energies, embody the mystery of
life itself.

It is because Blake conceives of these Zoas both as rebellious
forces precipitating the Fall and as the chief agencies for de-
liverance, that he supplements the human symbolism of head,
heart, loins, and body by a natural symbolism of earth, air,
fire, and water. He identifies the Zoas, in their failure to co-
operate in the well-being of man, with the four elements to
which man is subject. With the separation of the elements from
Albion, he ceases to be their master and becomes their prey.
The appearance of the four elements with the Fall is traditional.
In the beginning there was "one only element"; it fell into a
division of four. So writes Jacob Boehme and with abundant
authority. "And that is the heavy fall of Adam," he says fur-
ther, "that his eyes and spirit entered into the outward, into the
four elements, into the palpability, viz., into death, and there
they were blind as to the kingdom of God." A prey to the ele-
ments which beset him—his own powers in a state of contention
—Albion is, like Adam, blind to the kingdom of God. But there
is hope.

For the principle of the outward world passeth away again; for it

hath a limit, so that it goeth into its ether again, and the four ele-
ments into one again, and then God is manifested, and the virtue
and power of God springeth up, as a paradise again in the (one)
only element.

The doctrine is also Blake's. The four elements must return
again to the unity of Albion and his universe seen as one.

The psychological struggle, set forth as a war of the elements
for dominion over Albion, is Blake's war of the Gods. Its scale
is commensurate. The Zoas are giant figures whose impulses and
activities are reflected in every portion of the cosmos. Moreover
their war, like the contention of the elements, is never-ending.
As the psychological components of man in his struggle toward
the light they know the frustration of ages; but, like man, they
cannot be extinguished. Vanquished in the struggle, they die
only to be born again for renewed cycles of searching and strife.

It is in his presentation of the Zoas that much of the power
of Blake's myth lies. They are not the bloodless abstractions
common to allegory. Blake believed in them. They are in con-
sequence realities of the imagination, with power to terrify us
as they terrified their creator. No other poet has given us so
profound a sense of the helplessness of man before the primal
forces of life; and no other poet, so passionate a denial of that
helplessness. He fears these forces, because he sees them as
demonic, with power over him; but he takes hope from the
fact that these forces are in him—that they are himself. When
man shall have brought them again into harmony, they will
become once more his willing servants.

I

In presenting the individual Zoas it seems logical and con-
venient to begin with the head of the eternal man, proudly
erect in the zenith of the south. This is the abode of Urizen,
the Prince of Light, man's reason. But there are two reasons,
as all mystics agree, a higher and a lower. There is the mundane
faculty that is bound to the data of the senses, that seeks truth
in the external world and operates by means of analysis and
observation, that knows a thing only by its qualities and be-

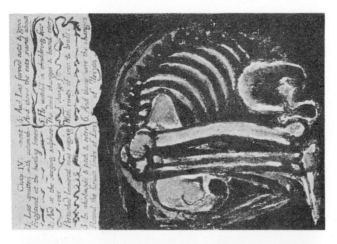

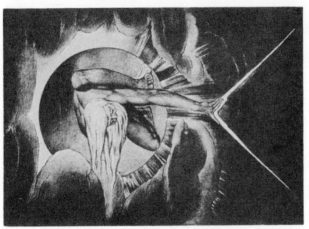

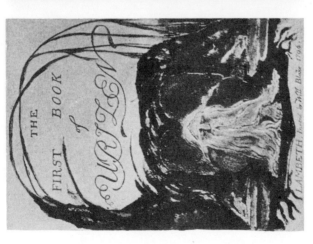

REPRESENTATIONS OF URIZEN

havior, that reasons about it and about and still finds ultimate truth elusive, that leaves man timid and skeptical. And then there is another reason, for which all mystics long and which they experience occasionally and momentarily in ecstasy, a reason that is the immediate perception of eternal truth. The seeker turns his gaze inward; sinks into a mood of contemplation; comes into communion with higher modes of being; and finally, if he reaches the goal of ecstasy, is almost or altogether deified and sees for a moment as God sees. Truth thus arrived at offers not the image and vestige of a thing, but the thing itself —the essence, not the qualities. It comes from union, not from demonstration; it brings a revelation, not an hypothesis.

In Eternity, when Albion's gaze was turned inward to the Divine Vision, not "outward to self," when his senses were flexible and large, when, in a word, the curse of the finite had not yet fallen, reason dwelt on a level such as we can now reach only in transcendent moments. Of this reason Urizen was the agent. We see so little of him, however, in his glory, that we cannot define his function in detail. We know that he is the Prince of Light, driving the chariot of the sun. We know also that he is a plowman and a sower, casting the seed of "eternal science" (complete illumination) upon the human soul. It is more important to remember that he is faith and certainty. No shadow of doubt concerning the cosmic scheme crosses his mind. It is his function to reason with the aid and support of faith in the Supreme Being, not (as Pope says) to

> Snatch from his hand the balance and the rod,
> Re-judge his justice, be the God of God.

This Urizen recognizes, until, seduced by doubt and selfhood, he attempts to alter the divine scheme and fails.

The attempt foredooms him to the abyss, but he arrests his fall. Coming to the edge and beholding in vision the spiritual chaos into which he is about to plunge, he takes upon himself the rôle of demiurge. He lays his compasses upon the deep and fashions a world out of chaos. Although his radiance is said to have faded, he can still bring Titanic energy to his task. In his

creative efforts he is reminiscent at once of the usurping demi-urges of the Gnostic systems and of the benevolent demiurge of Plato; for, while he boasts in the spirit of his Gnostic proto-types, "Now I am God from Eternity to Eternity," he intends well. Like Plato's demiurge he models his world, as far as pos-sible, on the eternal world. The memory of a lost Paradise pro-vides his pattern. Blake suggests the inferiority of Urizen's ra-tionally ordered world to the intuitive life of Eden by placing it at the level of the stars. In so doing he is making use of the ancient tradition that the supernal world lay beyond the stars, which were not in the beginning and which arose with a regres-sion from their ineffable source.

But how maintain an Eden by command when the spirit is unregenerate? How recover an eternal world when one distrusts the eternal plan? Like the Gnostic demiurge in the system of Basilides, who built an astral world and ruled until the time of Moses, Urizen builds an astral world and rules until the time of Noah. At that time he can no longer maintain the world he has created. He crashes from the level of the stars, where he had arrested the Fall, into the abyss, out of which arises the mortal world.

At this low level Urizen is an impotent figure. In the world of space and time he is little more than the counterfeit present-ment of his former self. Here he is the eternal priest, bound to the limitations of the mortal world by Los, the eternal prophet. The light of his mind and the creative power of his hands have passed to Los. Urizen is now the creeping, earthly reason, blind and aged, dependent upon the witness of his senses, seeking to buttress his feeble faith by demonstration, looking outward to self and nature, his faith changed to doubt, his certainty to negation. To suggest this degeneration, Blake makes use of a physiological change. The brain, which once was expanded on every side (as the *Kabbalah* says), is now confined in a dark cave, roofed over with a stony skull. The image merges the kabbalistic skull with the cave of Plato. The restricted mind of the walled-in skull delivers man to the corporeal life of the Platonic cave, in which only imperfect shadows of reality are perceived.

But our portrait of Urizen is not yet complete. He rouses himself from the lethargy which follows his fall to make one more effort toward dominion. What he could not accomplish in his astral world by Titanic rational energy he now undertakes to accomplish by means of guile. This, Blake believed, was the sequence of history; it is also the sequence of Satan's efforts in *Paradise Lost*:

> . . . our better part remains
> To work in close design, by fraud or guile,
> What force effected not.

The result is Mystery, with its ceremonies, its angels, its hierarchies, its promise of an "allegorical abode where existence hath never come." These are Urizen's new inducements to obedience to the laws which he imposes. The device is only too successful. Urizen is undone by his auxiliary. He must henceforth drag the web of religion, hopelessly entangled in his own creation. He who created Mystery for his own ends becomes its vassal.

Such, then, is Urizen, who by picturesque appellations and impressive drawings has been made the most familiar of Blake's characters. As the self-appointed guardian of man's moral welfare, he is the great Spectre, Old Nobodaddy, the Schoolmaster of Souls, the Father of Jealousy, the God of This World. In the first stage of his descent—as the demiurge, laying his compasses upon the deep—he is a superb figure. Less grand, his light and energy extinguished, but his giant form still suggestive of the demiurge, he sits blind and shackled, a tragic delineation of reason impotent. Declined still further, he is a shrunken figure, blind and aged, seated beside the rock whereon the mortal Albion sleeps, writing his commandments on tablets of stone beneath the Tree of Mystery. As the eternal priest he is portrayed reading from his books of brass and iron; as Mystery's vassal he sits helpless, caught in his own net, the "web of religion." As the "idiot questioner" who has reduced the world to abstraction he is a bony skeleton. No figure is drawn so often. The villain all but becomes the hero of the myth. Even when

he has lost his demiurgic fire, and sunk to mere negation, he carries on with a dogged persistence worthy of an immortal. I do not know where there is such another picture of tireless, endless, selfish persistency. For the laws fail and have to be rewritten; the books of brass and iron have to be interleaved. There is no respite from toil and care.

> But still his books he bore in his strong hands, & his iron pen:
> For when he died they lay beside his grave, & when he rose
> He siez'd them with a gloomy smile; for wrap'd in his death clothes
> He hid them when he slept in death. When he reviv'd, the clothes
> Were rotted by the winds; the books remain'd still unconsum'd,
> Still to be written & interleav'd with brass & iron & gold
> Time after time.

On he goes, consumed with care, bewildered with a host of problems of his own rational begetting, problems for which with the delusive arts he now employs he can find no solution. He is not consciously hostile to man; on the contrary, he pities him and would willingly save him at any cost except his own. In Urizen's stubborn selfhood there is the pity and terror of great tragedy, for it is a picture of mankind muddling along through the centuries, seeking El Dorado by every path except the right one, trying every means of salvation except the selfless one which alone will save. The thought of Urizen's capacity to carry on, if not fully to achieve his purposes, often frightened Blake—his mystical faith that regeneration was at hand being challenged by his rational observation of error's endless power to renew, his vision of the New Jerusalem being haunted by the eternal serpent's round of error. When shall Urizen, the usurper, the false guide, be recognized for what he is?

> Tho' thou art Worship'd by the Names Divine
> Of Jesus & Jehovah, thou art still
> The Son of Morn in weary Night's decline,
> The lost Traveller's Dream under the Hill.

The figure of Urizen in its completeness includes his feminine self—his Emanation—who is named Ahania. She is the most difficult of all the Emanations to understand. This is partly on account of the scarcity of evidence. She does not occur at all

in the later prophetic books; she passes off the stage early in the *Four Zoas*, and the *Book of Ahania* is not very helpful. Fortunately we can read our meager facts in the light of theory. In a general way the function of the Emanation (the feminine self) is clear. She exists for the repose and the renewal of the male. The analogy is from nature. Out of nature's passivity comes energy in ever new and living forms. So, too, in Blake, has each fundamental power, each living energy, a passive self in which it is reposed and renewed. At the same time this passive feminine self would seem to be the fine fruition of the inner masculine self. Again the analogy is from nature. The plant produces the flower; the ripened flower renews the plant.

What we are told of Ahania fits this conception of the feminine life. She is at once Urizen's repose and the source of his energy. In conjunction with Ahania Urizen is illumined with celestial light; he is the plowman and the sower, setting forth in the morning, his "hand full of generous fire," to scatter the seeds of "science" (Blake's term for the higher enlightenment) upon the soul. The *Book of Ahania* sets forth in sexual imagery this fruitful relationship of Urizen and Ahania. Elsewhere she is called the "cornfield" and the "vegetater happy."

What then is this mysterious self in which Urizen is rested and renewed? Blake terms it desire—desire which is later to be thought of as sin. It might easily be supposed that desire has here a specifically sexual connotation. Doubtless the intellectual stimulus afforded by gratified desire is one aspect of Ahania's fruitful influence upon Urizen. But Ahania's significance is wider than this. I think there can be little doubt that in Ahania we have the desire which Hindu philosophy repudiated in its quest of nirvana. She is in that case the whole of the mind's desire, whatever its character. Evidence for the assumption is supplied by the early prophetic books. The *Book of Ahania* makes it clear that the repressive ethics which arose in Palestine sprang from the repudiation of Ahania, while the *Song of Los* identifies that same ethics, which it symbolizes by Noah, Abraham, and Moses, with the abstract philosophy of Brahma. But were evidence lacking, the logic of Blake's system would demand

this wider interpretation. The Zoas are one within another. Urizen's desire must maintain his contact with them all. Despite the scope thus given to desire, we must not dismiss too lightly the sexual imagery in which Ahania is described. Since the contraries of life are sexual, the desire of one contrary for another, no matter to which plane of a fourfold existence it belongs, is in its final analysis a sexual desire.

As the principle of repose, Ahania is essential to Urizen's activity. She is the fallow period, the interval of "wise passiveness" in which the mental soil recovers its fertility. In this form Ahania provides for Urizen his contemplative life. She is the "dim waters" by which he laid his "head in the hot noon day after the broken clods had wearied" him, and where his "horses fed." She is in this capacity the subconscious moods of revery and dream out of which psychologists now say, and artists have always known, the creations of the mind take shape. She is essential to Urizen's fullness of comprehension, for she is also his intuitive and visionary self. The visions Urizen enjoys in his undivided state are the visions of Ahania. When she is lost to him, his intuitive perceptions fail, and he falls back upon his organic senses.

The eventual loss of Ahania is made certain by the ethical division of desire into rational and irrational forms. In its irrational forms desire was looked upon as a somewhat unmanageable element, the black horse of Plato's chariot; in its rational forms it was considered as rising toward the Absolute. The division led more and more in the direction of asceticism, and finally realized the danger implicit from the beginning. Plato had taught that the beauty of objects of sense stands as a mediator between mortal man and absolute beauty. Aristotle had taught that the lower form was potential in the higher. Logically, then, man cannot condemn the desire which arises from the objects of sense without impairing the desire which looks to absolute beauty. He cannot attack a portion of desire without attacking the whole of it.

Blake sounds a warning early. The Ahania who is enshrined in the western wall of Urizen's temple must be fed upon sacri-

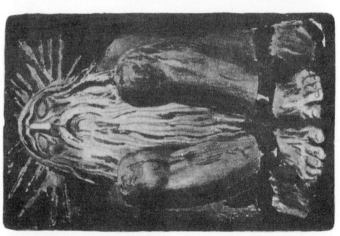

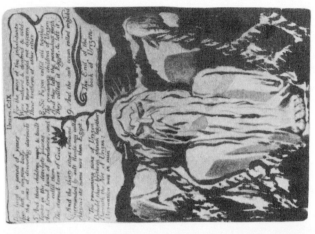

FURTHER REPRESENTATIONS OF URIZEN

fice. As the higher form of desire, she is magnified at the expense of the so-called irrational desires, and by being so magnified, is in danger of extinction. She is well aware of the insecurity of her position. When Urizen visited

> . . . the Labyrinthine porches
> Of his wide heaven, Trembling, cold, in jealous fears she sat
> A Shadow of Despair.

The danger to Ahania of a repressive ethics is emphasized by the scheming of Los and Enitharmon (Time and Space) to bring Ahania into the vortex of the Earth-Mother, who has descended into matter. If desire can be made to seem material (even in its irrational aspects), Ahania is doomed. Hearing the lamentations of Enion, the Earth-Mother, Ahania peers into the void, "and never from that moment could she rest upon her pillow." She foresees that condemnation of the pleasures of sense will extend to condemnation of all pleasurable things.

Urizen's break with Ahania comes when he sees in his unqualified acceptance of desire his own betrayal. In a vision of the future which she brings him he discovers that he has become a victim of his passive and indulgent self and that in so becoming he has been led to formulate a religion in which his rival, Luvah (the emotional life), is to be more powerful than he. Ashamed of his weakness, and thinking to avert the consequences, he names Ahania "Sin" and casts her out. Reason, in its search for the supreme good, has become ascetic. It has passed beyond the Greek condemnation of irrational desire to the Hindu repudiation of all desire. The speech which accompanies the repudiation of Ahania, though biased with anger, provides the only direct expression of her qualities.

> Shall the feminine indolent bliss, the indulgent self of weariness,
> The passive idle sleep, the enormous night & darkness of Death,
> Set herself up to give her laws to the active masculine virtue?
> Thou little diminutive portion that dar'st be a counterpart!
> Thy passivity, thy laws of obedience & insincerity,
> Are my abhorrence. Wherefore hast thou taken that fair form?
> Whence is this power given to thee? Once thou wast in my breast
> A sluggish current of dim waters, on whose verdant margin

A cavern shagg'd with horrid shades, dark, cool & deadly, where
I laid my head in the hot noon after the broken clods
Had wearied me: there I laid my plow, & there my horses fed.
And thou hast risen with thy moist locks into a wat'ry image
Reflecting all my indolence, my weakness & my death,
To weigh me down beneath the grave into non Entity,
. . . Thus I cast thee out.

Separated from Ahania, Urizen becomes the "selfish father of men." A spirit of wrath replaces the tolerance toward which his feminine desire inclined him. It is easy to see why Urizen's distrust of the pleasurable aspect of Ahania's influence over him should make for disaster. For pleasure, as Philo wrote, decrying it, brings the mind and the sensations together. Blake disagrees with Philo in looking upon such a conjunction not as a calamity, but as a necessity. So long as an intuitive understanding of the objects of sense is maintained, the senses are the feeders of the mind; when that understanding is lost they are the mind's destroyers. With Ahania cast out and his intuitive comprehension gone, Urizen is overwhelmed by the world of sense, incapable of seeing that it, too, is holy. Thus overcome he loses the power to create and becomes an impotent figure.

Cast out, Ahania is said to wander on the verge of nonentity and to be the "mother of pestilence." The conclusion is logical. For Ahania stood not only for Urizen's comprehension of the world of sense and hence his tolerance of it, but for the renewal of his mental energy. With her suppression the rhythmic alternation of energy and repose by which all life is characterized is disturbed. Mental energy is automatically inhibited. Albion could know no greater disruptive force. A moral and spiritual pestilence follows.

II

The heart of the giant Albion, at once the centre and the east, is the domain of Luvah, the emotional life. He, too, is a luminary, lighting the night of the intellect in its failure with the moon of love. Without this ministration, Eden, toward which Luvah travels in his nightly western course, could not subsist.

For the moon of love signifies the forgiveness of sin, the constant fulfillment of the religion of Jesus. No matter what mistakes may be committed, no matter how distraught the world may be, the solution of the problem, though unapparent to the mind at present, will eventually be found if only the emotions remain forgiving. For this reason Luvah shares with Urthona, another of the Zoas, the distinction of being a keeper of the gates of heaven.

> Mutual Forgiveness of each Vice,
> Such are the Gates of Paradise.

But Luvah is more than forgiveness. He is the whole gamut of the emotions, especially the active emotions as opposed to the passive ones personified in Vala, his Emanation. Conspicuous among the active emotions is the "eternal delight" which Blake associated with energy. In his unfallen state, when energy has not yet been restrained, Luvah is that delight—the characteristic Blakean joy that springs from a believing head, a loving heart, a creative imagination, and open, vigorous senses. Therefore he is the cupbearer, serving the golden wine around the eternal tables.

Though Luvah, like the rest of Albion's four great powers, has both a masculine and a feminine self, he is feminine in relation to the other Zoas. The heart has always been personified as feminine in contrast to the masculine head. The mind and the emotions are the male and female of many systems. Blake suggests Luvah's feminine character by making him a weaver, an occupation which distinguishes the feminine characters of the myth. In the looms are woven man's spiritual clothing. Its character depends upon whether the emotional life is vengeful or forgiving. The feminine emotions produce both the web of life and the web of death.

Since love plays so large a part in Albion's spiritual struggle, Luvah is the very substance of the myth. He is the point of man's departure from Eden, and the goal of his return. At the summit he is Christ; at the nadir he is Satan. He runs a course from the self-sacrificial love of Eden to the hatred and cruelty and

vengeance which distinguish the religions of the fallen world. This wide range of emotional activities is personified in part by Luvah in his various forms of Luvah, Orc, and Satan, and in part by his feminine consort, Vala, who in her fallen state carries the rôle of Rahab, and who is seen in multiple as the Daughters of Albion.

In his Christ-like and essential self Luvah suffers a continual crucifixion under the law; in his rebellious form of Orc, the anti-Christ, he is tormented as evil; under the Tree of Mystery, as the rebel Orc, he is tamed into Satan. He may appear in several of these rôles at once, as he does in life. Only after a Last Judgment shall we see love once more integrated.

Luvah starts on his downward path when he bargains with Urizen for the Chariot of the Day. Fired with an ambition that has its roots in an overweening pride in his own glory, he sets out to usurp Urizen's place as the light of the world. Successful in this attempt, he seduces Albion into a quest for righteousness in which the emotions, and not the mind, are to be the guide. His success ends in disaster: Luvah, like Lucifer, descends into the pit. The episode is modeled in part upon the disastrous ride of Phaeton. So, too, are the consequences. In Ovid's myth the heat of Phaeton's chariot awakens the sluggish polar serpent into frenzy. In Blake's myth the attempt of Luvah to drive the Chariot of Day brings into being the primal serpent whose appearance presages a fall and a temporal world.

As the Fall impends, Luvah and Urizen are in agreement. Luvah is proud of his passive self, and Urizen is proud of his prospective rôle as the great administrator of passivity. Urizen writes his laws of "mercy, pity, peace," laws which are intended to establish the dominion of the passive good personified in Vala, Luvah's feminine self. At the same time these laws will establish Urizen's position as the great lawgiver. Before long, however, Luvah's energetic self, maddened by the restraints imposed by Urizen, bursts forth in revolt. The personification of this revolt is Orc.

As a revolter Orc is an apparition of evil to the orthodox. They see him as a

Blasphemous Demon, Antichrist, hater of Dignities,
Lover of wild rebellion, and transgressor of God's Law.

He is pictured as a fiery demon, a dragon form, a purely anarchistic figure, "red Orc." "War," writes Blake, "is energy enslaved." When man builds his social structure by negation he may expect the fiery form of revolt and revolution. But, though the rational mind fears the fiery form of Orc, the imaginative mind knows that it is not evil, but rather an indictment of evil, a revelation of the mistaken character of the authority which has brought it into being. Orc is the personification of a deathless phenomenon, the spirit of revolution that arises when energy is repressed. Even Urizen recognizes in him the frustrate idealist,

. . . feeding thyself
With visions of sweet bliss far other than this burning clime.

In his temporal, "generate" form of Orc, Luvah is the child of Los and Enitharmon, who, as we shall presently see, are the spiritual regents of the temporal and fallen world. Like all revolt, Orc threatens to destroy the existing order. Los, in his fear for the order which he represents, is the true reactionary. He binds down Orc on the mountain top "beneath Urizen's deathful shadow." The authority of the law which Orc denies has been established. Incidentally the foundation of a religion of Mystery has been laid.

The suffering of the bound Orc is Promethean. Blake returns to its description again and again. His is a living death in quenchless flames. In it is all the torment of man who cannot endure his subjection to the God of vengeance in whom he nevertheless believes. Under such a God the deathless spirit of revolt forever latent in the heart of man becomes the unforgivable sin of blasphemy.

A shrewd method of dealing with revolt is to offer a meretricious compromise. This is the method that Urizen adopts in dealing with the rebellious Orc. A religion of Mystery, embellished with anodynes for present pain and with the promise of an "allegorical" heaven in which earthly injustice shall be re-

dressed, is offered by Urizen to Orc for his appeasement. Orc accepts the offering. He goes up the Tree of Mystery, losing as he does so his dragon form and becoming a serpent. In this form he is the serpent, Satan. He shows the subtlety of the serpent in that the Tree eventually becomes his. He shows the hypocrisy of Satan in that he suffers himself, an agent of revolt, to be tamed into an agent of acceptance. However, though Orc has been tamed, the spirit of revolt is not dead. It remains in the heart of man, a potential challenge to external authority and mistaken dogma. Later in the myth Orc provides the spark which consumes the Tree of Mystery, and the holocaust of a Last Judgment is his. Freed from his fetters, he provides the cleansing fire which destroys the whole temporal fabric. In these fires Orc himself consumes, appearing again in his eternal form of Luvah.

Vala, Luvah's feminine self and the passive emotional life, shares with Urizen and Luvah the weight of Blake's condemnation. In the *Laocoön* drawing Blake inscribes beneath the serpent on the left the word "Good" and the Hebrew word for Lilith, Adam's first wife; while nearby stand the words "Satan's wife, the Goddess Nature." In this sequence Vala's rôle is detailed. She it was who, by her intrigue with Albion, first turned man in the direction of the Fall. Her conquest of Albion means that he now defines the good life in terms of the passive emotions. Mercy, pity—the passive emotional life in all its aspects—constitute the new ethical ideal. Lilith, the seducer, is Vala, the good. Conceived of as an abstract good, Vala is the rationally built "shadow" of Jerusalem. As her substitute she is also her destroyer; for she personifies a selective principle, as Jerusalem personifies an inclusive principle. Under Vala's regency the active energies are condemned, and Albion is led away from Christ into the toils of Satan, the Accuser, whose wife Vala is therefore said to be. Furthermore, Vala's ascendancy to power is accompanied by the ascendancy of the whole phenomenal world, for the ideal which she represents is external and feminine. When woman attains to power over man, she gives character to both his ethics and his cosmos. A religion of au-

thority is attended by a philosophy of materialism. Nature and Natural Religion imply a feminine dominion. Vala, who is the source of this unhappy change, comes to be seen as "nature, mother of all." Her relation to nature is, however, ethical, not physical. She is not the outward body, but the ethical force behind it.

At the outset of her career and in her true nature Vala represents the gentle feminine emotions. As such she is the ideal which possessed Urizen when, in the early prophetic books, he came back from his "dark contemplation" bearing his laws of mercy, pity, peace—the ideal which in the *Four Zoas* Luvah left sleeping in Albion's brain. As such she is the "lily of Havilah," the pure and the good, with which the rationalizing Albion falls in love.

However, it is one thing to arrive at mercy and pity spontaneously and quite another thing to make of these virtues an abstract and rational ideal. Vala, who in her spontaneity was loved for her gentle purity, proves a jealous mistress. Albion soon learns that the passive feminine emotions can be achieved by selfish and rational means only at the expense of the active masculine energies. As a consequence Luvah is forced to "die the death of man for Vala, the sweet wanderer." The pursuit of love is carried on even at the cost of love itself.

It is because of this sacrificial character of the Good when it ceases to be spontaneous and becomes an ineffective rational ideal, that the love which Vala represents is seen as "sexual love" —a love given over to jealousy and hatred and cruelty. It is because of this same sacrificial character that she is seen, too, as the Goddess Nature; for Nature is Blake's symbol of a cruel, unregenerate life. The beauty, the deceit, the cruelty which Blake sees in nature are for him the outward witness to an inner force which is Vala in her unregenerate form—the feminine emotions in a selfish struggle for dominion over man. Vala is the heart of nature in this sense, its ethical import. It is from this fact that such cryptic phrases as "nature's cruel holiness," and "the selfish virtues of the natural heart," derive their significance.

We hear very little of Vala during the period of Old Testament history which follows the Flood. The mildness which is her nominal self does not characterize that period. It takes its character from Orc, who comes in a spirit of revolt against the suppression of energy for which the usurping Vala stands. Old Testament history, as Blake presents it, emphasizes the masculine contrary—Orc rather than Vala. It is characterized by revolt, and is dominated by a God of wrath.

Vala reappears in New Testament history in the guise of Mystery. She reaches the height of her power when, as Rahab, she attains to dominion over the Christian Church. What Blake means by Mystery may be stated briefly. It is a religion of externalities and ceremonies. Its remote and jealous God may be apprehended only through a mediator. It promises as a palliative for earthly injustice another life in an "allegorical abode." It offers absolution in return for submission and obedience. In short, it accomplishes the supremacy of Vala, the passive feminine emotions, by deceit and hypocrisy.

This, as Blake sees it, is the nadir of the religious life. The true God, who is Christ, is in the breast of every man. He is not, like Satan, a secret God. He does not disguise himself in the trappings of Mystery.

> I am not a God afar off: I am a brother and friend;
> Within your bosoms I reside, and you reside in me.
> Lo! we are One, forgiving all Evil, Not seeking recompense.

In contrast to the reality of the Eternal God, everything that Mystery offers is unreal. It pretends to love, but practices hate. It pretends to forgiveness, but practices envy, revenge, and cruelty. Nevertheless, the rational mind, weary of the long and futile struggle to subdue energy which cannot be subdued, turns eagerly to the new Mystery religions, among which Blake would have placed medieval Christianity. It worships Vala (the passive emotional life) at the command of a remote and transcendent God who promises an "allegorical" heaven in return for obedience. It does not know that in her man is worshipping his own feminine, sexual, and natural qualities. She

is in this rôle "the nameless shadowy female," a phrase Blake doubtless chose to parallel the "unutterable name" by which he alluded to the Satan whom man worships "under the name of God." He is, of course, satirizing the Jewish use of the name Adonai for the name Jehovah, too holy to be spoken; but he is giving us at the same time a picture of the Satanic God as he sees it—holy, elusive, unapproachable. This God is Urizen, his secret holiness, Vala.

Because the love and pity symbolized by Vala in her rôle of Mystery are meretricious, because they are but colossal sentimentalities by which the mind deludes itself, Blake calls her the harlot of Urizen (the rational mind). He identifies her with Babylon the Great of Revelations. In her, drunk with power and blood, is Mystery's fulfillment, but its origin was long since. Vala, who is Babylon, the harlot of the New Testament, is also Rahab, the harlot of the Old. A "sinless soul," "Albion's bride and wife in great Eternity," she becomes in her unregenerate form Vala-Rahab, the personification of unrighteousness.

Vala's final metamorphosis comes when, stripped of her garments of Mystery, she stands forth as Deism, which teaches that man is by nature good. The doctrine was anathema to Blake, the self-righteous assumption of the unregenerate. In Deism, the starkest of all religions, there is revealed, stripped of its obscuring garments of Mystery, the selfish desire of the female to dominate man. This is man's ancient holiness, the holy selfhood by which he fell. "O cruel pity! O dark deceit! Can Love seek for dominion?" cries Albion in his prophetic dread. Blake's answer is not only that it can, but that it has. The result has been six thousand years of Natural Religion.

Vala, for whose selfish exaltation these religions have all been devised, is pictured as a genuine seductress. Blake himself was afraid of her. And why not? She had sundered a universe by her religion of Good and Evil. She had fostered a "female will." She had imposed a feminine passivity upon the masculine energies, which are the "only life." She had made woman triumphant over man in a "sexual" ethics and a material philosophy. In the symbolism of the myth she had wrecked the cosmos.

Urizen and Luvah, who represent the head and the heart of the giant Albion, are easiest to understand. Urthona, the next of these apocalyptic figures, is considerably more difficult, for his rôle, being that of the "essential" man, is both intangible and comprehensive. In his temporal form of Los he is fittingly identified with the loins, for he is the great creative and seminal principle of the myth. In this form he is the arbiter of the world of Generation seen as an image of regeneration. Without him there would have been no spiritual rebirth.

Urthona, as the eternal form of Los, is identifiable with the Poetic Genius. In his temporal form he functions as the spirit of prophecy. This creative spirit which manifests itself in the poet and the prophet is the essential man. When Albion's fall is formally announced at the beginning of the *Four Zoas*, it is not Albion who is named as having fallen, but Los, the temporal form of Urthona, who is Albion's essential self.

> Los was the fourth immortal starry one. . . .
> Daughter of Beulah, Sing
> His fall into Division & his Resurrection to Unity,
> His fall into the Generation of Decay & Death & his
> Regeneration by the Resurrection from the dead!

Though the Poetic Genius falls, it struggles for the recovery of the eternal world. Of all the Zoas, Urthona alone "kept the divine vision in time of trouble." The essential man may fall, but he can never die.

The *Marriage of Heaven and Hell* tells us that the Jews identified the Poetic Genius with the First Principle. The identification seems to have been made in Urthona. He bears so close a resemblance to Boehme's First Principle that it seems reasonable to suppose that Blake had it in mind. All the darkness, the anguish, the contrariety, the strife, the continual will-to-be, expressing itself in a never-ending generation, which characterize Boehme's First Principle, and out of which, as out of a dark and consuming fire, a beneficent light comes, characterize the Urthona of our myth. For he, too, engenders the light. He is

Dionysus to Urizen's Apollo, the night over the grave of which day has its temple. He and Urizen are like the dark and light faces of the Zohar, antipodal poles of a single force. In Urthona we have the fires of genius, which to the unregenerate look like "torment and insanity," but without which, Blake tells us, the rational mind would soon be at a standstill. In Urizen we have the rational mind in a state of illumination, which springs, like Boehme's light, out of the dark and consuming fire. The fires are, of course, the fires of genius in the forge of the great smith, Urthona, who is heard relentlessly hammering in the darkness of the subconscious at the substance of thought. The close relationship of Urizen and Urthona was recognized in the early prophetic books, where the Fall was attended by the separation of Los and Urizen, and the task of rebuilding a world was given to Los. The separation of Los and Urizen is Blake's dramatization of an idea that was gaining momentum in his own day and came to a climax with Kant—the idea that there is a form of intelligence superior to the rational mind which the Enlightenment had extolled. By this superior intelligence, Blake believed, man once lived. Then Urizen and Urthona functioned as one. When man came to live by a lower intelligence, the two were separated. That is why, in the *Four Zoas*, Los is made to say to Enitharmon, "In the brain of man we live, and in his circling nerves," and why with the Fall he is said to have descended into the loins. Two levels of imagination are implied.

In the natural world, in which these great powers live in a state of separation, Urizen feels that destiny is his. He goes into the north (the region of Urthona) to peer into futurity. He sets bounds to destiny, he formulates iron laws, he expends a Titanic energy to maintain a static world, but he cannot alter this fundamental fact: futurity, which is essentially a world of change, is Urthona's. The whole of Becoming is in his hands.

It is because of this wide scope given to the Poetic Genius that Urthona is the most obscure of the Zoas. If we would understand him we must enlarge our conception of the Poetic Genius to include the impulse to create that underlies all life,

the impulse that is, perhaps, life itself. Deity has no wider implication.

Urthona's fall into division is not merely into the duality of male and female with which we are now familiar, but by the addition of a Spectre, into a triad, consisting of Los, Enitharmon, and the Spectre of Urthona. In Los and Enitharmon we have Urthona's masculine and feminine selves. In the Spectre we have the "reasoning negative," man's natural fear of a world that now appears as dual. In short, Los, Enitharmon, and the Spectre constitute Albion's conception of Being, as it is reshaped by the Fall.

The existence of this trinity is coincident with mortal life. It was occasioned by the Fall, it contributes to the Return, and ceases when time ceases. It is doubtless Blake's parallel to the Gnostic division of the Godhead, for purposes of creation, into one female and two male forms. Similar triads are found in Hindu and Hermetic systems. The division corresponds to the age-old division of man's powers into head, heart, and loins. Its appearance here within the Poetic Genius is but a parallel to the larger triadic condition within Albion himself; for Blake uses the triad of head, heart, and loins to suggest the threefold world which follows the destruction of the fourfold unity of Eden. This fourfold unity is imaged as the giant Albion, in whom man and his universe are one. When Albion's unity is destroyed, the eternal or unified body disappears and there are left only his component parts—head, heart, and loins.

Los, as the creative power symbolized by the loins and the temporal form of Urthona, is a central figure in the myth. As the fallen form of the Poetic Genius he is indispensable. He is pictured as wresting the Mundane Egg, the Generative world, out of the chaos induced by the Fall. He is the real arbiter of mortal life. We know him as the spirit of prophecy; we know him also as Time. The two functions go properly together. The very conception of time suggests its own end. In Blake's philosophy "Time is the mercy of Eternity," set going on a circular path to bring man back to Eternity when his errors shall have been resolved. This is the path traveled by Los, the spirit

of prophecy. He labors to bring the eternal world again into
being. Since he cannot do so without bringing his own world
of prophecy to an end, his is also the function of time. He is
therefore an historical, evolving figure. He is the kind and
degree of spiritual insight which man has in the successive
stages of his progression. Looked at from this historical and
evolutionary point of view, the apparent inconsistencies of his
character fall into harmony. In appraising his inconsistencies
we must remember that Los, no less than the other Zoas, suffers
an infection because of the Fall. Urizen's invasion of the North
(the substitution of rationalism for intuition) leaves prophecy
spectre-haunted and dominated by fear. It makes it cruel and
vengeful, or leaves it bewildered and impotent. Nevertheless,
we are to think of the prophetic spirit as invincible, as carry-
ing man somehow, despite imperfections, in the direction of a
reunited world. One of the unforgettable things about the pro-
phetic books is Los's incessant hammering on the anvils of time.
It is Blake's dramatization of the spiritual energy which he be-
lieves error may weaken or confuse, but never still.

As the spirit of prophecy, Los becomes the illumination of
the mortal world, replacing the sun of Urizen, who has fallen
into the abyss. He is indeed the sun of the natural world, as
Urizen is the sun of the eternal world, for there are two suns in
Blake, as there are in Swedenborg. The spiritual sun is the
pure intelligence of the unfallen Urizen. The natural sun is the
spiritual illumination created by Los when Urizen sinks into
total darkness. To this fact Los owes his name; for, as Professor
Damon has pointed out, "Los" is the reversal of "sol," as "Orc"
is, in effect, the reversal of "cor." The fitness of these names is
due to the fact that both sun and moon are in retrograde move-
ment. Both the head and the heart have turned the current of
their being away from God. In the early prophetic books Los
welds the scattered portions of light into a sun. This is the very
much blackened sun of the "dark religions." But, as in astro-
logical myths, the sun is reborn at the nadir of its decline, so
does the natural sun of the "dark religions" end in illumination.
The prophetic line terminates in Christ.

Los lays the foundation of Golgonooza, Blake's counterpart of the New Jerusalem, when, with Urizen's failure, the control of Albion's affairs passes into his hands. We may suppose, therefore, that he is conscious of his objective from the first. Ages, however, are needed to attain it. He has first to set his own house in order; he has yet to discover that he is himself in need of regeneration. In his prophetic labors Los passes through three stages—an unregenerate period, a regenerate period, and an inactive period.

The first phase of Los's activity is in the spirit of the Old Testament history. He is haunted by fear and animated by revenge. He binds down Orc. He enforces the moral law. Then he suffers a change. He "modulates" his fires. He teaches "peace to the soul of dark revenge." He loses all thought of self and practices forgiveness of sin. The spirit of Christ has become manifest in man. At the climax of Los's labors time might conceivably have come to an end. Indeed, it must have worried Blake to account for the epilogue of eighteen Christian centuries; for the Christian era, Los's third period, seems to Blake the lowest level of the spiritual life. The Prophets are no more. The prophetic spirit sinks into lethargy. It would seem that the Poetic Genius, having freed itself from its spiritual imperfection, may rest while the body of death, the error from which man suffers, is shaped for destruction in a Last Judgment.

Los's feminine self is Enitharmon. She is the spiritual garment of man in the Generative world, being in this respect the counterpart of Jerusalem in Eden. Now the spiritual clothing which Los desires in a troubled world is pity. But true pity, as we have seen in the discussion of Luvah and Vala, is imaginative and spontaneous, not selfish and rational. The attempt to achieve pity by false means ends in vengeance and strife, and in this character Enitharmon all too often appears. The tendency of pity to elude all rational pursuit is pictured as a jealous sexual struggle between Los and Enitharmon. The story of this struggle is biblical history; for Enitharmon evolves as Los evolves. She is in all things the outer aspect of the spiritual world of which he is the impelling spirit. The relationship is explicit

in the fact that she is Space to Los's Time. The comprehensive character of these two conceptions suggests how great an importance is given to the Poetic Genius. Though another set of characters personify the physical world, the Poetic Genius is its shaping force. The outer world is the physical symbol of the inner spirit. In this sense there is nothing arbitrary about the control which Enitharmon is said to exercise over space. Man's inner life and his universe are in direct relation.

In her evolution Enitharmon follows Los's cycle. She passes from the vengeance of Old Testament prophecy—the regime of the law in all its rigor—to the forgiveness of Christ, and then into a period of inactivity—the Christian centuries. During the first period she is represented as having barred the gates of her heart against Los. Obviously pity is not to be attained by a prophecy infested by rational fears. In the second period—the period of Christ and the Apostles—the "obdurate heart" is broken. The feminine contrary has succumbed, like Job's wife at a corresponding juncture, to the rigors of the strife. For a short, resplendent period Los finds her tractable. In contrition for her selfish past she weaves the "web of life" in the looms of Cathedron. This is the New Jerusalem toward which Los has aspired. Pity has been achieved. But this period of enlightenment soon declines, and Enitharmon sinks with Los into the lethargy of the eighteen Christian centuries. During these centuries Christianity ceases to be a thing of the spirit, retaining only its Christian name. This is the "sleep" of Enitharmon—the triumph of the recalcitrant female emotions as they are personified in Vala-Rahab.

The third figure of our demiurgic triad is the Spectre. He is a vague and terrifying creature, a phantasm of fear and doubt. He represents the effect upon Urthona—the inmost spiritual life—of Urizen's intrusion there. Reason cannot look upon a split universe (for which incidentally it is responsible) without feeling in behalf of the spiritual life, a consuming fear. The Spectre of Urthona is this fear—a horrible ogre of jealousy and doubt. All that the mind of man has suffered in its concern for a hypothetical soul in a world which is conceived to be dual is

personified in the Spectre of Urthona. He goes about shod and scaled in iron, a formidable figure, the real parent of the iron laws which Urizen writes. That as Spectre he has no existence apart from the rational activity of Urizen does not diminish his powers. He is there to affright whenever Reason, separated from intuitive faith, peers into the abyss of the future.

IV

Tharmas, the fourth and last of the Zoas, is the body of both the cosmos and man, or rather, he is the body's energy, for the outer and apparent body is personified by the feminine Enion. Tharmas is spoken of as the "parent power" and the "angel of the tongue," phrases which have a sexual implication. As bodily energy he is the regent of sex, but he is also something more. As the androgynous body—for the unfallen Albion knows no sex—he is the symbol of the united world. In Eternity Albion sees no antithesis between body and soul, nature and man, good and evil. On the contrary, the Eternals know that body is a portion of soul, that "everything that lives is holy," that man "looks out in tree and herb and fish and bird and beast." This all-inclusiveness of Tharmas has a parallel in the tenth sephira of the *Kabbalah*, in which all the others are united.

Because Tharmas, as the androgynous body, is the eternal unity, he is presented as a shepherd, his flock the minute particulars of life. Receiving them all into his fold, he is the "mildest son of heaven." His quarter is the West, the all-inclusive circumference. Blake lets us know how highly he values the unity which Tharmas implies by associating the West with Eden.

But Tharmas does not remain the undivided spiritual body. He becomes the victim of Urizen and Luvah in their selfish holiness. When the eternal senses fall from their high estate they are fixed at finite levels, while the eternal four become a finite five. At their organic level the senses interpret the world in terms of their contracted powers. In their first limitation they do not distinguish between Tharmas and his feminine self, whom together they have ceased to regard as man and now know

as nature. Later they trace evil to its source in matter and rend asunder the androgynous body by their conceptions of good and evil. Rent asunder, Tharmas becomes a multiple world, only to have the duality within multiplicity discovered and established. The androgynous body has become "sexual." Enion has been separated from Tharmas. As a result we have the vexed problem of duality and a "sexual" ethics.

In his multiplicity Tharmas loses his mildness and becomes the raging sea of space and time. As the multiple world of division he is the formidable enemy of Urizen, who has lost his intuitive understanding of physical things. He rises up in an overpowering flood of sense impressions to destroy Urizen and the world he has created. The patriarchal age in which man was nearer to Eternity than in the post-diluvian world comes to an end.

But Tharmas does not complete the destruction he intends. He is arrested by Los, who seems to see in the illusion of materiality which Tharmas provides, a useful tool in his struggle toward the return of the eternal world. In their alliance Tharmas regards Los as his "adopted son," and the two appear together as the loins of the fallen Albion. Together they lay the foundation of Golgonooza, Los's city of the spirit.

Enion, the Earth-Mother, is the least complex of the characters. She is the outer and passive side of Tharmas, the body. As the Fall begins, with the rise of Tharmas's spectre (doubt concerning the physical both in the universe and man), she creates the illusion, Nature. She is therefore pictured at this point as "a bright wonder, Nature, half woman and half spectre." Since her new creation contains the spectre's doubt, Nature is robbed of its former spirituality. It is now the path of Nature and Natural Religion, which man will follow in the interim between Eternity and Eternity. It is the Circle of Destiny.

Of Enion's union with the spectre of doubt, Time and Space are born, in the persons of Los and Enitharmon. Man has reshaped his idea of Being to accord with his newly conceived idea of the physical world; the conception of nature has supplied

him with kindred concepts, Space and Time. They prove un-
grateful children. As they grow and flourish they drive Enion
farther and farther into nonexistence. In short, as the concep-
tion of the temporal and the spatial gains hold upon the mind
of man, nature tends to become for him but lifeless matter. At
the depth of her degradation Enion speaks from the grave.
Blake gives to her, as she speaks from the pit of her humiliation,
some of the finest poetry of the prophetic books. She, who with
Tharmas made up the immortal body, is now the body of death.
In her lament is all the bitter wisdom accrued to man by the
Fall.

What is the price of Experience? Do men buy it for a song,
Or Wisdom for a dance in the street? No! It is bought with the price
Of all that a man hath—his house, his wife, his children.
Wisdom is sold in the desolate market where none come to buy,
And in the wither'd field where the farmer ploughs for bread in vain.

Enion is at this point Blake's dramatization of the biblical dic-
tum that the wages of sin is death. Having set his feet upon the
path of a murderous righteousness with Vala, Albion is faced
with the terror of extinction in Enion. His doubts of his body
have driven it into corruptible matter. Yet Enion's is also the
voice of hope. It is not for nothing that Los and Enitharmon
are born of her as Time and Space. By the identification of the
prophetic capacity with the temporal and the spatial, the illu-
sion of corporeality is made a principle of the Return. In the
grave Enion learns that the "time of love" returns, and sees man
gathering up the scattered portions of his immortal body. She
is here the mouthpiece for Blake's belief that the function of the
mortal is the return of the immortal. Having borne the burden
of corporeality, Enion learns its purpose. Life cannot be
quenched; it springs eternal. But error must be destroyed, and
as death, the "dark consumer," Enion is happy in her function.

In addition to the Zoas and their Emanations and certain
minor characters, which we shall not need to discuss here, Blake
has several sets of composite characters. Foremost among them
are the Daughters of Beulah and the Daughters of Albion.
They are man's feminine powers in two antithetical attitudes.

In the Daughters of Beulah we have these powers devoted to the well-being of man; in the Daughters of Albion we have them, in their obedience to reason, weaving the "natural" world of spiritual depravity. The one is Jerusalem seen in multiple, the other Vala-Rahab. The Daughters of Beulah are said to guard the body of Albion during his mortal sleep on the Rock of Ages; the Daughters of Albion, to bind down his perceptive powers and submit him to the corporeal illusion. The Daughters of Beulah personify a mercy and pity that is spontaneous and genuine; the Daughters of Albion, a spiritual hate masquerading as mercy and pity in the cruel and spurious forms of the moral law. The Daughters of Beulah, who by their selflessness keep man's senses open, prepare the conditions for a visionary life and are called Daughters of Inspiration. The Daughters of Albion, who in their selfishness bind down man's immortal senses, are called Daughters of Memory.

This division of the feminine life was probably suggested by the Gnostic division of the feminine aeon, one portion of which remained above within the Pleroma, while another portion descended into matter. In the system of Valentinus these two portions are personified—the heavenly as Sophia, the earthly as Achamoth. A separation of this kind is corroborated by the Bible. It is mentioned by St. James; it is central in the Apocalypse. Moreover, St. Paul conceives of Jerusalem, the Church, as living upon two levels, an earthly and a heavenly. On the one she is Hagar the bondmaiden, on the other Sarah, the wife. The one is Mt. Sinai, the other Jerusalem, our mother. All these contrasts are repeated in Blake's dual feminine—the Daughters of Albion and the Daughters of Beulah.

Finally there are the Eternals. Together they constitute the Council of God which, functioning as one man, Christ, exercises a determining influence over the fallen Albion's course. Who these Eternals are it is impossible to say. Are they those who never fell, those who have fallen, died, and reascended, or those who, though alive in the flesh, participate in immortality by their visionary powers? Or are they all of these? To the writer the last seems the most likely answer to this highly speculative

problem. It seems not unlikely that the Eternals, who find mental warfare an absorbing pursuit, represent the sum of freed intellectual energy in the whole cosmic system. All who have liberated themselves from the fetters of ignorance, whether alive or dead in the common sense of the term, participate in the activities of the Council of God.

III

The Setting

Eden, the land of life.
Jerusalem, p. 38.

There is from Great Eternity a mild & pleasant rest Nam'd Beulah.
Four Zoas, Night I, 86-87.

O Holy Generation, Image of regeneration.
Jerusalem, p. 7.

Of the Sleep of Ulro and of the passage through Eternal Death.
Jerusalem, p. 4.

BLAKE'S system has a twofold source. It is at once a reading of history and an interpretation of his mystical experiences. He found the two in accord. The macrocosm Albion, and the microcosm Blake, descend and return by the same path.

As with all mystics, ecstasy is basic in Blake's experience. In that state, it need hardly be said, the perceptions are so enhanced that one seems for the moment to have risen to a higher level of existence. Earthly confines and fleshly trammels seem to be transcended, and the mind expatiates in the freedom of the infinite. The experience reported by Plotinus is typical:

Many times it has happened: Lifted out of the body into myself; becoming external to all other things and self-encentered; beholding a marvelous beauty; then, more than ever, assured of community with the loftiest order; enacting the noblest life, acquiring identity with the divine; stationing within It by having attained that activity; poised above whatsoever within the Intellectual is less than the Supreme; yet, there comes the moment of descent from intellection to reasoning, and after that sojourn in the divine, I ask myself how it happens that I can now be descending, and how did the soul ever enter into my body, the soul which, even within the body, is the high thing it has shown itself to be.

Our present concern with this testimony is with its intimate

experience of rise and fall. This experience, taken simply, would give a universe of two dimensions, but Blake's system has four. We shall presently see why.

Even in Eternity, Blake reasoned, there were gentle falls. Never has the soul been able to maintain existence at the summit. Energy is spent and requires a period for its renewal. The cyclic round of seasons is witness to this eternal law. Before the Flood, which Blake treats allegorically and which stands in his myth between the spiritual and natural worlds, there were but two seasons—the quickening period of spring and the fallow autumn. In these two seasons are the energy and the repose of the spiritual world. They bear witness to Heraclitus's doctrine of the continual alternation of contraries. Blake expressed his acceptance of this doctrine in the *Marriage of Heaven and Hell*. "Without contraries," he writes, "is no progression. Attraction and Repulsion, Reason and Energy, Love and Hate are necessary to human existence." This fundamental antimony which underlies all life and gives to it its cyclic character corresponds to the sexual duality already noted in Albion and the Zoas. The energy and repose of the spiritual world are masculine and feminine. Eden, the world of energy, is masculine; Beulah, the world of repose, is feminine. Together they constitute the heavenly and the earthly paradise.

The idea of a twofold paradise is not original with Blake. The *Kabbalah*, for example, provided the suggestion, not only in its Upper and Lower Paradises, of which the Lower is a threshold of new life for souls ascending and descending, but also in its two countenances, the Large Countenance and the Little Countenance. Of these countenances, both are on a level superior to the earthly. The Large Countenance is associated with the brain, with concealment, with sleeplessness, with light, with undifferentiated unity. The Little Countenance, which emanates from the Large, and is a shadow of it in the lower world, is illuminated with reflected light, and is associated with manifestation, with the appearance of good and evil, with the beginning of multiplicity, with darkness and sleep and tears. Neoplatonic thought is similar. Plotinus conceives of the soul as

proceeding from supersensibles to sensibles and back again, while Proclus writes that energy emanates capacity, and capacity proceeds again into energy. In both cases alternation is simply a polarity which keeps the circuit of life in motion. Life in Blake's twofold Eternity revolves around such contraries. It is only in the upper paradise that life is real and eternal; on the lower level it is temporal and illusory. But so long as the lower paradise is recognized for what it is—a temporary sleep by means of which the waking life is continually renewed—the wheel keeps moving, and the life of "great Eternity" is continually fed.

The two levels of existence in Eternity become four when the soul fails to maintain even the lower paradisiacal level. This occurs when man, doubtful of energy and proud of repose, tries to perpetuate his repose. With this negation of energy, spiritual sleep deepens into spiritual death. The infinite universe shrinks into the finite. The ethereal body, hardening into flesh, becomes a tomb for the imprisoned spirit. This is the world of Ulro. But man is not permitted to perish utterly. A way of salvation is provided. A shaft of light pierces the tomb. Energy reappears and struggles for release from the temporal and the finite. This is the world of Generation. Eden and Beulah, the two unfallen levels, together with Ulro and Generation, the two fallen levels, constitute Blake's four worlds. They represent four states of the soul, corresponding to four degrees of spiritual vision.

I

The highest level of existence, where the Zoas function in their fullness and perfection, is Eden. The dominant characteristic of Eden, however, is not its fourfoldness but its oneness. "That thing there," Blake's Eternals would exclaim, "it is I." In Blake's Eden, as in Plotinus's World of Intelligence, there is distinction without division. Dean Inge quotes Plotinus's pupil, Porphyry, to this effect:

Particular souls are distinct without being separate; they are united to each other without being confused, and without making the Universal Soul a simple aggregate. They are not separated from each

other by any barriers, nor are they confused with each other; they are distinct like the different sciences in a single soul.

So, too, are Blake's identities at once distinct and universal.

> . . . General Forms have their vitality in Particulars; & every Particular is a Man, a Divine Member of the Divine Jesus.

The quality that makes particulars both universal and distinct, one as well as many, is imagination, which is, indeed, the term by which Blake's Eden is defined. From imagination comes that identification of one self with another which insures brotherhood and the forgiveness of sin. From imagination, with its capacity to accept every minute particular of life, taking home to one's own bosom a share of responsibility for particulars which self-righteousness would condemn, comes the perfect unity which is beyond rational achievement or even rational conception. From imagination comes the conception of life as ever changing, ever expanding, and the consequent release of energy for imaginative ends, which is the prime source of the Blakean delight. Upon this creative energy there is, in Blake's picture of the good life, no restraint; the bounding line is not a prison wall or an opposing reality; it is only the form and outline, perfectly responsive to the creative urge. Above all, there is no restraint from that greatest of all restraints upon imaginative living, the principle of selfhood. The self knows that it, too, but fixes and makes manifest the energy which flows into it from God. "In selfhood we are nothing" is part of the wisdom of Blake's Eternals. The self, then, like all outward things, has but a phenomenal existence; the reality is the creative influx, the human—or divine—imagination. Eden is the embodiment of this imagination; it is the unity, the inclusiveness, the "body" in which the concerted efforts of head, heart, and loins express themselves—the fourth and last and most precarious element of the fourfold life.

In Eden the Eternals enjoy the felicity which, according to Thomas Taylor's paraphrase of Plotinus, consists "in a perfect intellectual energy." Eden is not a refuge of holiness, it is a haven of intelligence. Blake's Eternals live a life given over to

"hunting" and "mental warfare," in "fury of poetic inspiration
. . . mental forms creating."

> . . . Albion! Our wars are wars of life & wounds of love,
> With intellectual spears & long winged arrows of thought.
> Mutual in one another's love and wrath all renewing,
> We live as One Man.

This is the selfless state of imagination, of complete intellectual
freedom. It is also the state of complete enlightenment, of the
immediate apprehension of truth, though even the Eternals may
fall into error. The illumination of Eden is the "science" of
Blake's system. The radiant sun is its symbol.

In the mental wars of Eden man "calls his enemy his brother,"
for prior to the Fall there is neither good nor evil, only truth
and error. The Eternals are not "talking of what is good and
evil, or of what is right or wrong, and puzzling themselves in
Satan's labyrinth, but are conversing with eternal realities as
they exist in the human imagination." Upon the brotherhood
of man, a form of love transcending sexual organization and con-
ceptions of good and evil, Eden is founded and maintained. For
that reason Eden is said to lie in the West, the region of the
all-inclusive Tharmas, the body of Albion, the symbol of the
universe seen as a man. Nothing is here condemned. Everything
that lives is holy. When man comes to believe the contrary, he
falls into repression, and the freedom of Eden is lost.

Eden is a world in which "all is vision." It is the state of mind
which Blake enjoyed temporarily in ecstasy, made lasting. The
inner and active contrary—the creative mind—is the one real-
ity. The outer world is plastic under the creative imagination.
The forms we see with our organic eye "in this vegetable glass
of nature" are feeble replicas of eternal forms, perfectly respon-
sive to the imaginative eye. The external world is shaped by
mental activities. In a way this is true also of the temporal world,
but because the temporal mind is subject to the illusions of
time and space, the external world is irresponsive. The eternal
mind, on the contrary, is free, and external forms are in perfect
correspondence with the exercise of imaginative energy. In this

respect Blake's heaven is like Swedenborg's, in which the land-
scape is in fluent correspondence with "the affections and con-
sequent thought of the angels."

But, as we have already seen, the Eden level is impossible to
maintain. Its mental exaltation cannot be indefinitely endured.
Infinity recedes, or if it does not recede, becomes an intolerable
burden. Clarity of vision and intensity of emotion cannot be
continuously borne. This is the perpetual discovery of the poet
and the mystic. In the terminology of Blake's myth, the "giant
blows in the sports of intellect" sometimes prove too much for
the contestants, and love is upon occasion strong enough to
"kill its beloved." Blake's recognition of this fact underlies his
conception of a twofold paradise. The soul, unable any longer
to endure a visionary world, descends to a world of appearance,
there to be reposed and renewed.

II

This temporary refuge is the world of Beulah. It is not a
primal state, like Eden, but is "eternally created by the Lamb
of God" out of mercy for "those who sleep." From the philo-
sophical point of view it is a world of appearance; from the
religious point of view it is a world of illusory forms and creeds
in which the mind may believe when the immediate apprehen-
sion of truth has been lost. In *Milton* this refuge is said to have
been created at the specific request of the Emanations which, as
the feminine and outward life, have but a secondary existence
in the mental intensity of Eden.

> But the Emanations trembled exceedingly, nor could they
> Live, because the life of Man was too exceeding unbounded;
> His joy became terrible to them; they trembled & wept,
> Crying with one voice: 'Give us a habitation & a place
> In which we may be hidden under the shadow of wings:
> For if we who are but for a time & who pass away in winter,
> Behold these wonders of Eternity, we shall consume.
> But you, O our Fathers & Brothers, remain in Eternity;
> But grant us a Temporal Habitation; . . .'

The creation of Beulah is reminiscent of Gnostic teaching as

reported by Irenaeus. We read in his discussion of Marcus that the Supreme Four "only reveals itself to mortals in its feminine form, for the world cannot bear the power and effulgence of its masculine greatness." The masculine effulgence which the world cannot endure is Blake's Eden; the feminine form in which it is revealed is Beulah. The relationship of the two worlds is the old philosophical one of Being and Manifestation. Eden is inner and primal. Beulah is outer and emanative, a manifestation of the inner and primal.

Being outer and emanative, Beulah is logically said to lie all around Eden. But it is also said to lie in the South, the quarter of the compass allocated to the head of the giant Albion. We may interpret this to mean that Beulah is a creation of the weary mind, and its apparent reality a mental illusion. This is as true of its religious forms as of its spatial effects. Eden, with its immediate apprehension of truth, is the eternal reality; Beulah, with its forms and creeds, a temporal shadow. But Beulah's shadow is sleep, not death. The mind has not fallen into deep-seated doubt; it has not sapped the very bases of existence; it has not awakened into a "false morning." Though it no longer enjoys an immediate apprehension of truth, it still retains its faith in an informing spirit within the world of phenomena. It is with reference to this beneficent condition that Beulah is said to have been created under "the shadow of wings." The mind sets neither the masculine nor the feminine contrary above the other, and so maintains the harmony of an apparently dual world. It is interesting to note that George Sandys, in his commentary on the second Metamorphosis of Ovid, speaks of the wings of the caduceus as the activity of the mind, insuring the peace and harmony of the masculine and feminine serpents beneath it and keeping in check the raging sea. Blake accepts this imagery without modification. Under the "pure wings of [the] mind," the seeming contradictions of a world of appearance do no harm, and the sea of time and space is held in check. When, however, the pure wings of the mind are folded, the appearances of Beulah are accepted as real, and an evaluation is set upon the masculine and feminine contraries. Their

harmony destroyed, the obscurity of Beulah deepens into the darkness of death and the abyss, and the sea, unleashed, rises as the flood of time and space.

The beneficence of the weary mind in Beulah is due to the forgiving emotions which sustain its faith. Beulah is the realm of Luvah, whose moon lights the night when Urizen's sun sinks to rest; for it is only by feminine forgiveness and self-sacrifice that the errors into which the weary masculine mind may fall are rendered ineffectual. Should the emotions turn self-righteous and vengeful, the latent possibilities which lie in the "outward spheres of visionary space and time" would come into actuality. The situation is expressed in symbolic imagery. The female is said to create

> . . . Spaces of sweet gardens & a tent of elegant beauty,
> Closed in by a sandy desert & a night of stars shining,
> And a little tender moon & hovering angels on the wing.

The gardens, the tent, the hovering angels, and the tender moon are emblems of truly piteous and forgiving emotions; the sandy desert and the night of stars signify the wilderness of rationalism which awaits the mind if these ministrations fail. Even in the waste land beneath the starry wheels, faith and forgiveness would restore the lost paradise. Over Albion's "corse of death" the Saviour bends saying: "If ye will believe, your brother shall rise again." Man no longer knows in Beulah, but he believes. A religion of faith replaces the "science" of Eden. Before the Fall, sleep, not death, was therefore the limit of the declension. Vala then wore Jerusalem—a more unselfish love than her own —in her veil. Luvah and Urthona remained true to their function of keepers of the gates of heaven. Love, that is to say, remained forgiving, and the imagination did not succumb to the blight of rationalism. The eternal senses, not having been diminished and fixed in their diminution, easily resumed their intensity and expansiveness. The way back into Eden was always open.

In man's conscious and untroubled possession of Beulah is his earthly paradise—"from great Eternity a mild and pleasant

rest." Here the senses are laved in the beauty of the external world, the emotions repose in their passive aspects of pity and peace, the mind rests in its own indolent pleasure. Incidentally, out of this repose will come the renewal of the masculine energy by reason of which Eden is possible. The "imaginative image returns by the seed of comtemplative thought."

Though Beulah is the world of the feminine, the passive, and the outer, the inner masculine spirit is not denied. The relationship is one in which the contraries are "equally true." Into Beulah, therefore, "no dispute can come." Man lives in peace, accepting an apparent duality, condemning neither contrary. The female will has not yet developed. The feminine world of phenomena makes no demand for itself. External nature does not lay claim to reality, as we find it doing after the Fall. The natural world still admits the validity of the supernatural world; forms and creeds are still recognized as manifestations of an inner spirit; the passive emotions have not set themselves up as Good.

The relationship of the contraries is expressed in sexual imagery. The absence of such imagery with reference to Eden signifies that there the contraries are in perfect union. There is no consciousness of masculine and feminine; man functions in the totality of his powers. But in Beulah there are sexes. This means that the duality which ever lurks in unity to the vexation of the philosopher has become apparent. In spite of this cleavage, which applies to each of Albion's four fundamental powers, the contraries are not yet at war. Though separate, they still live in harmony with one another. The term Beulah (marriage) admirably expresses the relationship. The success of the "married" state is due to the feminine contrary, whose attitude is that of the self-sacrificing wife. The Daughters of Beulah give, as did certain patriarchal wives, their handmaidens to their husbands. They hide away man's "loves and graces" (they wrap them in mantles of pity and illusion) that Satan's "watch-fiends" may not write them into the "scroll of mortal life" (condemn them for sin) . The return to the unified life of Eden is insured by

the self-sacrificial ethics of Beulah. The glory of the outer world, in all its aspects, is its service to the inner.

With considerable subtlety Blake relates the self-sacrificial ethics of Beulah to his theories of form. As the apparent world Beulah is also temporal. Its finite forms are merciful and temporary circumscriptions of the infinite for those who can no longer endure the infinite. They disappear when man ceases to require such limitations. By their passing the inner world is constantly renewed. The form dies in order that the imaginative impulse may be released for new expression. The masculine creative world of Eden is continually sustained by feminine self-sacrifice in Beulah. "Males immortal live, renewed by female deaths." The obedience of outward form to inner vision extends even to the landscape. Blake doubtless had in mind an hypothetical time when the outer world offered no hindrance to the visionary eye, but was readily transcended. Such an attitude on the part of the phenomenal world is in direct contrast to its attitude in Ulro. There the phenomenal (both ethical and physical) struggles to be taken for the real; the outer world is looked upon as more important than the inner spirit. In the physical world this means that space can no longer be transcended. We shall hear more later of Blake's theories of space, but what has been said should serve to show why Blake provides for spaces of two sorts—spaces of Beulah and spaces of Ulro. The former are merciful illusions, provided for the repose of the mind which has wearied of the visionary reality of Eden. They characterize an hypothetical age in which the visionary life that Blake enjoyed in ecstasy was an habitual experience. In contrast to the spaces of Beulah, which were so readily transcended, are the "Satanic spaces" of Ulro, which limit and enslave the mind that beholds them. Swedenborg makes a similar distinction between appearances regarded as illusion and reality.

So long [he writes] as appearances remain appearances, they are apparent truths, according to which every one may think and speak; but when they are accepted as real truths, which is done when they are confirmed, then apparent truths become falsities and fallacies.

It will readily be seen why Beulah, with all its feminine vir-
tues, is inferior to Eden. In the terminology of the Pythagoreans,
the monad has entered into manifestation and become the duad,
at the expense of its supernal unity. If the monad be regarded
as fourfold, one element of the quaternion—the divine unity
symbolized by Tharmas, the body—has been lost. A triad of
head, heart, and loins replaces the fourfold man. A threefold
Beulah replaces a fourfold Eden, while at the same time night
replaces day. One is reminded at this point that the night of
Dante's vision is ushered in by the three stars of contemplative
or passive virtue—faith, hope, and charity—which replace the
four cardinal virtues of active life as Blake's Beulah replaces
Eden.

In their harmonious relationship Albion's triadic powers—
head, heart, and loins—constitute the three heavens of Beulah.
But with the Fall their harmony is destroyed, and the sundered
powers engage in the strife which leads to the chaos of Ulro.
Both triads—the fallen and the unfallen—are divided by the
principle of contraries into two pairs, masculine and feminine.
The kabbalistic tree provides a close parallel, with a triple mas-
culine on the right, a triple feminine on the left, united by a
quaternion in the middle. The feminine triad, on the supernal
level, was probably associated in Blake's mind with the Graces,
and by almost certain inference, with Faith, Hope, and Charity.
This triad we find in the three daughters of the penultimate
Job illustration. In the fallen world it appears as the triple
Hecate. The masculine triad appears, in its fallen form, as the
three friends of Job, and as the three Accusers—Theft, Adul-
tery, and Murder.

Despite the felicitous character of Beulah there are many
potentialities of disaster. The pity and peace and repose of
Beulah, the illusions of time and space, the seductions of mere
outward nature, the formulation of creeds and beliefs, are all
sources of danger. The passive emotions may become blown
with pride in their own virtue. The wearied rational mind,
devoid of imagination, may lose its faith in the energies of life
and evaluate the contraries into Good and Evil. Should this

happen, the natural functioning of the contraries would be interfered with. The unified universe, its cohesion already strained, would fall into division. Needless to say, this happens. The head falls a prey to doubt, the heart to self-righteousness. Disaster is realized.

Because of the dangers inherent in the nature of Beulah, it contains the caves of sleep, and beneath it yawns the abyss of Ulro. The cave as a symbol of the corporeal life is a commonplace of ancient theology. But it is identified in Blake with the roofed-over skull which, according to the *Kabbalah*, is the first limitation of light, and which therefore suggests the nature of the caves of sleep in Beulah; they are identical with the limitations of the skeptical, selfish mind. To complete his figure Blake had only to unite the cave with the sleep of Adam, and so make of the descent of the mind into abstraction and unbelief the archetypal sleep which precedes the Fall.

> Man is a Worm. Wearied with joy, he seeks the caves of sleep
> Among the Flowers of Beulah, in his Selfish cold repose
> Forsaking Brotherhood & Universal love, in Selfish clay
> Folding the pure wings of his mind, seeking the places dark,
> Abstracted from the roots of Science.

The "selfish cold repose" of this quotation is the passive feminine life of Beulah which the rational mind finds more desirable at this juncture than the energy of Eden. With this evaluation by the rational mind of the feminine life of Beulah, the feminine contrary takes on the ambition of Lucifer and begins its long struggle for dominion over man. Since this selfish desire is a renouncement of Beulah's self-sacrificial ethics, the abyss which yawns beneath is said to lie within the empty heart—the East which Luvah abandoned when he rose into the zenith with the chariot of Urizen.

The abyss is the "void outside of existence," loveless and without faith, and as a consequence, without form. It is Blake's parallel to the primeval chaos. It is also the womb of the Book of Job; but since the rational mind, as it is about to fall, sees the appearances of Beulah as Nature, and its love and pity as a natural good, it is also the womb of nature. In it are all the

potential consequences of man's false reasoning about the ap-
pearances of Beulah. Later, with the bursting of the womb, all
of these consequences sweep over Albion in a destroying flood.
But the womb is not merely the abyss of nonexistence and death;
it exists also to give life. The chaos of the abyss but awaits the
creation.

III

Beulah is not lost without a colossal struggle. Urizen (the
rational mind) beholds in a vision of the future the moral chaos
toward which his path is leading, and is struck with horror.

No more Exulting, for he saw Eternal Death beneath.
Pale he beheld futurity, pale he beheld the Abyss . . .
He saw the indefinite space beneath, & his soul shrunk with horror,
His feet upon the verge of Non Existence. His voice went forth. . . .
Build we a Bower for heaven's darling in the grizzly deep;
Build we the Mundane Shell around the Rock of Albion!

The Mundane Shell is a created world and therefore not eternal.
It is transitional between Eternity and Time. It is a partial
analogue to the Creation in Genesis, with which, however, it
has little in common. But it has much in common with the
Creation in *Paradise Lost*, where the Son, standing like Urizen
on the edge of the abyss, commands peace and silence upon its
tumult, and laying his golden compasses upon the void, creates
our world. In Blake's well-known illustration of this passage,
the demiurge is Urizen unmistakably. There is in Urizen some-
thing too of Plato's demiurge, since both create a new and im-
perfect world as far as possible on the model of a better one.
But there is a much closer parallel with the Great Archon of
Basilides, who also was a Master Builder, and who ruled a
world that extended to the stars, where he himself resided, and
who imagined, like Urizen in his star-world, that he was the
only God.

The Mundane Shell is an heroic but futile effort to preserve
Beulah, whose dissolution Urizen has just seen in vision. The
bound which he is attempting to impose on destiny has a strik-

ing parallel in the boundary which encloses the Gnostic Pleroma and prevents the fullness of life from passing over into the void which, like Blake's abyss, is the abode of the outward and the material. The force which is moving in that direction was set in motion when Urizen changed from certainty to doubt, and Luvah from forgiveness to self-righteousness. There is still too much light of reason left in Urizen to endure these consequences, but at the same time too much selfishness to avert them. Selfhood misleads him, as it misleads everyone, into false hope.

> Stern Urizen beheld, urg'd by necessity to keep
> The evil day afar, & if perchance with iron power
> He might avert his own despair.

His hope is in the moral law. What the head can no longer believe, now that its faith is gone, nor the heart sustain, now that its forgiveness is gone, must be supplied, as best it can, by laws which impose the peace and good will which are no longer instinctive. Urizen's comforting delusion is that he will be the great lawgiver. "Now I am God," he exclaims, "from Eternity to Eternity." It is appropriate, therefore, that the world of the Mundane Shell should be built at the level of the stars. For the stars are third and last in the order of heavenly illumination. "There is one glory of the sun," writes St. Paul, "and another glory of the moon, and another glory of the stars." The stars have also been, ever since man began to observe their orderly and majestic revolutions, adduced as evidence of divine will and intelligence in the universe. The world of the Mundane Shell, built by this remnant of light left to the falling Albion, is a great rational achievement. It embodies the law in its beneficence and majesty, not yet sunk to the level of demanding an eye for an eye and a tooth for a tooth, but rather inculcating forgiveness, even as Jehovah set the mark of protection upon Cain. The *lex talionis* is potential in the abyss, and indeed inevitable; but this world of Urizen's creation is intermediate between Beulah and Ulro, between the principle of forgiveness written upon the heart and the ministrations of death written

and engraved on stones, between the religion of Christ and the religion of Moses.

Now the moral law may be looked at in two ways. It is said in the Epistle to the Hebrews that the first covenant was not dedicated without blood, but in the Epistle to the Corinthians that this covenant came with a certain glory, so that the children of Israel could not steadfastly behold the face of Moses for the glory of his countenance. Blake takes a similar twofold view. On the one hand this covenant, even in its early and beneficent stage, is not without blood. The heavens are filled with blood; brother and brother bathe in blood upon the Severn; the Divine Vision appears in Luvah's robes of blood, for Luvah himself is cast into the furnaces and sealed. On the other hand, this is a "golden world." The stars, which are its symbol, were

> . . . created like a golden chain,
> To bind the Body of Man to heaven from falling into the Abyss.

This chain of stars is obviously the chain of Homer, which had been dowered with Christian significance by Dionysius, and is preserved in that significance by Blake.

The necessity for the creation of the chain at this point— that is, for the formulation of the moral law—may be inferred from the statement that the

> . . . Divine Lamb, Even Jesus, who is the Divine Vision,
> Permitted all lest Man should fall into Eternal Death.

Though the chain is designed to keep Albion out of the abyss, it is not completely successful. There is a period in which Albion, like Job, sinks to a nadir and is in utter darkness. The significant thing is that the chain descends with him. In its descent the chain loses its golden and benignant character, and becomes iron and oppressive. This is the chain which descends upon Job, the chain with which Orc is bound upon Mt. Sinai. Blake hates the moral law, of which the chain is the symbol, yet he gives to it a regenerative function. Albion's release has been prepared for. The divine hand set a limit to the Fall and described Albion's path as circular. The fact that the chain has its inception in heaven and that the end must return to the

beginning, signifies that the law must conclude in its own annulment. To emphasize its transitoriness Blake identifies the chain in its descent with Time, the function of which is to pass away in order that Eternity may be regained.

But the moral law is not the only principle upon which the Mundane Shell is built. The Urizen who creates it has eaten of the Feast of Mortality with Los and Enitharmon, who are Time and Space. These twin children of Enion in her rôle of Nature have not yet attained to regency, but they have grown to sufficient proportions to influence Urizen's creation. As the epithet "mundane" suggests the temporal, the word "shell" suggests the corporeal, for Plato had used it with this significance in the *Phaedrus*, when he wrote that "we are imprisoned in the body like an oyster in its shell." The outward progression is also seen in the fact that the senses "roll outward," so that "what is within" is "now seen without." Thus viewed the world loses its unity. The Mundane Shell is physically a multiple world, as spiritually it is a world divided against itself. Adjoined only within the artificial unity of the law, the nations shrink and separate. Jerusalem comes down in dire ruin over all the earth. The imagery suggests a similar disaster in the physical world. The sun, the moon, the stars flee; and in the West, where Eden lies, the Atlantic mountains tremble. When the many errors inherent in the Shell cause it to crash, the sea of time and space rushes in to shut off Eden and make of it a lost Atlantis.

The profound changes which Albion's thinking underwent at this point regarding both his spiritual and physical selves is reflected in the imagery in which the Mundane Shell is described. It is made to suggest both heaven and earth. Urizen's creation is comprehensive. The Mundane Shell, identified with the heavens, is not completed until the rivers and seas and lakes are poured and the mountains and rocks and hills reared. This is as it should be. Earth is a reflection of heaven. Changes in the spiritual world demand corresponding changes in the physical world.

In the building of the Mundane Shell, Urizen labors with

demonic energy. Huge pyramids—forms of rational and con-
stricted thought—are hammered out upon the anvils and cast
into the abyss, where, after falling "many a league," each finds
its station. Upon this foundation the temple of Urizen is reared.
Rising in mathematic majesty, the "wondrous work" finally
binds in the very heavens, and receives "the eternal wandering
stars." Over this world Urizen is God, but outside it is a vast
unknown which fills him with constant anxiety.

While this world of the Mundane Shell is Urizen's, and there-
fore dominantly rational, the emotions play their part in its
creation. The labor at the furnaces (masculine and intellectual)
is supplemented by a corresponding effort at the looms (femi-
nine and emotional). Luvah, indeed, is sealed within the
furnaces; but Vala—a new and cruel Vala, subservient to Urizen
—is very active. Shut within the caverns of the mind—spaces
which once were open to the heavens, but are now roofed over
to form the corporeal cave—the looms (which are Luvah's spe-
cial symbol) begin their work.

> Beneath the Caverns roll the weights of lead & spindles of iron;
> The enormous warp & woof rage direful in the affrighted deep.

The looms weave the spiritual clothing. In the complexity of
this new pattern

> . . . many a net is netted, many a net
> Spread, & many a Spirit caught; innumerable the nets,
> Innumerable the gins & traps; & many a soothing flute
> Is form'd, & many a corded lyre.

The net of the moral law is beginning to take shape. It is Vala's
veil—her garment of pity—"frozen" by the rational mind into
the Mundane Shell. Frozen, it ceases to be the spontaneous ex-
pression of religious emotion, and becomes abstract and ex-
ternal. The looms which wove it were shut within the caverns
of the mind.

There is much to support the belief that in this heaven of
the rational mind, Blake was thinking of ancient Egypt, which
the Hermetists considered to be an "image of heaven." This is
the period of the mythical ancient Hermes, the Egypt before the

Flood, the traditions of which were often equated with the traditions of the Jews. Like the Mundane Shell, this ancient world suffered a cataclysmic destruction. The *Asclepius* affords us a posthumous prophecy of the end. Increasing impiety brings that holy land wherein for a time "the gods deigned to sojourn upon earth" to cataclysmic destruction. It must not be thought, however, that the Mundane Shell is to be identified with a geographical Egypt. The identification should be with a state of civilization which is primeval and patriarchal and nearer to Eternity than succeeding ages. Its religion is Druidism in its glory, before that religion had degenerated into sacrifice. Its extent is the inhabited world. Blake shared the belief, common in his time, that Druidism was the religion of the patriarchs and that its temples covered the earth.

Though it was built at the level of the stars, the Mundane Shell does not always remain there. The error which had been set in motion by the Fall pursues its course in spite of this tremendous effort to withstand it. At the time of the Flood, the Shell collapses, very much as Bishop Burnet's terrene shell collapsed, to be engulfed by the waters let loose from within, which in Blake's myth are waters of materialism. With this disaster man falls into the abyss which Urizen had foreseen and feared. He can still be saved, but to that end the world has to be created anew (in accordance with the biblical parallel), and the command of it passes from Urizen, whose light is now extinct, to Los (the prophetic genius), who has what light remains. To provide a little light in the moral darkness, a portion of the stars—probably that third portion which is dragged from heaven by the tail of the great dragon in the Book of Revelations—descend into the pit, there to become the moral law which demands vengeance for sin, a chain which binds man to cruelty, but with the beneficent intent of lifting him again to forgiveness. The evolution of the Shell is imaged in the descending chain, beginning as gold and ending as iron.

In its whole extent, therefore, the Mundane Shell reaches from Beulah, where it signifies the law of forgiveness, to Tyburn's brook, where it signifies the law of vengeance. Thus the

stars follow man along the whole course of his aberration, always being there for those (the prophets) who have eyes to see, lighting the darkness "till break of day." The Mundane Shell, therefore, continues to be what it began with being, an extension of Beulah. Originally created to preserve Beulah by rational command when the inner impulse to forgiveness (the moon) had failed, the star-world continues to perform this function, even under forms of temporary cruelty. In this extension the three heavens of Beulah (head, heart, and loins) become the twenty-seven heavens of the Mundane Shell, though still remaining basically triadic. That Beulah and the Mundane Shell are of one piece is shown by the fact that the twenty-seven heavens are ascribed now to the one, now to the other. Their essential identity also prevents the Mundane Shell from becoming, as at first sight it might seem to do, a fifth world in Blake's system.

Upon the Mundane Shell, as it descends even to Tyburn's brook to become a heaven for Ulro, Blake expends a great deal of imaginative ingenuity. The descent recalled to his mind a passage in the *Poimandres*, where the visionary sees darkness settling down "awesome and gloomy, coiling in sinuous folds, so that methought it like unto a snake." The Mundane Shell, settling down amid the moral darkness, coils itself into a great serpent, in whose twenty-seven folds are contained the twenty-seven churches, all of which are forms of serpentine religion. The number is appropriately in agreement with the number of divisions made by Plato in the space between the earth and Saturn. It is also appropriate that the number agrees, whether by design or chance, with the changes of the moon, the moon of love whose failure is written in the twenty-seven heavens. But there is not only a great serpent in the starry heavens, there is also a great polypus. This figure is from Ovid, who uses the polypus as an image of the feminine dominion in whose tentacles the masculine identity is extinguished. Since the moral law exalts the feminine emotions and represses the masculine energies, the polypus is an apt symbol. The feminine quality of Blake's polypus is revealed in the fact that it is a conglomerate of

emotions, dissipated and indefinite, unorganized by masculine intelligence. In so far as Urizen is in it he is impotent in his own right, a slave to the feminine passion for holiness. In so far as Los is in it, he is gradually transforming it. Its true character is expressed by the Daughters of Albion, who sit within it, "withering up the human form" by their "laws of sacrifice for sin," just as the masculine form was destroyed in Ovid's story by the nymph's embrace.

The polypus of the skies comes into being by virtue of the forty-eight Ptolemaic constellations and consists of their intervening voids. The number was fortunate for Blake in being a fourfold twelve and the number of the cities of the Levites. The stars, however—the forty-eight cities of the Levites—are but the boundaries of the voids, which are forty-eight "empires of chaos," whose fibres—the "tentacles" of the polypus—extend down into the sea of time and space, a conjunction of hatreds, a fourfold twelve enormity. Between the voids and the stars there is this difference:

> Los reads the Stars of Albion; the Spectre reads the Voids Between the Stars.

The dark "Newtonian voids" stand for the doubt and negation of the spectrous mind; the stars require for their creation or discernment some degree of prophetic faith and insight. The reader may remember how, in the illustrations to the Book of Job, the appearance of the stars marks Job's emergence out of the darkness of Ulro. It is because Los keeps in mind the original purpose of the law as suggested by his ability to read the stars, that he must recreate the Mundane Shell after it has been destroyed. He is said to build it continually around the polypus, transforming the religion of the priests into that of the prophets. The light of the stars as Los reshapes the Mundane Shell may be cold and feeble, for the imagination itself is deeply infected with doubt; the prophets disengage themselves from the priests but slowly. Nevertheless, the stars are better than the dark indefinite out of which they emerge. They are still a chain which keeps the body of man from falling into the abyss;

and the Mundane Shell, which from one point of view is a twenty-seven-fold serpentine deformity, is from another point of view "the place of redemption and of awakening again into Eternity."

<center>IV</center>

It has been said already that the bound which the Mundane Shell attempted to impose on destiny does not hold, but breaks at the time of the Flood and precipitates man into the abyss of Ulro. The abyss is roofed over by those dark interstellar spaces which are the Satanic wheels, and which, reaching down into the sea of time and space, make up the polypus. It is the cave of corporeal life, and corporeal life is the hell of Blake's system. "What are the pains of hell," he writes, "but ignorance, bodily lust, idleness and devastation of the things of the spirit?" In such a way of life is the absence of Christ, the negation of the good life, which has been the only hell acknowledged by many Christians. It is fittingly located in the empty heart—the East made void when Luvah abandoned it to rise into the zenith in the chariot of Urizen.

Since Los works within the precincts of Ulro itself, transforming it from a world of death into a world of Generation, constantly building the Mundane Shell, as has just been said, around the polypus, the worlds of Ulro and Generation are practically co-terminous, and a little difficult to distinguish. Strictly speaking, Ulro should be a state of pure negation, mere nonentity, so that

> . . . whatever is visible to the Generated Man
> Is a Creation of mercy & love from the Satanic Void.

But certain features of the landscape belong unquestionably to Ulro. As Los walks around, night and day, this is a portion of what he sees:

There is the Cave, the Rock, the Tree, the Lake of Udan Adan,
The Forest and the Marsh and the Pits of bitumen deadly;
The Rocks of solid fire, and Ice valleys, the Plains
Of burning sand, the rivers, cataract & Lakes of Fire . . .
The land of darkness flamèd, but no light & no repose:

The land of snows of trembling, & of iron hail incessant;
The land of earthquakes and the land of woven labyrinths,
The land of snares & traps & wheels & pit-falls & dire mills,
The Voids, the Solids & the land of clouds & regions of waters, . . .

The topography of Ulro, while very Blakean in effect, is to a large extent a composite of earlier versions of the underworld. The Bible, Virgil, Dante, Milton, and the rabbis would by no means exhaust the sources of that passage. The lake of Udan Adan, a lake "not of waters but of spaces, perturbed, black and deadly," may have been suggested by Virgil's black lake, the more probably because Thomas Taylor had praised Virgil's cave, black lake, and dark woods as emblems of corporeal nature. The dark fires, deprived of the intellectual quality of light, and the pits of bitumen are among the Miltonic contributions. But this is no place to study sources. It is more to our present purpose to observe that Ulro is the space provided for the Circle of Destiny. In this grim world the error which in its ethical aspect is Natural Religion has to be traversed. The path was prepared by Enion when, in terror and dismay, she wove the spectre of Tharmas into her own woof and assumed the rôle of Nature. The round of nature and the Circle of Destiny are one. The cycle will come to an end and return to its point of departure when the error, having been experienced in all its cruelty and falsity, shall be cast into the lake of fire. As a token of this conclusion a rainbow rests over Ulro.

The error which has to be experienced is that of a life based upon the outward, the passive, and the feminine, one aspect of which is an outward and natural, instead of an inward and spiritual, religion. Life in Beulah approximates to this condition; indeed, as a temporary repose it is necessary and desirable; but it is fatal to make it permanent. The passive and phenomenal life exists merely for the renewal of the divine energies. That is why Urizen's effort to stabilize Beulah in the Mundane Shell was bound to fail. It was contrary to the divine plan. The error had to run its course. In Beulah the superiority of Eden is still recognized. The Daughters of Beulah are self-sacrificial; they labor toward their own extinction. But in Ulro the energy of

Eden is feared and hated, and the Daughters of Albion, who are the correspondents in Ulro of the Daughters of Beulah, sacrifice man's energies to their own passivity and holiness. In every way and at any cost the feminine, who is also the outward and the passive, seeks her own permanence and dominion. In this struggle to seem infinite, her looms weave

<p style="text-align:center">. . . webs of torture</p>

Mantles of despair, girdles of bitter compunction, shoes of indolence, Veils of ignorance, covering from head to feet with a cold web.

To such a perversion of her true nature does the female come by thinking of herself as Good.

But the masculine principle, as well as the feminine, undergoes perversion. In so far as Ulro is "self-righteousness conglomerating against the divine vision," it is a perversion of the emotions. In so far as it is "abstract philosophy warring in enmity against imagination," it is a perversion of the intellect. Man's reason in Ulro has declined to the level of dependence upon sense impressions and phenomena, that is to say, upon the feminine and the outward. Its inward illumination is gone, hence the opaqueness of the landscape. With the light and warmth the fertility is gone, hence the sandy desert. The Urizen who is the "God of this world" is blind, aged, impotent. The reason which he represents cannot believe beyond demonstration, and demonstration is by means of experiment and logic; hence the Satanic mills. This reason does not cherish the "minute particulars," as imagination does; on the contrary it abstracts and dissipates. Under its disintegrating influence the once articulate feminine emotions are "scattered abroad like a cloud of smoke" among the Satanic wheels. The vengeful emotions, which are dominant in Ulro, are figured in the pits of bitumen burning. Of these passions and prejudices Urizen is the rational ally. The "iron laws," the pretenses and the hypocrisies out of which the social net is woven are to be associated with the mills of Satan and Beelzeboul which stand beside the lake of Udan Adan and round the roots of Albion's tree. With no faith in himself or in his fellow man, with no ideas to build with except

those deduced from his own identity, Urizen builds a world in which "man is by nature the enemy of man," a world with no principle of cohesion except mutual hatred.

Head and heart, then, combine in Ulro in what Blake calls an hermaphroditic union, because it means the extinction of masculine energy; but the triad requires for its completion the third member, the loins, which function in Ulro as the instrument of corporeal warfare, instead of mental warfare, as in Eden. This triad is in Ulro an antithesis or a travesty of its character in Beulah. The unbelieving head (the Accuser) delivers man over to self-righteous accusation. The cruel heart (the Judge) pronounces the cruel sentence in the name of love. The chaste loins (the Executioner) execute the laws which are "death to every energy of man, and forbid the springs of life." In this form the head, heart, and loins are the triple Spectre, the three-headed Cerberus who guards the gate of hell. They are paralleled by a feminine triad who may be thought of in Ulro as the three Fates, who appear in a very fine drawing as the triple Hecate. The foremost of the three figures is Vala, garbed in a black robe, with the serpentine book of good and evil open before her.

Blake's Ulro is conceived with keen insight into the forces which tend to make a hell of the life about us. Of these forces is not the triple Spectre a brief résumé? What phrase could better describe the darker aspect of our present situation than "incoherent despair"? Are we not caught in the tentacles of "a polypus of soft affections, without thought or vision?" And yet Ulro seems, as it should, a mere evil dream. Its landscape, under black enchantment, as it were, could turn paradisiacal as suddenly as it does in the *Marriage of Heaven and Hell* when it falls under the eye of the prophetic or poetic genius.

V

The fourth and last of Blake's worlds bears the name, Generation. It lies in the North, the realm of Urthona, the loins of the cosmic Albion. With his arrival here, he completes the path of experience. He has moved from Eden in the West, to Beulah

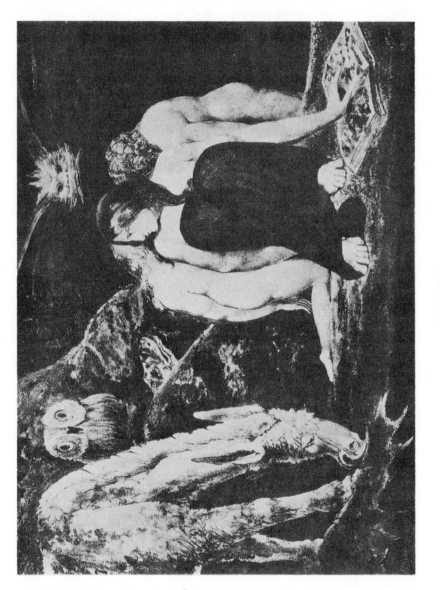

HECATE

in the South, through Ulro in the East, to Generation in the North—from the unified body, to the abstracting head, to the loveless heart, to the loins of Generation. The name, Generation, and the identification of this world with the loins, suggest its purpose. It exists to give life. "O holy Generation, image of regeneration," is the expression of Blake's faith. Generation will have fulfilled its function when it again makes manifest the Christ in man.

Though, as we shall see later, Generation may be logically said to follow Ulro, the two worlds are coextensive and coexistent, though not identical. Both come into existence at the time of the Flood, when the Mundane Shell crashes into the abyss. Ulro is the land of eternal death, Generation the means of release. The one is chaos—error in the abstract, hidden in obscurity; the other is creation—error made definite and knowable. "Error is created. Truth is eternal." In the world of Generation error is created (given a definite form) that it may be put off time after time. As creation, thus defined, is of necessity a continuous process, proceeding as long as error exists, Generation and Ulro are overlapping worlds. Both are coexistent with mortal life. In the one is all the error implicit in the nature which Enion spun; in the other, the consequences of that error turned to regenerative ends. The one is Babylon, a state of total unillumination; the other is man's painful and disheartening struggle to build the New Jerusalem.

Differences in the two worlds are due, therefore, to a difference in their animating purposes. The forces of Ulro would perpetuate error; the forces of Generation would have man know error that he may deny it. Experience is the working principle of the Generative world. Blake's Job has to fall into one affliction after another before he realizes that his God is no other than the God of his three friends. It requires a treaty of peace or a League of Nations to bring the dimly realized principles of international comity into pitiless visibility. It requires an effort toward change to understand the true nature of tradition. All such efforts are the work of Los, who makes them in the hope that the knowledge and experience of error

may restore the truth. He is therefore described as "giving a body to falsehood that it may be cast off forever."

The symbol for Los's creative accomplishments is the Mundane Egg. It rises out of the chaos which is Ulro like the cosmic egg upon the waters in various creation myths. It is drawn in *Milton* as an egg-shaped world surrounded by flames,—the chaotic ruins of Albion's four great powers. This ancient conception of the egg as the origin of mundane life had been given respectful attention in Blake's own day by Jacob Bryant, for whose mythology Blake had made engravings, and somewhat earlier by Thomas Burnet, whose theological writings Blake must have known. Its value for the myth lay in its suggestive power. In the egg-shaped world of Los is the existence of the future. The image of the egg augments the symbolism of the loins.

Though Generation is in reality the temporal world, it remains a hope rather than an achievement until the spirit of Christ is manifested. This event is not fortuitous, but the culmination of a progressive enlargement of vision. When at last the goal of forgiveness is reached, Christ, the symbol of that forgiveness, descends into the mortal body, the symbol of the law, taking upon himself the body of error that it may be put off eternally. Eternal death is defeated by the temporal and the mortal. The world of Generation may therefore be logically said to follow Ulro. It waits for its fulfillment upon the spirit of forgiveness which is Christ. This is why the *Four Zoas* defers the world of Generation until the seventh book.

This eventuality was prepared for at the time of the Flood, when the objectives of the Generative world were named, and the foundations of Golgonooza, Los's city of the spirit, were laid. This early foundation of Golgonooza, centuries before the spirit of Christ could make it really effective, has a parallel in Basilides, among the Gnostics, who said that Jesus was "mentally preconceived at the time of the generation of the stars." In Blake the preconception comes when the star-world fails. In Golgonooza is the purest imagination this world affords. The play of this imagination upon Ulro awakens it into Generation.

In the very heart of darkness stands "the spiritual fourfold London, continually building and continually decaying desolate," as the imagination flourishes or fades.

In the long struggle toward regeneration Los is pitted against Urizen, who rules Ulro in the interests of feminine passivity. Los's concern is with the masculine energy. His furnaces are symbols of that power. Into them must go the cruel and selfish forms of Ulro that they may be destroyed and more merciful ones created. When, however, the imagination is thwarted in its purpose by selfish opposition, the forms which issue from the conflict are new forms of selfhood and cruelty, forms abhorrent to the imagination, agencies of renewed torment to the human spirit, forms no better than before. The struggle is disheartening. Before it can end, doubt must be subdued to faith, reason to imagination, negation to affirmation, selfhood to selflessness. Los's doubts and despairs, his occasional triumphs, and his invincible determination suggest the vicissitudes of a distraught world seeking salvation. The following passage, eloquent of ages of distracted efforts, runs the whole gamut of emotions:

Los rag'd and stamp'd the earth in his might & terrible wrath.
He stood and stamp'd the earth; then he threw down his hammer
 in rage &
In fury: then he sat down and wept, terrified: Then arose
And chaunted his song, labouring with the tongs and hammer.

Though Los's labors are too often unsuccessful, he provides such illumination as the mortal world has. He is the purveyor of its religions and its philosophies.

 If the Sun & Moon should doubt,
 They'd immediately Go out.

This is what happens with the Fall. Urizen, the sun, and Luvah, the moon, of the supernal world, both fall into doubt and suffer extinction of their light. To replace these darkened luminaries Los hammers the remnants of Urizen's light into a temporal sun and creates the moon of Ulro, dismal substitutions both of them for their supernal counterparts, yet they serve

to light a world of darkness. He labors, too, to restore the world of stars, continually building the Mundane Shell around the polypus.

The creation of a temporal sun and a moon of Ulro suggests, with other considerations, that the two fallen worlds are in analogy with the two unfallen worlds. The alternation of energy and repose which characterizes the relationship of Eden and Beulah is true also of Generation and Ulro. In Ulro the sleep of Beulah has deepened into death; in Generation there is an awakening into activity. In Ulro the feminine will which imposes passivity is dominant; in Generation it is challenged by masculine energy.

The details of the regenerative process will be discussed in a later chapter. It is sufficient here to say that the Generative world which Los creates carries within itself the means of its own redemption. It is a world of time and space, a world of change in which error is repeatedly brought into concrete form for destruction. Without the temporal quality of Los's world, man must be kept eternally in error's power. When at last he frees himself from error, time will be at an end; for time is with Blake, as with Erigena and others, "the motion of things in Generation which pass out of nonexistence, into existence." It stands transitionally between eternal death and eternal life.

It is again a redemptive feature of the Generative world that the sexes have been separated, that the masculine energies have been liberated from the tentacles of the female polypus. There are sexes, then, in Generation, as there are in Beulah, but in what a different relationship! In Generation, masculine and feminine, in all the aspects which these symbols connote, are set against one another in mutual strife. Good struggles with evil, energy with restraint; the spirit wars with the flesh. Peace, when it does come, is usually the desolation of an hermaphroditic peace—energy bound in a feminine passivity. But there is always hope that the warring contraries, purified by strife, will come together in the peace of mutual understanding. When this occurs, the world of Generation will have fulfilled its function.

VI

Blake's four worlds bear a correspondence to his four degrees of vision. Eden, with its unity, its freed energy, its unconditional forgiveness, is fourfold vision or "science." Beulah, with its apparent duality, its passivity, its love which conceals man's "loves and graces" from the clouded intellect which would call them evil, is threefold vision or a religion of mercy. Ulro, with its reliance upon the organic senses, with its triumph of the outer world as moral justice and materiality, with its negations of energy and its spiritual hate which masquerades as love, is single vision—Natural Religion at its worst. Generation, by the creative energy of which Ulro is defined that it may be experienced and repudiated, is man's struggle toward the truth. It is Blake's twofold vision.

The four worlds seem also to be associated with the four continents: America, Africa, Asia, and Europe. The medieval world maps were regularly divided into three parts: Asia, Europe, and Africa; East, North, and South; America in the West being shut off by the Atlantic. This division suited Blake's fourfold world exactly. Certainly America, by its identification with the Lost Atlantis, becomes the lost Eden. The other three continents would thus symbolize the three mundane levels—Beulah, Ulro, and Generation. Evidence supplied by the early prophetic books seems to substantiate this inference. Egypt (Africa) marks the first stage of the descent, and would therefore be the equivalent of Beulah. The scene would then seem to shift to Asia, which, with its "twelve kings," would be the equivalent of Ulro. Revolt against the tyranny of the "kings of Asia" is supplied by Europe, which provides a striking parallel to the world of Generation. In Europe, Orc, the spirit of the French Revolution, frees himself from the fetters of Asia (the repression symbolized by the Mosaic code of Palestine) and prepares the way for the sweeping destruction of error in a Last Judgment; for Blake shared the hope of his time that the American Revolution had opened the way to the millennium. It

held for him a promise that the lost Paradise (America) would be regained. It is of interest that America, Africa, Asia, and Europe are the West, South, East, and North of the physical universe as Eden, Beulah, Ulro, and Generation are the West, South, East, and North of Blake's spiritual universe.

IV

Definite and Bound

The Infinite alone resides in Definite & Determinate Identity.
Jerusalem, p. 55.

*. . . with bounds to the Infinite putting off the Indefinite
Into most holy forms of Thought.*
Milton, p. 27.

THE preceding chapter noted a difference in the physical
characteristics of Blake's four worlds. At one extreme is the defi-
nite and integrated reality of Eden, the world of eternal life;
at the other is the unreal chaos of Ulro, the world of eternal
death. Between them are Beulah and Generation, worlds of
space and time, both having a measure of the definite, but the
one readily transcended, the other "fixed" and difficult to
transcend. These differences are not arbitrary. They are de-
manded by the metaphysics of Blake's universe.

Blake's theories of form proceeded directly from his assump-
tions concerning the nature of Eternity. This was for him the
world of ecstasy which he inhabited when in his visionary ex-
periences he transcended time and space. "In Eternity all is
vision." To this conclusion Swedenborg had come before him.
"The universe of the spiritual world is wholly like the universe
of the natural world, with this difference only, that things in
the spiritual world are not fixed and settled like those in the
natural world." Swedenborg goes on to say that when the angels
go away, their paradisiacal landscape disappears. When other
angels take their place, the landscape changes, for "these things
take form according to the affections and consequent thoughts
of the angels." This is substantially the position of Blake, for
whom "there exist in that eternal world the permanent reali-
ties of everything which we see reflected in this vegetable glass

of nature," but for whom those realities are "mental,"—visionary forms perfectly responsive to the imagination.

In contrast to the responsiveness of eternal forms, the fixed forms in which the natural man seeks reality are obtrusive, a "hindrance and not action." "Natural objects always did and now do weaken, deaden and obliterate imagination in me," is Blake's denial of a supposed reality in the world of appearance as it is reported by the organic senses. The illusion is the more pernicious because it stands between him and the visionary reality of the mind. In the illusory world of nature, Blake's visions deserted him. He labored without them to his infinite distress. We are told that when they abandoned him he was accustomed to kneel down and pray for their return. His was the familiar experience of the mystic. Despair is as certain as ecstasy. The visionary escapes but for a time. The world of sense and the wall of flesh soon drag him back to his prison house of limitation. Blake's experience led him to conclude with Thomas Taylor that the soul can be uninterruptedly blessed only "when it ascends with its ethereal vehicle perfectly pure to the pure spheres, . . . for then it is by no means hindered in the energies of divine contemplation." Not until man escapes from "all law of the members, into the mind, in which everyone is king and priest in his own house" can he know again the perfect intellectual felicity which is Eden. If this escape is to be more than a fleeting experience he must be permanently delivered from the mortal body and the world of sense.

How man lost his power of uninterrupted contact with Eternity through vision, how he acquired the limitations of the mortal man, and how at the end of time he shall be freed from them, are all questions pertinent to Blake's problem of form; for, as we shall see, form is determined by perception, and perception is a spiritual matter. As Albion's insight passes from the immediate perception of Eternity to the restricted consciousness of the five senses, his universe loses its visionary and eternal character and takes on the fixed and finite forms that we know. The visions of Eternity become "weak visions of time and space," fixed into unexpansive bulk, no longer obedient to

the will of man. This relationship of perceptual powers and physical form is expressed in Blake's theories of the definite and the bound.

Blake had all the artist's horror of the indefinite and the abstract. That way lies eternal death. In the morass of generalization, art and "science" are lost. No element of his philosophy kindles a more passionate emotion than the definite and the bound. "How do we distinguish one face or countenance from another," he writes, "but by the bounding line? . . . Leave out this line and you leave out life itself; all is chaos again, and the line of the Almighty must be drawn out upon it before man or beast can exist."

In this association of the "bounding outline" with "life itself," Blake was again rationalizing his experiences. His philosophy rests upon a substratum of personal psychology. The eternal world he saw in vision was of extraordinary clarity, sharply defined and minutely detailed. His affirmative testimony is abundant. "Vision is determinate and perfect." And again: "The painter of this work asserts that all his imaginations appear to him infinitely more perfect and more minutely organized than anything seen by his mortal eye." In contrast to the "determinate" character of things seen in the imaginative world, "Nature has no outline."

Inferences are obvious. The definite characterizes the world of imagination which Blake saw in vision. The definite forms he saw there are eternal forms—realities whose indeterminate and shadowy reflections we see in our mortal world. Conversely, the indeterminate characterizes the unreal natural world. To put it differently, what man sees with his eternal senses—his visionary capacity—is definite and clear. What he sees with his organic senses is indeterminate and vague. The difference in the definiteness of the eternal and mortal worlds is thus a matter of perceptive power. "The clearer the organ, the more distinct the object."

The assumption that man's perceptual powers suffered a declension with the Fall was traditional. It had been made, for instance, by Origen, Erigena, Boehme, and Swedenborg. Thus

the thinking which Blake inherited from others supported the conclusions derived from his own experience, and became a portion of the myth. Before the Fall Albion enjoys the expansiveness of the supernal senses, and consequently sees his world as "determinate and perfect." But the perfect and determinate character of his world is lost when, with the Fall, his perceptions shrink to the organic level.

The logic for the changes which the outer world undergoes with the decline of the perceptions lies in the nature of Blake's psychology. He had no use for the Lockean tradition. The mind is not a *tabula rasa*. It is not "conditioned" by outer circumstances. On the contrary, the perceptive organs are themselves creative. It is not the mind, but the world, which is "conditioned."

What man sees, then, is in accordance with his capacity for seeing—in accordance with his soul, his psyche. "Intellect" would be the typical Blakean word. The highest level of intellect—the level of the eternal senses—is imagination. Under its cohering power life is an ordered and integrated whole. But as imagination declines and the lower reason attempts to order life by abstract principles, the indefinite replaces the definite, the indeterminate replaces the bound. The lowest level of intellect is that form of rationalism which Blake personifies as the "idiot questioner," who is always capable of questioning, but never capable of answering. It need hardly be said that the idiot questioner sees only with his organic senses, or that the doubt his reasoning begets is a disruptive force. He is "the Spectre of Albion, destroyer of definite form."

For the connection of diminished perceptions with the Fall, Blake had the support of Christian tradition; for the kind of world which diminished perceptions see, he drew mainly upon Neoplatonism. In Plotinus's world Yonder, forms are both definite and translucent; they shine, as they do in Blake's Eternity, with their own internal light. Forms in this world, on the other hand, are dark and indefinite. Matter has intervened. Proclus follows his master in associating matter with the absence of order and intellect. "Take away order from everything that is

orderly, and what remains is matter. It is that which, if it had any creative power, which it has not, would produce disintegration in that which is integrated, disconnexion in that which is connected." There is no need to multiply examples, but one or two passages from Thomas Taylor are important because they were doubtless read by Blake. Expounding Plotinus, Taylor says that "the perfect soul . . . remains pure and perfectly bound in intellectual measure. But the soul which does not abide in this manner . . . is filled with an indefinite nature . . . participating of matter, looking at that which it cannot perceive . . . surveying absolute darkness." Expounding Proclus, he writes: "Very true being . . . consists from *bound* and *infinite*," whereas corporeal things "rush from the embraces of bound, and hasten into multitude and non-entity." The parallel with Blake's thought is exact. "Very true being" is "bound and infinite," and its bound is "intellectual measure." When that bound is destroyed, man descends into the darkness and chaos of the indefinite.

Though in Blake's myth imagination is an integrating factor, and reason an analytic or disintegrating factor, some further definition of "intellectual measure" is necessary. Imagination, as the existence itself, is an inclusive concept; in it all the other powers are implicit. At this high level reason and imagination function together. But imagination such as this is limited to the unfallen world. In the fallen world the powers fall into separation. Cut off from imagination, reason becomes an analytic power, the instigator of doubt, a completely disintegrating force. Yet there can be no doubt, I think, that reason plays its part in the achievement of bound. The *Marriage of Heaven and Hell* names reason as "the bound or outward circumference of energy." The myth bears out the assertion. Urizen is the great creator of the Mundane Shell period, and Los, his successor in the mortal world, has the assistance of his Spectre, whom he must first subdue. Left alone, the Spectre would of course create nothing. The indefinite is the product of the doubting and abstracting intellect. What is wanted is faith—faith and a vision of the future, an attitude of affirmation. These Los supplies. It

would seem, therefore, that the "intellectual measure" necessary to the achievement of definite form is provided by reason and imagination acting together in this relationship.

The four worlds which compose Blake's universe, ranging as they do from that degree of intellect in which reason is the servant of inspiration to that degree in which reason has dwindled into doubt and negation, reveal four corresponding degrees of definiteness and integration. Eden, the world of imagination, is "determinate and perfect." There the Divine Vision, the brotherhood of man, binds all the minute particulars of life into a completely integrated whole. By following Plotinus in insisting upon the preservation of every identity within an all-inclusive unity, Blake saves his eternal world from the abstract character of the One in Oriental philosophy, and retains for it its determinate character. In Blake's mind, the bound set by such integration offers no limitation; Eden is ever expanding and therefore infinite. We are reminded here of the *Kabbalah Denudata*, wherein Eden "is the brain of the Most Holy Ancient One and that brain is expanded on every side."

In passing from Eden to Beulah, Albion passes from "science" to faith, from certainty to belief, from a world of imagination to a world ruled by reason and the senses. Consequently he passes from infinity, at once definite and bound, to illusions of time and space. The illusions, intended to preserve the definite and bound in a world that has lost sight of infinity, are not, however, "fixed"; the expansiveness of the eternal world is a potentiality of Beulah. As the faith of Beulah culminates in the immediate perceptions of Eden, so do its illusions of time and space dissolve away in a consciousness of infinity. For that reason Albion is said to pass freely out of Beulah into Eden. He would seem at this point to be in pretty much the position of Swedenborg's angels, for whom appearances are apparent only, having not yet been "confirmed."

The spatial illusions of Beulah are devised as a protection to the mind grown weary in Eden. They constitute a barrier between the mind and the dissolution which accompanies its abstracting activities. The danger of dissolution is imaged in the

caves of sleep, in which, as in a roofed-over skull, the mind is limited and confined. In these caves of the weary mind, doubt replaces certainty, and the abstract and indefinite replace the definite. Here the rational mind reduces the physical world to matter, which, in Neoplatonic thought, "rushes from bound," descends into the "indeterminate," and has "little power of recalling itself into One." It should be remarked that the indefinite arrived at by the destruction of the definite bound is no less infinite and eternal than is the unity of Eden. In one is the negation of Eternal Death; in the other is the affirmation of Eternal Life.

To prevent the reduction of the definite and eternal world to the indeterminate of abstract matter the Daughters of Beulah "follow sleepers in all their dreams, creating spaces lest they fall into Eternal Death." Chaos is prevented because the bound lost with the unity of Eden is replaced by the illusory spatial bounds of the Daughters of Beulah.

The weaving of spatial illusions by the Daughters of Beulah is in accordance with the Blakean psychology already mentioned. Man recreates his earth in terms of his heaven. As he believes, so does he see, and as he sees, so is his earth. Consequently the feminine powers, who weave the spiritual body, are also the weavers of the natural body. This does not invalidate the assertion that form is a matter of intellect, since the Daughters, as true Emanations, weave in response to intellectual compulsion. The Daughters of Beulah provide spaces which are definite and bound for the protection of a mind which still retains its faith. When, however, the mind sinks into doubt and abstraction, the Daughters of Albion provide the vague and indefinite spaces of Ulro.

For the creation of spaces by the Daughters of Beulah, Blake is certainly indebted to Swedenborg, who named love as the space maker. He had evidently derived this conclusion from his capacity to summon in vision those with whom he felt himself to be in spiritual harmony. The Angels, he tells us, are visible to one another when in accord, and vanish when in disaccord. Moreover, his own experience had taught him that distance

was lengthened or shortened in accordance with desire. To the Angels, then, there is "an appearance of space and time in accordance with their state of affection and thought therefrom."

The Swedenborgian relation of space to affection prevails in Beulah. Always it is out of pity that spaces are made. The Daughters of Beulah are so inspired when they labor for the sleepers, and Enitharmon out of pity creates Canaan for the redemption of Satan. The power of love to sustain faith has already been spoken of. In Beulah the knowledge of Eden has gone, but its return is provided for by the faith which love sustains. This is the imaginative way of life. Consequently Beulah remains definite and bound. The infinite unity of Eden disappears with the loss of its superior vision, but diverse and finite appearances take its place. These are the outer parallel of diminished vision, for, "contracting our infinite senses we behold multitude"; but the spaces of Beulah are readily transcended because the eternal senses, though contracted, have not been "fixed" in their contraction. Though Albion no longer knows, he still believes. Consequently he retains his expansive powers.

Spaces have therefore both a literal and a symbolic value. Literally they suggest that the infinite and unified world has been made to seem finite and diverse; symbolically they suggest the substitution of other and lesser beliefs for the "science" which has been temporarily lost. These illusory beliefs stand between man and the chaos of doubt, as illusions of space stand between man and the chaos of matter. Space means, therefore, what we ordinarily understand by it, but it is in this sense no more than an outward witness to spiritual limitation. Canaan is not merely a place; it is also a spiritual outlook, a way of life. It is both a physical entity and its correspondent "thought and affection."

> And every Space that a Man views around his dwelling place,
> Standing on his own roof, or in his garden on a mount
> Of twenty-five cubits in height, such space is his Universe.

Every space is in this sense an exemplification of Blake's defi-

nition of creation as "God descending according to the weakness of man." He who no longer lives by the brotherhood of man must live by the law of his class; he who can no longer grasp the infinite must believe in the finite. All such spatial concepts are illusions, both in their literal and their symbolical meaning, yet they are merciful illusions, for they stand between man and the chaos which the loss of the Divine Vision implies —the physical chaos of the elements and the spiritual chaos of doubt.

The illusion of time accompanies the illusion of space. The spaces created by the Daughters of Beulah will endure so long as man needs them. Time, as the measure of that endurance, is the measure of man's infirmity.

> And the Male gives a Time & Revolution to her Space
> Till the time of love is passed in ever varying delights.

When man ceases to require the "space" provided for him, it ceases to exist. Does not the male live renewed by female deaths? This would seem to be true, whether the death is of the body, an outworn religion, or a corporeal world come to judgment. However, what is significant here is the ethical import. Because in Beulah man readily passes beyond the outer form to the inner spirit, the death of the form is said to be self-sacrificial. The female (always the outer form in Blake's mythology) willingly appears as spatial and temporal that man may wake again in Eden. So long as the female retains this attitude, the spatial illusion is a merciful provision.

Nevertheless, the potentialities for descent are inherent in Beulah. Danger lies in the space by which the indefinite is put off.

> The nature of a Female Space is this: it shrinks the Organs
> Of Life till they become Finite & Itself seems Infinite.

In short, the illusions of Beulah are taken for the reality. The portion is taken for the whole. The circumscribed belief appears infinite and eternal, the senses shrink to the organic level, and correspondingly, the physical form appears real.

With the acceptance of space as real, "Satanic spaces" make their appearance. Unlike the spaces of Beulah, which are illusory but evanescent, the Satanic spaces of Ulro look to their own perpetuation. Within them the phenomenal world (both ethical and physical) struggles to be taken for the real; the outer form declares itself as more important than the inner spirit. Instead of returning the mind, after a temporary confinement in some limiting but evanescent and therefore merciful space, to the visionary reality, these spaces seek to have their temporal illusions accepted as permanent realities. Swedenborg makes a similar distinction between appearances regarded as illusion and reality.

So long [he writes] as appearances remain appearances, they are apparent truths, according to which every one may think and speak; but when they are accepted as real truths, which is done when they are confirmed, then apparent truths become falsities and fallacies.

As the creator of spaces, Love must itself bear the responsibility for the Satanic space. In its self-sacrificial state love produces the spaces of the Daughters of Beulah—spaces which pass willingly out of the picture when man has ceased to need them. In its self-seeking state it produces the "perturbed, black and deadly" spaces of the Daughters of Albion—spaces which, appearing as the infinite and eternal, pass for reality. This is but another way of saying that so long as love remains self-sacrificial, man retains his faith in a spiritual reality beyond the world of appearance. When, however, love fails, faith is lost and the finite mind seeks for reality within the finite form.

Blake fixes this responsibility of love in the *Four Zoas*. It is when Luvah becomes self-seeking that the intellect falls a prey to its own abstracting and doubting powers. Consequently the definite bounds provided by the faith of Beulah are destroyed, and the Earth-Mother disappears in the indeterminate waste of abstract matter. This is the void in which is neither existence nor form. It has a parallel in the Gnostic void outside existence into which Sophia descended. Since the descent into the void is due to the failure of love to sustain faith, the abyss is said to

lie in the East, the heart of the giant Albion made empty by the failure of Luvah.

This void in the empty East is Ulro, the hell of Blake's myth. In this void the selfish emotions are activated by rational doubts and fears. Logically, then, Ulro should represent the extreme of disintegration and be without existence, since the doubts of the "idiot questioner" are the antithesis of imagination, and "imagination is the human existence itself." Blake is as usual consistent. Ulro is spoken of as the land of "eternal death"; it is the aggregate of the "abstract voids between the stars"; it is "non-entity's dark wild." The flexible spaces of Beulah here become "perturbed, black and deadly." Everything in this world is "without internal light." The souls who inhabit it have "neither lineament nor form." Satan, whose world it is, is "opaque, immeasurable." The masculine principle of this world, the Spectre, is the "destroyer of definite form." The feminine principle, the Emanation, is a "polypus of soft affections, without thought or vision." The incoherence of Ulro is Blake's analogue for the primal chaos. Both await the shaping hand of the creative imagination.

The Generative or created world rises out of the chaos of Ulro. As reason descends into doubt and the physical world takes on the indeterminate character of matter, Los, the finite form of the imagination, takes up reason's work. With this passing of control to the Poetic Genius, limit is put to eternal death, and the foundations of the heavenly city are laid. The Divine Vision is not to be lost, though ages of struggle will be needed to regain it. With the return of imaginative effort, we have a measure of the definite. Los's "egg-formed world" is wrested from the chaos around it. In it, as in the mythical mundane egg upon the waters, is the existence of the future. In creating his world, Los labors with "bounds to the infinite putting off the indefinite," constantly "circumscribing and circumcising" the measureless death about him. As he does so he gives concrete expression (spatial form) to the abstractions of Urizen. He shapes a religion of good and evil, he makes specific systems and, as their outer complement, a natural world in

which time and space and matter assume the proportions of reality.

Blake had learned from Swedenborg that the function of nature is to fix the things which flow unceasingly into it from the spiritual world. He adapts this thought to his need. His concern is with "the spirit of evil in things heavenly." For him the natural world exists that the error which proceeds from the spirit of evil may be fixed in specific form—"all mortal things made permanent, that they may be put off time after time." Not until error is brought out of the indefiniteness in which it lurks, and given a specific form by Los, can it be recognized and repudiated. "Truth has bounds, error none." One of Los's important labors is to see that bounds are provided. This is the creation at which he must labor so long as error exists unrevealed. "Error is created. Truth is eternal." In this creation of error, new religious forms and new philosophical systems must be constantly provided. The Spectre (man's rational and doubting self) must be "created continually . . . in the cruelties of moral law." The outward image of this spiritual creation is the egg-shaped world Los has wrested from chaos. In its widest implications, Los's creation is the mortal world.

In the created world (the Generative world of the myth) the physical universe loses the chaotic character of Ulro and takes on the "fixed" aspect that we know. Man can no longer transcend time and space at will. He has been given a "vegetated body" from the limitations of which he cannot escape. His spiritual perceptions have been made organic. This was for Blake a cruel provision; yet he sees in the placer of limits the remover of limits. Just as the purpose of systems is the ultimate release from all systems, so is the purpose of limits the ultimate removal of all limits. Los's definite systems lift man out of a world of intellectual chaos. So, too, do the fixed spatial forms reported by his organic senses deliver him out of the indefinite of matter. Los's "vegetated" world stands between man and chaos. It is the earth by which he escapes from the abstract hell of his own devising. When the purpose of Los's generative world

shall have been achieved, when, in short, the Generative earth shall have passed through its revolution of time, it, too, will come to an end. Meanwhile, he who frets at mortal limitations may solace himself with the thought that

> . . . whatever is visible to the Generated Man
> Is a Creation of mercy & love from the Satanic Void.

V

Contraries

Spectre and Emanation

But the Spectre like a hoar frost & a mildew rose over Albion,
Saying: 'I am God, O Sons of Men! I am your Rational Power!
Am I not Bacon & Newton & Locke, who teach Humility to Man,
Who teach Doubt & Experiment, & my two Wings Voltaire, Rous-
* seau?*

<div align="right">Jerusalem, p. 54.</div>

Man is adjoin'd to Man by his Emanative portion,
Who is Jerusalem in every individual Man; and her
Shadow is Vala, builded by the Reasoning power in Man.

<div align="right">Jerusalem, p. 44.</div>

Two bleeding Contraries, equally true, are his Witnesses against me.

<div align="right">Jerusalem, p. 24.</div>

EVERY mystic has to wrestle with the age-old problem of the
One and the Many. The vision of a multiple universe is a night-
mare of the soul which must give way, before benediction can
descend, to a vision of multiplicity in unity. "One thing in all
things have I seen" is the eternal mystical refrain. Ordinarily
the conviction of unity is mainly emotional—a thing intimately
and powerfully felt, but incapable of rational explanation. The
more intellectual mystics, however, among whom Blake holds a
distinguished place, endeavor to solve the problem in a way
that satisfies the mind as well as the emotions. Perhaps the
commonest approach to an intellectual solution of this problem
is by way of the duality always apparent within a disunited
world. Around this duality the intellectual mystic weaves a
doctrine of contraries. He achieves for them a mystical unity
when he submits the contraries, in which are proclaimed and
summed up the duality and hence the latent multiplicity of the
universe, to some sort of conjugal yoke. Possibly Heraclitus, the

reputed father of the doctrine of contraries, cannot be called a mystic. Nevertheless the mystical tradition is steeped in this doctrine. Swedenborg, Boehme, Hermes, the Gnostics, Philo, the *Kabbalah*—the list reads like the line of Blake's spiritual ancestry—all recognize but reconcile life's apparent duality by a mystical union of contraries.

Blake's philosophy rests squarely upon this tradition. "Without contraries," we read in the *Marriage of Heaven and Hell*, "is no progression. Attraction and repulsion, reason and energy, love and hate, are necessary to human existence." In this triple enumeration of the contraries several of the most important in Blake's system are omitted, notably a pair that was destined to become the very foundation of his system, and the summary of all the others—masculine and feminine. The idea that the fundamental duality of the world is sexual is also in accordance with tradition. The mind and will of Swedenborg, the mind and sense of Philo, the Creator and creation of St. Paul, the active and passive, hidden and manifest, inner and outer of the Gnostics, the intellect and will of Paracelsus, the light and dark of the *Kabbalah*, the tincture and substantiality of Boehme— all are regarded as male and female. In Blake they are boldly personified as man and woman. In the extent and variety of his sexual symbolism Blake seems to have been approached by Paracelsus. The following paragraph by Franz Hartmann, which purports to be a summary of the matter in Paracelsus, could stand equally well as a summary of Blake:—

Woman, as such, represents the will (including love and desire), and man, as such, represents intellect (including the imagination). . . . Woman represents the substance; man represents spirit. Man imagines, woman executes. Man creates images; the woman renders these images substantial. Man without woman is like a wandering spirit—a shadow without substance, seeking to embody itself in a corporeal form; woman is like a flower, a bud opening in the light of the sun, but sinking into darkness when man, her light, departs. The divine man (the angel) is male and female in one, such as Adam was before the woman became separated from him. He is like the sun, and his power may be reflected in men and women alike; but woman, as such, resembles the moon, receiving her light

from the sun, and man without woman (in him) is a consuming fire in want of fuel.

Assuming, then, that life is made up of contraries, and that these contraries can be collectively personified as man and woman, the question still remains, How are man and woman to be brought into mystical union as one flesh? This is accomplished by bringing the contraries together in the realm of undifferentiation, allowing them, however, to separate into a pair of polar opposites in the realm of phenomena. In their polarity the one contrary derives from the other—the outer from the inner, the passive from the active, the woman from the man. In Taoist doctrine the undifferentiated One divides itself into a set of polar opposites, *yang* and *yin*, which are light and dark, active and passive, masculine and feminine. "However, both *yin* and *yang* are only active in the realm of phenomena, and have their common origin in an undivided unity, *yang* as the active principle, appearing to condition, and *yin* as the passive principle, seeming to be derived or conditioned." This relationship is found in the Gnostic system of Simon Magus, wherein the contraries are called the hidden and the manifest. "Of this twofold nature," says Hippolytus, who describes the system, "he [Simon Magus] calls the one side the hidden and the other the manifest, saying that the concealed parts of the fire are hidden in the manifest, and the manifest produced by the concealed." Likewise we read in Boehme that "every essence consisteth of two essences, viz., of an inward and an outward, one seeketh and findeth the other; the outward is nature, the inward is spirit above nature; and yet there is no separation, but in that which is included in a time." Boehme conceives of the contrary essences as a dark, bitter fire-life, and a mild, sweet light-life, each having "its own source and driving," yet one being within the other, for "there is but one root from whence they proceed." Hermes brings us a similar report. "For all things are twain," he says, "Maker and made, and 'tis impossible that one should be without the other; . . . for each

of them is one and the same thing." The doctrine is also Swedenborg's:

There is the spiritual, which is the inmost of the cause, and there is the natural, which is its effect, and the two make one; and in the natural the spiritual does not appear, because the latter is within the former as the soul is in the body, and as the inmost of the cause is in the effect.

Early in his career as a philosopher, before his system had become complicated, Blake adopted the theory that the outer and passive derives from the inner and active. In his little tract entitled *All Religions Are One,* he stated: "That the Poetic Genius is the true Man, and that the body or outward form of Man is derived from the Poetic Genius." Thus the inner genius, later to be thought of as masculine, develops into a consistent outward expression of itself, later to be thought of as feminine, much as a given root develops into a given flower.

Though the contraries in these philosophies are essentially one and the same thing, and neither can subsist without the other, there is never any doubt as to which is superior and which inferior. The masculine principle, which in all these philosophies is inner, active, intellectual, eternal, and creative, is superior to the feminine principle, which is outer, passive, sensible, temporal, and created. The masculine creative energy is superior to the feminine thing created—*natura naturans* to *natura naturata.* One remembers St. Paul's exhortation to refrain from worshipping the creation (feminine) and go back to the creator (human and masculine). As Erigena says, the man must rule the woman.

Although in Blake's system, as in many earlier ones, the feminine contrary derives from the masculine, and is in a sense subordinate to it, Blake brings the feminine principle into something like equality with the masculine by emphasizing the functional unity of the contraries. The two contraries (masculine and feminine) constitute an organic unity. They represent expansion and contraction, energy and repose, like the systole and diastole of the heart. To ebb and flow is a law of life. The tide of energy could not flow again if it did not ebb. In another

metaphor life is cyclic, eternally renewing itself by revolving around the polarity of contraries. Energy subsides into repose, but this repose is the mother of fresh energy. Day darkens into night, but night longs for the day and light is reborn. Spring falls into the fallow autumn only to rise again after a long sleep. This cyclic polar round provides for the constant renewal of the energy which was for Blake "eternal delight" and the "only life." It is the divine plan.

Though the sexual contraries, like the duality which they personify, sum up the whole multiple universe, they are, for the purposes of the myth, often restricted to mind and emotions. In this restriction they bear to each other the organic relationship of source and emanation with which we have just been made familiar. The feminine emotions emanate from the masculine mind "uncurbed in their eternal glory"; they are the outward manifestation of inner mental energy. As the outward principle of repose, they provide the religion of mercy, pity, peace in which the mind renews its faith and certainty and recovers its immediate perception of the unity within the duality. It need hardly be said that the intellect from which the emotions emanate is not the lower reason, but imaginative comprehension. Such comprehension, Blake believes, results in a fitting and adequate emotion. Seek to comprehend a work of art, for example, and the emotional response (if you succeed) will come of its own accord. Approach the subject, on the other hand, with prejudice and passion and you will fail of both comprehension and its attending emotion. Understanding must come first. In no other way can the mind be freed for all but intellectual consideration. In no other way, too, can the emotions remain pure and satisfying.

Reasoning upon the same problem, Philo had argued that the subordinate contrary, whichever it may be, is transmuted into unity with that which dominates. If the feminine emotions, he says in effect, are second to the masculine mind, both become fused together as mind. But if the masculine mind is second to emotions, then both are dissolved into flesh and fleshly passions. The man must rule the woman, if only that the woman may not

rule the man. This is near to Blake's position. Actually, neither contrary rules in his system; but the emotions are regarded as an expression of mind, and the sensible world as the manifestation of inner spirit. The reversal of the relationship between masculine and feminine which prevails after the Fall means that the emotions take primacy over the mind, and that the feminine husk and covering all but extinguishes the masculine inner spirit. The result is a "woman's world."

It is easy to see, then, how great is the violence done to the divine plan when man, in his impiety, begins to reason about his apparently dual self and sets the feminine contrary above the masculine—the emanation above its spiritual source. If we shift our attention from man, in whom these contraries exist, to the contraries themselves, we may say that trouble comes when the feminine contrary, no longer content with being derivative and passive, usurps the function of her superior. The principles of life are thrown into reverse. The effect is taken for the cause. The emotional life takes precedence over the intellectual life. Beulah sets itself up as Eden. When this happens Eden and Beulah are both lost, and the sexual strife of the sundered contraries is set up in Ulro. The struggle in Ulro takes many forms. It is the emotions threatening to engulf intelligence. It is outward nature threatening to extinguish the inner light. It is conventional technique warring against original genius. It is the moral ideal of a passive instead of an active good. In brief, the division is fourfold—of the head, heart, loins, and body, with all that these imply. It is not always possible to grasp all of the implications of feminine dominion, still less to express them; but they are felt in the myth. Eventually, however, the wars of Ulro are succeeded by conditions in the Generative world whereby the hostile masculine and feminine are brought together in a temporary and imperfect union, out of which, nevertheless, regeneration may result, and Beulah, and ultimately Eden, be regained. Thus the whole of Blake's myth and the philosophy which lies behind it can be summed up in terms of the contraries.

Blake's private and personal experience had bred him to his task. The strife which he depicts in the myth on an historical and cosmic scale had often been enacted on the microcosmic stage within himself. A born mystic, he was haunted by the demon of rationalism. A hater of systems, he could not rest without one of his own. He was now Los, the inspired Prophet, and now Urizen, the doubting Spectre. One set of voices said: "Follow the gleam." Another set urged: "Paint like Rembrandt. Engrave like Bartolozzi. Win recognition at any cost." Nor did his struggle end with his artistic indecisions. There were other no less severe contentions between his inner principle, energetic and masculine, and his outward principle, passive and feminine. The delusive beauty of mere outward nature and the delusive pleasure of intellectual revery often threatened the integrity of his mind. Psychological dissociation was an ever present danger. Hence the reality, the comprehension, the marvellous fairness, in his depiction of the contending figures. The personages of his cosmic myth were familiar denizens of his own breast. His own triumphant struggle against disorganization within himself gave him the insight to depict a disorganized but finally triumphant world.

When the two contraries are in perfect union, they function in the totality of their powers, unconscious of their sexual pattern. In this state they constitute what Blake calls the "humanity." The *Zohar* has the same conception. The male is not called man, it says, except in union with the female. With the loss of the Divine Vision,

> The Feminine separates from the Masculine & both from Man,
> Ceasing to be His Emanations, Life to Themselves assuming.

To the divided halves of the severed unity Blake gives the names Spectre and Emanation. Sometimes the separated feminine contrary is called a Shadow; but more frequently the term Emanation is used to designate the feminine contrary, whatever her state. Since the whole universe is made up of contraries, the struggle between Spectre and Emanation has a vast variety of applications. It may be applied, for example, to a split personal-

ity, to the conflict of good and evil, to the struggle of mind and emotions, or to the great cosmic schism itself.

The separation of the humanity into male and female comes about when the masculine reasoning power falls into doubt and selfhood, and withdraws itself from imagination.

> Entering into the Reasoning Power, forsaking Imagination,
> They become Spectres.

In the imagery of the early prophetic books, Urizen separates away from Los. Since, however, the imagination is the essential man, eternal and indestructible, it still remains, though it suffers from the secession of its component parts. In its depleted state it is the fallen Poetic Genius, personified in Los. It is still the masculine contrary, for Blake will not allow the doubting reason—the Spectre—to be a contrary; it is pure negation. The situation is admirably illustrated in the Job pictures. There Job, as one contrary, speaks with the voice of the impaired but still living Poetic Genius; Job's wife is the other contrary; while the three friends are Job's triple Spectre, whose rational fears impose their negations upon the contrary selves of Job.

Though in the later prophetic books Blake insists that the Spectre is a mere negation, it is to the effect of his labors rather than to himself that the term should be applied. Actually he is an active, contending figure. He has been specifically defined.

> This is the Spectre of Man, the Holy Reasoning Power,
> And in its Holiness is closed the Abomination of Desolation.

He is the aggressive mental factor, the rational power which refuses to believe without demonstration. He is described as a ravening, hungering, thirsting force, ever in pursuit of the felicity from which by his holy reasoning power he persistently cuts himself off. That felicity is, of course, the spontaneous emanative life of Eden and Beulah. In the ethical world it is the emotions bending themselves to the well-being of man. In the physical world it is nature responsive and subservient to the inner masculine energy which begets her.

No such specific definition as Blake gives to the Spectre exists for the Emanation. In her state of union with the male she is

all those outward effects which result from activity of inner spirit. Possessing a significance as wide as woman, she is variously designated as limited, spatial, evanescent, passive, emotional, perceptual, external, and emanative. A commentator, later than Blake, defined the Gnostic Emanations as "spiritual fructifications." That is very close to Blake's meaning. His Emanations are the fine flowering of life, the "loves and graces" of the unfallen Albion. They are the sum total of the spirit's manifestation.

In union with her masculine source—the proper relation of the contraries undisturbed—the Emanation provides a "concentering vision," whereby faith in the unity of all life is maintained. The mind, having in this state a sympathetic and intuitive understanding of the Emanation (the life of the world of manifestation), accepts the body and its energies—all of them —and knows them to be good. Enion and Jerusalem remain intact. God is seen in his works. Man and his universe are one.

The great cosmic break in which the fine relationship of the contraries is destroyed is the work of the Spectre. Blown with pride in his emanative life, he abstracts from it a set of qualities called Good. In his arrogance he believes that these qualities which he admires are due to his own activities; he does not realize that they are but the result of the undisturbed functioning of an harmonious whole. This is a mistake about which Swedenborg had much to say. The angels in his heaven never think of appropriating any of the divine attributes to themselves. They know that the good which is in them is of God, not of themselves. To think otherwise and suppose that they are the authors of perfection would be to separate themselves from heaven and the Lord and enter upon the path that leads to hell and the falsities therefrom. This angelic wisdom is known to Los. He declares:

> . . . No Individual ought to appropriate to Himself
> Or to his Emanation any of the Universal Characteristics . . .
> Those who dare appropriate to themselves Universal Attributes
> Are the Blasphemous Selfhoods & must be broken asunder.

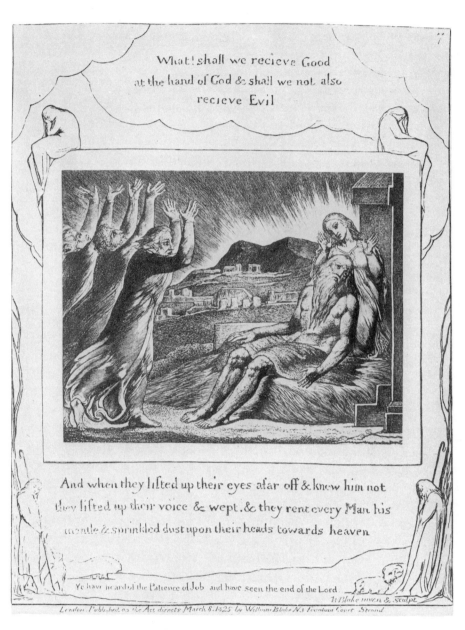

What! shall we recieve Good
at the hand of God & shall we not also
recieve Evil

And when they lifted up their eyes afar off & knew him not
they lifted up their voice & wept.& they rent every Man his
mantle & sprinkled dust upon their heads towards heaven

Ye have heard of the Patience of Job and have seen the end of the Lord

W Blake inven & sculpt

London.Published as the Act directs March 8.1825. by William Blake N.3 Fountain Court Strand

ILLUSTRATIONS OF THE BOOK OF JOB, PLATE VII

Nevertheless, the Spectre continues in his selfhood to find an absolute good in his Emanation, a good of which he, of course, regards himself as the originating cause. The irony of the situation is that man, by thinking of himself as the source of his own good, becomes thereby the source of his own evil. Having abstracted from his emanative life a set of qualities which he calls Good, he is soon plagued by another set which defy that Good. His former pride gives way to shame.

> The Spectre answer'd: "Art thou not asham'd of those thy Sins
> That thou callest thy Children? lo, the Law of God commands
> That they be offered upon his Altar. . . ."

It is the first step on a path that knows no end. The new ideal of holiness is so intolerant and imperious that the "loves and graces," one after another, are "buried alive in the earth with the pomp of religion." The cosmic body suffers along with the human body, the two being inseparable, as we know. Once the mind gives up its faith in unity, and so in the holiness of all life, it beats a continual retreat before the monster of multiplicity. The natural universe is shattered before the Spectre's doubting and holy inquisition, and the sinful aspects of the not-Me are driven, one after another, into exile under condemnation of the holy Me.

> Shame divides Families; Shame hath divided Albion in sunder.
> First fled my Sons, & then my Daughters, then my Wild Animations;
> My Cattle next; last ev'n the Dog of my Gate; the Forests fled,
> The Corn-fields & the breathing Gardens outside separated,
> The Sea, the Stars, the Sun, the Moon, driv'n forth by my disease.

That portion of the emanative life which is still approved— the passive that obeys reason—is the Good the Spectre desires. It is personified in the gentle Vala, the feminine emotional life. Under the Spectre's influence she is driven by her desperate efforts to maintain an impossible ideal into the cruel Rahab. Seen in multiple, she is the Daughters of Albion, those relentless enforcers of the moral law. The result of Vala's failure is "miseries' increase" and a renewal of the Spectre's ardor.

That portion of the emanative life which does not obey the

Spectre is the Evil condemned by Albion in his shame. Over against Vala is Jerusalem, the "harlot" sister who forgives. Over against the Daughters of Albion are the Daughters of Beulah, who remain true to Humanity, practicing a forgiveness which includes the Evil the Spectre deplores. The latter are true Emanations, the former are not. They do not spring spontaneously from inward faith and energy, nor are they content to vanish before a new creative urge. At best they are but shadowy abstractions, whose only reality is in the mind of the deluded Spectre. Having ceased to emanate the good, he formulates an artificial good and sets it up as an arbitrary ideal for a world which has forgotten how to live by the God within. He worships a "stolen" Emanation and enforces her worship upon others.

But the worship of a "stolen" Emanation, a rational ideal, gives the Spectre no peace. The emotional structure he tries to shape takes on unlooked-for forms; the Emanation he had hoped to command eludes him. Keats's dictum, "That if poetry comes not as naturally as the leaves to a tree, it had better not come at all," expresses the same thought. The Emanation, the outer form, is inevitably right only when inseparable from inspiration; it cannot be rationally fashioned. Blake gives the thought an ethical turn by associating the imagination with selflessness, the rational mind with self. Sown in the selfless imagination, the seeds of desire flourish. They perish in the soil of rationalism made barren by selfish fears.

Nevertheless the Spectre continues to desire his lost felicity. He engages in a futile pursuit of the Emanation. "He hunts her footsteps thro' the snow and the wintry hail and rain." Try as she will, however, the Emanation cannot satisfy his demands for holiness. The Spectre's rational and unsatisfied pursuit of an emanative felicity which is the fruition of life imaginatively lived and which cannot be rationally achieved, Blake describes as lustful; the inevitable tendency of that felicity to elude rational search is described as scorn. But scorn serves only to augment the "indefinite lust"; the Spectre is insatiable. He tracks the Emanation through the "frost and snow" of abstraction, never, of course, obtaining the union he desires; for his

rational and selfish pursuit of the Emanation delivers him into
a suppression of the energies out of which the emanative quali-
ties he desires come, and so automatically cuts him off from
the qualities themselves. His hunger and thirst, indicative of
his ardent pursuit of righteousness, ironically suggest the Eucha-
rist. He is said to drink up the Emanations—the passions. He
breaks up the sacrificial body—the divine unity, whether of
Enion as representing the physical world or of Jerusalem as
representing the ethical world. But his ardent pursuit gets him
nowhere. The emanative life cannot be recovered by rational
means.

The consummation the Spectre desires will not come about
till he is himself overcome, till the pillars of his pride are broken
and the falsity of his rational labors exposed. Then, the pursuit
ended, the Emanation will in characteristic fashion show her-
self ready to yield. The psychology is in part that of the vision-
ary whose inspired achievements are the result of unconscious
rather than conscious effort. There is little doubt that when
Blake ceased to struggle for artistic expression it often came un-
expectedly. Small wonder, then, that to await the vision was for
him an act of faith, the attempt to force it by rational means an
act of doubt, ending inevitably in pain and confusion. Blake
applied this principle to the field of ethics. If man lives by
brotherhood and allows the contraries to function unimpeded,
he achieves God. If he seeks outwardly a God who is wrought
in his own image and lays his energies upon that altar, he
achieves Satan.

Though the Spectre is the aggressor, by one of those ironies
which Blake was so keen to perceive, the offensive in this war
of Spectre and Emanation passes into the hands of the female.
Having been set up as an ideal, she achieves power over the
mind of man. Blake allegorizes her power as an aggression in
her own interests. The pernicious "female will" develops. In
Eternity there is no such thing as the female will. There woman
is the spontaneous and contented Emanation of man. But in her
abstraction, in the separation of Spectre and Emanation, she
attains to a will, the gift of the unwitting Spectre. The logical

outcome is the dominion of the female. Let nature be seen as something apart from man, and man will presently be seen as the offspring of nature—"a worm of seventy inches." Let the moral law be seen as something separate from the inner light, and the inner light will soon be threatened with extinction. Let body be seen as something apart from soul, and soul will be explained as a functioning of body. Let artistic form be seen as something separate from the inspiration which should beget it, and inspiration will be smothered. At the high point of woman's power over man, their original relationship is reversed. The female becomes the hidden spring of action, and in Blake's allegory passes inward. The Spectre, no longer a free creative agent, betakes himself outward to be her guard. Thus the feminine is "elevated inward." She occupies the "throne of God," and "man is no more." The Spectre, little more than a thirst for "existence," is relegated to the subordinate position of her protector. In variant imagery she has become his tabernacle, and he her priest. We have as a result the dominion of all outward and feminine things. Of all these, Blake hates and fears nature and moral justice most.

The life of the fallen world, as these pages should have made clear, is rooted in the outward feminine. The progress of the Fall is the shift in that direction. Man has substituted the effect for the cause.

> And every Natural Effect has a Spiritual Cause, and Not
> A Natural: for a Natural Cause only seems; it is a Delusion
> Of Ulro, & a ratio of the perishing Vegetable Memory.

"Mental things are alone real"—this is the basic principle of the Blakean philosophy. Nature must be explained by man, body by soul. Form is the gift of inspiration. Moral good emanates spontaneously from brotherhood. The spiritual life, however you look at it, is rooted firmly in the energetic masculine. The unspiritual life is built upon the passive feminine.

The tradition in which Blake was nourished held the view just expressed. Jacob Boehme speaks thus quaintly of man's descent: "Because he forsook the spirit, and went with his spirit

into substantiality, therefore the substantiality captivated him."
The tradition derives from the Gnostics and Neoplatonists.
Whatever the differences between these schools, they were agreed
about certain fundamentals. Both believed that the soul, for one
reason or another, had turned her desire away from the source
of her being and descended into matter, and that she would
return by shaking off materiality, turning her desire again to
the source she had forsaken. Speaking of the procession from the
origin of all things to the last and least of them, Plotinus says
of the World Soul, that looking upward to the source of her
existence she is filled with intellect, but turning downward she
generates an image of herself, the world of sense and nature.
In Blake's myth the Emanations, which, like Plotinus's Soul,
emanate from intellect, play a similar rôle. Turning from their
intellective masculine source and willing their own selfish good,
they drag man down into the "natural" world, whose cruelty is
an image of their own cruelty in seeking dominion over man.
Deliverance will come only when the feminine emotions forego
their separate identity as Good, and become again the spontane-
ous expression of the imaginative mind. "I care not whether a
man is good or evil," thunders Los, "all that I care is whether
he is a wise man or a fool. Go, put off holiness and put on in-
tellect." That assertion is Blake's equivalent for the Neoplatonic
belief that to shake off materiality, the soul must turn its desire
again to its intellective source.

A material monism and the moral law—in other words, the
dominion of the feminine world of sense and emotion—come
as near to satisfying the Spectre's rational demands as anything
he can achieve. Blake sees all such negations of the spirit as
sterile unions of Spectre and Emanation. To suggest this steril-
ity he uses the term hermaphroditic. These hermaphroditic
forms must be broken time after time, and the masculine and
feminine contraries set free.

> . . . Los with his mace of iron
> Walks round: loud his threats; loud his blows fall
> On the rocky Spectres, as the Potter breaks the potsherds,
> Dashing in pieces Self-righteousness, driving them from Albion's

Cliffs, dividing them into Male & Female forms in his Furnaces
And on his Anvils: lest they destroy the Feminine Affections
They are broken.

These separations must continue until the negation of the law
shall be destroyed and a genuine pity—a truly emanative ex-
pression—be achieved. Ultimately the holy selfhood must cease
and the Spectre be reunited with his Emanation. But until man
shall be sufficiently regenerated to live by faith, until he can
give up his essentially blasphemous attempt to reorder life in
accordance with his own selfish notions, we shall have the
Spectre and a sundered universe. Meanwhile, the Spectre must
pass from selfhood to selfhood, as tenacious of life as life itself.

Blake's picture of the spectrous mind embodying itself in one
error after another in its search for emanative felicity owes
something to the theory of reincarnation, wherein the soul passes
from error to error, from body to body, from dream to dream,
like a man (as Thomas Taylor says) "passing in the dark from
bed to bed." I do not think that Blake believed in individual
reincarnation; but he applied the idea to the progress of the col-
lective mind as it embodies itself in error after error in its long
struggle toward the light. In the course of its revolution from
eternity to eternity the mind shapes its beliefs into metaphysical
bodies whose forms are clear indications of the states and stages
of its progress.

Ancient tradition posited a spiritual (or ethereal or subtle)
body for the life eternal. Whether Blake believed in such a body
literally is not now the question; the metaphorical significance
is all that matters here. This spiritual body of humanity is the
"mercy, pity, peace and love" which are the spontaneous emo-
tional expression of a mind firm in the belief that everything
that lives is holy. Moreover, it is a genuinely emanative body. It
is not sought by the selfish and futile means which the unre-
generate rational mind employs. It comes without seeking as a
natural outgrowth of faith and intellect working at the centre.

When, however, the mind sinks into doubt, which is a disin-
tegrating force, it falls (unless it is saved in Beulah) into the
chaos and darkness and death of Ulro. In this state the Spectre

has no body. By this Blake means not what we think of as a disembodied spirit but a creature of doubt and negation, impotent to emanate any emotional fabric wherein its troubled spirit might find rest. In the history of the race periods of this kind come between two ages, one dead, the other powerless to be born. Lacking any positive faith or satisfying body of belief, the Spectre is little more than a thirst for "existence," an insatiate mental hunger. If man were dependent on his rational mind alone, he would have been lost forever when he first descended into Ulro; but he has an element of imagination (Los) which cannot be utterly extinguished, and this comes to the rescue. Laboriously and imperfectly Los creates a succession of creeds and codes and beliefs wherein the disembodied Spectre can find a temporary respite from his dark void of doubt and despair. These systems of thought are imaged, in accordance with St. Paul's conception of the Church as the body of Christ, as "bodies," and summed up in three "churches." In the building of these "churches" Los does not work alone; he is the creative agent, but the Spectre has a part—too large a part, alas!— in their construction. These bodies of belief, provided as a temporary and artificial substitute for the lost emanative body, are called hermaphroditic. They are not the natural flowering of faith and intellect, but artificial and sterile combinations of doubting minds and sterile emotions. They are better than the void, but they do not save. One by one they give way, and a new one—little better than the last, perhaps, but better than stagnation—must be provided. It is by this process that the Spectre is "created continually . . . in the cruelties of the moral law." Los hastens these changes, hoping against hope that suffering will teach the Spectre wisdom, and that a sexual, or generative, body capable of giving birth to Christ, may be engendered. For ages he is unsuccessful, but at the time of Christ the Spectre is temporarily subdued, and a body of saving faith is grown. This body which, in contrast to the sterile hermaphroditic body, is capable of engendering new life is called the body of Generation. It is a mortal body, to be laid off, like the linen grave clothes, when the mind is ready for the fullness of eternal

life. The *Four Zoas* makes it clear that this Generative body is
the Christian Church. Not, of course, that church which wor-
ships the body of sin and law which Christ cast off, but that
Church of true disciples who have received the spirit of truth
which Christ offered and with it the power to become sons of
God.

It would seem as if the achievement of a body of Generation
(image of regeneration) should bring the progress of error to
conclusion, but it is not so. While a portion of mankind is able
to put on the Generative body, another portion persists in self-
hood and error, and for these new hermaphroditic bodies have
continually to be created. The tale of churches which began
with Adam is carried on to Luther. Los gets no respite from his
labors at the anvil. His work is a continual death and resurrec-
tion, the shaping of error into "bodily" form that it may be ex-
perienced and cast off time after time. That error will presently
be cast off forever instead of reshaping itself in an eternal round
is the prophetic hope. Blake's own work was dedicated to that
end. The purpose of his system was release from systems—to
destroy the spectrous negation, restore the mind to faith and
brotherhood, and thus enable it to regain its lost emanative
felicity. The vision of perfection hovered before his eyes. In his
brain—we have his own word for it—the Spectres of the dead
took sweet form in the likeness of Christ.

VI

Sex Symbolism

O all ye Nations of the Earth, behold ye the Jealous Wife!
Jerusalem, p. 94.

Once Man was occupied in intellectual pleasures & energies:
But now my Soul is harrow'd with grief & fear & love & desire,
And now I hate, & now I love, & Intellect is no more.
There is no time for any thing but the torments of love & desire.
Jerusalem, p. 68.

THE attempt to find in sex the origin and solution of religious problems is wide-spread. Sex permeates the Mysteries, both Egyptian and Greek. It supplies the imagery for certain essential teachings of both the physical and spiritual alchemists. Yet no phase of Blake's mythology has mystified his commentators more. For this the ascetic tradition of the Christian Church is largely responsible. Blake's symbolism disturbs us because it follows the less familiar paths of heterodoxy. Sex is with him, as with the Gnostics and the Kabbalists, a fundamental mystery. For that reason his system repeats the point of view of certain Gnostic systems which made of the history of mankind the love story of the sundered contraries.

Blake brought to his consideration of sexual matters not merely the capacity to develop a system as logical as a code, but deep emotional convictions as well. His preoccupation with the subject in the early lyrics suggests a disturbing personal experience. He had probably been thwarted in his sexual desires, and he saw the society around him thwarted like himself. He believed with all the passion of his ardent nature that the sexual experience is noble, even divine, and that to look upon it as ignoble,

> And render that a Lawless thing
> On which the Soul Expands its wing

is nothing less than blasphemy toward God. In so far, however, as his preoccupation with sex is literal, it is no part of this chapter. What has been overlooked, I think, in relation to the theme of sex in these early works, is that even there the beginnings of symbolism may be found. Man and woman are not merely the separated halves of our sexually divided self, but they are already tending to become the separated contraries, in whose unity is the entire cosmos. As time goes on and Blake's sexual urge gives way to an increasing philosophic urge, sex, as such, is swallowed up in the wider aspect of the contraries, masculine and feminine. The literal meaning, however, of man and woman is never entirely lost; and Blake doubtless took a humorous and ironic satisfaction in the possibility of dual interpretation. Los and Enitharmon, indulging in their "torments of love and jealousy" remind us all too well of domestic infelicity; so well, in fact, that the significance of their struggle as one of Spectre and Emanation has been missed.

No small part of the interest in Blake's symbolism of sex is due to the ingenuity with which he constantly fits his psychology of sexual behavior, inferred from his observation of the sexual drama going on within and without his own doors, to the cosmic schism. Not only Los and Enitharmon but all the personifications of the contraries adhere to the sexual pattern. Woman, the passive contrary, is restrained, reactionary, lacking in courage. Though the emotional life, she is nevertheless afraid of passion. She is chaste, jealous, and intolerant. She is given to secrecy and guile. Yet her emotional patterns result from the mental outlook of the man, the active contrary. In her timidity is reflected his own intellectual uncertainty. He is, or ought to be, aggressive and experimental, yet he too often succumbs to the fears which his activities awake in woman, and regulates his energies by her demands. The respect with which he regards her conservatism is rewarded by the imperiousness with which she keeps him in the goalless pathway of fear and inhibition. In his impotence he is, like Arthur, "woman-born and woman-nourished and woman-educated and woman-scorned." He defers to woman only to find himself her slave. The complicated pic-

ture of the contention between Spectre and Emanation, indeed, the whole drama of the myth, can be read amusingly in literal terms of sexual behavior, though it is, of course, the philosophical interpretation which is important. It would be truer to say that both meanings are philosophical, for Blake seriously believed that the contraries around which his system is built are male and female and that their relationships, no matter what their aspect, are at bottom sexual. It is largely because of this fact, which would not have troubled the intellectuals of the third century, but which does trouble the intellectuals of today, that Blake's sexual symbolism has remained obscure.

In its widest sense, then, Blake's sexual symbolism sets forth the whole problem of duality. Like the Spectre and Emanation, whose relationship it portrays, it applies to a duality in both the physical and ethical worlds. The struggle of spirit and matter, of good and evil, of mind and emotion, are all set forth in sexual terms. In a narrower range the symbolism stresses the ethical struggle, because without a fall, the spirit would never have warred with the flesh, the inner and outer worlds would have remained at peace.

At one extreme of this sexual struggle we have an apparent dualism, harmless in its consequences, because man has not yet begun to reason about it. We have therefore a religion of forgiveness and the physical universe seen as an expression of the inner spirit. What we have at the other extreme is neatly summed up for us in the first chapter of Romans: "For that they exchanged the truth of God for a lie, and worshipped and served the creature rather than the Creator." The law rather than the God within us, the clay rather than the breath that informs it, the outer expression rather than the indwelling spirit—woman rather than man.

Toward this latter extreme the feminine contrary, abetted by reason, has been struggling ever since dissension began. With the Fall the feminine contrary lays aside her devotion to Albion, and pursues her own selfish interest. Enitharmon, in her contention with Los, speaks for the whole of womankind:

In Eden our Loves were the same; here they are opposite.
I have Loves of my own; I will weave them in Albion's Spectre.

The result of this new attitude on the part of the feminine contrary is the ascendancy of the whole outer world. In this world religions of authority have a part, since they are structures reared by the emotions, although the mind is the directing force. The authority exercised by religion is one phase of woman's struggle for supremacy over man in the cosmic strife. The story of the Fall is therefore the story of Albion's surrender to woman. It marks the ascendancy of a religion of authority and a material world.

Boehme had also identified the Fall with the ascendancy of the outer world, which he, too, conceived of as woman. Adam fell because he turned away from God and imagined "after the spirit of this world"—after the "Venus" within him. As a result "the heavenly image became earthly." Had Adam not turned from Sophia, the heavenly wisdom, to Venus, the spirit of this world, the earthly substantiality would not have conquered him. Blake's summary, though not so explicit, is more picturesque.

What may Man be? who can tell! but what may Woman be
To have power over Man from Cradle to corruptible Grave?
There is a Throne in every Man: it is the Throne of God.
This Woman has claim'd as her own, & Man is no more.

So long as a right relation of the sexual contraries is maintained, Albion lives in a spiritual world; when that relation is disturbed, when the feminine contrary begins her struggle for supremacy, he falls into a natural world. In the first category we must place Eden and Beulah; in the second, Ulro and Generation.

The different relationship of the contraries in the four worlds is indicated by different sexual symbols. These are the androgyne, in whom the contraries are so intimately united that sexual organization is transcended, the divided sexual man, whose contraries are nevertheless "married" and living in a state of harmony, the hermaphrodite, in whom the feminine is dominant, and the divided sexual man whose contraries are at war with one another.

The story begins with the androgynous Albion. His is the "human" form as distinguished from the "sexual." "Humanity is far above sexual organization." In Albion's sexless state is imaged the imaginative life of Eden, complete, unified, single in purpose. Here the contraries are indissoluble, their adjustment so perfect that neither is recognized. Duality is as yet not even apparent. The androgynous and cosmic Albion contains, like Adam Kadmon, the sun, the moon, and the stars within his limbs. All life is one. All natural forms are "men seen afar." This knowledge of the identity of all his members Albion loses with the Fall, for as he descends, his perceptive powers decline. In Eden they are flexible, contracting and expanding as he wills. Consequently the problem of multiplicity has for him no terrors. He knows that the Many and the One are but two ways of looking at life; contracting his infinite senses he sees Many, expanding them he sees One.

That Blake felt these expansive powers to be akin to his own visionary capacity there is little doubt. Isaiah, in the *Marriage of Heaven and Hell*, speaks both for Blake and the unfallen Albion: "I saw no God, nor heard any, in a finite organical perception; but my senses discovered the infinite in everything." As the androgynous Albion falls, his perceptions lose their power to contract and expand, and shrink to the fixed level of the organic senses which hedge in the sexual man. As a consequence, the world appears diverse; the unity of the androgyne disappears.

This limitation of perceptual powers is the work of the Daughters of Albion, in whom Blake personifies the collective feminine life in a state of separation from man. As long as man's feminine powers remain selfless, his perceptual powers remain flexible; when his feminine powers develop a selfish will, his perceptions decline to an organic level. Blake pictures the Daughters of Albion as they

> . . . sit within the Mundane Shell,
> Forming the fluctuating Globe according to their will.
> According as they weave the little embryon nerves & veins,

The Eye, the little Nostrils & the delicate Tongue & Ears
Of labyrinthine intricacy, so shall they fold the World.

As the unity of Eden disappears and the apparent duality of
Beulah takes its place, Blake's symbol changes naturally from
the androgynous man of supersensible perceptions to the sex-
ual man in whom the perceptions, though not yet fixed, have
diminished from their expanded to their contracted level. In
Beulah, it will be remembered, the fundamental masculine and
feminine contraries are equally true. In this earthly paradise the
rational mind recognizes an inner and an outer life, a life of
the spirit and the flesh, of the mind and the emotions, of reality
and appearance. For that reason there are sexes in Beulah.
Though the contraries are here distinct identities, they maintain
an essential harmony. Albion is now conscious of both, but not
until he has fallen does dissension arise. In Beulah he continues
to perceive the truth beyond the appearance and to keep duality
innocuous by a religion of faith and forgiveness.

Blake's use of Beulah (marriage) to symbolize the felicitous
relationship of the as yet harmonious contraries is apt. Sweden-
borg had pointed the way by his use of conjugal love to sym-
bolize spiritual good. Around conjugal love as a starting point
Blake builds a whole symbolism of woman's love, making it
express those changes in thought and emotion which he alle-
gorizes in the changing relationship of Spectre and Emanation.
Woman's love is, of course, fourfold, as are the Zoas and their
component contraries, but Blake stresses its ethical implications.
Its range from free love to chastity and jealousy is made to sug-
gest the range from forgiveness to vengeance. In the ideally
"married" state woman's concern is for the well-being of man.
Jealousy has no place in their relationship. Freedom is its char-
acteristic, and forgiveness its code. The outer and inner worlds
remain at peace, for no portion of life is denied. "Embraces are
comminglings from the head even to the feet," and not, as we
shall find them later, when division has entered in and forgive-
ness been lost sight of in the mysteries of the moral law, "a
pompous high priest entering by a secret place." As the feminine

emotions seek for supremacy in the moral law, they persuade the masculine contrary that "woman's love is sin." The sacredness of all life (which the forgiving love of woman implies) is denied, and an ethics of repression is set up. The outer world is cut off from the inner. In terms of the symbolism, a veil of secrecy is drawn between man and woman. This veil is the moral law, the veil before the holy of holies, removing God from common things and making his worship a ceremonious rite. Jealousy now enters into the relationship of the divided contraries. Their union becomes sterile, for "man is adjoined to man by his emanative portion." In her "married" state the Emanation insured the brotherhood of man. Now, turned chaste and cruel and vengeful, she fosters division.

> How then can I ever again be united as Man with Man
> While thou, my Emanation, refusest my Fibres of dominion?

But in Beulah conjugal love is still untroubled by strife. The success of its "married" state is due to the feminine contrary, who makes there no claims for herself. In Beulah the world of sense does not interfere with spiritual perceptions. Love remains spontaneous, resolving the antinomies which an illusion of duality reveals. Because of such feminine behavior the inner and outer worlds remain at peace. Blake emphasizes the admirable behavior of the feminine contrary in Beulah by picturing her as wholly free from jealousy, delighting to give her handmaidens to her husband. In turn he (the inner world of the intellect) rewards her with the gems and gold of Eden; he expends his energies in the adornment of a religion of mercy and forgiveness, and in the endowment of the manifest world with the spirit of God.

Against the danger of strife in a world of contraries this attitude on the part of the feminine world is a necessary safeguard. So long as love remains forgiving and the world of sense does not obliterate spiritual perceptions, no part of life will be condemned as evil, nor will nature be thought of as the origin of man. There will be neither a religion of vengeance nor a material philosophy. On the contrary, the feminine world is in its

self-effacing capacity the means by which the mind renews itself. Soothed by the feminine emotions and laved in the beauty of the senses, the mind regains its powers, and the illusion of duality disappears. In a figure reminiscent both of the sleep of nature and of the relaxing power of the sexual experience, Blake presents Beulah as a fallow period of the mind, a feminine repose which makes for the mind's renewal. The emotional attitude which characterizes this repose Blake thinks of as a willing giving of self on the part of the female, a self-immolation in the interest of the masculine or spiritual world, of which, it will be remembered, the female is but an emanative part, the passive and external side. This self-immolation is pictured in sexual terms. In Beulah, the female devotes herself to the gratification of the male.

But the situation is full of danger. In Boehme's account of the Fall Adam's "hunger was set after the earthliness [the woman] in him," because in his pride he lusted to know and prove the vanity of good and evil which she had impressed into his fair image. The import of Blake's myth at this point is substantially the same. Albion, too, turns to the woman in him, as she is personified in Vala, the feminine emotions as they function in Beulah. She is the Good in which he prides himself, for Albion's lust for the woman in him is his own self-righteousness. Proud of his passive feminine emotions, he makes of them an object of desire. The Vala of this period is said to have Jerusalem in her veil, an obvious assertion that when pity and love are first made into an abstract Good, Evil and the rigors of moral justice are not anticipated. So completely does Albion's rational mind accept the feminine ideal at this point that pity and love are said to absorb him.

Albion's surrender to the woman in him is made complete when the identity of Tharmas is merged with that of Enion. The "married" sexual man now gives way to the hermaphrodite, in whom Hermes is absorbed by Aphrodite. With this loss of identity on the part of Tharmas, the body of man which was hitherto regarded as "human" appears as "natural." Man becomes a child of nature; earth, the Great Mother. The result is

the addition of a feminine cosmos to a feminine ethics, the addition of Nature to Natural Religion.

In making this early philosophy express a belief in the natural origin of life Blake was speaking with authority. Aristotle had said that most of the early philosophers were content to seek a material principle as the first cause of all things. For his further identification of the material principle with the female Blake had a greater, even an irrefutable, authority. His Hebrew Bible told him that God made man out of the female (the Adamah), a term which his King James version rendered as the "dust of the earth."

Except in a few discarded pages of the *Four Zoas* Blake makes no attempt to present the hermaphrodite literally. In a general way he uses the term to denote a checkmate and consequent sterility. As usual, it is the ethical or religious significance that is emphasized. For religion, as Blake sees it, tries to answer the problem of the contraries. It is an attempt to reconcile two classes of men who ought not to be reconciled, in other words, to impose one of the contraries of life upon another, to try to govern both by laws deduced from one. It would seem that man should do no more in a world that appears dual, than to continue to forgive and to have faith in the divine order. To rationalize appearances and to build an emotional structure upon those rationalizations is fatal. Upon such a basis, Blake believes, do religions rest.

Because religion is thus tied up with the problem of the contraries, religious experience may be set forth in sexual terms. Its pattern is determined by Albion's abstract thinking about a universe that seems to him dual. Blake adopts St. Augustine's triple division of spiritual history and gives to it a sexual interpretation. That there may be no doubt that he is writing of spiritual matters, he designates these three divisions as "churches." The first is hermaphroditic, the other two are double-sexed. In the hermaphroditic church, which extends from the Creation to the Flood, we have duality resolved by man's complete absorption in his feminine self. Nature and Natural Religion are the result. In the double-sexed churches,

which complete the temporal cycle, we have an open dichotomy, the energetic male in revolt against feminine dominion. Here we no longer have good alone, but good and evil. We no longer have pity alone, but pity and wrath. We no longer have nature alone, but nature and man.

The first of the three churches, the hermaphroditic, covers the period during which man resolves a troublesome duality by regarding both contraries in feminine terms. It is said to have extended from Adam to Lamech. We must assume, I think, that Blake chose these names—as he chose those by which he identifies the double-sexed churches—for their symbolic value rather than for their chronological accuracy. Blake's designation of the first church as the period in which man succumbed to his self-righteous lust for the woman in him is borne out by the biblical account. This is the period of the giant race, the Nephilim, who found the daughters of men fair. We hear little of the consequences except that when violence filled the land, God sent a devastating flood. This association of the Nephilim with a surrender to the feminine and the outward was not original with Blake. Origen, with the authority of Enoch, had interpreted this incident in biblical history as a turning toward the corporeal.

By associating the hermaphroditic Albion with the Nephilim and the Nephilim with the Druids (whom he agreed with his age in regarding as the ancestral people), Blake was enabled to interpret the violence which destroyed the hermaphroditic church. This church, it will be remembered, extended from Adam to Lamech, the father of Noah, and was destroyed, like the Nephilim, in the Deluge. The popular association of Druidism with human sacrifice enabled Blake to suggest by this symbol the vengeance for sin which characterized the hermaphroditic church in its decline and finally brought about its destruction. Though it began with a belief in a natural monism and a natural good, it ended with the dichotomies of spirit and matter and of good and evil, and by consequence with a law of vengeance. The flood in which the hermaphroditic church is destroyed is a flood of materialism and at the same time a flood of time and space, for which reasoning about the contraries is

responsible. But this violent assertion of the temporal and the material brings about a violent counter-assertion of the eternal and the spiritual. The world has become dual and sexual, and its churches correspond. The hermaphroditic church gives way to those which are double-sexed.

Blake ascribes the decline of the hermaphroditic, or Druidic, church into vengeance to the fallacy of a passive ideal of good, as personified in Vala. Albion's liaison with her is followed by doubt and "stern demands of right and duty," which presently develop into so overwhelming a consciousness of sin that laws of mercy, pity, peace must be devised as a safeguard against the ravages of pity itself. The conclusion is a logical one; self-righteous pity requires an object of pity, and good has no validity apart from the not-good. "What!" cries Job, "shall we receive good at the hand of God and shall we not also receive evil?" Once Vala has been abstracted into a religious ideal she attains to power over the mind that so regards her. The "female will" has been developed. The exercise of that will in the interest of femine supremacy—of good, if you will—leads man away from his knowledge of the spiritual kinship of all life, and ultimately delivers him into vengeance for sin.

Blake's use of the "female will" enables him to answer a question which puzzled the Neoplatonists. If the soul is native to Eternity, does it not retain a memory of its former state? And if it retains a memory of that state, why does it not go back? Blake's answer is that the female, struggling for supremacy, will not permit man to retain that memory. The fallen world is her empire. "If once a delusion be found, woman must perish and the heavens of heavens remain no more." For that reason the "disobedient female" (the recalcitrant emotions and the world of sense) obliterates Eternity by creating the conditions of her supremacy—the illusions of moral justice and a material reality.

Because Albion's preoccupation with Vala ends in repression and vengeance, the fall into sex is presented, with Blake's characteristic irony, not as a fall into license, but as a descent into chastity. Man, who took to himself acquiescent woman, finds her withholding herself. The love and pity in which he prides him-

self, and which he sought to perpetuate by law, evade him, revealing themselves only in the cruel garments of vengeance.

> Have you known the Judgment that is arisen among the
> Sons of Albion, where a Man dare hardly to embrace
> His own Wife for the terrors of Chastity that they call
> By the name of Morality?

Despite Blake's characterization of moral justice as chaste, its hermaphroditic love, which imposes feminine passivity upon masculine energy, is the lechery of his allegory. Though it acts not, it desires. It mingles love and jealousy—the lust of the spectrous mind and the chaste inhibitions of the feminine emotions. In contrast to the "chastity" of Babylon is the "free love" of Jerusalem, whose unconditional forgiveness is "harlotry" to the self-righteous.

In contrast to the hermaphroditic church, which looks upon the chaste female as "good" and inhibits the active energies, the second and third churches are double-sexed and subject to internal strife. The duality which the hermaphroditic church resolves by merging the identity of one contrary with that of the other becomes in these succeeding churches an open problem. In these two churches—the churches from Noah to Abraham and from Abraham to Luther—authority struggles with revolt, the spirit struggles with the flesh. Instead of a single first cause seen as nature, we now have both spirit and matter. Instead of a "natural good" we now have both good and evil. With the double-sexed churches the struggle between good and evil begins in earnest. In this struggle the active energies are pitted against reason in its support of the passive and feminine aspects of life. In the sexual symbolism of the myth the masculine and feminine contraries are separated, like Adam and Eve, for a world of sexual strife. The result is a "sexual" religion. With the double-sexed churches, which arise after the hermaphroditic church has been destroyed in the flood of time and space, the mortal and Generative world begins. Out of sexual strife a life-giving generation is to come. With the appearance of the double-sexed churches, the giant androgyne becomes a sexual man

whose senses, no longer flexible, have been "fixed" at the organic level. In the separation of the sexes in the Generative world we may see the cosmic schism which divides it.

In determining what Blake means by the separation of the contraries it is necessary to remember that as Spectre and Emanation their significance is as wide as life itself. Nevertheless, since Blake has himself stressed the ethical and physical significance of feminine dominion, it is possible in these fields to be specific. Abstracted from man—in a state of separation from him—the self-righteous emotions become the moral law. At the same time the active energies rise up as evil in order that the emotions may be broken in their struggle with revolt and return to forgiveness. "For I through the law am dead to the law," writes the Apostle. Out of man's struggle with the law comes the law's regeneration. Likewise, the fallacy of man's natural origin is discovered through the struggle of the spirit with the flesh. Or, to express the same fact more nearly in terms of the myth, the feminine side of the cosmos is made willing to forego a separate existence as Nature because the separation of the spirit and the flesh has driven her into matter and made her taste of the bitterness of death.

With the return to the world of forgiveness as symbolized by Christ, sexual separation will have achieved its purpose; for the end of the separation is for Blake, as it was for Swedenborg, the return of the contraries to their original unity. As Swedenborg puts it, the intellectual and voluntary principles (the masculine and feminine contraries) were separated that they might be made "capable of renovation." Blake's statement suggests a similar purpose:

But when Man sleeps in Beulah, the Saviour in mercy takes
Contraction's Limit [Adam], and of the Limit he forms Woman,
 That
Himself may in process of time be born Man to redeem.

The end of the sexual separation is the birth of Christ. With his birth the inner and outer worlds will again be united.

We are further told how redemption (the "renovation" of

Swedenborg's system) is accomplished. The female "is made receptive of generation, through mercy, in the potter's furnace." Los, the arbiter of mortal life,

> Opens the Furnaces of affliction in the Emanation
> Fixing the Sexual into an ever-prolific Generation.

Obviously, in the open dualism which has been created the female is to be purged of her selfhood and made again willingly subservient to the male. Generation, "image of regeneration," is to be accomplished by sexual strife. This strife is carried on in the "womb of nature," the loveless abyss of Ulro, out of which comes the destroying flood of materialism and vengeance, but in which there burn also the fires of generation which accomplish the rebirth of man.

Though the separation of the sexes which characterizes the double-sexed churches is necessary to regeneration, it is a catastrophic thing. Man is not happy in a sundered universe. Both double-sexed churches are characterized by rationalism, cruelty, an appalling lack of insight, and a futile searching. The conflicting claims of the contraries in these two churches appear as sexual strife. Their "sexual" love is in reality "spiritual hate." The Emanation, who in Beulah had no thought but for the well-being of the male, is here the "chaste" moral law. She scorns the Spectre's pursuit—his search for mercy, pity, peace. She cuts him off from his emanative felicity—his emotional and sensuous well-being. Her repulse serves only to renew his ardor and prolong his unsatisfied pursuit. Jealousy characterizes their relationship.

Both double-sexed churches tend to resolve their strife by subjection and compromise, a fact which explains why Blake sometimes speaks of them as hermaphroditic. As in the church before the Flood, the identity of one contrary is lost in that of another. All Blake's anathema is poured out against these hermaphroditic unions—forms of natural religion in which the semblance of harmony achieved is but the dread impotency of negation. Back of every such sterile union is the illusion that the ideal for this warring world is the static arrived at by coer-

cion. This is the ideal of Urizen, whose heroic efforts are wasted in an attempt to resolve the sexual strife.

In Swedenborg's theological system, when a church degenerates (becomes "vastated" is his phrase), it is destroyed in a Last Judgment. In Blake's mythology, whenever the warring contraries resolve their difficulties in a coercive hermaphroditic union, they must be separated for renewed strife. Again and again Los separates these combinations, freeing the male and female for a world of generation, only to have new combinations of mind and emotions set up, new restrictions imposed, new hermaphroditic equilibriums attained. Separation must go on and strife be resumed, until such time as the contraries shall achieve a true generation—that is, until man shall undergo a regeneration. Until he can again see both contraries in a mystical unity, he must not be allowed to achieve a unified world by the obliteration of one of them. Until he can achieve the mystic unity of brotherhood, he must be torn by strife.

The essential difference between the two double-sexed churches is suggested by the difference in their sexual patterns. During the period when the feminine contrary must struggle hardest with revolt we have the jealous God of the Old Testament. Consequently the first of the double-sexed churches is female-male, "a male within a female hid as in an ark and curtains." At its center, as its motive power, is Orc, whose rebellion forces the abettors of moral justice to create the vengeful God of the Old Testament. When revolt has been tamed by deceit, we have a God of Mystery and a more merciful ethics. The second of the double-sexed churches is therefore male-female. Its motive force is Vala-Rahab, the rational ideal of pity as it is supported by the trappings of Mystery.

Historically, the first of the double-sexed churches is insignificant, extending from Noah to Terah; but mythologically it is important because it introduces red Orc, the "Antichrist, hater of dignities." In him is personified man's rebellion against the moral inhibitions of the chaste female. Orc's appearance is the logical result of the hermaphroditic church. Cosmic Albion likes a bad bargain no better than his mortal counterparts. Having

set up a system of feminine ethics, Albion is appalled to have a portion of his emanative life condemned. Under the spell of the "chaste" Vala, Albion sees Jerusalem, the free Emanation of man, as a harlot daughter and is overcome by shame. In short, the Spectre's desire for righteousness involves the discovery of a sinful corporeality in the emanative life and is followed by increasing intolerance in his ethical life. The emotions can be "chaste" only by making the body appear unchaste. This "commerce to sell loves with moral law" costs Albion too many of his "loves and graces" to be long pleasing to him. His revolt bursts forth in the fiery form of Orc.

The use of Terah in connection with the first of the double-sexed churches suggests that Blake saw the rise of idolatry as synchronous with the appearance of Orc. The curtailment of man's energies by a self-righteous ideal turns him from the God who demands that ideal. Baal and Ashteroth rise up to rival an ascetic Jehovah. The very real danger of these alien Gods to the Judaic religion is symbolized by Orc's incestuous desire for Enitharmon, in whom is personified sexual man's religious life. The terrible fear that Orc will supplant him causes Los, the Prophet, to bind him down with "the chain of jealousy"—the code of Sinai.

Suffering under the law, allegorically expressed as the agony of the bound Orc, is directly responsible for the rebirth of pity. Blake suggests this change from vengeance to mercy by making the second of his double-sexed churches, and the last of his triad, descend from Abraham, whom God released from the sacrifice of Isaac. The change comes as a beneficent release to man, tormented by vengeance and harrowed by a consciousness of sin. Consequently this church is male-female—"the female hid within a male." Unfortunately, its feminine principle of pity is to a very small extent regenerate. The Vala who is born of Enitharmon is speedly metamorphosed into Mystery. She appears as Vala-Rahab, whose garment of delusive pity conceals the recently repudiated code of Sinai. With this perversion the female will achieves its triumph; the feminine emotions gain a supremacy that will endure throughout the Christian centuries.

Mystery, the supreme exercise of the kindred sexual qualities of secrecy and deceit, has made man tame. His suffering has been decreased, however, not by removing the cause, but by alleviating the symptoms. Were this the whole story, the sexual division would have been a failure; but in the acceptance of Mystery by the prophets Blake sees their immolation as a willing submission to priestcraft in the interest of mercy. The emotions as a whole have not been regenerated, but the emotional life of the Poetic Genius has been. Because of this emotional change within the Poetic Genius Vala's birth is said to have broken the obdurate heart of Enitharmon so that Los could enter in. The pair lay aside their sexual jealousy, their lust, and their scorn. Los is made to say: "I will . . . teach peace to the soul of dark revenge, and repentance to cruelty." Through the purging of the prophetic emotions, the Poetic Genius, which is Blake's essential man, has achieved its purification. Submitting to Urizen, because of its love for man, it has freed itself from Urizen's power. The Christ has been born. Generation has been achieved.

Blake enriches the symbolism in which he portrays the rebirth of man by making use of the circumstances surrounding the birth of the historical Christ. The Christ who was born of woman is the Christ born within the tradition of the law. To this the virgin birth gives witness; a "chaste" ethics is paralleled by an immaculate conception. Yet Christ's very being is a repudiation of the religion which engendered him. As Swedenborg says, in effect, the Lord did not acknowledge Mary as his mother, because with regard to his inmost he was not her son. Mary thus becomes a convenient symbol for the contact between the contiguous universes of Ulro and Generation—between the religion of the priests and the prophets, of Rahab and Jerusalem. She stands at once for the chastity of a restrictive ethics and, by having given birth to an illegitimate child (for Blake scoffs at her virginity), for a forgiveness which defies chastity. She stands both for the law and for freedom from the law. In so far as she personifies the law she is that maternal humanity which Christ must put off eternally "lest the sexual generation swallow up regeneration." Hers are the "sexual gar-

ments" which Christ will wholly purge away with fire. In that
sense the religion of generation which was meant for the destruc-
tion of Jerusalem has, in Blake's own words, become her cover-
ing till the time of the end. Out of the cruelty of the dark re-
ligions has come forgiveness of sins.

To pursue the symbolism still further, the female has been
made receptive of generation. Through the pangs of childbirth
(the torment consequent to sexual strife) death has been over-
come by life. The fruit of sexual strife, the babe of forgiveness
has been born. Man who fell by woman has been redeemed
by woman. This is also the teaching of the Apostle: "But when
the fullness of time was come, God sent forth his Son, made of
woman, made under the law, to redeem them that were under
the law." Man's emotions have been so purified by his spiritual
sufferings under a God of vengeance, that Christ has become
apparent on earth. Love which, following the selfish reason,
plunged man into a spiritual abyss, has by its own immolation
delivered man out of that abyss.

With Christ's coming, Rahab (Vala in her unregenerate
form) is revealed as the "dragon red and hidden harlot." She
who once accused Jerusalem is now seen as the real culprit,
the harlot of the kings and priests of the earth. Without her
self-seeking there had been neither good nor evil; without good
and evil, no law and no priests; and without man's abasement
before the laws, no kings. When man shall be finally released
from Rahab's power, the material illusion will also disappear.
The ethical division and the physical division attend each other.

Revealed as the true harlot, Vala becomes also the Magdalen
taken in adultery. This opprobrium, once hurled by the self-
righteous Albion upon Jerusalem because her love was free
and forgiving, is now transferred to Vala. But as Magdalen,
Vala is also the woman whom Christ forgave. In a very beauti-
ful passage, the imagery of which is from Isaiah, Blake sets forth
the new ethics symbolized by a Magdalen forgiven.

> Lift up thy blue eyes, Vala, & put on thy sapphire shoes.
> O Melancholy Magdalen! behold, the morning breaks.
> Gird on thy flaming Zone, descend into the Sepulcher.

Scatter the blood from thy golden brow, the tears from thy silver
 locks,
Shake off the waters from thy wings, & the dust from thy white gar-
 ments.

Thus regenerated Vala may go forth again as a sower of Urizen's
seed, "to scatter life abroad over Albion." A genuine pity will
once more fructify the earth.

 The change from the spiritual unity of Eden to the hermaph-
roditic and sexual churches is paralleled in Blake's allegory
by the change from the divine body, the androgynous man who
in his expansiveness is also a universe, to the sexual body which
symbolizes the contraries in their state of separation. The de-
velopment is accompanied by many vicissitudes. With Albion's
shame, with his newly acquired conviction of sin, comes the
dispersal of his androgynous body. One by one his members are
accused and flee from him, one by one they are mentally de-
livered over to Satan to be written into his mortal scroll (con-
demned as sin). So far does the partition extend that Albion
becomes finally "a little grovelling root outside of himself."

 By Laws of Chastity & Abhorrence I am wither'd up,
 Striving to Create a Heaven in which all shall be pure & holy
 In their Own Selfhoods.

 The diminished stature of the sexual man is thus a witness
to the law of separation by which he lives. The mortal and
sexual body arrived at by the separation of good and evil stands
in direct contrast to the unified androgynous body which is the
Saviour's kingdom and in which all things have a part. It im-
plies a belief in a retributive justice, and is a symbol for the
mistaken dogma of the twenty-seven heavens. The identification
of the mortal body with the moral law is frequent and varied:

 And his body was the Rock Sinai.

 Come Lord Jesus, take on thee the Satanic Body of Holiness!

 Assume the dark Satanic body in the Virgin's womb,
 O Lamb divine!

 . . . by his Maternal Birth he is that Evil-One,
 And his Maternal Humanity must be put off Eternally,
 Lest the Sexual Generation swallow up Regeneration.

For the process by which the immortal disappears in the mortal, the androgynous in the sexual, Blake makes use of a tradition which also appealed to Jacob Boehme. The spiritual body is without blood or bones. But as man sinks down in spiritual degradation, his bones come into being, and a network of veins covers them from sight. Blake's drawing of Urizen as a fleshless skeleton leaves little doubt concerning the significance of Albion's bony structure. Reason is a hard, constricting force, condensing into a solid all that it encounters. Indeed, that is one of the objects of Urizen's labors, "a solid without fluctuation." Only with the creation of such a solid does the "great opposer of change" hope to find peace. The frequent association of the network of red veins with Vala's veil suggests Luvah's responsibility for the second anatomical change. The cruel heart, now gorged with blood, encompasses Albion with its veiny pipes. But, because the religion of blood is converted by Los into an instrument of salvation, blood is made also to suggest redemption. In its first appearance it is noted as a "globe of life-blood trembling." In this form it is Enitharmon whose appearance as Pity terrifies the Eternals, apparently because they know that the worship of pity is a bloody rite. Nevertheless the religion of Enitharmon is the means of salvation, and the globe of blood which images it, a promise of life. Later, in order to complete his physiological scheme, Blake added the stomach, which he called the furnaces of Los. No doubt he saw in the symbol the dual function of destruction and construction which attends all of Los's labors at the furnaces.

But most important of all, in the capacity of the mortal and sexual body to suggest spiritual degradation, is the change which, with the hardening of the bones, overtakes man's spiritual senses—that is, the Zoas themselves. Weakened by rationalization, they rush inward, no longer able to discern that the "streaky slime in their heavens" is not transparent air. At this extreme they become the fixed organic senses of the sexual man.

By attributing to Tharmas, the Tongue, both touch and taste, Blake is enabled to make the transition from the four

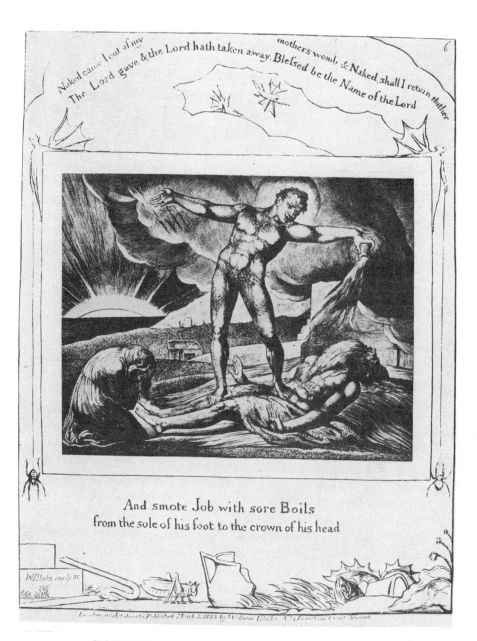

ILLUSTRATIONS OF THE BOOK OF JOB, PLATE VI

eternal senses to the finite five. To Urizen is given the Eye, to Urthona the Ear, to Luvah the Nostrils. Cornelius Agrippa reports the tradition which conceived of two sets of senses, an internal four and an external five. In Blake there are not two sets of senses, but as man moves, in the course of the Fall, from an inward to an outward life, his four senses, eternal and intuitive, become five, organic and finite.

Ah! weak & wide astray! Ah! shut in narrow doleful form,
Creeping in reptile flesh upon the bosom of the ground!
The Eye of Man, a little narrow orb clos'd up & dark,
Scarcely beholding the Great Light, conversing with the ground;
The Ear, a little shell, in small volutions shutting out
True Harmonies, & comprehending great as very small;
The Nostrils, bent down to the earth & clos'd with senseless flesh,
That odours cannot them expand nor joy on them exult;
The Tongue, a little moisture fills, a little food it cloys,
A little sound it utters, & its cries are faintly heard.

With the loss of his supersensuous powers comes man's enslavement to the illusion of materiality. By that illusion, which seems to make the moral law necessary, "the disobedient female" retains her supremacy over man. By it she tends also to resolve the duality of a sundered world into the vast hermaphroditic conception of a material reality; for her struggle for dominion is identical with the attempt to resolve the duality which troubles the rational mind. Her efforts are expended in "weaving to dreams the sexual strife."

As the conclusion to a chapter which has unavoidably been analytical, it should be said once more that Blake's employment of sex is not a superficial personification of his various sets of contraries. The four Zoas, in whom are comprehended the fourfold nature of man and the universe, are living, even demonic forces, and they are also, as befits such forces, sexual. At the very foundation of life lies the sexual dichotomy, capable of harmony or of strife. In terms of this relationship is written the history of the world. The illusion of good and evil is of cosmic importance because it creates a division between the contraries potent to destroy the whole fabric of life.

VII

God and Man

God is within & without: he is even in the depths of Hell!
Jerusalem, p. 12.

"GOD only acts and is, in existing beings or men." This conception of an innate God, which Blake formulated in the early days of the *Marriage of Heaven and Hell*, is a fundamental postulate of his system. It supplies the logic for a lost golden age, in which the innate God was manifest, and sustains a faith in its return. It makes man responsible for his own failure, and provides him at the same time with a way out of failure. Finally, it denies the transcendent God which reason creates and the validity of the law which reason devises. By such a God and such a law man perishes. By the God within, who may be obscured but never destroyed, man lives again.

The nature of this innate God, whom Blake defines as an inner translucence, is clear. He is no other than the Christ of whom Blake said to Crabb Robinson, "He is the only God," adding after a moment, "And so am I and so are you." To this vision of man as Christ, Blake applies the term "human." From that level man has fallen. To it he will return. There is nothing higher than the potential, or as Blake would have said, the essential, man.

> Thou art a Man, God is no more;
> Thy own humanity learn to adore.

The essential man, thus defined as the human which is Christ, would seem to be identical with the Poetic Genius. The Bard in *Milton* sings:

> According to the inspiration of the Poetic Genius,
> Who is the eternal, all-protecting Divine Humanity,
> To whom be Glory & Power & Dominion Evermore.

The Poetic Genius has therefore not the limited meaning usually ascribed to it. It is the birthright of all, the God within man. "As all men are alike in outward form, so (and with the same infinite variety) all are alike in the Poetic Genius." Presumably, then, had the Poetic Genius not been obscured by the Fall, all might still know the immediate communion with God through vision which is its peculiar capacity.

The God of this visionary revelation is Christ. He is the fullness of life, the source of every good and perfect gift. Ethically he represents the forgiveness of sin, since this supreme achievement of human conduct is the gift of imagination, wherein one loses one's own identity in that of another, while the selfhood, on the contrary, binds another to its delight. Esthetically, Christ, the imagination, is the source-spirit of art in the Blakean sense of revelation. Anything less than revelation, anything that is an imitation of perishing vegetable memory, is not art. Socially, Christ is the spirit of brotherhood. Anything less than brotherhood, any compromise by way of charity or other makeshift, is not Christian. As the human (or divine) imagination, Christ is also the intelligence, since intelligence, in the Blakean use of the term, is mind lifted to the level of imagination. Christ is specifically named as the giver of every mental gift, and he is, by certain inference, that God who is the "intellectual fountain" of humanity. He is the Divine Vision, the Human Existence itself, the Universal Humanity, the One Man in whom the Eternals meet.

The religion of Christ is the Everlasting Gospel. This religion is entirely inward; it has no outward ceremonial. Its worship consists in honoring the imagination in whatever human breast it happens to reside. It has no other temple, unless we take into account the fact that all things are "men seen afar." From Blake's reliance upon the inner spirit comes his hatred of ceremonial. It is for him a part of the outward, the passive, and the feminine which drag man down from the height of Eden. In his Swedenborgian period Blake valued the New Church in part because it consisted "in the active life and not in ceremonies at all." Blake's hatred of ritual and ceremony was the same in kind and degree as that of a later disciple of Sweden-

borg, the elder Henry James. The function of religion, James
said, interpreting Swedenborg (and incidentally Blake), is an
inward or spiritual death—death to the selfhood in man. But
professional religion, being unable to endure this living and
inward death, substitutes for it an outward death enacted in
ritual and ceremony; and this pious substitution, which Blake
would have called a pretense and an hypocrisy, leaves the self-
hood "unimpaired and unchallenged, to expand and flourish
in *saecula saeculorum.*" "Professional religion," James declared,
"thus stamps itself the devil's subtlest device for keeping the
human soul in bondage." The modern Church, said Blake,
"crucifies Christ with the head downwards." Christ himself, we
read in the *Marriage of Heaven and Hell,* "acted from impulse,
not from rules," impulse meaning not romantic whim, but the
spontaneous action that comes from perfect imaginative sym-
pathy. Los preaches on the same theme:

But still the thunder of Los peals loud & thus the thunders cry:
 . . . Go to these Fiends of Righteousness!
Tell them to obey their Humanities, & not pretend Holiness . . .
Go! tell them that the Worship of God is honouring his gifts
In other men, & loving the greatest men best, each according
To his Genius, which is the Holy Ghost in Man: there is no other
God than that God who is the intellectual fountain of Humanity.
 . . . Go! tell them this & overthrow their cup,
Their bread, their altar-table, their incense & their oath,
Their marriage and their baptism, their burial & consecration. . . .
He who would see the Divinity must see him in his Children,
One first in friendship & love, then a Divine Family, & in the midst
Jesus will appear.

The world of the Poetic Genius or the Divine Humanity, in
which man consciously participates in the God who is Christ,
is the world of imagination. It is "the real and eternal world
of which this vegetable universe is but a faint shadow, and in
which we shall live in our eternal or imaginative bodies, when
these vegetable mortal bodies are no more." Imagination is
therefore Reality, the "human existence itself," the True Being
of the philosophers.

Conceived of objectively the world of imagination is the

Divine Body of the Saviour. Its supreme characteristic is its inclusiveness. Christ, the spirit of brotherhood and imagination, accepts everything, rejects nothing. In his vision the whole cosmos is potentially human. "All are men in Eternity, rivers, mountains, cities, villages, all are human." Since this world of imagination suffers no limitation or division, it includes error and imperfection. So long, however, as error is honestly intended and honestly forgiven, it does not imperil the unity of Blake's Eternity. The thing that does imperil it, the thing that may split it in twain, is selfhood. The selfhood is a dividing principle, as imagination is a unifying principle. It reasons from its own moral standard and divides the world as a consequence into good and evil. This is Blake's interpretation of the "spirit of evil in things heavenly" mentioned by St. Paul in the verse which stands as an epigraph to the *Four Zoas*. This spirit of evil—the selfhood—is latent in every man; it is the devil in him. No man can entirely overcome his selfhood; the latent devil will manifest himself from time to time. Only the imagination can be entirely selfless. This is the level of Christ, which man may reach, but which he seems unable to maintain. For this reason no man can be entirely good. Every man is both good and evil. This fact of human experience requires mutual forgiveness, and forbids any man to pass self-righteous judgment upon another. Blake told Crabb Robinson: "That there is a constant falling off from God, angels becoming devils. Every man has a devil in him, and the conflict is eternal between a man's self and God." Angels remain angels by practicing forgiveness. For every act of forgiveness is a crucifixion of the self —"a little death in the divine image"; whereas moral justice is the vindication of one's own holiness upon the supposed sinfulness of others. Moral justice has therefore no place in the world of imagination, which lives by the law of brotherhood. "It is not," Blake wrote, "because angels are holier than men or devils that makes them angels, but because they do not expect holiness from one another, but from God only." But this God —the Poetic Genius—does not demand holiness, and is himself capable of error. To Crabb Robinson Blake denied that "pu-

rity" was of any value in God's eyes ("He chargeth his angels with folly"), and he extended the liability of error to the Supreme Being ("Did he not repent him that he had made Nineveh?"). The ideal of holiness is inconsistent with Blake's ideal of humanity.

> To be Good only, is to be
> A God or else a Pharisee.

The price of entrance into Blake's heaven is therefore not holiness, it is a still higher price: selflessness and the willingness to forgive. "The spirit of Jesus is continual forgiveness of sin; he who waits to be righteous before he enters into the Saviour's kingdom, the Divine Body, will never enter there." Forgiveness, indeed, is the cornerstone of Blake's ethics. It is the working principle which prevents the error which exists even in heaven from being regarded as sin and breaking that united world upon the rock of Good and Evil. Forgiveness is the wisdom which Jesus had and which other divine teachers did not have. It is the "gnosis"—the secret knowledge which brings salvation. This knowledge or understanding on the part of man brings him into correspondence with God, who, "if [he] is anything, he is understanding." It is by understanding such as this that the emotions, the servants of the mind, are made forgiving. Hence Blake's insistence upon intellect.

> I care not whether a Man is Good or Evil; all that I care
> Is whether he is a Wise Man or a Fool. Go! put off Holiness,
> And put on Intellect.

Everyone who uses his own gifts for the building of Jerusalem, who honors the gifts of God in other men, and who refrains from passing moral accusation is a disciple of Jesus and an inhabitant of Blake's eternal world, whether in this life or in another.

It ought to be obvious that Blake's world of imagination is not the romantic escape into a world more beautiful and agreeable than actuality. Esthetically it has something in common with the romantic quest for freedom and beauty, but Blake's world is conditioned by an ethics which is no part of the

romantic picture. To seek esthetic refuge in an ivory tower is not a Blakean solution of an intolerable situation. Blake does not avert his eyes from the world of experience; he seeks to conquer it. He knows as well as Dr. Johnson that the world is "bursting with sin and sorrow," and agrees with him in denying the alleged goodness of the natural man. But the two prescribe very different cures. The one believes in "severe laws, steadily enforced." The other asserts that "the glory of Christianity is to conquer by forgiveness." To the elect (a class to which Johnson does not really belong), the idea of conquering by forgiveness will always seem to be a romantic illusion. Blake knew that as well as anyone. The elect of his system are incorrigible. They will never be able to annihilate their pride and their self-righteousness "at the judgment seat of Jesus the Saviour," where the Accuser is cast out. So long as the majority of men remain in mental bondage to the elect, the world of mortality and its corollary, moral justice, will continue. In the spirit one may be free, but "not in the mortal body." "You cannot have liberty in this world without what you call moral virtue, and you cannot have moral virtue without the slavery of that half of the human race who hate what you call moral virtue. . . . While we are in the world of mortality we must suffer." At the Last Judgment Christ will come, "as he came at first, to deliver those who were bound under the knave, not to deliver the knave." The elect will be rendered innocuous, and mankind freed from their dominion. All this will take place, not through the intervention of an external God, but through the liberation of the spirit of Christ within man himself. If this be regarded as romantic illusion, Blake is open to the charge.

When the selfhood becomes assertive, and moral justice and the belief in good and evil (offspring of the selfhood) become the way of life, "this world," the world of necessity or experience, comes into being. The latent spirit of evil in things heavenly becomes actual. The law, which ought not to be necessary at all, and which, when necessary, should be ready and eager—as the female is in Beulah—to die in order that the

sleeping inner spirit may live again, is now seen as something permanent and holy, conferring upon its votaries a special sanctity. A personal holiness, which delights in the crucifixion of one's neighbors, takes the place of brotherhood and the sacrifice of self. Real as this world is "to those to whom it seems to be," it is not real to the eyes of the philosopher. This is because the selfhood and the life of manifold evil which it begets do not participate in the only good, which is imagination. They are negations—negations upon energy, which is "eternal delight" and the "only life," negations upon imagination, which is "the human existence itself."

To define evil and explain it away as negation is a well-known mystical solution of that insoluble problem. A typical and striking sentiment may be quoted from Erigena: "The loss and absence of Christ is the torment of the whole creation, nor do I think that there is any other." Blake writes to the same effect: "What are the pains of hell but ignorance, bodily lust, idleness and devastation of the things of the spirit?" It is obvious that Blake knows that the pains of hell are in one sense real, although they have their source in philosophical unreality— as real as bodily pain which originates in a neurosis. But like the bodily pain, they are self-induced. They are not the will of the eternal God, but the result of a denial of the God within by selfhood and doubt.

In this hell of man's own devising Urizen is king. It is for this reason that Blake speaks of him as the God of this world. He is the devil (of doubt and unbelief) who is always wrestling with the angel and who often drags him down. He is the Prince of Tyre, of whom it is written:

Thou sealest up the sum, full of wisdom and perfect in beauty. Thou wast in Eden the garden of God; every precious stone was thy covering, the sardius, the topaz, and the diamond, the beryl, the onyx, and the jasper, the sapphire, the emerald, and the carbuncle, and gold. . . . Thou hast walked up and down in the midst of the stones of fire. Thou wast perfect in thy ways from the day that thou wast created, till unrighteousness was found in thee. . . . By the multitude of thine iniquities, in the unrighteousness of thy traffic, thou hast profaned thy sanctuaries; therefore have I

brought forth a fire from the midst of thee, it hath devoured thee, and I have turned thee to ashes upon the earth in the sight of all them that behold thee.

We see the unfallen Prince in Blake's drawing, "Satan in His Glory." There the selfhood has arisen in the pride of its righteousness, but the consequences of its self-assertion have not been realized. They are still but potentialities in the outer realm of the stars and time and space. When man sinks into the abyss of the selfhood, these potentialities become actual and he can escape from them only by the regenerative instrument of mortality. Time and space, once potential, now become actual that Satan may be turned "to ashes upon the earth."

Christ and Satan stand at opposite poles of human experience. They represent summit and nadir—eternal life and eternal death, heaven and hell, Eden and Ulro. Between them are the intermediate worlds of Beulah and Generation, each with its own God; for Blake's system provides, not only for the eternal God, the Divine Humanity, but for the Gods whom man in his need creates in his own image. The nature of man's created Gods depends upon his attitude toward the contraries; more strictly, upon the relation of the contraries to one another. Indeed, the whole problem of religion is one of this relationship. Philosophy and religion are of one piece; the rational mind and the self-righteous emotions support each other. For, out of the contraries, with which the philosophic mind concerns itself, "spring what the religious call good and evil." There are two classes of men, Blake writes, "and they should be enemies; whoever tries to reconcile them, seeks to destroy existence." Nevertheless, this is the way of authoritative religion. Satan who as the selfhood is its exponent, seeks to reconcile the contradictions of life by submitting both contraries to laws which he deduces "from his own identity." He divides the world into good and evil and attempts to force the whole into the pattern he knows as "good." Opposed to him is Los, the temporal form of the imagination, who, as the prophetic genius, would restore the contraries to their eternal unity in the bosom of the Saviour. The fate of the contraries, and, as a consequence,

the God whom man worships, depend therefore upon the course of the never-ending struggle between the selfhood and the poetic or prophetic genius.

In Eden, where the contraries function together in perfect unity, life is lived in understanding, in energy, in brotherhood, and in forgiveness, and Christ is recognized as the true and only God. A different situation prevails in Beulah. There duality, with all the dangers and problems that it involves, including a religion of authority, are present to the consciousness. But faith and forgiveness still prevail. Neither contrary is set in moral evaluation above the other. The senses are not condemned, and the emotions are not required to be holy. Religion has become outward, but it is still merciful. The spirit has been forsaken for the letter, but the letter and the law are understood as a provisional support for the fainting soul which has lost its innate sense of brotherhood—understood as a symbol and a reminder of a lost celestial paradise and as the means of regaining it. A conscious crucifixion of the selfhood is regarded as a discipline having for its end the restoration of unconscious selflessness. The creed of the church in Beulah—the Gothic church of the drawings—is therefore simple and benevolent. It may be summed up in a single precept: the forgiveness of sins. This is not the forgiveness of Christ, who forgives without thought or question; it is the forgiveness of man, tempted by pride in his own righteousness to punish the unrighteous, yet mindful of the fact that forgiveness and brotherhood are the basic law of the good life. The kindly Jehovah, the best God man is able to conceive at this time, is God of this earthly paradise. Under Jehovah forgiveness becomes a "covenant." He forbids vengeance. He protects Cain. When Plotinus wrote that "reason uttered is an image of the reason stored within the soul," he expressed the precise relationship between Blake's Christ and Jehovah. Christ is the God within the soul, Jehovah the "uttered" image. Both he and his religion are merciful creations—beneficent and outward finite forms designed for those who cannot endure the inward, the immediate, and the infinite. We catch sight of him in the opening Job illustrations,

where, however, he soon darkens and dwindles, and presently disappears before a rising selfhood which drags down not only Job, but his God as well, into Ulro and the dominion of Urizen.

In Ulro one contrary struggles for, and often achieves, dominion over the other. The rational mind, accepting the senses as the sole source of knowledge, denies the spirit and posits a material reality. The emotions, appalled by a sense of evil inherent in matter, take vengeance upon the life of the senses and seek to suppress the bodily energies. As a consequence the kindly Jehovah disappears. "If you avenge," writes Blake, "you murder the divine image and he cannot dwell among you." At this point man knows no God but Satan, though he continues to worship him under the names of Jesus and Jehovah. Unlike Jehovah, Satan is a "secret" God. Man knows no contact with him. He is remote, abstract, and jealous, "hidden from the human sight." Not realizing that the vengeful God under whom he suffers is but a projection of himself into the heavens, man attributes the change to a change in God himself. His hitherto kindly God has withdrawn in anger. Not until the spectrous mind realizes that all life is holy will man recover the true and intimate God whom he has lost. The return of this true God waits therefore upon the discovery of the selfhood, which denounces a portion of his emanative life (the feminine contrary) as evil. Until the Spectre shall make that discovery he can find no lasting peace. But this is not the way of the Spectre. Blinded by his rational efforts to the truth within and cut off as a consequence from his emanative life, he seeks in spaces remote "the eternal which is always present to the wise." The result is a transcendent God of his own devising in whose cruelty and secrecy is reflected the Satan which begets him.

The return of the contraries to their original harmony is made possible by the world of Generation. In the imagery of the Job series the God of this world is the God of the whirlwind. He is the equivalent of Los, the redemptive genius of the mortal world. Los is, of course, capable of higher levels than this; at the end of *Jerusalem* he is transfigured into the likeness of Christ; but as the finite form of the imagination, he

descends with man. Though sinking low, he preserves enough of imaginative vision to provide deliverance. Even in the depths of Ulro there remain some vision of the good life and some determination to achieve it. This vision and this determination are embodied in Los, whose function is to restore the divine vision, little by little and time after time. Thus he is the angel who directs the storm created by Urizen's war between good and evil. In one of the early prophetic books, when Los rears his head in the abyss, contemplative thought begins, and embryonic life appears in the chaotic void. Elsewhere the function of the seed of contemplative thought is defined as the restoration of the imaginative image. If we give to contemplation its theological meaning of an enraptured regard of things divine, the imaginative image—the life of Eternity—is restored by way of Los's vision of it. He tries to liberate the energies and purify the emotions. He awakens the dead in Ulro to a life of Generation, hoping to pass them on through regeneration to a kindly Jehovah and finally to Christ himself. But this, his true and destined function, is only gradually realized. Under the spell of Urizen, Los too is a votary of the law. He partakes of the wrath of the Elohim, the God of vengeful judgments. The priests and the prophets have nominally the same religion, but the prophetic line, which Los directs, retains a consciousness of the heavenly virtues, mercy and forgiveness, though it practices them imperfectly. As time moves on, the prophetic vision clears and the prophetic line gains the ascendancy. The Elohim becomes Jehovah-Elohim; wrath becomes mercy. With this beneficent change, the contraries are restored to harmony. In the Job series we see this God of the Generative world as the God of the whirlwind, in whose garments of storm both the right and left movements, symbolic of forgiveness and of wrath—of the "current of creation" and the "wheel of religion"—are visible.

The relationship of the contraries to the four worlds and their respective deities is beautifully exemplified in the Job series. Job and his wife constitute the essential contraries, the mind on the one hand and the emotions and the senses on the

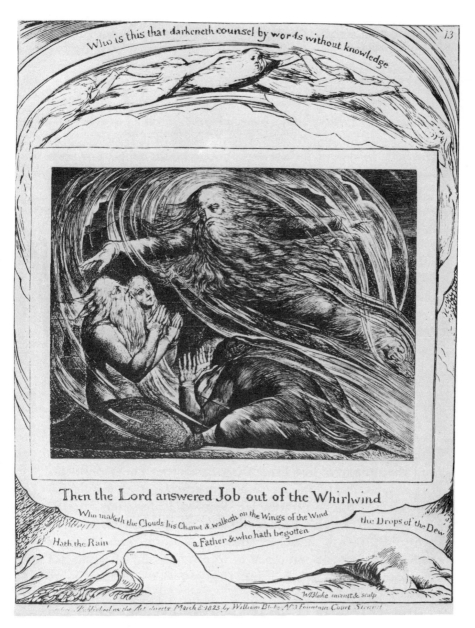

ILLUSTRATIONS OF THE BOOK OF JOB, PLATE XIII

other. But Job is himself divided. For the mind may take either of two levels—the level of imagination or the level of rationality. When rationality becomes dominant, the Spectre emerges, boasting with Urizen, "The Spectre is the man, the rest is only delusion and fancy." The Spectre in Job is represented, in its triple form (head, heart, and loins) by the three friends. The higher, or imaginative, mind, though weakened and confused by the divorcement of its lower self, nevertheless persists, and is represented in the person of Job himself. He is the true man, the incarnation of the obscured but not extinguished inner translucence, the embodiment of the faith which can exclaim, from the pit of despair, "Though he slay me, yet will I trust in him." In Job, then, and his three friends is represented the sum of his intellectual life; in Job's wife his emotional and sense life. As the relation of the two factors changes, his God changes. In Beulah, where the story opens, and through which Job passes on his return journey, Job and his wife live in harmony with one another. The mind, that is to say, tolerates the life of the senses, and the emotions remain forgiving. In this relationship the contraries are "married," and God is seen as the outward but benevolent Jehovah. But as the trouble which is latent even in the opening pictures comes to a head and Beulah sinks into Ulro, Job and his wife are estranged and separated from one another. Job looks upon his feminine sense life as evil; as a consequence his feminine emotional life turns vengeful. The mind posits an external God as angry and jealous as itself, a Satan which it nevertheless continues to worship under the name of the true God. As the experience of error begins to have its inevitable effect of restoring truth, and Job and his wife lay hold of the understanding which "is acquired by means of suffering and distress and experience," God appears as the God in the whirlwind. It has been observed by Mr. Wicksteed that these three Gods—Jehovah, Satan, and the God in the whirlwind—are in the likeness of Job, but when Job enters into Eden and the spirit of Christ is awakened within him, this spirit transforms him into its own image.

Blake sums up the whole theory of his eternal God, who is

Christ, and of his man-made Gods, who appear in various forms, in this way: "He who sees the infinite in all things sees God. He who sees the ratio only, sees himself only." To see the infinite in all things is to recognize the unity of the contraries. It is to live by the brotherhood of man, according to the Divine Vision, which is Christ. It is the imaginative way of life. To see only the ratio, which is the lower and outward reason evident in the self, is to see the contraries as good and evil. It is to live by the law of a God who is made in the image of man. It is the rational way of life.

The path away from God could not lead inevitably back if God did not descend along with man.

For God himself enters Death's Door always with those that enter,
And lays down in the Grave with them in Visions of Eternity,
Till they awake & see Jesus & the Linen Clothes lying
That the females had woven for them.

God himself descends to assume a form created in the likeness of man in order that man may rise again in the likeness of God. He, the eternal truth, takes upon himself the temporal error into which man has fallen in order that the error may not be eternal. He appears as Jehovah, as the God of the whirlwind, even as Satan himself. The working of the divine plan is illustrated in the progress of Old Testament religion. Outwardly the religion of the priestly line and the prophetic line was the same. Both parties, as Blake suggests in the *Marriage of Heaven and Hell*, adopted the same history. Inwardly the prophetic spirit, the inextinguishable Poetic Genius, developed a transforming vision. A religion of vengeance became a religion of mercy. The vengeance of the God which both invoked is Satanic, but the mercy attributed to him reveals that the Divine Vision had not been completely lost. After ages of suffering it was recovered in Christ. This transformation could not have taken place if the Poetic Genius had not shared the fortunes of the fallen intellect—if a religion of vengeance had not had its prophets as well as its priests. If man is to be freed from the Satanic religion which reason devises, the spirit of Christ as

seen in the regenerated Los, the spirit of prophecy, must appear within it. Jesus, "the image of the invisible God," must take on the "dark Satanic body" of the law in order that he may expose its fallacy and cast it off. God "becomes as we are that we may be as he is." Blake elaborates his imagery to express the complexities of this conception. He tells us, for example, that Jehovah becomes "a weeping infant in the gates of birth." Forgiveness under the law, as symbolized by Jehovah, is reborn after ages of vengeance, as the spirit of Christ in New Testament history. There the new-born infant is wrapped in that heritage of the law, the garments of Mystery, which he will put off in the grave of time, just as Christ, the weeping babe who is born of Mary, will leave his mortal body in the tomb.

Since Christ descends to take on and put off mortality, we see him in two forms—an eternal form and a mortal form, a "human" form and a "sexual" form. The one is the supernal Christ, embodiment of the Divine Vision, which man need never have lost. The other is the mortal and sexual Christ, image of the spirit of forgiveness reborn after ages of struggle between the sundered contraries. He has assumed the body of death that he may put it off in a spiritual rebirth. This body of death —the whole religious structure reared upon the selfhood—is the "mortal" body which is crucified upon the "stems of mystery." Christ descends into the grave of time and the "dark religions," but he leaves there his mortal body and rises again into eternal life. In the life of the mortal Christ there is, then, an image of man's spiritual history. Christ's maternal birth, his crucifixion, and his resurrection have all a symbolic cosmic value.

A difficulty which attends the elucidation of Blake's theology is illustrated in this matter of descent. The divine names are not clearly differentiated from one another. Who is it that descends? It is sometimes God who is named, and sometimes Christ. In one instance it is Jehovah. And it is Los who keeps "the Divine Vision in time of trouble," and brings Christ into being here on earth. It is hardly possible to set up infallible distinctions between all these names. Yet these inconsistencies

are probably apparent rather than real. There is one God,
Christ; the others are personifications of the manner in which
he is at different times understood. As the spirit darkens and
sinks from one level to another, Christ, being the essential
humanity, must of necessity descend with man. Jehovah, too,
may be thought of as descending. Though an external God who
requires a covenant, he nevertheless embodies the forgiving
spirit. His worshippers have not yet lost sight of the Divine
Vision. Blake's apparent inconsistencies in the use of divine
names would seem therefore not to invalidate the belief that
in his mind dark Urthona, that basic mysterious imaginative
urge which comes into manifestation through the temporal form
of Los and struggles always to become Christ, was the equivalent
of God. He would therefore be akin to the "divine darkness"
of certain mystics. He would also have the providential power
sometimes ascribed to him, as when the finger of God touches
the seventh furnace of Los, or when the Eternals meet as one
man, Christ, in the Council of God. Of this "invisible God"
Christ would be the image in Eden, an image, however, of the
God within the human breast, while Jehovah would be the
outward image in Beulah. All would be forms of the imagina-
tion or Poetic Genius. But even if this could be accepted as the
pattern which the system demands, occasional deviations would
have to be admitted.

Does the conception of an innate God and a reality defined
in terms of the imagination deny all objectivity to God and the
eternal world? The question is akin to another one: To what
extent are Blake's spatial metaphors to be taken literally? Are
heaven and hell, for instance, simply states of mind, inde-
pendent of spatial rise and fall? Many passages in Blake's writ-
ings lead us to conclude that the realities of the imagination
have only a subjective validity. What one sees in vision has
reality; what one sees with the organic perceptions has none.
"Mental things are alone real." In the *Marriage of Heaven and
Hell*, the poet asks the prophet Isaiah: "Does a firm persuasion
that a thing is so make it so?" The answer is that "all poets

believe that it does." The firm persuasion creates its own world.
What man believes, he sees.

> . . . as in your own Bosom you bear your Heaven
> And Earth; & all you behold, tho' it appear Without, it is Within
> In your Imagination.

It would appear, therefore, that if the world of imagination
were not perceived by anyone—a calamity it is Los's function to
prevent—it ought, logically, to cease to exist, since there is no
remote and external God in whose mind its existence could be
maintained.

Nevertheless there are certain other passages which seem to
set the eternal world in Neoplatonic independence of the tem-
poral world. The early prophetic books make it perfectly clear
that a portion of the eternal world—it would seem the larger
portion—does not fall. The only thing that is not clear is the
identity of those Eternals who separate off the falling world and
retreat from it in horror. Are they "reprobate" portions of
Albion who never cease to believe, or can they be other and un-
fallen Albions? It is also to be observed that the soul is not sub-
merged at death in some Great Memory; on the contrary, it
passes into a world in which are the "permanent realities of
everything which we see reflected in this vegetable glass of
nature," preserving at the same time its own identity, losing
only its finite limitations. From that world Blake's poetic in-
spirations come. His visions are divine revelations of its truths.
In spite, then, of Blake's insistence that there is no remote and
transcendent God, there would seem to be a transcendent world
in which the innate God is fully realized.

It is possible that the seeming paradox of a world at once sub-
jective and objective is to be explained by the belief in a plur-
ality of worlds. Should this hypothesis be accepted, the world
of imagination would be sustained, not only by the insight that
still remains to Albion, but also by Albion's co-Eternals, who
did not fall. Truth and vision and reality would then have, as
they seem to have, both a subjective and an objective validity.
Albion's world would remain his subjective creation, but be-

yond him and independent of him would be the worlds of the unfallen Eternals. From them he might renew his strength, much as the poor pilgrim on life's way gathers strength from the vision of the Prophets. However, if Blake played with the idea of a plurality of worlds, he seems to have abandoned it, or not to have carried it to the conclusion just formulated; for we read in *Jerusalem* that every age renews itself from Los's halls, and Los can hardly be ascribed to any being except Albion.

> All things acted on Earth are seen in the bright Sculptures of
> Los's Halls, & every Age renews its powers from these Works,
> With every pathetic story possible to happen from Hate or
> Wayward Love; & every sorrow and distress is carved here;
> Every Affinity of Parents, Marriages & Friendships are here
> In all their various combinations, wrought with wondrous Art,
> All that can happen to Man in his pilgrimage of seventy years.

We would seem obliged, therefore, to seek an answer to the question of the relationship between finite forms and archetypal patterns in the dual form of Urthona-Los. Los is finite and temporal; Urthona is eternal. Urthona is the capacity and indomitable will to imagine which makes man human. In the exercise of that capacity man falls to the level of Los, but the capacity remains unimpaired. Were man to deny it utterly he would sink into eternal death. Fear of such an eventuality is expressed in the myth. There are passages, especially in *Jerusalem*, which suggest that the world of Generation may lapse into Ulro, that Los's "creation" may be destroyed. But faith triumphed over fear. Los will not fail. But were he to do so, his failure would be only for a time, for Urthona, from whom he derives, stands sure. He provides an imperishable reality independent of all that is finite and temporal. He is the ultimate source of Los's visions, the real master of Los's halls. His is the world revealed in vision, his the world in which we may live partially now and fully hereafter. In the dual nature of Urthona-Los lies, perhaps, the best answer to the problem of the subjective and objective, the temporal and the eternal.

Astrological Symbolism

Religion, the Sun and the Moon of our Journey.
Letter to Hayley, Dec. 28, 1804.
The Kingdom of Og is in Orion: Sihon is in Ophiucus.
Milton, p. 37.

FOUR great stars, four angels, the four beasts of the Apocalypse, the four Apostles, have all been set by tradition to define or to guard the four corners of the heavens. The allegorical value of such association was plain to Swedenborg, a suggestion, we may be certain, that Blake did not miss. We read in the *Divine Love and Wisdom* that man "is in some quarter of the spiritual world, whatever quarter of the natural world he may be in," and that an angel changes his quarter "according to the increase or decrease of love with him." By identifying the head, heart, loins, and body of the cosmic Albion with south, east, north, and west Blake achieved an effective scheme for suggesting spiritual conditions.

The scheme allows both lunar and solar movements to contribute to a description of spiritual change. The sun is emblematic of man's masculine or mental life, the moon of his feminine or emotional life. The one is identifiable with the head, the other with the heart. Each of these great luminaries has its proper quarter and each moves across the heavens to alien quarters. By noting their positions Blake appraises man's spiritual well-being. The sun, for example, is at its maximum splendor in its meridian position and in the south. The south is thus its proper quarter, the zenith its proper position. When it drops into the nadir, the light of the sun goes out; mental illumination fails. Likewise, when in its solstitial journey the sun reaches the tropic of Cancer, the year is at its turning. The

retrograde movement begins, and winter impends. Any appearance of the sun god in the north (the realm sacred to Urthona) is thus of sinister import, for winter, like night, must be taken to mean the eclipse of mental illumination. There is, however, one important differentiation to be made. The major eclipse of winter implies a fall. The minor eclipse of night (provided the moon of love has not been extinguished) must be thought of as the normal fatigue of the mind, a period of relaxation in which it is renewed for increased activity. During the period of the mind's normal relaxation, man is illuminated in his night of mental darkness by the moon of Beulah— a love so all-inclusive that it provides a sustaining faith. When the moon fails, night, like winter, becomes a disaster.

This use of the sun and moon to suggest the relationship of knowledge to faith is a well-known bit of occult symbolism. As Eliphas Levi puts it:

If science be the sun, belief is the moon—a reflection of the day amidst night. Faith is the supplement of reason in the darkness left by science before and behind it. . . . The trespasses of reason upon faith or faith upon reason are eclipses of sun or moon. When they come about, both source and reflector of light are rendered useless.

The trespasses suggested here by eclipses of sun and moon are in Blake's myth suggested by changes in the position of these heavenly bodies as they move through the zodiac.

The proper quarter of the moon is in the east. This is the point at which the orb first becomes visible when, as a full moon, it rises as the declining sun sets in the west. Its position on the eastern horizon, therefore, admirably suggests the power of love to sustain the faith of the weary mind. It rises to dispel the darkness as the mind sinks to rest. But the moon, like the sun, can fail. Its ultimate failure is foreshadowed early, when, in the first quarter, it rises at noon and appears at sunset high in the sky. This is the "young man," Luvah, whose lamentable ambition is to usurp Urizen's place in the chariot of the sun. His appearance in the zenith and the light of day is a trespass upon the realm of Urizen and a portent of disaster.

The zodiacal journey, which the sun completes in a year, and

the moon in a little more than twenty-seven days, depicts, as the foregoing descriptions indicate, the courses of rational and emotional error. On the other hand, the diurnal motion of both the sun and moon depicts the normal ebb and flow of life. Since both the sun and moon move from east to west in their diurnal courses and from west to east in their courses through the zodiac, these two movements stand in spiritual contrast with each other. The east to west movement is spiritual; the west to east movement, unspiritual. The one is the "current of creation," the other, the "wheel of religion." This contrast rests upon the conceptions of ancient astronomy. The world of antiquity looked upon the westward movement of the stars as right-handed and auspicious, and upon the eastward movement of the planets as left-handed and inauspicious. In the myth the latter movement, the "wheel of religion," comes into being with the Fall, and is set, like the turning sword, to guard the tree of life.

> I stood among my valleys of the south,
> And saw a flame of fire, even as a Wheel
> Of fire surrounding all the heavens: it went
> From west to east, against the current of
> Creation, and devour'd all things in its loud
> Fury & thundering course round heaven & earth. . . .
> And I asked a Watcher & a Holy-One
> Its Name: he answer'd: 'It is the Wheel of Religion.'
> I wept & said: 'Is this the law of Jesus,
> This terrible devouring sword turning every way?'

The suggestive quality of these contrasting movements is very great. Since the east, the quarter assigned to Luvah, is figured as the centre of the giant Albion, the east to west movement is from within outward, from the world of Luvah to the world of Tharmas, the inclusive Eden in the west. The resultant universe is the expanding world of the Eternals, proceeding from the love within to a unified and all-inclusive world without. It stands in contrast to the contracted world of mortals, in which the procedure is from west to east, from the world of particulars and appearances without to the empty heart within. In this case the resultant world is as constricted as the loveless east (the

heart) which the moon abandoned when it rose into the zenith to take the place of the sun. The east to west movement suggests, therefore, the unified world of imagination proceeding from an inward faith; the west to east movement, the loveless rational world proceeding from a reliance upon observations of sense.

As Albion falls he carries his celestial light with him in ever diminishing strength and splendor. The heavenly light with which his world is illumined is at all times, therefore, an indication of his spiritual condition. The eternal world of Eden and Beulah is lighted by the sun and moon in their diurnal courses. When that world fails and the Mundane Shell is created as a barrier against utter dissolution, light is provided by the stars which in their multiplicity represent the break-up of the eternal sun and in their unified westward movement represent the effort to retain some vestige of eternal values. When the starry Mundane Shell crashes into the darkness of the abyss, the planets, moving irregularly eastward, make their appearance. To counteract their maleficent influence Los creates a temporal sun and a temporal moon, feeble but indispensable replicas of their eternal counterparts.

The first diminution of light is indicated, as we have just said, by the star world. This world was created to keep the body of man from falling into the abyss, when both the sun and moon had failed. When knowledge ceased to be intuitive and love ceased to be spontaneous, when, in astrological imagery, the eternal order was threatened by the departure of Urizen, the sun, into the north (the realm sacred to Urthona), and of Luvah, the moon, into the south (the realm sacred to Urizen), the diminished reason became Albion's guiding light. Out of fear it built the world of law that Albion might not descend into chaos. The ordered round of constellations is Blake's beautiful and appropriate symbol for the order imposed by law upon a world from which unity had fled. The symbol draws an added value from the Stoics' association of the stars with reason's ethereal fires. The star world of the law is the great rational achievement.

Since the movement of these stars is from east to west, we

must assume that reason is laboring at this point to preserve some semblance of the Divine Vision. For the stars are the remnants of the divine light left to fallen man. They are given him "till break of day,"—till the sun (the mind) and the moon (the emotions) struggle through the darkness of error and re-achieve the light.

Blake pictures the building of the star world as a great mathematical achievement. He describes the stars, with some elaboration, as pursuing their courses in "mathematic motion wondrous along the deep." The association of the stars with mathematics is obvious and ancient, but Blake would seem to have had some remarks of Thomas Taylor specifically in mind. Taylor had made use of the association when he interpreted the starlight which guided Ulysses "over the dark ocean of a material nature" as the light of "mathematical science." The stars themselves he explained as the ideas "from which the light of science is derived." Blake, who set less store by mathematics than did Taylor, adopted the idea, but interpreted it in his own way. For him a mathematical world was evidence that man had ceased to live by faith and demanded "demonstration."

> If the Sun & Moon should doubt,
> They'd immediately Go out.

This is precisely what happens in Blake's myth. The changing of their quarters by the sun and moon is essentially an act of doubt. The rational life and the emotional life each feels that the world would be better ordered in accordance with its own plans. As a consequence their light goes out. The mathematical star world, in which demonstration takes the place of intuition, is created to take its place.

Jacob Boehme had a similar conception of the star world. Reversing the modern usage of *vernunft* and *verstand*, he associated the star world with *vernunft*, the lesser intelligence which governs our world. It was for him a fragment of *verstand*, the higher intelligence which is from God. It was "compacted out of God," but "the stars are not the heart and the meek pure Deity, which man is to honour and worship as God; but they

are the innermost and sharpest birth or geniture, wherein all things stand in a wrestling and a fighting." Boehme's higher intelligence, which is God, is Blake's Eden; its light is the unfallen sun. Boehme's lesser intelligence, "compacted out of God," is Blake's star world, the Mundane Shell.

The creation of the star world is preceded in the *Four Zoas* (the one complete account of the achievement) by the feast of mortality. This feast is also the nuptial feast of the youthful Los and Enitharmon. The appearance of Urthona, the essential man, in the male and female forms of Los and Enitharmon indicates that the rational mind now sees the universe as dual. Urizen evidently expects his star world to reconcile this duality, to minimize the consequences of a separation into Spectre and Emanation, in a word, to accomplish the "marriage" of Los and Enitharmon. He draws his inferences, in true rational fashion, from the outward, rather than the inward, principle. His true alliance is with Enitharmon, not with Los. Consequently the creation in which he hopes to reconcile the strife of the contraries is predominantly feminine—a "natural" world. Law is its principle, and the stars are its symbol.

Like Beulah, whose illusions it is designed to perpetuate, the Mundane Shell is a world of time and space. As a world built at the level of the stars, time there should logically be measured by the sidereal year of the Druids, which, being determined by the rising and setting of the Pleiades, had two seasons—spring and autumn. Blake's belief, which is specifically stated in the *Descriptive Catalogue*, that there were but two seasons before the Flood may have had its origin in this ancient calendar, though the fact that summer and winter (as the Rev. Dr. Burnet pointed out) are not mentioned in the Bible until after the Flood, could not have escaped his attention. That these two seasons should be spring and autumn is demanded not only by tradition, but by the logic of his system, with its alternate periods of energy and repose. In the *Four Zoas*, there is a transition between the original two-seasonal year and the present four-seasonal one. Summer is explicitly stated to have been the season of the Mundane Shell. It would seem, then, that

this, the first summer, heralded the change from the two-seasonal world of Eden and Beulah to the four-seasonal world of Ulro and Generation. When the Flood of time and space and corporeity becomes imminent, the stars of law fail, as the sun of intellect and the moon of love had failed before them. Urizen descends into the pit; the sidereal year ceases; and the solar year, measured by the passage of the temporal sun through the zodiac, takes its place. Winter, whose darkness and cold are the outward witness to the extinction of man's inner light and warmth, enters the cycle. The whole extent of the zodiac will have to be traversed.

The zodiacal journey, which we are now about to chart, is a matter of inference; but the inferential evidence, once seen, is so convincing that the existence of a zodiacal year, embracing the cycle of the temporal world, cannot be doubted. It will be necessary to retrace our steps to the beginning.

For the convenience of the reader who may have forgotten his almanac, I offer this ancient rhyme:

> The Ram, the Bull, the Heavenly Twins,
> And next the Crab the Lion shines,
> The Virgin and the Scales.
> The Scorpion, Archer and He-Goat,
> The man that holds the watering pot,
> And Fish with glittering scales.

The Ram, or Aries, marks the vernal equinox; the Crab, or Cancer, the summer solstice; the Scales, or Libra, the autumnal equinox; and the He-Goat, or Capricorn, the winter solstice. The crucial times for the sun in this seasonal journey are, of course, June, when, having reached its northern limit at Cancer, it begins its retrograde movement, and December when, at Capricorn, it again turns upward. For this reason the appearance of the sun god at Cancer foreshadows the fall of the rational mind; his appearance at Capricorn, its reawakening. The remaining solar mansions in the zodiac are treated as steps in the decline and reascent.

In the early prophetic books the intuitive life of Eden has been lost when the story opens. In the *Four Zoas*, although

prior events are described, the action begins as the corruption by which Albion is to fall is revealed. This means that the sun has already entered Taurus, since the Bull is the symbol of Generation, the finite scheme set going when Eternity is lost. Urizen and Luvah, the sun and the moon, are plotting the activities by which, contrary to their expectation, their own downfall is to be accomplished. Urizen, the sun, is to invade the north, the realm of Urthona. Luvah, the moon, is to seize Urizen's Chariot of Day. In making his journey into the north, Urizen is animated by a desire to "look on futurity." One is startled to find the phrase in Mallet's *Northern Antiquities.* Odin reproaches Loki, the slayer of Baldur, the sun god: "Senseless Loki, why wilt thou pry into futurity? Frigga alone knoweth the destinies of all, though she telleth them never." It is Urthona alone who knoweth the destinies in Blake's myth, a lesson Urizen has yet to learn. Luvah, too, has yet to learn a lesson: that the feminine emotions must not dominate the masculine mind, this being the significance of his usurpation of Urizen's Chariot of Day. The dominance of the feminine at this point is suggested in various ways. Taurus itself, strangely enough, is feminine in its astrological significance, and the legendary associations of certain northern configurations support the symbolism of the Bull. The Great Bear, sometimes called Charles's Wain, sometimes Arthur's Chariot, sometimes the Plough, has seven stars, four in a rectangle, three in a curved line. These three are sometimes seen as oxen. Blake transforms them into the bulls of Luvah dragging the plough of Urizen, an admirable image of the surrender of the masculine mind to the feminine emotions. He further emphasizes feminine ascendancy by identifying the neighboring constellation of Arcturus, or Boötes, with Arthur, whose chariot the Plough is sometimes said to be, and by fastening upon Arthur, whose legendary history he believes to have been derived from Albion, the ignominy of complete subservience to the woman: "O woman-born and woman-nourished and woman-educated and woman-scorned."

The zodiacal sign which follows the Bull is Gemini, the Twins. It seems logical to suppose that in this constellation we

have the birth of that intrepid pair, Los and Enitharmon, the twin concepts, Time and Space, children of the natural world which has just come into being. Albion's divine humanity has been divided. Henceforth Urizen will have the vexed question of duality to deal with.

Cancer, the northern limit of Urizen's progress, is a crucial sign. Porphyry's *Cave of the Nymphs* describes it as the Gate of Men by which souls descend. Macrobius, drawing upon Pythagoras, says that souls about to descend are still in Cancer and so of the order of the gods. "But when," he continues, "by falling they arrive at the Lion, the rudiments of birth and certain primary exercises of human nature commence." He further explains that when Plato speaks of the descending soul as "staggering with recent intoxication," he has in mind "the new drink of matter's impetuous flood." The starry cup, placed between Cancer and Leo, signifies "that descending souls first experience intoxication in that part of the heavens, through the influx of matter." Having partaken of this drink, the soul finds oblivion creeping into its recesses and descends.

Blake follows this tradition closely. Urizen (the sun) has at this stage of his journey his intoxicating drink. At the nuptial feast of Los and Enitharmon he shares with them the "nervous wine" and breaks the "fleshly bread," nutriment which in the eternal world would have been the "bread of sweet thought and the wine of delight." In drinking of the starry cup—the same cup, presumably, which Eve holds in the fourth illustration to *Paradise Lost*—Urizen has his first heady drink of matter. He accepts the illusions of time and space. Indeed, his preoccupation at this "feast of mortality" is with the world of phenomena; his alliance is with Enitharmon, rather than with Los. Regarding himself as the arbiter of the natural world and its mortal destiny, he distrusts and fears Los as a "visionary of Jesus."

The feast just mentioned is frequent in astrological myths. It usually celebrates the marriage of the Lion with the Virgin, who stands just behind, holding something invitingly in her hand—an apple, a flower, a sheaf of wheat. The Virgin may therefore become the Eve of the Zodiac, the temptress of the

skies; and the object which she holds, the fruit of the tree of good and evil. The zodiacal Lion of Blake's myth is Urizen; the zodiacal Virgin, Enitharmon, whose ascetic religion and repressive ethics fit her for that rôle. Astrological symbolism would require, then, that Urizen, not Los, should marry Enitharmon. Blake's deviation is really less than it appears. For Urizen is present at the feast, and the quarrels which arise therefrom show that he, rather than Los, is Enitharmon's counterpart. In accepting Los and, more particularly, Enitharmon, Urizen accepts not only the concepts Time and Space but also an ascetic or virgin ethics. His acceptance of duality and his drink of the cup of matter make the virgin ethics inevitable.

Leo, which follows Cancer, is the summer sign, the period of the sun's greatest heat. It aptly suggests the period of reason's greatest activity. Summer attends the Mundane Shell, the interval between Urizen's compromise with time and space and his descent into the pit. His burst of activity at this period is due to a vision of the future, which revealed to him the abyss, the pit of winter, the abode of chaos and blank darkness, into which he is presently to fall.

> . . . he saw Eternal Death beneath.
> Pale he beheld futurity, pale he beheld the Abyss. . . .
> He saw the indefinite space beneath & his soul shrunk with horror,
> His feet upon the verge of Non Existence.

He labors titanically to avert his fate. He commands a whole new world to be constructed.

> Build we a Bower for heaven's darling in the grizly deep;
> Build we the Mundane Shell around the Rock of Albion!

The Mundane Shell—the star world—which now comes into being, is an attempt to put "bounds to destiny," to construct a kind of Gnostic Pleroma, binding in the fulness of life from the emptiness outside. It would reconcile the apparent duality of a sundered world, which Urizen had accepted at the feast of Los and Enitharmon. It would prevent, by laws of "mercy, pity, peace," the spirit of man from falling into vengeance.

In a word, it would put a check upon the fall into chaos, physical and spiritual.

> Thus were the stars of heaven created like a golden chain,
> To bind the Body of Man to heaven from falling into the Abyss.

It may be observed that Jacob Boehme thought of the stars in exactly the same way. It was there, in his mythology, that Lucifer, the great hierarch and the first great apostate, dwelt with his angelic host. It was there, too, as Urizen is soon to learn, that the world has its "finite original and beginning."

The fitness of Leo as the zodiacal sign in which Urizen constructs the star world is obvious, for Leo is the house of the sun. It is also fitting, in its way, that the sacrifices which characterize the Mundane Shell should have a parallel in the sacrifices which, according to Macrobius, were anciently offered to the manes when that hostile sign arose.

Of the seductive character of the Virgin, the next zodiacal sign, we have already heard. Holding the fruit of the tree of good and evil toward Adam (Boötes), the astral woman tempts the astral man, even as she herself is tempted by the adjacent serpent. The Virgin is the rôle commonly assigned to Vala, whose place is taken, however, in Old Testament history, by Enitharmon. Her virginity lies in her ascetic ideal of good, an ideal which is bound to break into the duality of good and evil. To this ideal Urizen subscribed when he surrendered the Chariot of Day to Luvah; to the nascent duality he subscribed when he sat at the feast of Los and Enitharmon. Very soon the rational mind, which has had its first drink of "matter's impetuous flood" and created a natural universe, will accept the Virgin's tempting offer of the fruit of good and evil and sink into vengeance for sin. Urizen's star world will then cease to be an effective bound to destiny, and all will descend into the pit.

For a little while, however, the harmony Urizen seeks seems to have been achieved. At Libra, the Scales, the sun hangs in the balance between the upper and lower worlds. Days and nights are of equal length. This autumnal balance Urizen can maintain because in fashioning the star world, he erected the

strong scales "that Luvah rent from the faint heart of the fallen man." The balance between the contraries, which man lost when he saw his world as dual and set the feminine contrary above the masculine, has apparently been reachieved. The love and forgiveness which were spontaneous under Luvah's rule are now commanded. The Mundane Shell (the star world of the law) is at its perfect functioning.

It does not function long. Urizen eats of the Virgin's fruit of good and evil, he casts out Ahania, calling her Sin, and the star world crashes into the abyss, the first division of which is Scorpio. Instantly Tharmas rises up to engulf the fallen god of light in a flood of angry waters—the biblical Deluge, but in Blake's myth a dark ocean of materialism. The flood is also in agreement with the Egyptian association of Scorpio with the autumnal rains and the overflowing of the Nile. But Scorpio signifies evil of every kind. It is, indeed, the most maleficent of all the signs, and it has been looked upon as the evil principle by divers peoples. It is the abode of Typhon, the leader-up of the hosts of hell, who extinguishes the sun god's light, binds his hair with the frosts of winter, and drags him to the bottomless pit of the southern hemisphere. Blake has authority, therefore, for extinguishing the light of Urizen and binding him to the illusions of the world of time and space and corporeity in which he now finds himself. Bound to these illusions, the rational mind can no longer read the stars, which command the forgiveness of Eternity. There is no light within with which to see the light without. Such light as remains is possessed by Los, the imagination, who painstakingly shapes the temporal sun and the moon of Ulro. Theirs is the feeble light of a wintry season.

A great deal of the hatred of Scorpio was doubtless owing to its confusion with the neighboring constellation of the Serpent. In fact, the southern sky is dotted with serpent configurations. Blake utilizes the serpentine aspect of Scorpio and the southern sky by making the Mundane Shell, as it descends into the abyss along with man, a serpent heaven of twenty-seven folds. These are the twenty-seven folds of the dragon Orc, the rebellious heart of man, around which, as around a spirit of evil upon which to

take their vengeance, the self-righteous create their churches. At the root of every religion of authority is the disobedience of man. The twenty-seven heavens of the Mundane Shell are in this sense the disobedient and enslaved Orc. They evolve as reason's attitude toward Orc evolves, reflecting reason's hatred and fear of Orc's revolt and its pity for his suffering. Their number is probably derived from the twenty-seven lunar mansions, the twenty-seven phases of the moon in its journey through the zodiac. It may also owe something to Plato's twenty-seven-fold division of the space between the earth and Saturn.

The numerous serpentine configurations of the southern sky and the confusion of Scorpio with Serpens give to Blake's serpent symbolism an added scope. The progress of Urizen through the zodiac is paralleled by the increasing power of the serpent. As the sun approaches the north, Draco, the polar serpent, is exalted in Gemini; as it passes into the south, Scorpio (or Serpens) becomes its house. So, too, as Urizen approaches the north and Los and Enitharmon are born, presumably under the sign of Gemini, the primal serpent comes into being. It is the symbol of Nature and Natural Religion, in which Urizen is now beginning to believe. But as his belief in a natural monism gives way to a duality of matter and spirit and his laws of peace become laws of vengeance, the Mundane Shell descends from its exalted level even to Tyburn's brook, and with its twenty-seven serpentine convolutions arches in the mortal world. The potentialities of the serpent (Draco), frozen in the north, were awakened by Urizen's intrusion there; in Scorpio the serpent triumphs over him, becoming his very habitation.

The conception of the southern sky as a twenty-seven-fold serpent arching in the mortal world probably owes something to the Gnostic serpent which enclosed in its round the mundane egg. It has another analogy in the serpent Midgard, which encircled the earth.

The descent into the abyss does not go unheralded. Scorpio is preceded by the bright star, Lucifer. In the spring, as a star of exceeding brightness and beauty, and riding high in the heavens, it heralds the approaching summer. It is then known as the eve-

ning star, or Venus. In the autumn, having fallen from the seat of pride almost to the horizon, and shining only in the early dawn, it is known as Lucifer, Son of the Morning, a rebel angel cast down from its high estate into lowest hell. At this season it is the herald of autumn, foreboding the pit.

As one cast down from heaven and running in advance of the Dragon, Lucifer has been assumed to be the rebel angel who incited a third of the hosts of heaven to disobedience. These disobedient stars appear in Blake's myth as that one-third of the host which Urizen swept out of heaven with him when he fell. The allusion is, of course, to the Dragon of Revelations, whose "tail drew the third part of the stars of heaven and did cast them to the earth." This is Draco, whose fall away from the north pole was said to have swept a third part of the stars out of heaven. They reappear in the pit as attendant luminaries of Scorpio. We may regard these fallen stars as the law in its decline into vengeance. The stars not dragged down we may regard as the law in its beneficence, commanding forgiveness, forbidding punishment.

The wintry signs heralded by the fall of Lucifer are the period of darkness and cold in which the sun god is overcome, the period, in Blake's myth, of mental darkness and emotional cold, a hell of ignorance in which the sense world is taken for reality and vengeance for sins is practiced. The triumph of darkness and hell is not, however, to be permanent. The dead sun is reborn, hell is opened to heaven, the experience of error leads to its renunciation. Celestial signs and tokens of ultimate redemption were not wanting. Christian astrologers believed that they could discern a child in the Virgin's lap. Volney and others observe that as the Virgin and the Herdsman sink below the western horizon, Perseus rises in the east, with his sword and the snaky head of Medusa. In *Europe* Vala (the Virgin, with whom Volney equates the Medusa) has "snaky hair," which is spoken of as "brandishing in the winds of Enitharmon," while Los himself, who, like Perseus, is to be the deliverer, "rears his head in snaky thunders clad," for he, too, before his conversion, is the creator of a serpentine religion. But even without preliminary

signs and tokens, the process of redemption would work itself
out. The principle of deliverance and the seeds of regeneration
are even in the Dragon, as the alchemists knew. Therefore, al-
though the astrologers looked upon Scorpio "as the accursed
constellation, the baleful source of war and discord, the birth-
place of the planet Mars," the alchemists considered that only
when the sun was in Scorpio could iron be transmuted into gold.
Moreover, they associated Scorpio with the groin, as Blake asso-
ciated it with the loins, by which generation (the image of re-
generation) is accomplished and a religion of vengeance is
transmuted into a religion of mercy. The religion of which the
serpent is emblematic is a "sexual" religion, in which the con-
traries war in "sexual" strife that they may in the end achieve
a true generation. The consummation of winter is the return
of spring; the end of darkness is the return of light. The pur-
pose of bondage under the law is release from the law. The
course of Satanic and serpentine error must terminate in
Christian truth.

The significance of Sagittarius, the Archer, who follows Scor-
pio, can only be conjectured. He is said by astrologers to shoot
continually at the heart of Scorpio and to slay both it and the
sun. Blake drew the figure as an old man leveling a drawn bow
as the sun sinks beneath the horizon. It seems likely that he is
intended to represent the rational power which darkens the sun
and enslaves Orc, but which, as it is employed by the Prophets,
becomes, whether consciously or not, a means of redemption.

At the nadir of the cycle is Capricorn, the Platonists' Gate of
the Gods. It is here, in all astrological myths, that the sun, the
infant saviour of a stricken world, is reborn—here that a new
year begins. For three days at midwinter the sun appears sta-
tionary, its light greatly obscured. The Greeks accounted for
these three days by the descent of Orpheus into the realm of
Pluto. In Christian astrology the vanished god went down into
Hell during this time to cheer those who were held there in
captivity. The legend is of particular interest to readers of Blake
for the light it throws upon the sixth book of the *Four Zoas*.
In this book Albion's long spiritual disease reaches a turning

point. Urizen awakens, and, like the god in the legend, begins to explore the hells about him. With intolerable difficulty and pain, but with indomitable courage, he explores three wasted worlds, his own ruined world to the south, the empty world of Luvah to the east, the frozen world of Urthona to the north. The world to the west cannot be explored. It has been closed to man since the Fall. Having ceased to behold the unified world of the Eternals, man can no longer enter Eden. Nor can he comprehend Tharmas, upon whose acceptance unity depends. Urizen sees him only as a raging ocean of materialism washing through all the ruined worlds. As the result of the disheartening situation which his explorations reveal, Urizen decides to build a world "better suited to obey his will." The result is Mystery, in which the reborn Christ is enveloped and by which Christianity is to be dominated. Yet, despite the imperfections of the world of Mystery which Urizen now builds, Christ is reborn. The "obdurate heart" of Enitharmon is broken. The Prophets lay aside their selfhood and a genuine pity activates their deeds. Urizen may obscure the Christ in Mystery, but ultimately he, too, will discover his selfhood, and the sun will shine again in all its splendor.

Volney, speaking of the youthful saviour who is both the new-born Christ and the reawakened sun, tells us that "in his infancy, this restorer of divine and celestial nature would live abased, humble, obscure and indigent. And this, because the winter sun is abased below the horizon, and that this first period of his four ages or seasons is a time of obscurity, scarcity, fasting and want." This is the period defined by the two remaining zodiacal signs, Aquarius and Pisces, both of them watery and, therefore, material signs. Blake's myth is in accord with this ancient teaching. The eighteen Christian centuries are for him evil centuries, centuries in which the new-born Christ might well be said to live in indigence and obscurity. In Blake's own day material philosophy had all but obliterated the mystical thought in which alone he found sustenance. Nevertheless, he rejoiced in the prospect of an imminent judgment. The very prevalence of error meant that it was being shaped for the

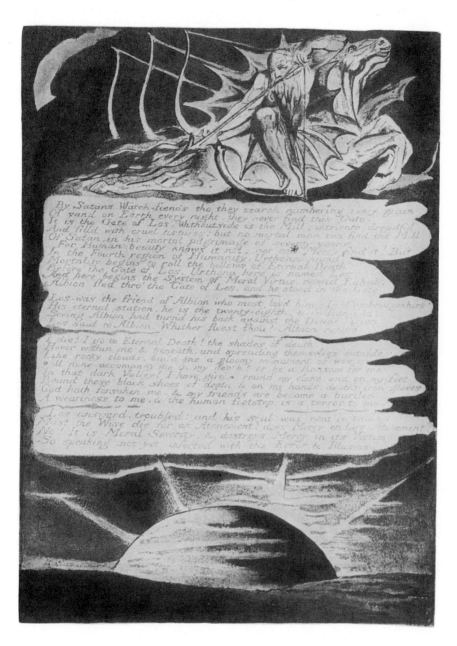

JERUSALEM, PAGE 39

judgment day. Los was giving to it "vegetable" forms that it might be consumed in mental fires. Presently the sun would penetrate the obscurity in which it had been enveloped since its reawakening—would, in short, burn away the error which had obscured it. Albion would awake and rejoice with Blake in his deliverance.

> The Sun has left his blackness & has found a fresher morning;
> And the mild moon rejoices in the clear & cloudless night.

IX

The Fall

Turning his Eyes outward to Self, losing the Divine Vision.
Four Zoas, Night II.

> . . . *I called for compassion; compassion mock'd;*
> *Mercy & pity threw the grave stone over me & with lead*
> *And iron bound it over me for ever. Life lives on my*
> *Consuming, & the Almighty hath made me his Contrary,*
> *To be all evil, all reversed & for ever dead, knowing*
> *And seeing life, yet living not.*
>
> Jerusalem, p. 10.

AS THE mind of man has reflected upon the reason for the Fall, seeking therein an explanation of our present plight, it has arrived at a variety of explanations. Disobedience, of course:

> . . . foul distrust, and breach
> Disloyal on the part of Man, revolt
> And disobedience.

But mere disobedience—the violation of a taboo—is satisfying only to the primitive mind. What incited to disobedience?

An almost universal answer is—the selfhood. So says the *Theologia Germanica:*

And when the creature claims for its own anything good, such as substance, life, knowledge, or power, as if it were that, or possessed it, or as if that proceeded from itself, it goeth astray. What else did the devil do, and what was his error and fall, except that he claimed for himself to be something, and that something was his and was due to him? This claim of his—this "I, me and mine," were his error and his fall. And so it is to this day. For what else did Adam do? It is said that Adam was lost, or fell, because he ate the apple. I say, it was because he claimed something for his own, because of his "I, me and mine." If he had eaten seven apples, and yet never claimed anything for his own, he would not have fallen; but as soon as he called something his own, he fell, and he would have fallen, though he had never touched an apple.

In selfhood the ground is prepared for the seeds of pride and ambition. The selfish soul will listen when the spirit of Lucifer says within it: "I will ascend into heaven, I will exalt my throne above the stars of God. . . . I will be like the Most High." Was not the Gnostic demiurge fired by the same ambition? Did not the serpent say to the woman that if she and her husband ate of the tree they should be "as God, knowing good and evil"?

Or has the soul made a wrong choice, as Plato thought, mistaking evil for good? Empedocles believed that the wrong choice was in turning from love to strife. By such a choice, he thought, had he become "an exile and a wanderer from the gods," an inhabitant of a world red with animal and human blood.

Or was man beguiled into disloyalty by lovely woman? Eve's share in the matter is well known. And so Milton says of Adam:

> Against his better knowledge, not deceived,
> But fondly overcome with female charm.

Lovely nature is no less seductive. In Paradise, says Boehme, nature had but a visionary existence, being rooted in the second principle—the Son, the Word. But Adam lusted to know the world of sense in a sensuous way. He left the second for the third principle—the outward world, the world of sense and the four elements, "and it laid hold on him." "And that is the heavy fall of Adam, that his eyes and spirit entered into the outward, into the four elements, into the palpability, viz., into *death*, and there they were blind as to the kingdom of God." Such is Boehme's adaptation of a traditional explanation. Plotinus and others among the Neoplatonists had found in the story of Narcissus an allegory of the Fall. The soul, admiring its image in the water—in a material medium and a flowing existence—forsook its spiritual estate and plunged after the outward and unreal image in the mirror, only to find itself in a material world of death and decay. Such is the fate, Plotinus says, of one who "undisciplined in discernment of the inward," goes in pursuit of the outward image.

As the natural world is often pitted against the spiritual world, so the outward reason, which draws its conclusions from

outward nature, is often pitted against the inward reason, which has faith and knows by intuition. Reason rather than nature is, then, the initial source of the trouble. Swedenborg interpreted the prohibtion placed upon the tree of knowledge of good and evil as forbidding man to investigate the mysteries of faith "through the medium of perceptions originating in self and the world." Erigena explained the Fall as being an irrational preference for the Creature over the Creator.

Or was the Fall, as the *Zohar* suggests, "an outcome of the blind turning toward conception and generation, so that in this sense Eve was made victim as a result of her own womanhood"?

It may already have been observed by the reader that these various explanations overlap. In Blake's theory of the Fall they are fused into a unity which preserves the significance of the diverse yet related parts.

It was pointed out in Chapter I that the pattern of Blake's metaphysics embodies two contrasting sets of qualities, or principles, one conceived of as lying at the centre, the other at the circumference. At the centre, it will be remembered, are the active, the masculine, the imaginative and the one; at the circumference, the passive, the feminine, the rational and the many. The Fall is the gradual movement from the inner position to the outer. All of these contraries are carried forward in the myth, so that it becomes very complicated. It is at all times several layers deep. Overtones and primary tones may be equally important. The attempt to elucidate the story from all these points of view would be exceedingly cumbrous, and the matter is further complicated by the fact that there are several versions to consider. This chapter cannot be a complete commentary even on one of them. It will take the *Four Zoas* as a basis, since that version is at once the clearest and the most complex, and will emphasize now this aspect of the progression and now that, proceeding always as rapidly as possible.

Blake's story is in conformity with the Bible, as he read it. But, as Blake said in the *Marriage of Heaven and Hell*, "both parties have adopted the same history."

> Both read the Bible day & night,
> But thou read'st black where I read white.

There is, however, a notable departure from authority at the beginning. Albion is not newly created and untried. He is an Eternal, with Eternity—that is, humanity in its perfection—behind him. To this supersensuous state he is native; to it he will return. He did not proceed from chaos. He is not indigenous to time and space.

Many suppose [we read in the *Descriptive Catalogue*] that before the Creation all was solitude and chaos. This is the most pernicious idea that can enter the mind, as it takes away all sublimity from the Bible, and limits all existence to creation and to chaos, to the time and space fixed by the corporeal, vegetative eye, and leaves the man who entertains such an idea, the habitation of unbelieving demons.

Man's origin is therefore not temporal but eternal. But he has forgotten his eternal origin, and, having forgotten it, has acquired a mortal body and a temporal universe. How he made this change from the eternal to the temporal is the story of the Fall.

Blake writes, in the *Descriptive Catalogue*, of "states of the sleep which the soul may fall into in its deadly dreams of good and evil, when it leaves paradise, following the serpent." The Genesis of Blake's myth is, like its famous progenitor, a study in good and evil. But the drama has passed inward. The tree, the serpent, even Jehovah, are spiritual apparitions. The fruit of which Albion ate was matured in his own brain, the result of his rationalizations about the energies of life. For good and evil in the accepted sense do not exist. They are but evaluations which the reasoning intellect places upon the contrary forces of life. "Good," we read in the *Marriage of Heaven and Hell*, "is the passive that obeys reason. Evil is the active springing from energy." Both are "necessary to human existence." To accept both is to live the life of faith, to keep the infinite senses expansive, to see life as a unified whole. But faith and the acceptance of the contraries depend upon the immolation of the selfhood. To impose one's own selfish and holy identity upon the world, to call a portion of it evil and seek to suppress it, to order the whole of life by laws deduced from a part—this attempt is Blake's descent to Avernus.

The Garden of Blake's myth is Beulah. This region, which lies all around Eden, is the embodiment of the outer contrary in all its aspects. It is therefore full of danger. It ought, of course, to recognize its inward and higher source, and so preserve its faith, but there is always the possibility that it may awaken into activity of its own, begin to reason in terms of "I, me and mine" —as it does in the opening pages of *Jerusalem*—and to reason also on the basis of phenomena, taking the appearance for the reality. Should it do so, it would drag man down into a multiple and corporeal world whose moral equivalent is the conception of good and evil and the rod of moral justice. The danger is the greater because the world of phenomena is there, shimmering in spirituality, but tempting man, as Boehme said, to "eat," and so to lose hold of the second principle—the Son—and fall into the third and outward principle, the world of sense and corporeity. And the self—being outward and feminine and natural—is there to instigate these errors; and the woman is there to be their instrument.

When these and other forces come into action, there follows Blake's equivalent of Milton's war in heaven and of the Greek war of the gods. In the *Four Zoas* four gods and four goddesses contend together. The archconspirators are Urizen and Luvah. Tharmas (the body) is a helpless and innocent victim. Enion, his outer self, retreats as far as it is possible to go—into the dark extremities of the world, the mental conception of abstract matter. Tharmas becomes no more than the vital principle of a Stoic or a deistic world. Los and Enitharmon also pay the price, having to descend into the world of Generation. Urthona's body falls and becomes a serpent, the prototype of the serpentine religions. Boehme had a similar idea. Observing that the spirit and the body are in correspondence, he asserted that "the image of man cometh to be the image of the serpent."

In the early prophetic books, written before Blake's philosophy had become basically fourfold, this premundane struggle is dual. It is between Los and Urizen, the imagination and the reason. The surging fires which are awakened by Urizen's selfhood and regression are described as "dark" and "sulphure-

ous." Blake must have been thinking at this point of Boehme, whose symbol for the dual unity of God as Father and Son was a flame, with its dark base of consuming fire and its bright top of light. The consuming flame is the Father, an angry and jealous God; the light is the meek and forgiving Son. But the fire is also sulphureous. On this analogy, when Urizen, the god of light, retires into his fire-source, he stirs up angry and jealous and sulphureous fire and smoke. Now the fire source—the Father—is in Boehme also the first principle and "eternal nature." Should this principle express itself in the outward and temporal third principle without passing through the meek and forgiving second principle it would engender a dark, mortal, corporeal world of four angry elements. This is exactly the kind of world which emerges out of Urizen's regression into selfhood.

In the early prophetic books it is Urizen who initiates the Fall. In the *Four Zoas* Luvah seems to be the first, if not the only, begetter of that disaster. His responsibility in the expanded fourfold version is not far to seek. For Luvah, especially as he expresses himself through his consort Vala, is lord of Beulah, and Beulah is the state of man in his temporal repose. In this state "his tincture was quite wearied," as Boehme said of the falling Adam. Into such a weariness Albion had fallen when Vala, the outward and passive form of Luvah, lured him to possess her, just as outward nature, in Boehme's story, lured Adam to know her sensuously. Albion's possession of Vala, who is at once the heart or soul of nature and the gentler feminine emotions, signifies that he has chosen her as his ideal of good. This brings forward an element in the Fall about which Blake says so much and I have said so little that I choose it as the medium of progress now. This is the rôle of pity. It has a prominent place in all Blake's accounts of the Fall. He had it in mind when, in the early prophetic books, Urizen is made to write his laws of mercy, pity, peace; he gave it a place in the *Gates of Paradise*; and he made it the central theme of the *Four Zoas*, in which pity is personified in Vala and made Albion's seductress.

The nature of Albion's repose in Beulah has already been

described. His presence there means that he has found the pace of Eden, where energy is free and active, too swift for his lagging spirit. He has come to prefer repose to activity and the restraint of a delusive "good" to liberty. Beulah is, in general, the world of the passive emotions—quiet, tender, given over to outward impressions and dreamy intuitions. Into Beulah doubt and denial do not come, because love and pity are (until the Fall) adequate to the situation. Should sin be imputed, it would be forgiven. Under the protecting cover of the tender emotions the mind renews its energies and returns to Eden to taste again creative joys and share in the mental warfare that comes with replenished powers. So Albion may be supposed to have lived before the Fall; but at this great crisis, wearied more than usual, he lost himself in his respose and could not return.

We may take all this to mean that Albion had come to look upon the security, the lessened energy, and the emotional serenity of which Beulah is the symbol, as the good life. The Fall is thus a Narcissistic thing. Albion has fallen in love with his own passive self as it is manifested in the relaxation of Beulah. Proud of the pity and love in Beulah, he accepts Vala as Good. Evil is but a step away.

Shifting the emphasis from Albion to the Zoas, who are his psychological components, Blake represents Luvah as falling into a selfhood, submitting to the desire to dominate man. Vala, Luvah's feminine consort and his passive self, is left sleeping in Albion's brain. Possessed by Vala, Albion can no longer find his way back into Eden. He has given himself to love (more especially in its feminine aspect of pity); he has found it good, but having succumbed to its dominion, he is no longer free. For dominion requires subjection, and pity requires a need for pity. Love can be elevated into a position of worship only at the cost of love itself. Blake would have agreed wholeheartedly with D. H. Lawrence's *Retort to Whitman*:

> And whoever walks a mile full of false sympathy
> Walks to the funeral of the whole human race.

This is the dreadful wisdom of experience. Albion, who willed

for himself the pity of Vala, saw the blessing he had invoked
become a curse, for

> Pity would be no more
> If we did not make somebody Poor;
> And Mercy no more could be
> If all were as happy as we.

Herein lies the explanation of the double epithet, Vala-Rahab.
The love of Eden left man free, whereas "the selfish virtues of
the natural heart," the holy love of Blake's hatred as symbolized
by Vala's absorption of Albion, forces man into cruelty and re-
pression. Vala, the "sinless soul," "Albion's bride and wife in
great Eternity," becomes under the compulsion of the rational
mind and the self-righteous emotions, which have converted her
into an abstract ideal, the "dragon red and hidden harlot" whose
Biblical counterpart is the harlot of the Book of Revelations.

This is not to say that love and pity are not in themselves
necessary and desirable qualities; they are made objects of
Blake's disapprobation only when they become agents of self-
righteousness. Blake must have felt, however, that such an asso-
ciation was not a matter of exception but of likelihood. We read
in *Jerusalem* that men are caught by love, women by pride.
The intellect deteriorates when self-righteously it accepts love
as a guide to life; the fallen Urizen's arts are "pity and meek
affection." Love deteriorates when self-righteously it yields to
pride in its own perfection. To this generalization Blake seems
always to have adhered. Certainly the feminine emotions are
made to share with the rational intellect the responsibility for
every fall that Blake portrays.

Blake had himself suffered greatly from officious pity. Prob-
ably he dreaded it because it weakened his faith in his own
creative powers. In the myth a false pity invariably plunges its
recipient into doubt. It is in this sense a form of accusation
leading to self-doubt and that mental sterility which are in the
myth made consequent upon a separation into Spectre and
Emanation. It is this, I think, that Blake has in mind when he
tells us that "pity divides the soul, and man unmans." It must
by its very nature call to the attention those qualities of life

which the rational mind deplores, and which it will, if left to itself, proceed to condemn. Man can therefore be saved from the potential evil within pity, only by a higher pity. It must be genuine enough to be understanding and hence forgiving, or man is lost. "Without forgiveness of sin love is itself eternal death."

The genuineness or falsity of Vala's pity is suggested by her relation to Jerusalem. Unfallen, she is said to have had Jerusalem in her veil. In the Job series Vala and Jerusalem are first pictured together, suggesting as nearly as possible a single figure; but in the fifth illustration, the theme of which is indicated in Job's self-righteous plaint, "Did I not weep for him who was in trouble? Was not my soul afflicted for the poor?" Jerusalem and Vala appear on opposite sides of the page. Pity, become self-righteous, has ceased to be forgiving.

Blake found the idea of the cruelty hidden in pity particularly easy to express in the Job pictures because of the Old Testament tradition that prosperity is God's gift to the righteous. The needy recipients of Job's charity have been subconsciously condemned as sinners, just as Job, once he has fallen upon adversity, is consciously so condemned by the three pitying friends. This perversion of the emotional life in which the Fall has its inception is less felicitiously expressed in other accounts. In the *Four Zoas* Luvah is said to have turned his back upon the Divine Vision. The figure is from Swedenborg, for whom man turns "backward from the Lord if he is in love of self and the world."

Albion's absorption by pity is followed by a rational scrutiny of all his qualities. His rational mind deplores what his pity accuses. And now the second Zoa fails Albion. Urizen, who should have turned man again toward the Divine Vision, constructs instead a philosophy of good and evil. The divine voice commanded: "Go forth and guide my Son who wanders on the ocean!"

I went not forth: I hid myself in black clouds of my wrath.
I call'd the stars around my feet in the night of councils dark.

For Urizen's disobedience we have been dramatically prepared.

As the idea of Good creeps insidiously into Albion's brain in the person of Vala, Luvah seizes the horses of light to run in his chariot of pride and rises into the zenith of Urizen. Reason is henceforth to be the slave of an emotional ideal. In exchange for the chariot Luvah gives to Urizen the wine of the Almighty, a potent drink at the fountain of love and pity, which sends him, in his newly awakened fear of life, peering into futurity to make his

> Laws of peace, of love, of unity,
> Of pity, compassion, forgiveness.

This anticipatory view of the future is properly the realm of Urthona, whose imaginative vision must henceforth be troubled by Urizen's doubts and fears. The self-righteousness that first led Albion to look upon Vala as Good has permeated his entire being. Under the newly acquired belief in good and evil Albion looks upon Jerusalem, the Emanation of free man, as impure. He sinks down in shame, covered with sore boils, every boil a separate and deadly sin. The Age of Innocence is no more.

In his discussion of the problem Blake attributes to Urizen a selfhood no less pronounced than that of Luvah, for over the empire of good and evil, which he himself created, he will be "God from Eternity to Eternity." Looking on futurity he will so order and command that life shall be lived as he thinks it should be lived, not as it might be lived in the fullness of man's powers. As the lawgiver he will be worshipped under the names of Jehovah and Jesus by all those misguided souls whose eyes he has blinded to the truth. He will be the God of this World, the Nobodaddy of Blake's disdain.

The first of the Zoas to feel the poison of good and evil is the Body. In Tharmas, the body of the united universe, all the minute particulars of life have found a place. But now that Albion is turning holy the emanative life is under accusation; the Emanations are fleeing to Tharmas, their sanctuary, and he "cannot turn them out." Albion is submitting to the passive and feminine ideal of Good, and the female, eager to impose her ideal, is turning chaste and reprobating a portion of herself.

Enion (the outward body) feels the impact of the rising holiness, and accuses Tharmas of sin. She views him with jealousy and suspicion. "Why," he cries:

> "Why wilt thou Examine every little fibre of my soul,
> Spreading them out before the Sun like stalks of flax to dry?
> . . . nought shalt thou find in it
> But Death, Despair & Everlasting brooding Melancholy."

The bitterness of prophecy is in these words, as Enion is soon to learn. The error cannot be stopped. She too is accused of sin, as she once accused Tharmas. Obviously Albion, in his new holiness, suspects first bodily energy and then bodily substance. As a result the spiritual body of the universe is breaking up, presently to be replaced by a natural and multiple body. Tharmas must be slain that Luvah may rise in his pride.

The sin which Enion finds in the dark recesses of Tharmas's soul has the same significance as the harlotry of which Jerusalem is accused. Under the regime of liberty each had symbolized a particular phase of unity; now that "stern demands of right and duty" have replaced liberty, each must feel the weight of every condemnation. Tharmas and Enion both feel that some modification of their life is necessary.

Since it is now Enion rather than Tharmas who bears the weight of accusation, a labyrinth must be provided for her, some illusion in which she may be protected from the disintegrating forces now at work. The term "labyrinth" suggests a refuge with many avenues of escape from self-righteous reason and avenging emotions and a maze of devious pathways in which the soul may lose itself. It apparently consists of all that is involved in the concepts Nature and Natural Religion. Such a labyrinth is said already to have been prepared for Jerusalem. A similar protection must now be provided for Enion. In her despair Enion turns to Tharmas:

> I am almost Extinct, & soon shall be a Shadow in Oblivion,
> Unless some way can be found that I may look upon thee & live
> Hide me, some shadowy semblance, secret whisp'ring in my Ear,
> In Secret of Soft Wings, in mazes of delusive beauty!

What an exact description of the web of nature which Enion is about to spin! She feels herself on the way to dark, blank, abstract matter, where she would be but "a shadow in oblivion." To prevent that extinction, she weaves a nature which is but a "shadowy semblance" of eternal nature, but which nevertheless is full of "mazes of delusive beauty," wherein she can be honored and protected, as under the "shadow of wings." Nine days she weaves, "and nine dark sleepless nights"—

But on the tenth trembling morn, the Circle of Destiny complete,
Round roll'd the Sea, Englobing in a wat'ry Globe, self-balanc'd.
A Frowning Continent appear'd, where Enion in the Desert,
Terrified in her own Creation, viewing her woven Shadow,
Sat in a dread intoxication of Repentance & Contrition.

Thus the Circle of Destiny takes shape, and with it the concepts Nature and Natural Religion.

The quality of nature in the first period of mundane history will be discussed in a later chapter. Blake had reason to believe that nature in that epoch was conceived of as a material monism. Call it animism or hylozoism or pantheism if you like, but such a life or spirit within nature would not meet Blake's standard of spirit or imagination. The Stoics, who brought the monistic tendency to its culmination in the Greco-Roman world, materialized even God. A material monism is the fundamental error with regard to nature. It first appeared when Enion spun Tharmas into her web. It kept asserting itself against rival conceptions, until in Blake's own day nature stood forth naked and unashamed, a material and mechanistic world. The Stoics and Epicureans had manifested themselves again in the Deists. "Bacon," says Blake, "is only Epicurus over again." Finding in Reynolds "a plain confession that he thinks mind and imagination not to be above the moral and perishing nature," Blake comments: "Such is the end of Epicurean or Newtonian philosophy; it is atheism." With the appearance of English deism and French atheism, the error implicit in Enion's Circle of Destiny is revealed. This error with regard to nature has for its ethical counterpart an error which likewise kept asserting itself against rival conceptions, an error common, as Blake says, to Druids,

Greeks, and Deists, the error, namely, that "man is righteous in his vegetated spectre." Divested of its picturesqueness, this may be read: Man is by nature good. The goodness of the natural man has its counterpart in the goodness of nature.

Blake sees neither one as good. The nature which Enion spun is in his eyes feminine, outward, passive, self-righteous, chaste, and cruel. It is in all these respects in accord with the inner spirit which begot it. It has already been said to have been created as a "covering" for sin. As man turned passive and feminine and holy and found himself plagued with a sense of sin, he sought to recover his old complacency. He turned for moral support to a nature made in his own image. To it he could look as the source of the morality in which he prided himself. He could bolster up his failing faith with a belief in natural goodness. Self-righteous man worshipping a self-righteous nature —that is the curse under which man and nature suffer together. In the myth Enion is made to lament that she has planted a false oath in the earth. It seems right to assume that the curse and the oath are one. In the web which Enion has spun nature's spiritual qualities, like Tharmas himself, have been obscured. "Why," asks Tharmas, "hast thou taken sweet Jerusalem from my inmost Soul?" Enion's absorption of Tharmas is the physical parallel of Vala's absorption of Albion. In Blake's sex symbolism this is the hermaphroditic stage between the androgynous man of Eden and the sexual man of Generation. As theologians used to say, mind became absorbed in sense; man in outward nature. Unable any longer to worship the Divine Vision, which required the forgiveness of sin (spiritual self-immolation), man transferred his worship to that image of himself which he found in nature. The man prostrated himself before the woman, and the woman assumed dominion.

The errors inherent in the Cycle soon begin to assert themselves. Man's conception of Being is reshaped to accord with his new beliefs. Urthona (man's essential self) is reborn as Time and Space in the persons of Los and Enitharmon. The temporal replaces the eternal. The concepts Time and Space cost Enion

her claim to spiritual reality. As the finite and the spatial take
hold on the mind of man, the Earth-Mother withers into a thing
of clay. Descending into matter she goes outward into the strife
of the four elements. She is now the sense world divorced from
Plotinus's world of Soul or from Boehme's second principle. The
light of her life has gone out.

> . . . all that I behold
> Within my Soul has lost its splendor, & a brooding Fear
> Shadows me o'er & drives me outward to a world of woe.

The inner spirit having turned self-righteous, the body pays the
price in Enion's blood. Creature is the prey of creature. The
curse placed upon the earth in Genesis is in effect.

The sufferings of a natural world deprived of its spiritual
heritage are something that only a mind which is at once meta-
physical and poetical can adequately express. In Gnostic mythol-
ogy matter yearns for its source, but Enion's grief moves us as
does human pain.

> I am made to sow the thistle for wheat, the nettle for a nourishing
> dainty:
> I have planted a false oath in the earth; it has brought forth a
> poison tree:
> I have chosen the serpent for a councellor, & the dog
> For a schoolmaster to my children:
> I have blotted out from light & living the dove & nightingale,
> And I have caused the earth worm to beg from door to door: . . .
> What is the price of Experience? do men buy it for a song,
> Or wisdom for a dance in the street? No! it is bought with the price
> Of all that a man hath—his house, his wife, his children.
> Wisdom is sold in the desolate market where none come to buy,
> And in the wither'd field where the farmer plows for bread in vain.

It is Enion's distress which is the main incentive to Urizen's
stupendous effort—the Mundane Shell. For in her—the body
looked upon as matter—he sees the ultimate of the dissolution
which attends the path upon which Albion's four rebellious
Zoas have set out. As Albion sinks down upon his couch in
Beulah, there to be tenderly watched over by Beulah's Daugh-
ters during his long sleep, he hands the sceptre to Urizen, who

rises to take it like an evening star, but having risen, is struck with horror at the sight of the abyss beneath,

Pale he beheld futurity, pale he beheld the Abyss
Where Enion, blind and age bent, wept, in direful hunger craving,
All rav'ning like the hungry worm & like the silent grave.
Mighty was the draught of Voidness to draw Existence in.
Terrific Urizen strode above in fear & pale dismay.
He saw the indefinite space beneath, & his soul shrunk with horror,
His feet upon the verge of Non Existence.

But nonexistence must be prevented! There must be some footing over the abyss, some check upon the Fall, some bond with Eternity.

Thus were the stars of heaven created like a golden chain,
To bind the Body of Man to heaven from falling into the Abyss.

The star world—the Mundane Shell—has been described in Chapter III. It is a natural world, rationally conceived and mathematically executed. Its philosophy teaches a natural monism, and its ethics mark man's first acquaintance with the law. It is a tremendous attempt on the part of Urizen to justify the position which he has taken in the outward, the passive, the feminine and the natural, and to hold in check the evils inherent in this position.

It would be impossible to convey, without too copious quotation, any sense of the tremendous energy that Urizen expends in the creation of his world. Blake had an imaginative and sympathetic understanding of the effort and the suffering involved in the transition from an instinctive life to a rational life.

The culture of the Mundane Shell Blake ascribes, like the antiquarians of his time, to the ancient Druids, a supposed prediluvian people. There was a tendency in his age to trace races and cultures to a common source. M. Bailly, for example, wrote of an ancient people, destroyed and forgotten, yet distinguished in philosophy and science, who were the common ancestors of the Chaldeans, the Chinese, the Hindus, and other ancient peoples. To these sharers in an ancient culture the patriotic Briton added the Druids. John Smith, in his *Gaelic Antiquities*, sup-

poses that the Druids were of the same antiquity as the Magi of Persia, the Brahmins of India, and the Chaldeans of Babylonia and Assyria. Among the tenets of all these he finds "such conformity as plainly evinces that they are all sprung from the same root, the religion of Noah and the ante-diluvians." Out of teaching such as this Blake constructs his conceptions of religious history. All religions were in the beginning one, the religion of Jesus, the Everlasting Gospel. All peoples were likewise one—the ancient Druids, who were spread widely over the earth. All religions other than the Everlasting Gospel were forms of Druidism. In the Mundane Shell we have Druidism in its glory.

The Mundane Shell owes several of its characteristics to Jacob Boehme. The association of the stars with reason is by no means peculiar to Boehme, but it is significant that they also represent his third principle, the principle of outward and temporal life, the principle, as Boehme says, of "this world," the world of which Urizen, as we know, is God. The world of the Mundane Shell, emerging out of the concepts time and space, marks the inception of the finite and the temporal life, and it is built at the level of the stars, where, according to Boehme, life has "a finite original and beginning." The firmament, he says further, is a "partition or division between the outermost and the innermost birth or geniture," or more simply, "it is the gulf between time and eternity." The Mundane Shell also is a partition between time and eternity, a partition set up with enormous energy to withhold the tide of the material and the finite, a partition which, being set up by a mind already more than half committed to the material and the finite, soon breaks down. Boehme says once more:

Behold! the stars are plainly incorporated or compacted out of or from God, . . . for the stars are not the heart and the meek, pure Deity [the Son] which man is to honour and worship as God; but they are the innermost and sharpest birth or geniture, wherein all things stand in a wrestling and a fighting.

And the wrestling and the fighting are said to be a struggle between love and wrath. This is precisely the situation of the Mundane Shell. Founded in the sharp geniture of the self, not

in the forgiveness of Christ, it is torn by love and wrath contending together—the law of "mercy, pity, peace" contending with the instinct of the natural man to take vengeance for sin.

Because vengeance is held in check only by Urizen's beneficient law, Urizen's temple, with Ahania enshrined, like the Shekinah of the *Zohar*, in the western wall, dominates the Mundane Shell. Ahania's position is important. As Urizen's feminine desire, she is Blake's counterpart to the Eros of Plato. In this sense she is the urge toward perfection in which Urizen finds the wellsprings of his activity. To her presence then, his beneficient laws are due. But her position in the western wall, the quarter assigned to Eden, is false. In the exaggerated importance thus given to Ahania is revealed the self-righteousness from which Urizen suffers. He is at present too greatly preoccupied with his feminine desire, too eager for perfection in his holiness. The price is heavy. Urizen must pay for his emotional serenity by the suppression of his active energies. In the Mundane Shell the strong energies are condensed "into little compass." For that reason the enshrined Ahania is fed upon sacrifice.

Urizen, who retains in this period (through Ahania) some of his higher perceptions, is aware of the impending dangers. His beneficent laws are proof of that. Yet his present concern with desire leads him to a consideration of both its rational and irrational forms. At the same time he is troubled by the problem of materiality. Readers of the *Four Zoas* will recall Urizen's tremendous anxiety in the "porches," where, we may suppose, he meditated upon the outward world, which was beginning to impinge upon reason and sense.

For many a window, ornamented with sweet ornaments,
Look'd out into the World of Tharmas, where in ceaseless torrents,
His billows roll, where monsters wander in the foamy paths.

Reason is beginning to see chimeras (like the angel in the *Marriage of Heaven and Hell*) in a material world. Ahania is no less anxious. She knows that Urizen's survey of the sense world from the "porches" may result in finding its desires evil, and may therefore culminate in the condemnation of all out-

ward things, including herself, Ahania, his own desire. She remonstrates with him, pointing out that his artificial laws have proved ineffectual in curbing the unregenerate desires. Her hope is that he will renounce the selfhood through which the desires are rendered unregenerate, and not desire itself.

> Why didst thou listen to the voice of Luvah that dread morn,
> To give the immortal steeds of light to his deceitful hands,
> No longer now obedient to thy will? thou art compell'd
> To forge the curbs of iron & brass, to build the iron mangers,
> To feed them with intoxication from the wine presses of Luvah,
> Till the Divine Vision & Fruition is quite obliterated.
> They call thy lions to the fields of blood; they rouze thy tygers
> Out of the halls of justice, till these dens thy wisdom fram'd,
> Golden & beautiful, but O how unlike those sweet fields of bliss
> Where liberty was justice, & eternal science was mercy!

Having gone thus far, Ahania determines upon a bold stroke. She shows Urizen a vision of the future—a vision of man going down into the dark world of Generation, of the diminution of the senses, of nature's degeneration into a serpent, and of the serpentine religion that issues from it. Who is exalted in that religion? The emerging figure appears as feminine, cloudy, piteous, sorrowful—it is Luvah, Urizen's great rival! And the vision is true, for as the Christian religion developed in the Middle Ages, it exalted Vala over Urizen.

The vision had just the opposite effect from what Ahania intended. Instead of renouncing his selfhood, Urizen increases it, and lays the blame upon Ahania. Forgetting that Ahania's fault does not lie in her passive and pleasurable character, upon which, incidentally, his own renewal depends, but upon the false position in which his self-righteous pride has placed her, he persuades himself that he, "the active masculine virtue," has been betrayed by his passive feminine Emanation, even as Luvah was betrayed by Vala. He sees in her his indolent feminine bliss, his indulgent self of weariness, his passive idle sleep. Without her, he believes, he would never have lost himself in an indolent passivity, and without an indolent passivity he would never have formulated the effeminate religion which Ahania's vision has revealed.

His visage chang'd to darkness, & his strong right hand came forth
To cast Ahania to the Earth. He seiz'd her by the hair
And threw her from the steps of ice that froze around his throne,
Saying: 'Art thou also become like Vala? Thus I cast thee out!'

The casting out of Ahania is catastrophic. "A crash ran thro'
the immense." Urizen and Ahania both fall into "a world of
darkness." The sea of time and space and sense rises in a swell-
ing tide to shut off Eden in the west and make of it a lost
Atlantis.

 . . . The bounds of Destiny were broken.
The bounds of Destiny Crash'd direful, & the swelling sea
Burst from its bonds in whirlpools fierce, roaring with Human voice,
Triumphing even to the Stars at bright Ahania's fall.

The story has at this juncture its usual authority in Scripture.
The suddenness with which the Mundane Shell is destroyed in
the flood of Tharmas is paralleled by the abruptness with which
the God who had mercifully protected Cain turned in his wrath
and destroyed a wicked world. In the sixth chapter of Genesis
Blake found a warrant for his theory that the Fall was a pro-
gressive movement of the masculine mind outward into the femi-
nine world of sense, where it was captivated. There we are told
that God's wrath was evoked because the Nephilim found the
daughters of men fair and violence filled the land. In the myth
Urizen discovers that he too has found the female fair, and that
she has delivered him into the hands of the enemy. His anger,
like Jehovah's, precipitates the Flood, and brings about the de-
struction of the world which preceded it.

There are also many analogies with sources outside Scripture.
The Hermetic writings say that man, desiring to live in nature,
burst through the boundary of the spheres and "showed to down-
ward nature God's fair form." Valentine writes that the pleroma
(the sphere of the supersensible gods) was broken, like the
bound of destiny, by the descent of Sophia. The void, or the
abyss into which the Zoas fall, is of the same nature as the abyss
in Boehme, where it is the world of God the Father in separa-
tion from the Son, the dark fire-source in separation from the
light, the first principle alone, without manifestation. It is the

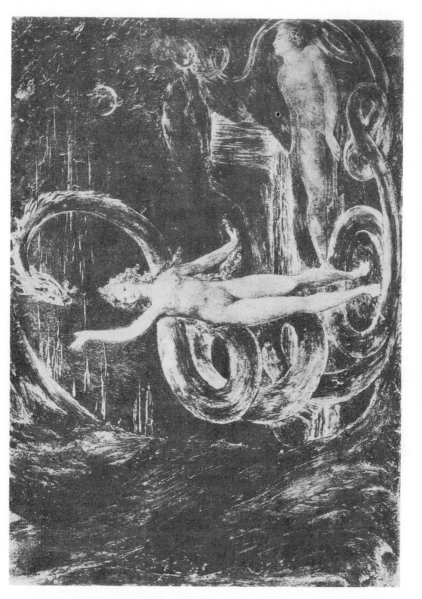

EVE TEMPTED BY THE SERPENT

world into which Lucifer and his cohorts fall. There are also several analogies with the description of the Flood given by Thomas Burnet. His account of the disintegration of the surface of the earthly sphere—the shell of the mundane egg—wherein all the waters were as yet contained, and his ingenious association of the eruption of the pent-up waters with the bursting of the womb of nature, as suggested in the Book of Job, certainly left its traces on Blake's myth. The shell of Blake's mundane egg breaks up, and the four Zoas fall (in *Milton*) "toward the center, sinking downward in dire ruin." Over these ruins flows the swelling flood of Tharmas, as the sea of space and time and sense. In the *Four Zoas* the womb of nature is not mentioned at this point, but in *Milton* as the virgin Ololon and Milton approach the verge of nonexistence, Ololon exclaims:

> Is this the Void Outside of Existence, which if enter'd into
> Becomes a Womb, & is this the Death Couch of Albion?

In the bursting of the womb is the rending of the fabric in which Tharmas has slumbered ever since Enion spun him into her web of nature. During that time he had no recognized identity of his own, but shared the qualities of Enion. The swelling flood is the release of Tharmas from the web which bound him.

In certain of Blake's drawings the descent into the pit is headlong. Man falls with his head down. There is in this an echo of Swedenborg, who says that as man fell progressively downward and outward, the image of God in him became inverted until, with the Flood, it was upside down. But Blake's conception is more complex than this. It certainly derives from Aristotle, who, noting that both the Pythagoreans and Timaeus speak of the movement of the heavens from east to west as a movement to the right, argues that, since the movement appears to be to the left as one looks north, the north pole must be down and the south pole up, and the cosmos "standing on its head." This is precisely Blake's figure. In the present position of the poles we see the south now

> . . . sunk beneath th' attractive north that round the feet,
> A raging whirlpool, draws the dizzy enquirer to his grave.

Cosmic Albion has fallen with his head down; the zenith (once Urizen's quarter) has become the nadir; the head has sunk to the loins (the sexual religion has replaced the Divine Vision); heaven has descended into hell. In the astrological symbolism the sun god sinks, at the autumnal equinox, into the darkness of winter.

The Fall is now virtually complete. The imagination has surrendered to the reason, and reason, in turn, has been extinguished by the senses. For the extinction of reason in a flood of sense Blake had, as usual, abundant authority. In Paradise, says Boehme, Adam lived in an inward principle, and so living, he had control over the four elements; but when he moved outward into the "external humanity," the four elements got control of him. Philo has a striking picture of the mind overwhelmed by sense impressions.

It is a cruel thing [he writes] that the inlets of the senses should be opened wide for the torrent of the objects of sense to be poured, like a river in spate, into their gaping orifices, with nothing to stay their violent rush. For then the mind, swallowed up by the huge inpouring, is found at the bottom, unable so much as to rise to the surface and look out.

There, at the bottom, "dashed in pieces," a ruin beneath his ruined world, lies Urizen "in a stonied stupor," helpless before the huge inpouring of sense impressions. It should be observed that in the act of casting out Ahania, Urizen's "visage changed to darkness." Henceforth there will be no light in his eyes, no strength in his "strong right hand." He becomes a blind and impotent figure. The light of the world, such as it is, will be in the eyes of Los, "that Prophetic boy," whom Urizen had feared.

In the impotence of Urizen and the bewildering multiplicity of the world of Tharmas is the chaos of the abyss. In this chaos is the wreck of the hermaphroditic world, in which the feminine contrary had absorbed the masculine. In the newly created world which follows, the contraries are separated, so that each may be disciplined and regenerated independently.

> But Mercy chang'd Death into Sleep.
> The Sexes rose to work & weep.

This, as we shall see later, is the method employed in alchemy. Though the separated elements will reunite in fresh hermaphroditic combinations, the continual hope is that they will come together as the higher law ordains. This is the method that Swedenborg attributes to the Lord at this great crisis. When, he says, in effect, the (feminine) will became corrupt, and the (masculine) mind, equally corrupted, was so impacted with the feminine principle that it could not be regenerated, "it was arranged by the Lord" that the two principles "should become separable, and thus capable of renovation." It was also arranged by the Lord, Swedenborg continues, that the new man after the Flood should be of a different quality from the "most ancient people." Boehme has a similar idea. Adam became corrupt and weary, and fell into a sleep. "Here he was undone; and if the *Barmherzigkeit,* or the mercy of God, had not come to help him, and made a woman out of him, he would have still continued asleep." In Blake's myth Albion—the cosmos—is awakened out of death by the mercy of God, which effected a separation of his male and female principles; and the reconstructed world is different from the ancient one in that the female principle is adjoined to the male in forms of "death and decay." The earlier monism is replaced by duality.

The separation in the realm of matter is hardly less catastrophic than the separation in the realm of mind. When the flood of sense rolls in, Tharmas rises up, "struggling to utter the voice of man, struggling to take the features of man, struggling to take the limbs of man." He is trying to regain his former spiritual status, but in so doing he becomes the antithesis of matter. Spirit and matter—Tharmas and Enion—are set in mutual opposition.

Enion soon feels the weight of moral condemnation. For a brief moment, it is true, she believes that her soul's splendor has returned—that the physical world will again be seen as human and spiritual. Instead she discovers that, as she had once accused Tharmas, she is now herself accused. For Tharmas, following Urizen's example with Ahania, blames Enion for the suffering the physical world has undergone, and casts her from

him. He will be what he can, but she must remain in the deeps of matter, where her misguided efforts led her. A dual physical world has been achieved. It is a complement to the duality already achieved in the moral world. With the recognition of sin, Urizen's laws of mercy are repudiated. Henceforth the world will know both good and evil and the rigors of vengeance for sin.

Still, Tharmas is not satisfied. Though, as the principle of life within the physical universe he scorns matter, he cannot live without it. Separated from Enion, he finds himself little more than a formless and meaningless will to be. What is more, he can find no release from his suffering; he is now "immortal in immortal torment." Deathless in his despair, he wanders seeking oblivion. Enion alone can provide it. It is to satisfy this hunger of one contrary for another that the mortal world is made. It is built at Tharmas's command in forms of "death and decay," in the hope that "some little semblance" of Enion may return. In short, a mortal world is the logical answer to a dualism of spirit and matter. It is the only conceivable world that will take account of both the physical contraries, one of which has been driven into matter.

The *Zohar* has its own account of the mortality of the world. "If the world," it says, "had been created in mercy (by Jehovah), everything in it would have remained indestructible; but since it was created in rigor (by the Elohim), everything in the world is perishable." In Blake's myth the postdiluvian world created by the Elohim is a mortal world created in rigor; but it is also a merciful creation, in that it is a means of escape from eternal death.

The rigor of this new world is dramatically expressed in the binding of Urizen, that is, in his commitment to the witness of his organic senses. The binding brings Los forward as the second demiurge. It has been observed that there are two types of demiurge in ancient theology. There is the demiurge of Valentine, who corresponds to "the vegetative and generative power of the soul," and there is the demiurge of Plotinus, who is the intelligence. The latter is Urizen; the former Los, who has com-

mand of the vegetative and generative world. Taking command, he first binds Urizen to the temporal illusion. Rolling his furnaces around him—those "furnaces of affliction" in which the temporal world must suffer—he takes the "thundering hammer of Urthona," and forms

> under his heavy hand the hours,
> The days & years in chains of iron round the limbs of Urizen,
> Link'd hour to hour & day to night & night to day & year to year,
> In periods of pulsative furor.

Next comes the commitment to the material illusion. Urizen's diminished perceptions are fixed, one by one, in their diminution. The once eternal mind, whose infinite wisdom had been metaphorically expressed by its position in the zenith, by its openness to the heavens, by its identification with faith and certainty, can henceforth know only what the five senses report. Man will see all things through the "narrow chinks of his cavern."

Despite the imagery in which the binding is described, we may assume that it is accomplished by prophetic teaching. The intellect and the perceptions are in direct correspondence. A decline in the one implies a decline in the other. When Urizen sinks into stupor, Los, the second demiurge, the "vehicular" form of the eternal imagination, molds his teaching upon Urizen's belief in duality; but, in order that the error may eventually be resolved, he assumes a finite and temporal order. Under Los's teaching the perceptions are narrowed, and to these narrowed perceptions the rational mind is bound. Ironically, Los himself becomes the victim of his own teaching. Looking upon the bound Urizen, he becomes what he beholds. He too suffers a decline.

> In terrors Los shrunk from his task; his great hammer
> Fell from his hand; his fires hid their strong limbs in smoke.
> . . . Terrified at the shapes
> Enslav'd humanity put on, he became what he beheld;
> He became what he was doing; he was himself transform'd.

For a long time Los's prophetic line will have very much the

same religion as Urizen's priestly line. But mercy tempers the rigor of the binding. The divine hand places a limit to the Fall.

> . . . Los felt the Limit & saw
> The Finger of God touch the Seventh furnace, in terror;
> And Los beheld the hand of God over his furnaces.

The instrument of this new insight is Tharmas. At the time of the Flood, power passes temporarily into his hands, since the invading tide is his own element, now seen as a bewildering and material multiplicity. However, he acts as it were under inspiration. It is he who commands Los to "rebuild this universe," "rebuild these furnaces." He issues the ultimatum: "Death choose or life." Apparently Los's only chance of re-establishing the spiritual and eternal world is to bind reason for a time to a material and temporal world. Consequently the religion the prophets foster assumes the existence of both the temporal and the eternal, the material and the spiritual, and sets the two at war. What happens from now on applies, therefore, alike to the Fall and to the Return.

Urizen's binding, for all its cruelty, is an act of consummate justice. The mortal world which he is now forced to perceive is the objectification of his beliefs. But his binding has also its aspects of mercy. He is bound to the illusion of the mortal that he may experience its fallacy and free himself from it. The Job series subjects the patriarch to a similar necessity. He too must experience the consequences of his error before he can be freed from it. Experience is with Blake the essence of regeneration.

To emphasize this aspect of what must otherwise seem a tragic limitation, Blake gives to Los the rôle of the God in the whirlwind as he appears in the Book of Job. In almost the exact words of the God who stayed the sea when "it brake forth as if it had issued out of the womb," Los restrains Tharmas, who would destroy the world: "Hitherto shalt thou come, no further; here thy proud waves cease." Tharmas must bewilder Urizen with a material and multiple world, but he must not make the obscurity complete. The Divine Vision must not be lost. Consciously or unconsciously (for he, too, suffers a spiritual degradation) Los labors for its return.

The immediate effect of Urizen's binding is the loss of the eternal world. With the elusiveness of God we have been made familiar by the Old Testament. Plato's *Statesman* has a theory of periodic withdrawal.

There is a time [it says] when God himself guides and helps to roll the world in its course; and there is a time, on the completion of a certain cycle, when he lets go, and the world being a living creature, and having originally received intelligence from its author and creator, turns about and by an inherent necessity revolves in the opposite direction.

This opposite direction is the movement of Blake's "wheel of religion," the movement of the sevenfold planetary cycle which governs the world of necessity, and which moves, inauspiciously, from west to east. It is also the direction of the sun in its journey through the night. The Platonic withdrawal of God has an interesting parallel in the *Book of Urizen*, where the Eternals erect "a tent with strong curtains" as a barrier between them and the mortal world. Now Plutarch, commenting on the world of necessity from which God has withdrawn, sees in it an evil principle at work. Here too there is an analogy with Blake. In his world of necessity or experience which rises after the Flood, an evil principle is at work, if only as a temporal illusion. The eternal God, who "is always present to the wise," disappears because man no longer lives by the faith that is in him. The Satanic God, who may be said to replace him, the Satanic God whom man worships without consciousness of that worship, remains unrevealed, for he too dwells in man, and man in his ignorance seeks him elsewhere. The Job pictures suggest a similar loss or withdrawal of the eternal world. With the God who torments him Job can find no contact. Job is aghast when in the process of time he is revealed as his own Satanic selfhood.

The mortal world, which is now established, has regeneration for its purpose, but the accomplishment is still far off. The curve of the Fall continues to descend, while regeneration grows and gathers strength. We shall therefore follow the course of the Fall a little farther.

What goes on, in the *Four Zoas*, immediately after Urizen has

been bound, is conjectural. To comprehend it we must look to other sources. In the *Book of Urizen* the binding of the sun god is followed almost immediately by Los's pity. In the Job series the sea of space and time appears in illustration six, while the three friends come in their devastating pity in illustration seven. In the *Four Zoas* this sequence of the mortal illusion and pity is less explicit, but it seems likely that here, too, a self-righteous pity comes into play. If this was Blake's idea in both his earlier and later mythology, it is hardly likely that the *Four Zoas*, which was written in his middle years, abandons the belief. Outside the myth there is evidence to show that Blake believed a false pity and a false humility to be one of the most pernicious consequences of self-righteousness. The self-righteous man is only too prone to make his neighbor (a sinner) the victim of officious pity. He is his brother's keeper in the wrong sense. Often he speaks even of himself in terms of pity as a sinner, and sometimes he is sincere. He is a mortal worm in his own sight. Plotinus observed this degradation and protested. He saw, as Blake saw, that as man moves outward from the world of Soul into the world of sense, the sense world overawes him, and he abases himself before it. Let man remember, Plotinus urges, that the universal soul is in him, and let him honor himself as he honors soul. Blake repeats the admonition.

> God wants not Man to humble himself;
> This is the Trick of the Ancient Elf.

Jesus was not "Antichrist, creeping Jesus," but one who spoke to man in this wise:

> If thou humblest thyself, thou humblest me;
> Thou also dwelst in Eternity.
> Thou art a Man, God is no more,
> Thine own Humanity learn to Adore.

A false pity, inducing a false humility, was one of the prime errors in the Fall, and one that has to be expiated in Los's "furnaces of affliction." Los himself, however, suffers under it for a long time. Binding Urizen, and becoming as a consequence what he beheld, he too accepted the burden of sin and, having

accepted it, loses himself in pity for the sinner. The change in Los is dramatically expressed by his terror at the thought of the fate he has inflicted upon Urizen, by his pity for Urizen, and by the birth of Enitharmon in the form of pity. It has its biblical analogue in the God who repented that he had destroyed the earth by a flood and consequently set a rainbow in the sky. Having become as Urizen, the prophetic line pities man as a sinner, and invokes the moral law against the neighbor and the self. This essential error was probably intended to be amplified in the *Four Zoas*. A notation near the end of Night IV reads: "Bring in here the globe of blood, as in the *Book of Urizen*." Now this globe of blood in the *Book of Urizen* embodies itself as Enitharmon, to whom the horrified Eternals give the name Pity before they flee from the scene.

As a symbol of the antithetical aspects of the religion which Los and Enitharmon represent, the globe of blood could hardly be surpassed. Blood is everywhere in Blake a symbol of cruelty, suggestive of the crucified Christ; yet it is here seen, in spite of the horror it inspires, as the "globe of life-blood trembling." This is the significance of the religion of Los and Enitharmon which comes into being after the Flood. It exercises a cruel pity that man may free himself from the dominion of pity. It crucifies Christ that Christ may live. The globe of blood is Blake's symbol for the spiritual purpose of mortal life.

> The red Globule is the unwearied Sun by Los created
> To measure Time and Space to mortal Men every morning.

This is the temporal sun, which Los created to light the darkness of Ulro when the Divine Vision was lost to man. We have already identified it with the "sexual" religion by which Los achieves regeneration.

In the Job series pity such as this stirs the patriarch to revolt, which his accusers hasten to rebuke by calling his rebellious utterance blasphemy against the God of vengeance whom both he and they worship. If our conclusions are correct and Los in the *Four Zoas* accepts the burden of pity as well as sin, the parallel between the two accounts is exact. What is more, the

birth of Orc, "Antichrist" and "hater of dignities," gains an additional motivation. Luvah, now no longer able to "endure," bursts forth from Enitharmon as the terrible child, red Orc— the cosmic parallel to the revolt which the self-righteous pity of his friends awoke in Job.

The story of Orc's birth is told in the *Four Zoas* with amazing economy. The solemn revolutions of the mortal world now set in motion for the first time, the turning wheel of religion (the sword at the tree of life), and Enitharmon's labor in giving birth to Orc, the spirit of revolt, are all seen as one convulsive movement.

Faint & more faint the daylight wanes, the wheels of turning darkness
Began in solemn revolutions. Earth, convuls'd with rending pangs,
Rock'd to & fro & cried sore at the groans of Enitharmon.
Still the faint harps & silver voices calm the weary couch;
But from the caves of deepest night ascending in clouds of mist,
The winter spread his wide black wings across from pole to pole;
Grim frost beneath & terrible snow, link'd in a marriage chain,
Began a dismal dance. The winds around on pointed rocks
Settled like bats innumerable, ready to fly abroad.
The groans of Enitharmon shake the skies, the lab'ring Earth;
Till from her heart rending his way, a terrible Child sprang forth
In thunder, smoke & sullen flames, & howlings & fury & blood.

Orc's birth into the world at this time is a necessary part of the regenerative scheme. Man is freed from his error through strife. By opposing Los's self-righteous religion Orc becomes "Evil" to the orthodox, the necessary complement to the self-righteous forces of Good. Without Orc's presence in the world we should be condemned to endless error. Self-righteousness, having nothing to oppose it, would eternally prevail.

Though Orc contributes so largely to a final regeneration, he figures in one major episode that must be construed as directly in the line of the Fall. Indeed, though the Generative world which rises after the Flood is all part of a regenerative cycle, it too sinks to a nadir, a vision of horror from which fear carries it into an ascending arc. The binding of Orc is still on the descending side.

Employing the sexual symbolism which is fundamental to the myth, Blake attributes to Orc incestuous designs upon Enitharmon, and a desire for Los's death. It is the Oedipus complex, but the statement needs interpretation. The inner meaning is that the sternly ethical religion of the prophets is endangered by Orc, the spirit of revolt, who sees in Enitharmon the natural and feminine principles deified in the religion of Baal and Ashteroth. The episode represents a real conflict in Old Testament history. Los is filled with a consuming fear, and finally binds Orc down with the Mosaic code upon the mountain top. The binding is done "beneath Urizen's deathful shadow." The prophetic genius is still deeply infected with rational doubt. Priests and prophets have hardly begun to separate.

The sufferings of the bound Orc are described in some of the finest passages of the prophetic books. Blake sees his binding as a calamity so colossal that man can never wholly free himself from its results.

> . . . not Enitharmon's death,
> Nor the Consummation of Los could ever melt the chain,
> Nor unroot the infernal fibres from their rocky bed.
> Nor all Urthona's strength, nor all the power of Luvah's Bulls,
> Tho' they each morning drag the unwilling Sun out of the deep,
> Could uproot the infernal chain; for it had taken root
> Into the iron rock, & grew a chain beneath the Earth
> Even to the Center, wrapping round the Center; & the limbs
> Of Orc entering with fibres, became one with him, a living Chain
> Sustained by the Demon's life.

The calamity of Orc's binding is the support it offers to moral justice. Coercion intensifies revolt, and revolt intensified is used to justify coercion.

The suffering of Orc begets pity of two sorts. It awakens a genuine pity in Enitharmon and so helps to bring into being the spirit of Christ by which mankind is to be redeemed. This consummation is the end of the labors Los projected when he laid the foundations of his spiritual city at the time of the Flood. At the same time Orc's suffering stirs Urizen, who has not yet learned that pity is a matter of the inner spirit, to new

activities. Los's efforts regenerate; Urizen's efforts enslave. For that reason the rest of the chapter will be devoted to Urizen's efforts rather than to Los's. They are properly a part of the Fall.

It should be noted that Urizen's affiliations, despite his repudiation of Ahania, are still with the female. With Orc safely bound by the prophets he looks forward to the restoration of a passive world. In the eternal world the passive self and the energetic self live together in harmony. In the temporal world the two are at strife, with Urizen continually trying to allay the strife by imposing the passive upon the energetic, that he may create a world amenable to his will. So long as the spirit of revolt is active in the world, he can do little. During the years of Orc's activity, Urizen lies in a "stonied stupor"; but once Orc has been safely bound by the frightened prophets, Urizen rouses himself from his lethargy. Roused by that "deep pulsation that shakes my caverns with strong shudders"—the terrifying energy of the enslaved Orc—Urizen sets out to explore the abysses in which man is lost. He finds them a chaos of ruined worlds. Not one quarter has escaped. Not one Zoa remains unfallen. All is waste.

In the sixth book of the *Four Zoas* Blake describes Urizen's attempts to find a way out of the difficulties which beset him. It is a "journey obstinate," heart-breaking in its apparent futility, but superb in its endless persistence. He finds the fourfold world ruined beyond any other poet's imagination. His first impulse is to curse the failure of his efforts. But as he travels on he finds man already cursed beyond his curse, and his soul melts in fear. As he travels he writes, endlessly recording the terrors of the abyss. His records are today Old Testament priestly literature, though Blake leaves us to infer their identity. As the eternal priest Urizen is also the eternal scribe.

Urizen's travels lead him in time to the empty east, the ruined world of Luvah. Here he sees a chance to build

> . . . another world better suited to obey
> His will, where none should dare oppose his will, himself being King
> Of All; & all futurity be bound in his vast chain.

The location of that world in the empty east—the heart—suggests that pity is to be its motif. The jealous god of the immediate past, whom the prophets have magnified, will be replaced by the more merciful god of the future. Having failed to suppress energy by means of vengeance, Urizen will now try mercy. But this is not yet a genuine pity, as Urizen's words make clear. It is founded upon self, a priestly challenge to the prophets whose power is so great that they can make a proud people accept their captivity in Babylon as just. Vala is about to be reborn, only to be speedily metamorphosed into Rahab and supported by Mystery.

The success of Urizen's plan involves the taming of Orc. It is a long story, only the essentials of which can be given here. As Urizen sits contemplating the suffering Orc, envious of his living energy, fearful of his strength, he tries by all his rational arts to cool Orc's fires of revolt. To his surprise, the Tree of Mystery takes root beneath his heel, and, like an upas tree spreads until he extricates himself with difficulty from its branches. So narrow is his margin of escape that he is unable to bring away his book of iron laws. Apparently Blake feels that Mystery, which characterizes the later Jewish and the early Christian church, had its inception in the mystery which surrounded the giving of the tables of the law. Jehovah's secret revelations to Moses have their logical culmination in the Mystery of the Book of Revelations.

Blake's denunciation of Mystery is as vehement as St. John's. He sees in it reason's trick for insuring the feminine supremacy of the moral law. By enshrouding the law in Mystery and creating the conception of a transcendent God who promises an "allegorical" heaven, Urizen succeeds in taming Orc, who goes up the Tree of Mystery, accepting the hypothesis of good and evil in which it is rooted, less, one gathers, from a belief in Mystery than from a desire to escape from the prophets who torment him. In the creation of Mystery is the tragedy of Orc's binding. Had he not been enslaved by the prophets, Urizen would never have succeeded in taming him and luring him up the Tree.

With this acceptance of Mystery Orc loses his dragon form, and becomes a worm, the traditional serpent in the tree, some-

what misplaced chronologically, to be sure, but otherwise
authentic enough, and with something seductive to say to both
Vala and Enitharmon. It is an interesting commentary on
Blake's philosophy of revolt, that Orc, whom the prophets
thought it necessary to bind, serves the eternal world; but Orc
grown tame and mocking is the Devil's own.

With the taming of Orc and the establishment of Mystery
the selfish feminine world achieves its triumph. The feminine
world of obedience and restricted energy toward which Urizen
has been struggling has been accomplished. The full import of
that supremacy may be inferred from the activities of the Daugh-
ters of Albion, in whom the recalcitrant feminine forces are
personified. Secure in their position within the Mundane Shell
(the heavens of religious belief man has created for himself)
the Daughters of Albion so mold the perceptions that "whatever
is seen upon the Mundane Shell, the same [may] be seen upon
the fluctuating earth, woven by the sisters." We may interpret
this to mean that man comes to see his immortal universe in
terms of the mortal heavens which his erring reason and emo-
tion have devised. This is what it means to be born of the
Adamah—to be made subservient to the female will of which
Blake stood in mortal fear.

Is this the Female Will, O ye lovely Daughters of Albion, To
Converse concerning Weight & Distance in the Wilds of Newton &
 Locke?

Man has been caught in a relentless wheel. Moral law sup-
ports a philosophy of corporeality and is in turn made neces-
sary by it. Once pity becomes self-righteous, we have delusions
of spirit and matter and of good and evil. Once we have delu-
sions of good and evil, we create the moral law. Revolt against
the moral law is silenced by the creation of a God of Mystery
whose will the law is seen to be.

Those who foster these delusions on which Mystery rests are
"the oppressors of Albion."

They mock at the Labourer's limbs; they mock at his starv'd Chil-
 dren.
They buy his Daughters that they may have power to sell his Sons;

They compell the Poor to live upon a crust of bread by soft mild
 arts;
They reduce the Man to want; then give with pomp & ceremony.
The praise of Jehovah is chaunted from lips of hunger & thirst.

This is a perversion of Christianity, a religion which gives lip
service to Christ, but magnifies Satan. It masquerades as love
and pity, "calling that holy love which is envy, revenge and
cruelty." This is the religion of Rahab, the "generate" Vala,
the "dragon red and hidden harlot" of Blake's system. It is also
the policy of the kings, who unite with the priests to keep man
tame.

So long as the female will prevails, this perversion of Chris-
tianity and the illusions it fosters will go on, for, "if once a delu-
sion be found, woman must perish." Nevertheless, the regime
of the law by which she is magnified must come to an end.
At this stage of our narrative the delusion remains undis-
covered. As a consequence man thinks of himself as a mortal
worm. His is the humility of the vanquished. In his abject
state he lives a life of emotional repression and mental sterility.
He denies imagination. He degrades art. He fears the future,
but he finds no joy in the present. He distrusts energy, but
spends such energy as he preserves in order to sustain the
forces which would keep him a worm. He believes himself a
Christian, but in his fear of life he is no Christian. "Jesus is
the bright preacher of life." In terms of Blake's sexual symbol-
ism the natural man is subject to chastity, cruelty, deceit, all
those qualities by which woman retains her dominion over
man. Do away with the selfish will and make man's feminine
qualities serve the interest of humanity as they once did, and
the illusions they foster will cease to be. But for the present
man finds himself paying homage to those qualities which
before the Fall existed by him and for him.

 There is a Throne in every Man; it is the Throne of God.
 This woman has claim'd as her own & Man is no more.

To woman, in her dominion, even the rational mind, her
age-old ally, is subject. Mystery, by which the rational mind
sought to cajole man into obeying the moral law with promises
of an "allegorical" heaven, proves the mind's undoing. It is

caught in a net of its own devising. Urizen must henceforth go about dragging the net of religion, which the Daughters of Albion have spun in obedience to his command, or sit huddled in the "dens of Urthona," lost in the mazes of a religion of Mystery. Reason, which created Mystery as a conscious deception, comes itself to be deceived. Eventually the web of Mystery is destroyed, but the rational mind enjoys no liberation. It frankly accepts the Nature and Natural Religion of the Deists.

Fortunately, as man's rational efforts carry him downward, his imaginative efforts liberate forces which arrest the Fall and prepare the way for a return. Blake suggests this conviction by his use of the limits, Satan and Adam. When these "limits" are "fixed," when Satan and Adam become apparent on earth, Albion begins to waken on his couch. The symbolism takes on meaning when we remember that Christ has often been regarded as the second Adam. As Satan becomes manifest in the activities of Urizen and the rebellious female which we have just described, the second Adam, who is Christ, is made manifest in the activities of Los.

The *Gates of Paradise* has these lines:

> But when once I did descry
> The Immortal Man that cannot Die,
> Thro' evening shades I haste away
> To close the Labours of my Day.

That vision of immortal man that cannot die comes when Christ is born "in Mystery's woven mantle"—when the prophets bring the Christian spirit into being in a religion of Mystery. Man should now be making his way toward a Last Judgment and a repudiation of error. Blake never abandoned his faith in this belief. It did not, however, prevent him from seeing how appalling a portion of mankind was still in the toils of formalism and authority. Under its Laocoön coils all that mattered to Blake—liberty, imagination, brotherhood—was in danger of extinction. At the root of this unhappy state of affairs was the selfhood of man. Nothing short of an inner purification could save him. Christ (a new and liberating spirit in man himself) must come in self-annihilation to cast off the whole social and religious structure reared upon the selfhood.

X

Alchemical Symbolism

My soul is seven furnaces.
Jerusalem, p. 67.

Here Los, who is of the Elohim,
Opens the Furnaces of affliction in the Emanation,
Fixing the Sexual into an ever-prolific Generation.
Jerusalem,'p. 73.

IF ANY figure is central and dominant in Blake's myth, it is
that of fire—the fire that burns in Los's "furnaces of affliction,"
the fire that is forever consuming the mortal and erroneous
forms of temporal existence, the fire that is refining the spiritual
gold in the crucible of man, the fire that is personified in the
dragon Orc. To understand the function of these fires and Los's
manipulation of them, we must turn to alchemical analogy.
There alone can we find full comprehension of Los's labors at
the furnaces and the anvil, of his continual separation of her-
maphroditic forms into their masculine and feminine compo-
nents, of the change of contraries into their opposites, of their
final and perfect union. In a word, the alchemical process repre-
sents in miniature the drama of regeneration as Blake saw it,
human and even cosmic. For the rationale of the whole alchem-
ical tradition, physical as well as spiritual, pagan as well as
Christian, had been shaped in large part by the same forces that
had shaped his own system. By the end of the eighteenth cen-
tury alchemy had run its course. Blake's interest in it was purely
speculative. But in that myth, as in many others, he recog-
nized poetic truth, and seeking, as he did, to weave into his own
system fragments of poetic truth from a wide diversity of
sources, he could not and did not ignore the poetic truth of
alchemy.

The aim of alchemy was, as everybody knows, the transmuta-

tion of the baser metals into gold. The fascination of this age-old and world-wide dream lay not merely in human avarice, but equally, perhaps, in human curiosity; in it the desire to grow rich beyond the dreams of avarice united with the passion to discover the ways of nature. Alchemy was not the baseless fabric of a dream; it had a foundation in natural laws—or in what passed as such in the days when alchemy flourished. "Nature," the alchemists keep reminding us, "overcomes nature; nature delights in nature; nature rules nature." To discover the way in which nature could be made to overcome herself to the personal advantage of the alchemist was the end of the secret art.

The principles which seemed to provide a theoretical basis for the alchemists' dream were drawn from the science and philosophy which prevailed in the Alexandrian world in which the art of alchemy took shape. One of these principles involved the idea of a cyclic change of elements to and from an original all-embracing source. When Heraclitus declared that all things are in a state of constant flux, and that the original fire descends from its ethereal plane through air and water to earth, and re-ascends, cycle-wise, through water and air to join its fire-source, he laid, without knowing it, one of the foundation stones of alchemy. The physical theories of the ancient world allowed for the change of the four basic and universal elements into one another, whether within their own cycle or by way of an hypothetical First Matter. From such physical thinking a group of basic alchemical precepts were easily deduced: the idea that "all is one and one is all"; the idea that this oneness involves a process of cyclic change in which one element is transformed into another; and finally, the idea that First Matter is the source of the elements themselves. A First Matter, a quintessence, a virgin water—some primal unity, call it what you will—lies at the basis of alchemical theory. "There is," we read in *A New Pearl of Great Price*, "from the beginning of the world only one element or First Matter out of the conflicting qualities of which the four elements are generated by division." The application of this physical theory to alchemical theory is obvious.

What has been generated by division can be regenerated into union; and gold, as the pure goal of all the divided metals, can be restored from their baser forms.

Akin to this theory of cyclic change and basic unity is the Neoplatonic principle of emanative and gradient being. The creative impulse, it was supposed, moves out by emanation from the One, like the rays of the sun in diminishing strength and splendor until, at its remotest dissemination it reaches a nadir in matter. If this be true, it is logical to suppose that what has proceeded from the One may return to its source over the same path. The cycle requires to be completed; and progression toward perfection is as reasonable a conception as progression from perfection. The theory of the returning cycle probably received support from Aristotle, who held that "in all things . . . nature always strives after 'the better.' "

Now, with regard to metals, the perfect state is, by assumption, gold. Nothing less is nature's intention, and the womb of earth is a vast matrix in which the process of return is continually taking place. If, in spite of this, gold is still scarce, it is because the process is impeded by natural imperfections. Nature herself is a frustrated alchemist, or at best a very slow one. The alchemist in his laboratory can speed the process. The philosopher's egg is an artificial replica of the womb of nature; in it the generative process may be hastened, just as, Paracelsus says, flowers may be forced in winter.

An important corollary of the theory of emanation is the belief that all things are alive and sentient, down to the very dust in which the emanative principle is exhausted. Since all things have proceeded from the One, all things must retain some vestige of their spiritual source. The fire may be locked up in the flint, the gold may be, as it were, suffocated in a mass of alien metal, but the living fire and the living gold are there. Alchemical theory required its votaries to think of the world as living and to be sensitive to the presence of life even in forms of apparent death. Thus taught, their Neoplatonic imagination, like Shelley's, conceived of a world in which

. . . the one Spirit's plastic stress
Sweeps through the dull dense world, compelling there
All new successions to the forms they wear;
Torturing th' unwilling dross that checks its flight
To its own likeness, as each mass may bear;
And bursting in its beauty and its might
From trees and beasts and men into the Heaven's light.

From this conviction came two of the most characteristic and important features of alchemy—the stone and the elixir. Both are comparatively late developments, much later than the simple theory of transmutation. The stone which being projected upon metals transmuted them into gold, and the elixir which being assimilated into the human body cured physical ills and prolonged life were both a bit of the divine original quintessence or First Matter, laboriously extracted from their terrene environment. Having been extracted, they operated as transforming agents, torturing the unwilling dross to their own likeness. Thus, physics and metaphysics contributed their support to the alchemists' ambition; Sendivogius could say, with some plausibility, "Our science is not a dream. . . . It is the very truth of philosophy itself."

Alchemical theory found further support in some crude notions about biology. On the organic level changes in nature are going on continually. Some of these had been observed and were subjected to the law of analogy in support of a similar change in metals. Geber, for example, notes that the worm is turned into a fly, the strangled calf into bees, the wheat into darnel, the strangled dog into worms. "But if they otherwise argue," he continues, in the *Sum of Perfection*, "that species is not changed into species, we again say, they lie." Similarly, then, one metal can surely be changed into another. Biological analogy was pressed still further, until it was supposed that metals had their "seeds" and that they "generated" one another in a way analogous with that of living organisms.

The theory of change in metals rested upon a peculiar theory of metallic structure. The principle of contraries, of which so much has been said in the previous chapters, came to the support

of alchemy. All metals, according to the well-known theory, are composed intrinsically of two alone—sulphur and mercury—in varying degrees of purity and proportion. If these two elements were impure or if their combination was incorrect, the less perfect metals were the product. How it is that sulphur and mercury engender the seven metals is an Hermetic arcanum which the Magi themselves do not explain. They insist, however, that by sulphur and mercury are not meant the substances commonly so called, but rather certain occult principles, sulphur being in some occult manner the principle of fire, and mercury in an equally occult way, the principle of water. The fire, of which sulphur is the principle, is the occult world fire, originating from God and deriving thence to all the creatures. The occult water, of which mercury is the principle, is the feminine aspect of the fire, the mother of all things, as fire is their father. These two elements, sulphur and mercury, compose the famous Hermetic androgyne, the twofold principle of all the metals and, in many speculations, of all the world. They are not only male and female, but also sun and moon, inner and outer, active and passive, two capable of becoming one—repeating in all these respects the qualities of Blake's contraries.

In the time of Paracelsus, perhaps by Paracelsus himself, a third principle—the principle of salt—was added to the foregoing two, forming the triad of salt, sulphur, and mercury familiar to readers of Paracelsus and Boehme. This new principle, the salt, is the congealing principle which provides an imperfect body for the imperfect contraries. It is also "our earth," as sulphur and mercury are "our sun" and "our moon." Although the Magi had got along without the triad, its appearance became inevitable when theosophy became dominant. Three combines with four to make seven, and with seven to make ten. Furthermore, the principle that *tria sunt principia omnium rerum* had to be harmonized with the principle that all things are composed of the four elements.

In the numerology of the ancients, then, we have an interesting relationship, which bears upon Blake's imagery, of the four elements, the three principles, the two contraries, and the single

unified First Matter which is the object of the quest. The mystical character of these numbers the alchemists love to emphasize; the Pythagorean tradition is part of their inheritance. The *Golden Casket* sums up the matter thus:

> All things are compounded in triads.
> They also rejoice in the number four.
> Yet they resolve themselves into unity.
> For otherwise nothing could exist.

This statement unaccountably omits the duad. In this respect Sendivogius's statement is superior:

For as the three principles are produced out of four, so they in their turn must produce two, a male and a female, and these two must produce an incorruptible one, in which are exhibited the four elements in a highly purified and digested condition, and with their mutual strife hushed in unending peace and good will.

Thomas Vaughan puts it succinctly. The First Matter, he says, "is the quintessence of four, the ternary of two and the tetract of one."

The relationship of the triad to the duad—of the three principles to the contraries—provides the logic for the alchemical process. We have already noted that the contraries are sexual. The masculine sulphur and the feminine mercury, woefully adulterated and impacted in their terrene forms, have to be set free from whatever hinders their perfect union. The element of salt in the triadic combination plays the rôle of body, and forms quite literally a muddy vesture of decay for the indwelling sulphur and mercury (soul and spirit). It has to be broken and calcined before the two contrary principles (the elements of one) can be released, that they may later reunite in their purified forms.

The right union of the separated contraries is even more difficult than the separation itself. Failure at this point is almost inevitable; the process has to be repeated endlessly. Without infinite patience nothing can be accomplished. "Festination," Geber asserts, "is from the devil's part." The trouble is that the sexes—the newly liberated sulphur and mercury—resist all efforts to bring them into harmonious and fruitful union. Instead

they engage in furious contention. When the union does occur and the two are reduced to peace and made one, the cessation of hostility comes through feminine submission. The dead gold (the masculine sulphur) is converted into living gold by the death of the feminine mercury. The one element achieves life by the death of the other. "Hence the sages bid you revive the dead (that is, the gold which appeared doomed to a living death) and mortify the living (that is, the mercury which, imparting life to gold, is itself deprived of the vital principle)."

In the course of time the sexual implications of the process were much elaborated. A truly Blakean imagination played upon the problem. Sulphur became the father, and mercury the mother, of metals. The red and the white gold—the sulphur and the mercury—were the man and the woman, the husband and the wife, the king and the queen, the red slave and the white spouse. The culmination of the whole process was the marriage of Adam and Eve. The idea of an "alchemical marriage" was developed in great detail; indeed, the whole cosmos was subjected by the alchemists, as it was by Blake, to sexual symbolism; so that Paracelsus could see "the form and frame of the universal created world" as a vast womb in which the seeds of the sun and moon were carrying on the great work of generation.

The kinship between the alchemists and Blake should begin to be apparent. The four Zoas, who, it must be remembered, are universal principles, parallel the four elements. Zoas and elements alike have fallen into division and decay, yet both alike retain within them a higher principle, an "inner translucence," a "First Matter," by virtue of which they are capable of transmutation. It is by reason of this inner translucence that every particle of matter in both systems is alive and sentient. "Everything that lives," in Blake's well-known phrase, "is holy." It is because of this deathless principle that the Zoas, like the elements, must traverse a cyclic round and, through a process of purifying change, return to their primordial perfection. It is by means of this inner principle, identifiable in Blake's system with Christ, that man is regenerated and transformed, just as the baser metals are transmuted into gold by the philosopher's

stone. Neither the inner translucence nor the First Matter is completely effective until freed, the one from physical, the other from spiritual, dross. To accomplish the liberation of this inner principle is the aim of both physical and spiritual alchemy.

Fire is the great liberating and regenerative agent.

Vulcan [we are told by Basil Valentine] is the master and revealer of all arcana. Whatever the Vulcan of the greater orb leaves crude and perfects not, that in the lesser world must be perfected by a certain other Vulcan, ripening the immature, and cocting the crude by heat, and separating the pure from the impure. . . . For by separation and fire, which perfecteth its vexation, venemosity is taken away, and a change is made of the evil into good.

In Blake's myth this "other Vulcan" is, of course, Los. He, too, is the master and revealer. Blake makes him a smith, but his task is that of the Vulcan who changes evil into good through the vexation of fire. The crucible of the alchemists, the philosophic egg, has its parallel in Los's Mundane Egg, drawn in *Milton* subject to occult fires. Is it pushing analogy too far to see in Golgonooza (Los's fourfold London, the spiritual centre augmenting itself within the Mundane Egg) a parallel to the "fifth element" which the alchemists believed lay at the centre of the yolk and was the source of life?

The process that goes on in Los's furnaces is strikingly similar, in its basic pattern, to the process of alchemy. As gold must be tried seven times in the fire, so is Los equipped with seven furnaces. The alchemist labors with the three principles to which the four elements have been reduced; similarly, Los set up his furnaces when, the eternal unity of the divine body having been destroyed, the four Zoas appear as a triad of head, heart, and loins. In both systems the triad is resolved by means of a sexual struggle between the separated contraries. The idea of a dual and sexual division as a necessary part of the regenerative process is found also in Swedenborg, where it applies, as it does in Blake, to the whole cosmos. In the myth, it will be remembered, when the warring triad (head, heart, and loins) had brought man into an impasse,

> . . . mercy chang'd Death into Sleep
> The Sexes rose to work & weep.

The resolution of this sexual conflict is brought about in Blake, as it is in alchemy, by the immolation of the feminine contrary. In other words, it is by the willingness of the emotions to take upon themselves a self-sacrificial spirit of forgiveness that the spectre of doubt (and the fiction of good and evil which it begets) is laid. Sin as a concept ceases to have significance when it is forgiven. With this change of spirit on the part of the feminine contrary, the way is open for the destruction of the selfhood and the union of the contraries in a new spiritual body. In the Job pictures it is self-sacrifice on the part of the wife that enables Job to bring his triadic and dual selves (the three friends and Job and his wife) into harmonious unity in a glorified body bearing the likeness of Christ. In the *Four Zoas*, Enitharmon's heart-gates have to be broken before Los can enter in and make of the warring and selfish twain an indissoluble Christian one. Thus the wheel of change runs from four to one in both alchemy and Blake.

In addition to these general similarities the myth presents many alchemical details, especially those growing out of an elaboration of the doctrine of contraries. Not only do the four elements change, one into another, but opposites pass into opposites in a great variety of ways. Without this interchange of contraries the Great Work could never be accomplished. Active becomes passive, and passive, active. Bodies become notbodies, and not-bodies, bodies; the fixed must be made volatile, and the volatile, fixed; the highest must become the lowest, and the lowest, the highest. The sulphur, which in natural gold is outward, must be turned inward. The common mercury, which is male, corporeal, and dead, must become female and living. Concealed and manifest, moist and dry, bitter and sweet exchange places. Reversal seems to be a law of the alchemical process. It is likewise a law of Los, Blake's "lord of the furnaces." Man, Blake tells us, must be continually changed into his direct contrary. The Spectre complains that

> . . . Life lives on my
> Consuming, & the Almighty hath made me his Contrary,
> To be all evil, all reversed & for ever dead.

And Los sees "the four points of Albion reversed inwards."

What Blake means has been explained in previous chapters. The feminine and natural world has usurped the place of the masculine and spiritual world. The diverse world without is no longer controlled and unified by the God within; on the contrary, the divinity within has itself been made subject to the passivity and diversity of the world without. The current of existence has been reversed, and with it the functions of the contraries have been interchanged.

The fantastic imagination which played over the alchemical process produced a host of other symbols and images, certain of which may or may not have influenced their counterparts in Blake. The work proceeds with a definite succession of colors, and these, in turn, with a definite succession of animal forms. Black, white, and red are the basic colors, but there are certain transitional stages. The feminine mercury passes from black to white through an intermediate stage in which all the colors assert themselves. The symbol of this stage is the peacock's tail. The appearance of this symbol is a good omen; it means that the fire is doing its work, that death is awakening into life, or, as Paracelsus puts it alchemically, "it showeth the workings of the philosopher's mercury upon the vulgar mercury." Of this particular fact Blake must have been aware, for, although he does not make use of the peacock's tail, he does use the iridescent colors of the serpent to suggest the trial by fire in the furnaces of Los. It is because Albion connects the "serpent of precious stones and gold" with suffering in the furnaces that he feels such contrition when he sees the jeweled serpent dazzling about the hem of Christ's garments.

I behold the Visions of my deadly Sleep of Six Thousand Years
Dazzling around thy skirts like a Serpent of precious stones & gold.
I know it is my Self, O my Divine Creator & Redeemer!

There is a double allusion in this image: first to St. Clement's statement that the high priest's robe is the world of sense, and second, to a passage in the Wisdom of Solomon, in which it is written:

For upon his long high-priestly robe was the whole world pictured,
And the glories of the fathers were upon the graving of the four rows
 of precious stones,
And thy majesty was upon the diadem of his head.

But to Albion the jeweled serpent reveals the long torment of
the furnaces which Christ has had to bear, and for which his
own self-righteousness has been to blame. If this inference needs
more support, it can be supplied by a passage in *Milton* which
specifically says that "the serpent of precious stones and gold"
was formed in "our dark fires."

Fading of the iridescence of the peacock's tail into an all-
inclusive white indicates success. It means that the volatile has
been fixed, and that the white silver, token and promise of the
red gold, has been secured. It means, further, that the feminine
mercury, having been rendered "white and candid as snow,"
has been itself transformed, and can therefore exercise its trans-
forming power. This transformation would seem to mean in
alchemy, as in Blake, that the feminine contrary has been ren-
dered self-sacrificial; hence the appearance of the pelican feed-
ing her brood with her own blood. Equally important is the
white eagle, the spirit of the volatile feminine mercury. The
repeated ascension and descension of the eagle suggests the
repeated rarefaction and condensation of the mercury within
the retort. By this activity the sublimated mercury gradually
transforms the body into soul, the gross into fine. It is of spec-
ulative interest that Blake draws the eagle in the pit, where its
function probably is to lift the natural world into the realm of
the spiritual.

It will already have become apparent, from the simple selec-
tion of elements and aspects of alchemy chosen for the purpose
in hand, that the application of alchemical symbolism to the
spiritual life was inevitable. Had others not made it, Blake him-
self would have done so. However, the transition began as early
as the Reformation, when physical alchemy, after repeated fail-
ure in the laboratories, began to take refuge in the realm of
symbols. In the new spiritual alchemy the alembic is man,
the fires are the fires of spiritual tribulation, the stone is Christ.

There is a hint of the coming change in Paracelsus, but it is Heinrich Kunrath, according to Mr. Waite, who marks the true point of departure. In his *Amphitheatre* the elements of the secret art have been turned into a Christian, kabbalistic and alchemical theosophy. Another alchemical theosophist, the author of the *Water Stone*, works out the analogy between the earthly, or chemical stone, and "the true and heavenly stone, Jesus Christ." He interprets the alchemical process as the conversion of the spirit of the Old Testament into the spirit of the New. The fire is divine fire, the tincture by means of which conversion is accomplished is the blood of Christ. In Boehme there is a sevenfold wheel of change, whose stages roughly correspond to, whether or not they are derived from, the seven stages in alchemy. In the first four of these stages the spirit is shut up in a dark consuming fire, a fire without light, a fire which symbolizes the wrath of God the Father apart from Christ. But in the fifth stage the will of these four undergoes a death; a new will, with its center in the heart, is generated; the light of love shineth in the darkness, and the cycle pursues its regenerated course. Thomas Vaughan united alchemical symbolism with his kabbalistic and Rosicrucian speculations, but was surpassed in this very effort by Robert Fludd, in whose cosmic and kabbalistic alchemy any fact of transmutation, whether physical or spiritual, could be subjected to alchemical imagery and terminology.

Blake's alchemy, like Fludd's, is cosmic. It could hardly be otherwise, since in Blake's philosophy man and God and the universe are one. It has been said of Boehme that he "cast God into the alchemical retort." The logic of Blake's system required him to do no less. The fire which lights the furnaces of Los is the occult world fire, operative in both the universe and man. It is called both vegetable and mental. It is vegetable because it consumes the mortal and the erroneous; truth is eternal and withstands the flame. It is mental because of the mental anguish resulting from the falsities by which man lives. The two fires are not really distinguishable except in function. They

are at once destructive and regenerative. They destroy error, they refine truth. *A Vision of the Last Judgment* says of the two beings who represent vegetable fires that they strip Mystery "naked and burn her with fire; it represents the eternal consummation of vegetable life and death with its lusts. The wreathed torches in their hands represent eternal fire which is the fire of generation or vegetation; it is an eternal consummation." The process which is continually going forward in these fires has the same goal as all Christian alchemy—the conversion of the spirit of the Old Testament into the spirit of the New, of vengeance into forgiveness, fire into light, Satan into Christ. The fires will burn for the length of Time, for mankind and the whole temporal world are in them. When they have done their work, the temporal will be restored to the eternal, man to Christ.

In one or two respects, which are very important, the sources of Blake's fire imagery go beyond the confines of alchemy. Blake's conception of fire would seem to unite the ancient tradition which makes fire the substance of mind, with that of Jacob Boehme, who saw in it the dark, wrathful first principle. The fusion is accomplished by making light, which Boehme called an emanation of the wrathful fire, the unfallen mind. When the mind falls, it slips back into its dark fire-source— the world of experience in which ignorance and passion are compelling forces. The regression is described in various ways, but with reasonable consistency as to basic meaning. In the *Four Zoas* we are told that when Luvah stole Urizen's light it became a "consuming fire." In the Job pictures, when Job sinks into selfhood and loses sight of the true God, his mental state is imaged in the fire "fallen from heaven." In the *Book of Urizen*, when Urizen becomes a "self-contemplating shadow," the "flames of eternal fury" run over the heavens "in whirlwinds and cataracts of blood." In all of these instances the hell of bitter experience is in the process of formation. According to the *Book of Urizen*, there is no light from these wrathful fires, for Blake follows a tradition of which we read in Her-

rick's *Noble Numbers,* a tradition supported by Dante and St. Thomas Aquinas:

> The fire of hell this strange condition hath
> To burn, not shine, (as learned Basil saith).

But fire does not mark the depth of the decline. So long as there is fire, there is destruction and renewal, and out of these there is always the possibility of regeneration and the return of the light of heaven. The danger is that the restless energy of fire may subside, even into ice. A cold and selfish world, without the principle of change, is the goal of Urizen's endeavor.

The fire force which prevents this eventuality is personified in Orc, the temporal form of Luvah. Orc, it will be remembered, is the child of Los and Enitharmon. Under the repression of a religion of rationalism, such as the unregenerate Los creates, the emotions become a dark and tormenting fire with both the will and the power to destroy the forces which harass them. Luvah appears in the fiery form of Orc. With his birth the Generative world begins—the Generative world out of which regeneration is to come. Without the terrible strength of his consuming passions it is hard to see how the error which Los "creates" would ever meet the destruction for which it is shaped. Every time a religion, a philosophy, or a created form of any sort is demolished, human passion, as symbolized by Orc, provides the destructive power. Even as the tamed Satan in the Tree, he provides the spark by which Vala consumes her "harlot robes" of Mystery. When he is freed, the world knows the sweeping renovation of a Last Judgment.

As the principle of revolt in the fallen world, Orc is the "evil" of the orthodox, struggling against the passivity and the negation they would impose. He is antichrist, he is revolution, he is anarchy and chaos. This is his obvious significance, but he is more than this. In him is all the anguish of self-righteous man in a struggle with his own self-righteousness. His is the torment of man who believes himself a sinner and his God a principle of wrath against which he revolts, only to see himself in his revolt as a blasphemer against his God. He

is that something in man which endures the torment, the cause of which it cannot define because it is hidden deep within himself.

Los's regenerative fires are lighted and his cosmic alchemy really begins with the establishment of the mortal world which is to be the instrument of regeneration. This world arises, as we know, out of the ruins of the Mundane Shell. Up to that time the progress of the Fall might be looked upon as providing the raw material for the process. In Beulah the four eternal elements (the Zoas) become three—head, heart, and loins. Tharmas, the fourth Zoa, the united body made possible by a believing head, a forgiving heart, and energetic loins, is temporarily lost. In the mortal world head, heart, and loins become the three principles of the alchemists. Each falls into its opposite, the head becoming skeptical, the heart cruel, the loins chaste. Together they constitute the triple Elohim, the creator of the mortal and natural world. Unlike Jehovah, who personifies a gentler ethics, the Elohim is a cruel God, the equivalent of Boehme's God out of Christ. In the natural world which the Elohim creates man shrinks into a "mortal worm." The condition would be one of eternal death except that a way out is provided. The mortal worm is "translucent all within," and the Elohim was ordained, as Fludd says, "to indue the darkness" occasioned by God's withdrawal. Thus in man and nature the material for the philosophic fire is provided—a spiritually dead body with the seeds of regeneration within it.

The regenerative principle asleep within the dead body is Los, the imagination. It is the one faculty which would never accept the situation permanently, whose restless energy would seek and find release. But, like the adept in spiritual alchemy, Los can have no success until he has himself been regenerated. At the outset he lives and acts under the shadow of Urizen. After all, the prophets were for many generations not so different from the priests, though the two lines were destined to separation. When Los does at last become regenerate, saying,

> . . . I will quell my fury & teach
> Peace to the soul of dark revenge, & repentance to Cruelty,

he goes about his task with amazing energy and patience. This is the rôle we see him playing in *Jerusalem*.

> Loud roar my Furnaces, and loud my hammer is heard:
> I labour day and night.

Los handles the purification of the contraries in the furnaces in accordance with alchemical tradition. As in alchemy the imperfect triple body (salt, sulphur, and mercury) has to be broken, and the masculine sulphur and the feminine mercury freed for purification in the fire, that they may be united in the one only essence, so must sinful man, his doubting head and cruel heart selfishly combined into a mortal body, be subjected to trial by fire, that his divided selves may be reunited in the one man Christ. But, though man himself is metaphorically the sum of all that is in the furnaces, the forms (or bodies) which Los continually breaks down should be thought of as forms of government, of religion, of what you will—forms constructed by a crafty head and a cruel heart. The intellectual life (the theory, the dogma) of these forms must be broken down in order that the chastened emotions may be set free for a new fixation under the guidance of a liberated intelligence. In alchemical parlance, two must be drawn out of three and separately purged before the transforming union can take place.

> Los with his mace of iron
> Walks round: loud his threats; loud his blows fall
> On the rocky Spectres, as the Potter breaks the potsherds,
> Dashing in pieces Self-righteousness, driving them from Albion's
> Cliffs, dividing them into Male & Female forms in his Furnaces
> And on his Anvils: lest they destroy the Feminine Affections,
> They are broken. Loud howl the Spectres in his iron Furnace.

Like the alchemists, Los meets with continual failure. One form—some form of government, let us say—no sooner breaks down in the fires of experience and on the anvil of the prophetic imagination, than another form conceived in craft and selfishness takes its place. The serpent round of error continually renews itself. Los's efforts are coextensive with mortal life.

In *Jerusalem* Los's long labors at the furnaces come to a triumphant conclusion.

> For lo! the Night of Death is past and the Eternal Day
> Appears upon our Hills.

Albion awakens from his cold sleep upon the Rock. He recognizes Christ as the "universal humanity"—seeing in him also the "likeness and similitude of Los." The two converse together "as man with man." Albion sees that his own selfhood has been the cause of his "deadly sleep of six thousand years." Repentant, he

> . . . threw himself into the Furnaces of affliction.
> All was a Vision, all a Dream; the Furnaces became
> Fountains of Living Waters flowing from the Humanity Divine.

The "living waters" will be immediately recognized by all who are familiar with alchemical theory and symbols. The mercury of the sages is a supernal water. The stone is a "water stone." Even the fire (the sulphur) is water or an element that combines into a single essence with the water principle. "Of this fire," says Philalethes, "a sage might well say: 'Behold, the fire which I will show you is water.'" In Boehme there is a fire principle and a light principle (corresponding to Father and Son) which combine when the wrathful fire passes into light through regeneration in the "sweet water in the heart." A fire which is transformed into the water of life is, indeed, a commonplace among the spiritual alchemists. Bernard of Trevisa writes of a "clear pellucid fountain, in which our king is cleansed and strengthened to overcome all his foes." One tract has the very phrase, "a fountain of living water."

The vegetation which the vegetable fires continually consume has for its symbol in Blake, as in alchemy, the serpent or dragon. The serpent in alchemy represents the material to be transformed, nature raw and crude, capable of transformation, but as yet untouched by any transforming principle. Often there are two serpents, or the dragon is double headed, indicating the eternal masculine and feminine of which nature is composed. One serpent is winged, the other wingless. The wingless

serpent is the sulphur, the masculine, the fixed; the winged one is the mercury, the feminine, the volatile. Very similarly, the serpent is the symbol of Blake's natural or Generative world, the world in which Los's regenerative labors take place. It stands at once for the "serpent bulk of nature's dross" and the "serpent reasonings" which build upon it the edifice of Natural Religion. Nature and Natural Religion are the error by which man fell and because of which he suffers and will suffer until he breaks the serpent round and passes, as by a saving gnosis, to a higher level. This is the serpent by which, in the painting entitled "The Elohim Creating Adam," Adam is entwined, as he lies prone upon a serpentine and natural world floating upon the abyss, with, however, the redemptive promise of the rainbow in the background. This is also the serpent by which the triad of falling figures is encircled in one of the illustrations to the *Book of Urizen*. In short, the serpent is the image of the infinite considered as finite. Blake's statement is explicit: "Thought changed the infinite to a serpent." The remains of ancient serpent temples discovered by eighteenth-century antiquarians were factual and symbolic evidence of the error:

> Then was the serpent temple form'd, image of infinite
> Shut up in finite revolutions.

The process of changing the infinite to a serpent began as soon as man, surveying the contraries with a misguided pity, took to "weeping over the web of life." As a result Enion sank into matter, and the Circle of Destiny was set in motion. Incidentally the twin serpents also appear in Blake. In the *Laocoön* they appear as Good and Evil. That is doubtless also their significance in the fourteenth illustration of Job, where, with the masculine and feminine contraries united under a kindly Jehovah, Vala finds the twin serpents a manageable pair.

It has become evident already that the serpent symbol, like the fire symbol, reaches beyond the confines of alchemy. Basically, the fire is undoubtedly alchemical. Undoubtedly the serpent has an alchemical significance, but one would hardly say

THE ELOHIM CREATING ADAM

that it is basic. Certain other aspects of Blake's serpent symbolism derive from other sources. Like so many symbols in the Blakean tradition, the serpent has a double meaning, based in this instance on the nature of the serpent itself. For while, on the one hand, it is a poisonous creature crawling upon its belly and eating (supposedly) the dust, it has, on the other hand, in its capacity to cast its skin and (supposedly) to renew its youth the secret of rejuvenation and immortality. These two aspects of the most mysterious of all creatures have long fascinated the minds of men looking to nature for revelations of the divine mind. In the one aspect it has been seen as the humid principle, mere matter; in the other, as the principle or symbol of redemption. If the serpent has been the primal serpent which deceived the whole world, it has also been, notably among certain Gnostic sects, the Logos, the Saviour. In the same way it has been in one rôle a separator, coming between two elements or principles which should be one, as between Adam and Eve in the Garden of Eden, or between Luvah and Vala in the *Four Zoas*, and in another a bond of union, a sexual union between man and God. The sexual significance is, indeed, omnipresent, and this too, in a dual form; for the serpent has been at once the symbol of sexual generation and of mystical rebirth. In this dual capacity the serpent appears in Blake; for though the serpent is the symbol of error, it is by the experience of error that man is redeemed. In the Job series Job's vision of the serpentine Satan whom he has served opens the way for his redemption. One of the marginal comments upon this illustration says: "Satan himself is transformed into an Angel of Light, and his Ministers into Ministers of Righteousness." In this conception the whole process of spiritual alchemy is summed up.

The Return (Regeneration)

*. . . A World of Generation continually Creating out of
The Hermaphroditic Satanic World of rocky destiny.*
<div align="right">Jerusalem, p. 58.</div>

*Every scatter'd Atom
Of Human Intellect now is flocking to the sound of the Trumpet.
All the Wisdom which was hidden in caves & dens from ancient
Time is now sought out from Animal & Vegetable & Mineral.*
<div align="right">Milton, p. 25.</div>

*All mortal things made permanent, that they may be put off
Time after time.*
<div align="right">Four Zoas, Night VIII.</div>

IT GOES without saying that regeneration must be in terms
of unification. The severed Spectre and Emanation must unite
as one. Man's discordant masculine and feminine selves must
end their strife, and the female return to her original life of
self-annihilation. "Sexes" must cease to be. The warring Zoas
who, as abstractions, became Gods with dominion over man,
must once more take their places in Albion's bosom, servants
to the only God, the Divine Humanity. All distinctions between
Albion and his universe must disappear. Man must come to
see that "everything that lives is holy." The awakening Albion
of Blake's myth

> . . . looks out in tree & herb & fish & bird & beast,
> Collecting up the scatter'd portions of his immortal body.

The giant androgyne is being re-assembled.

In Blake's symbolism the sexual garments are exchanged for
the human; the mortal disappears in the immortal, the natural
in the spiritual, the corruptible in the incorruptible; fire is
changed into light, night into day, and winter into spring. In
language divested of imagery, Blake's regenerated world substi-

tutes faith for doubt, and gives inspiration and intuition authority over reason and the witness of the senses. With this reliance upon an immediate vision of truth, belief in a material reality disappears. Man no longer believes in good and evil, having come to know that "nothing is displeasing to God but unbelief and eating of the tree of knowledge of good and evil." Because of this recovered knowledge moral justice no longer prevails. The Divine Vision, the law of brotherhood, replaces the individual law of the dark religions, and "sweet science reigns."

In short, in Blake's regenerated world we have the familiar return of the mystic to a lost paradisiacal state. Such a return implies the birth of the Son of God in the soul. This rebirth is imaged in the Job pictures by Job's appearance in the likeness of Christ. Albion's regeneration necessitates a similar change, but with the universal liberation which the wider symbol signifies, the cosmos is also freed from the vanity laid upon it.

Before liberation can take place, the hidden Satan who wrought Albion's downfall and made regeneration necessary must be disclosed. Borrowing his imagery from St. Paul, Blake writes that "Albion must sleep the sleep of death, till the man of sin and repentance be revealed." This man of sin and repentance, who is at the same time Satan, is of course, man's self-righteous pride in his own holiness. As we discovered in Blake's account of the Fall, that holiness expresses itself in a selfish and rational exploitation of pity and love, virtues which ought to be unselfish and imaginative.

The exposure of this hidden holiness (the selfhood of pity and love) is made by Christ (the selfless love), who appears in mortal life, and in biblical imagery rends the veil before the inner tabernacle and draws aside the curtains of the ark. Christ appears in Blake's myth when Los is himself regenerated and prophetic activity becomes definitely Christian. He is Blake's symbol of the renewed spirituality of that time. The function of Old Testament experience is, therefore, to bring Christianity (the Christ) into being; the function of Christian experience

is to tear away the veil of obscurity which shrouds the hidden holiness.

The exposure of the hidden holiness in Albion is a work of centuries. Rahab (the fallen Vala) "sat deep within him hid, his feminine power unrevealed." Moreover, the world is loath to believe love a transgressor, as Blake discovered when he tried to fix the responsibility for spiritual failure. In *Milton* he answers those who believe that "pity and love are too venerable for the imputation of guilt" with what must have been to him irrefutable proof: "I am inspired! I know it is truth!"

The process which brings into being the Christ who is to reveal the selfhood is Blake's world of experience. His own cup of wisdom had been filled at that bitter well. "I have indeed fought through a hell of terror and horrors (which none could know but myself) in a divided existence; now no longer divided nor at war with myself, I shall travel on in the strength of the Lord God, as poor Pilgrim says." Struggling with his artistic problems, Blake had come to the conclusion that no man can know true art until he has experienced and cast out false art. Albion's peace is as dearly bought. Mankind and the individual arrive at their regeneration by the same path. "To be an error and to be cast out is a part of God's design."

If Blake could trust the sages whom he read, he was justified in this conclusion. Plotinus had written that the soul which had abandoned its proper status could always "recover itself by turning to account the experience of what it has seen and suffered here, learning, so, the greatness of rest in the Supreme, and more clearly discerning the finer things by comparison with what is almost their direct antithesis. Where the faculty is incapable of knowing without contact, the experience of evil brings the clearer perception of good." If Blake did not read this particular passage in Plotinus, it is certain that he read to this effect in one author or another, for this is a well-known paradox. Any virtue, it is said, comes into clearer consciousness by knowing and rejecting its antithesis. Truth is regained and reaffirmed by the experience and rejection of error.

The error to be experienced and rejected may be summed up as the consequences of self-righteousness.

> And he who makes his law a curse
> By his own law shall surely die

is the principle of the Generative world. Luvah, in whom the self-righteous will is first made manifest, is bidden, as he enters upon his tribulation in the furnaces, to "learn what 'tis to absorb the man." Job, whose charity has been a matter of pride, falls a victim to the devastating pity of his three friends. With Albion the process is the same. Having unknowingly set up Satan as his God, he must suffer under Satan that he may return to Christ. Because of his comprehensive character, the tribulations he suffers under Satan are cosmic in scope. They reflect the consequences of self-righteousness both to man and his universe.

It is difficult to sum up these consequences concisely. In so far as it is possible to do so in a single phrase, they may be said to be the externalization of both God and the universe. In his pride in his emotional life, Albion makes of pity an abstract ideal, and presently comes to think of the God who dwells in his own breast as hidden and remote. Having looked to nature (once the cosmic body) as the source of the virtue in which he prides himself, he comes to see in it a material reality. What was within has come to be seen without. Having lost his God and his cosmic body, both of which were once part of him, Albion appears as "a little grovelling root outside of himself." This picturesque image is derived from Porphyry, who thus described man cut off from "existence" by thought. The image merges in Blake's mind with the sexual mandrake root to provide a satiric description of the natural man. In this shrunken spiritual state Albion suffers under a remote (and fictitious) God who exacts vengeance for sin, and knows the despair of the mortal in a material world.

The course of experience, which is at once the course of error and the process by which Satan is revealed and regeneration accomplished, is in the hands of Los and Enitharmon.

Feeble as their light may be, selfish and misguided as their purposes often are, they nevertheless embody the instinct for perfection which the Poetic Genius—the imagination—can never entirely lose, and which enables man slowly yet surely to turn the experience of error into the apprehension of truth. Theirs is the faculty by which man walks through fires and yet is unconsumed, the faculty by which he will contrive, late or soon, to banish the "war of swords" and "form the golden armour of science for intellectual war." The changing world which they create—the world of experience—is at the same time a world of "demonstrative science." It begins with the Flood, and has as its first great act of "demonstration" the binding of Urizen—the commitment of him to a belief in a finite and temporal world. Having doubted his eternal universe, Urizen must be bound to the limitations of the finite and the temporal that he may experience the consequences of his unbelief. Likewise Luvah, who tempted the world with the siren Good, must appear to the postdiluvian world as Orc, the antichrist, that he may know the pain of Evil. With these portentous embodiments of error the temporal and material world begins, and it will continue to give to error a "created" and transitory form, to be experienced and cast off time after time, until the experience of temporal error reveals the lineaments of eternal truth. In a striking image Blake sees the temporal world as "a cradle for the erred wandering phantom," whose destiny it is to grow into a "human," that is to say, a Christ-like, form.

The ability of Los to make the illusions of the finite world contribute to redemption resides partly in his function as Time. Blake's conception of time has so much in common with Plotinus's, that it is difficult to believe that he did not draw upon that source, directly or through Thomas Taylor. Plotinus describes time as attendant upon the "external life" of the Universal Soul, and as the "activity of an eternal soul . . . exercised in creation or generation." It arose when nature, "wishing to become its own mistress and to enlarge the sphere of its activities, put itself and time together with itself, into motion." Los's world of "creation" or "Generation," which is also a

temporal and external world, arose with a similar determination on the part of nature. But the Plotinian conception is profoundly modified by the idea of a cosmic fall and of time as the medium of restoration. This idea of time as a redemptive agent might have been supplied by Erigena, who defined time as "the motion of things in generation, which pass out of non-existence into existence." In this assertion there is Blakean terminology as well as Blakean idea. Los's world of Generation is the world in which things pass from nonexistence (the world of eternal death) into existence (the world of eternal life).

> Time is the mercy of Eternity; without Time's swiftness,
> Which is the swiftest of all things, all were eternal torment.

The power of Los's temporal world to effect the change from eternal death to eternal life lies in its mortal forms. In the destruction of these forms by the restless energy of time lies man's hope of release from error. "All that can be annihilated must be annihilated." The eternal will live on. For that reason error must be provided with a mortal body capable of destruction by the energy of time. Blake expresses the idea dramatically in *Milton*. There the poet who has returned to repudiate his Satanic teaching is seen in mercy putting clay upon the dry bones of Urizen. Obviously these dead bones can live again only by first becoming mortal.

It is from her capacity to give to death a mortal body for destruction that Enitharmon, who is Space, in correspondence to Los, who is Time, shares in the redemptive process. As Space she represents that contraction of the infinite which is the outer parallel of diminished vision. In her capacity for contraction she makes possible the division of infinite error and its formulation in mortal form. She makes possible the Herculean efforts of Los:

> . . . Circumscribing & Circumcising the excrementitious
> Husk & Covering, into Vacuum evaporating, revealing the lineaments of Man,
> Driving outward the Body of Death in an Eternal Death & Resurrection.

Without Enitharmon's capacity to give finite form to the infinite, the indefinite would never be resolved into the definite, the nonexistent would never become existent. The restless energy of Los would spend itself in futile endeavor.

The kind of space under which man at any period lives is in direct relation to the degree of selfhood in the prophetic vision. When prophetic activities finally become selfless, "spaces" appear as merciful circumscriptions of the infinite, illusions of a finite reality created for temporary needs. Such "spaces" disappear as insight increases. In contrast to the space which passes because it is the creation of unselfish imagination, we have the "Satanic space" which strives to seem infinite in order that the illusion it provides may remain. In moral justice taken for the word of God, in nature seen as a material reality, in any social order acclaimed as permanent, we have illustrations of man's slavery to Satanic "space." Such spaces are the result of Urizen's attempts toward a static world.

It is evident, therefore, that Los and Enitharmon must themselves be regenerated before their efforts can reach a successful culmination. Theirs must be the self-sacrificial spirit. Lacking that spirit, they will labor (consciously or not) to preserve the situations of most advantage to themselves. Their spaces will be, to some degree, "Satanic." The Christian centuries are not ushered in until Los undergoes a spiritual change. The conclusion is inescapable that the conversion of the spirit of wrath into the spirit of forgiveness is delayed by the prophets' pride in their own denunciation of sin and by their own love of power. Before man can become Christ, the spirit of Christ must appear in the prophet who points the way.

As the arbiter of the world of experience, the creator of its finite and changing forms, Los is lord of the furnaces, which together constitute the cycle of experience through which man passes in the interim between Eternity and Eternity. These are the "furnaces of affliction" in which man is tempered and refined, and out of which, after the purifying process, he is to be delivered, even as the Israelites were delivered out of the iron furnace of Egypt. The condition of deliverance is revealed in

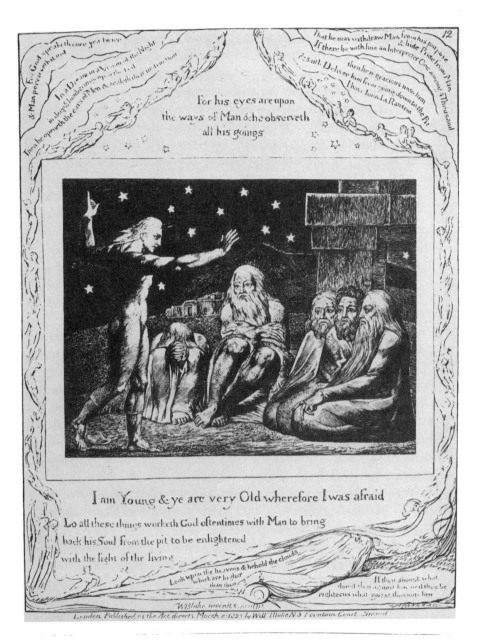

ILLUSTRATIONS OF THE BOOK OF JOB, PLATE XII

equivalent of Swedenborg's natural world, fixes the "spirit of evil in things heavenly" to which man succumbed when he lost Paradise, following the serpent. The sum of these fixations is the world of Generation, whose function is to serve regeneration. The end of creation, in Blake as in Swedenborg, is the return of all things to the Creator. It is for this end that Los is continually

Fixing their Systems permanent, by mathematic power
Giving a body to Falsehood that it may be cast off forever,
With Demonstrative Science piercing Apollyon with his own bow.

It is because Los labors to give falsehood a body to be cast off that his created world is of necessity a mortal world. The end of Los's systems is freedom from all systems. For that reason destruction is as important as creation. Both processes are necessarily continuous, for error, like the vegetable world which is its symbol, has power constantly to renew. Blake tells us that the Spectre must be continually created in the cruelties of the moral law, that he must pass from selfhood to selfhood. The spiritual creations of Los, like their vegetable counterparts in nature, are "continually building, continually destroying." Death is an important factor in either case—a continual destruction of the old that there may be a continual birth of the new.

The continual destruction and renewal of error which characterizes the Creation is further exemplified in the sexual symbolism. The systems which Los creates for demonstrative purposes are hermaphroditic—sterile spiritual forms. They are hermaphroditic of necessity, because they are projections of a doubting mind dominated by selfish emotions. They cannot serve the purpose for which they were intended. Consequently they must continually be broken upon Los's anvil that in the end a world of Generation may be created from a world of death. Los's creative labors reach fulfillment when the "generative" body capable of giving birth to Christ replaces the sterile hermaphroditic body. In short, man in his struggle toward enlightenment must shape and destroy in unending succession until he can build without thought of self.

The fruitful generative body which Los creates is the Christian Church. Since it rests upon the hypothesis of good and evil, it too is a body of error, but it differs from the hermaphroditic form which preceded it in its forgiving spirit. This appearance of the spirit of selflessness within a Satanic system is the equivalent of Christ's assumption of the body of death. This body of death is the whole structure reared upon the selfhood. It is the twenty-seven heavens, the multiple forms of the dragon Orc, the "sexual" religion which the prophets shape.

By reason of the spirit of Christ within it, the body of death becomes a mortal body. Christ takes it on to "put it off on the cross and tomb." Having assumed it, he gives it to be cut off that man may rise again. The necessary mortal link between eternal death and eternal life has been provided. Had the spirit of Christ not appeared within the Satanic system, there would have been no way to put it off. The succession of hermaphroditic forms must have continued endlessly.

Blake may well have had in mind St. Paul's doctrine of the transitoriness of the law. Certainly he seems to say that in its acceptance of the Judaic law as Christian tradition, Christianity (the spirit of Christ) takes upon itself the body of death. Knowing, however, that "where the spirit of the Lord is, there is liberty," the Christian spirit looks upon the "ministrations of death written and engraven on stones" as a glory which is passing away. The body of death is but for a time. This attitude is in striking contrast to that of the Pharisees. For them the law is unchanging, the inviolable will of God who has elected Israel over all the peoples of the earth.

This identification of the body of death with the moral law stresses the ethical significance of mortality. Actually, however, this body is fourfold, as man is. It has been described in the body which Milton comes back to put off. He hopes by doing so to annihilate rational demonstration as a substitute for faith, memory as a substitute for imagination, and idiot questioning as a substitute for knowledge. All these are comprehended in the body of death. In its widest implications the body of

death is the natural world. When it is finally put off, the natural world is replaced by the eternal.

We have already seen that in the ethical world the assumption of the body of death by Christ waits upon a change in the emotional life. Enitharmon must be made amenable to Los's purpose before he can succeed in his creative efforts. This is the equivalent of saying that vision must remain unproductive until man has the will for reformation. He can follow the intellectual vision only so far as his emotions let him. This necessary change in the emotional life is suggested in the *Four Zoas* by the breaking of "the obdurate heart" of Enitharmon. When her heart has been broken, when the spirit of vengeance has been replaced by pity, Enitharmon becomes for the first time in mortal history the willing ally of Los. He may therefore bring his creative labors to a fruitful conclusion; prophetic aim and prophetic accomplishment become one.

> For Los could enter into Enitharmon's bosom & explore
> Its intricate Labyrinths, now the Obdurate heart was broken.

II

The process by which the will is inclined to spiritual ends constitutes Redemption, the second great division of Los's labors. Redemption is inseparable from Creation and goes on with it. It has as its purpose the restoration of the contraries to their proper relationship by the purification of the feminine. To this end the contraries must first be separated. Los's postdiluvian world is dual and sexual. In it the triad head, heart, and loins engages in a sexual struggle. As with the alchemists, three are made two. This means that the cosmos, which Enion made to appear as Nature, is now to be seen as spirit and matter; that the sexless man of Eden, having become the hermaphrodite, is now separated into the sexual man of generation; that the emotional life, having asserted a natural good, must now be looked upon as good and evil.

For centuries this separation into male and female had been considered as necessary by theologians who pondered upon God's reason for taking Eve out of Adam's side. The *Kabbalah*

Denudata tells us that the Deity conformed himself as male and female that the Son might be born; without that conformation the universe could not have existed, but must have remained formless and void. Swedenborg's explanation is similar. When the will became corrupt, the intellect became corrupt also. In this state of agreement between the intellect and the will (Swedenborg's masculine and feminine principles) the will could not be renovated. For that reason God arranged that the two principles should be separated, that renovation might take place. Blake's thought is essentially the same.

But when Man sleeps in Beulah, the Saviour in mercy takes
Contraction's Limit [Adam], and of the Limit he forms Woman,
 That
Himself may in process of time be born Man to redeem.

The struggle between the masculine and feminine contraries —the struggle between mind and emotions, between reason and sense, between Spectre and Emanation, between the inner and the outer in every sense—constitutes a trial by fire, a spiritual purgation. In Blake's fires, as in the fires of alchemy, the feminine contrary is purified first. If man fell by woman, it is by woman that he is redeemed. The feminine emotions, driven to desperation by the increasing severity of the rational mind, turn from vengeance to forgiveness in their own defense. In the *Four Zoas* Enitharmon's change of heart seems to be brought about by the sufferings of the bound Orc and her own fear of a God of Mystery. Likewise the terror which Eliphaz's cruel God awakens in Job's wife inspires Job's vision of his own Satanic God, and leads to his spiritual rebirth. In both cases the emotions have been driven by the doubting rational mind into such narrow and cruel forms, such perversions of their true nature, that a sudden conversion is induced. Blake's dictum that "fear and hope are vision" is sustained by his allegory. Worn out by strife, and in fear of annihilation, the feminine contrary relinquishes her "female will," forsakes the Spectre, and shows herself once more willingly subservient to the higher or "human" masculine. Made to partake of the wine of anguish, that which had been cruel becomes merciful. Redeemed from error's

power, the female unites herself again with her masculine contrary. As Blake puts it, the female "is made receptive of generation through mercy in the potter's furnace." The sterile feminine world is made spiritually productive. Christ is born in Vala's woven mantle.

Such then is the redemptive process. By means of it the emotional life (the feminine contrary) is made self-sacrificing and the original relationship of the contraries is restored. In its widest application the union of the contraries means the removal of all antagonism between the world of manifestation and the world of spirit. In a narrower sense it means that the mind and the emotions are again united in the service of man. Eventually the contraries must be united in all classes of men as, with the breaking of Enitharmon's heart, they are united in the Poetic Genius. This is the consummation Blake has in view when he sees in Generation the "image of regeneration."

The manner in which the regenerated emotions serve the inner spirit is seen in the weaving of Enitharmon. Once her heart has been broken and enlightenment has come in, she sets up the looms of Cathedron and weaves for the Spectre the spiritual clothing which Los desires. It was noted in an earlier chapter that in his doubting quest the Spectre is said to be disembodied. Under the restraint of the moral law he possesses a sterile, hermaphroditic body. By Enitharmon's weaving he is provided with a body of "vegetation." This is the generative body, capable of giving birth; it is also the mortal body put off at the resurrection. We may infer, therefore, that Enitharmon is here weaving religious forms in which the Spectre may find rest after his spiritual nonexistence, but which he will later put off in a spiritual rebirth.

In the *Four Zoas* the weaving of Enitharmon is concentrated at a single point, the time of the birth of Christ. Since the birth of Christ in personal form is nowhere mentioned in this work, he would seem to be the increased spiritual insight of the early Christian era as symbolized by the new activities of Los and the weaving of Enitharmon. Before Enitharmon can weave the new forms, Los has first to "modulate his fires," he has

first to temper his wrath to the new ideal of mercy. He has then to draw "the immortal lines upon the heavens," in short, to restore the Divine Vision which has been lost.

The "bodies" which Enitharmon weaves for the disembodied Spectres at this point are suggested by the Pauline division of mankind into Elect, Redeemed, and Reprobate. Incidentally this classification affords a vision of the whole regenerative process, for it is for these three classes that Creation, Redemption, and Judgment are devised. Since Blake put his own interpretation upon this classification, he was able to see in it a provision for the spiritual peace of mankind. Man, who has been tortured by a conception of sin, is to be freed from his burden by the weaving of Enitharmon. The self-righteous are permitted to think of themselves as the Elect; the Redeemed, who have been hounded into unbelief by the Elect, are given freedom from their fears by vicarious atonement, the gift of the Reprobate. The reprobate rôle goes to the Christ himself—to all those who, in a doubting world, have never ceased to believe or to give themselves willingly for others, at whatever cost. Christ in "Luvah's robes of blood" moves across the pages of the prophetic books, a striking witness to the violence done to the Divine Vision by six thousand years of strife. In the persons of the Reprobates of all ages he has suffered a continual crucifixion that the Elect and the Redeemed might find peace. As Blake phrases it, Christ put on Luvah's robes of blood "lest the state called Luvah should cease."

The Christian spirit which animates Enitharmon, once her heart has been broken, is suggested by the description of her weaving. The spiritual forms which the disembodied Spectres put on are woven from emotions made tenuous and pliable in the furnaces of Los. These emotional fibers are drawn from Enitharmon's bowels, an obvious reference to the bowels of compassion. The Daughters of Albion, whose labors are in opposition to those of Enitharmon in her enlightened moments —for she, too, can sink to their level—also spin from their bowels, but far different clothing. Seeking first to unravel from the Spectres the clothing which Enitharmon has woven, they

weave it anew in "forms of dark death and despair." Out of them proceeds the web of death in opposition to the web of life which Enitharmon weaves. The material for Enitharmon's web is perfected in the furnaces of Los; that of the Daughters of Albion is cut from the rock, a reference to the hard, materializing influence of the rational intellect. The one has its fibres deep in the experiences of life; the other in a cold rationalization which is at best but a fear of life. In the distinction between the weaving of Enitharmon and that of the Daughters of Albion we see the importance of the furnaces and the sexual separation. Not until man has been tried by fire is he willing to build out of mercy. Not until he builds out of mercy will he give his "body," that is, his mortal systems, to be destroyed that man may live again. This is the mortal and generative body toward which Los strives.

Though the burden of regeneration is placed upon Los and Enitharmon, the pivotal figure of the scheme is Christ. He is the only God, the divine humanity, the existence itself. When man lives by Urizen's "beast-formed science" he is in nonexistence. The change from nonexistence to existence—the change from Satan to Christ—is accomplished when Enitharmon out of pity weaves the generative body of Christianity for the Spectre. In doing so both she and Los comprehend that the peace of mankind is to be achieved by their own extinction. The prophetic race which preached the wrath of God will come to an end. The Christ, as seen in their self-sacrificial pity, has been achieved. Nonexistence has been exchanged for existence. The sexual world has become a generative world, and so a mortal world which passes out of existence that man may become immortal. Clothed in the habiliments of the Elect, the Redeemed, and the Reprobate, the newly "created" cross the Arnon and pass out of Moab into Canaan, out of the kingdoms of Satan into the kingdom of Christ. Albion begins to awaken upon his couch.

The image of the Arnon is drawn from the twenty-first chapter of the Book of Numbers, wherein the river Arnon and the Red Sea are associated: "Wherefor it is said in the book of the

Wars of the Lord, what he did in the Red Sea, and in the brooks of Arnon." Now in Gnostic mythology the Red Sea is the means of escape from the body (spiritual death) which is Egypt. The Arnon in Blake's myth has the same significance; it is meant to suggest the passage from the body of death (the law) into the generative body (Christianity), by which man lives again.

The importance of Enitharmon's weaving is emphasized by its association with the "fixing" of the limits, Adam and Satan, which had been named, apparently as objectives, when Los laid the foundations of his spiritual city of Golgonooza and began his regenerative labors. The "fixing" of the limits would seem to mark the success of Los's endeavor. They are presented as limits set to the Fall, a level beneath which the divine hand will not let man go. In Adam, the limit of contraction, we have the extreme degree of recession from the thought of all things as one, the giant Albion. In Satan, the limit of opacity, we have the degree to which Albion's inner translucence (the Christ within him) has been obscured. The one limit implies the other. You cannot have Satan without shrinking the infinite universe to the stature of the individual, the me—without making of the immortal and sexless Albion the mortal and sexual Adam.

In his association of the limits with the weaving of Enitharmon, Blake would seem to be combining the "fixation" of the alchemists with the Gnostic doctrine that Christ in his incarnation took upon himself all mankind. The Christian assumption of the Elect, the Redeemed, and the Reprobate is similarly inclusive. The important thing, from the standpoint of the limits, is that in accepting this classification of mankind Christ took upon himself both Satan and Adam. As the historical Christ took upon himself mortality when he appeared in bodily form, so does the spirit of Christianity take upon itself mortality when it accepts the body of the Elect, the Redeemed, and the Reprobate which Enitharmon has woven. Satan is in this classification as well as Christ, for it rests upon the selfhood and tacitly accepts the mistaken hypothesis of good and evil. For this reason Christ is said to have been born in "Mystery's woven mantle," a garment of Babylon. For Blake,

to whom virginity stood for a restrictive ethics, the fact is appropriately symbolized by the virgin birth.

This acceptance of the structure built by the selfhood is not, however, a surrender to Babylon. Satan and Adam have not been "fixed," Christ has not taken on the body of death, to make permanent the limitations of fallen man. The sexual religion will not permanently replace the Divine Vision. Such an hypothesis is the assumption of the unbeliever.

> Voltaire insinuates that these Limits are the cruel work of God,
> Mocking the Remover of Limits & the Resurrection of the Dead.

On the contrary the limits, like other fixations under Los's hammer, have as their ultimate end the removal of all limitations. Christ appears in the mortal form of man that man may take on the immortal form of Christ. He appears within the law that the law may be transcended. In this descent of Christ, Blake seems to say, lies man's only hope of release from error. None from Eternity to Eternity could escape the forms of "dark death and despair" woven by the daughters of Albion,

> But Thou, O Universal Humanity, who is One Man, blessed
> for Ever,
> Receivest the Integuments woven.

Christ, as he is seen in the regenerated Los and Enitharmon, must take upon himself the mortal body of error (created into the Elect, the Redeemed, and the Reprobate), but having assumed it, he will

> . . . Give his vegetated body
> To be cut off & separated, that the Spiritual body may be Reveal'd.

He takes on "sin in the Virgin's womb" that he may "put it off on the cross and tomb." In the wider application the cross is, of course, the Tree of Mystery on which Blake's Christ is crucified; the tomb is what is left of mortal life, the eighteen centuries during which the Christian ideal must take upon itself the spiritual death of the moral law disguised as a religion of Mystery. Christ goes down into the grave that man may rise again. "God becomes as we are that we may be as he is."

III

The putting off of the body of death is the process of Judgment. Just how it is to be accomplished is a matter of conjecture. The *Gates of Paradise* has this stanza:

> But when once I did descry
> The Immortal Man that cannot Die,
> Thro' evening shades I haste away
> To close the Labours of my Day.

The picture accompanying the next stanza shows the traveler peering in at the open door of the grave and discovering its secrets. It seems probable that when Christ becomes apparent upon earth in the weaving of Enitharmon, Albion descries the immortal man who cannot die, and, having been vouchsafed that vision, may be expected, like the traveler, to close the labors of his day. In this case the eighteen Christian centuries become the open door to the grave, and give to Blake who hated their perversion of Christianity, a justification for their existence. Just as the traveler peering into the open door saw revealed the riddle of existence, so does man looking at the Christian centuries see there a like revelation. Presumably he will then proceed toward the Last Judgment and immortality. Certainly, as we shall see, there is much to support this interpretation.

The man who in the *Gates of Paradise* looked in at the grave descried there the female "weaving to dreams the sexual strife." The web she weaves is the melancholy web of life, which, it must be admitted, has all the appearance of the web of death. The eighteen Christian centuries are for Blake a corresponding revelation of feminine error. Indeed, so completely does a perverted Christianity reveal the feminine selfhood by which man fell that Blake sees the Christian centuries as woman's triumph. He even applies to them the epithet of death. "Thus in a living death the nameless shadow all things bound." When Los and Enitharmon tacitly accept the philosophy of good and evil, and permit the Christ to be slain upon the stems of Mystery, they make "permanent" the feminine selfhood which pretends to

love that it may destroy love by "moral and self-righteous law." In short, they permit the feminine error to spread itself through the Christian centuries as an open book for all to read. In these centuries Vala, "drawn down into a vegetated body" is triumphant over all.

Like all things in Blake's system, the triumph of Vala is providential. All mortal things, for which Vala, as the seducer of the rational intellect, is responsible, are made permanent,

> . . . that they may be put off
> Time after time by the Divine Lamb who died for all:
> And all in him died, & he put off all mortality.

The eighteen Christian centuries exist that this may be accomplished. They are alloted to man for the putting off by Christ of the mortal body of error, which he assumed with the Elect, the Redeemed, and the Reprobate.

So much, then, for the situation which awaits the Last Judgment. But Blake is not content to let things rest in the vague hope that once man has seen the vision of Christ he will repudiate Satan. The man who in the *Gates of Paradise* descries "the immortal man who cannot die" makes haste "to close the labours of his day." So, too, in the larger account are there positive efforts at repudiation. Foremost among such efforts is the "creation" of "states" by the newly liberated spirit of Christ. The process implies a shift of emphasis from the sinner to the sin by ascribing evil to a state rather than to the individual.

What Blake means by "states" may be inferred from his designation of the twenty-seven heavens as states of Adam and Satan. With the appearance of the Christian spirit Albion looks upon the twenty-seven heavens, which previously he had regarded as literal history, as the visionary record of his struggle toward enlightenment. This is made clear in the *Descriptive Catalogue*:

It ought to be understood that the persons Moses and Abraham are not here meant, but the states signified by those names, the individuals being representatives or visions of those states as they were revealed to mortal man in the series of divine revelations as they are written in the Bible.

The twenty-seven heavens are therefore symbols for states of error common to the human soul. Through these states "the immortal man who cannot die" (the Christ within continually struggling for manifestation) passes as does a traveler on his way.

Albion does not "create" the doctrine of states until the spirit of Christ is awakened within him.

Descend, O Lamb of God & take away the imputation of Sin
By the Creation of States & the deliverance of Individuals Evermore.
 Amen.

With Christ's acceptance of the twenty-seven heavens their purpose is revealed. They are a means, not an end—a way of spiritual tribulation, leading to the New Jerusalem. Regarded as an end, the twenty-seven heavens are the body of eternal death; recognized as a means, they become the mortal body of states, which the soul puts off in the progress of regeneration.

It has been said that Blake's doctrine of States frees us from moral responsibility. On the contrary, Albion does not create a doctrine of States until he has ceased to attribute his disorders to a jealous God, and has accepted his own responsibility for his unhappy condition. In Blake's myth the consequences of error are inescapable. Albion cuts himself off from the living God and descends at once into the hell of Ulro. So, too, with the individual. He may, if lucky, escape the condemnation of his fellow men; he cannot escape the Ulro of his own spiritual poverty. All those whose hearts are given over to malice, hatred, and vengeance traverse the wheel of Ulro. It may be escaped only in true Gnostic fashion, by the birth of Christ in the soul. The doctrine of states is witness to such a birth. It is in itself nothing less than a changed interpretation of spiritual experience. It is in that sense the immediate avenue of escape, but the real escape is in the regeneration by which a change in outlook is made possible.

But the creation of States is apparently not Blake's only way of putting off error. The eighth book of the *Four Zoas* seems to say that Rahab is responsible for the destruction of much of her own work. When Christ puts on the "integuments" of Rahab, he makes it impossible for her to smite him without de-

stroying her own handiwork. Every blow aimed at Christ is a blow given to Mystery.

> Rahab beholds the Lamb of God;
> She smites with her knife of flint; she destroys her own work
> Times upon times, thinking to destroy the Lamb blessed for Ever.

It seems probable that Blake had in mind the various heretical sects of the Christian centuries before the Reformation—sects which, though enveloped in Mystery, were yet imbued with the spirit of Christianity. As the orthodox struck at these sects, the mortal body derived from the orthodox themselves was destroyed, and the Christian spirit reasserted itself. This assumption finds support in the fact that Rahab is at this time presented as appearing in multiple.

> It was the best possible, in the State call'd Satan, to Save
> From Death Eternal & to put off Satan Eternally.

This putting off of Mystery reaches a climax with the Reformation.

> The Synagogue of Satan therefore, uniting against Mystery,
> Satan divided against Satan, resolv'd in open Sandehrim,
> To burn Mystery with fire, & form another from her ashes;
> For God put it into their heart to fulfill all his will.

With Mystery destroyed, there is gone from the female the means by which she has obscured her selfhood and imposed her will upon man. In Deism, which rises out of the ashes of Mystery, there is revealed to Albion, with no obscuring veil, the Natural Religion with which his descent began. Christ's purpose in taking upon himself the garment of Mystery has been fulfilled. The veil has been rent. The hidden selfhood which is Satan has been revealed.

With Deism the Circle of Destiny completes its round. Albion is back again where the Fall began, but in a position, Blake hopes, to realize his error. He has traveled from the natural monism of the ancient world through the dualism of the Jewish and Christian religions, only to find himself again in the naturalism of the eighteenth century. Presumably he must now either repudiate his error or travel again the round of nature.

> The Ashes of Mystery began to animate; they call'd it Deism
> And Natural Religion; as of old, so now anew began
> Babylon in Infancy, Call'd Natural Religion.

One cannot comprehend Blake's belief that error has a natural cycle and that the cycle had reached its conclusion in his own day without feeling a genuine sympathy with his passionate hope and his equally passionate despair. One comprehends also the exaggerated importance he attached to his own prophetic rôle. What a fiery spirit could do to insure the Last Judgment and prevent a retracing of error's path, Blake meant to do. Amid the general apathy of the time Blake may well have felt that the Herculean task of furthering the Last Judgment was left to him, who knew himself to be the inspired spokesman of the Eternals.

Though the Last Judgment comes as a climax to the process we have been describing, Judgment is, like Creation and Redemption, continuous. But whereas Creation and Redemption are for the Elect and the Redeemed, Judgment is primarily for the Reprobate, though the Redeemed, once they have been freed from the power of the Elect, also proceed to Judgment. The Reprobate are those whose faith is invincible and who live by self-sacrifice and forgiveness, as the Elect live by vengeance and the sacrifice of others. Their type is the regenerate Los, and he, in turn, is the exact equivalent of the regenerate Prometheus in Shelley's play. As Prometheus turns from hate and defiance to love and forgiveness, and willingly endures all that Jupiter can heap upon him in order that man may eventually be freed from Jupiter, so Los bids "peace to the soul of dark revenge," and preaches and practices forgiveness in a world of hate. Prometheus speaks as Los might have spoken—as he often does speak—when he declares to Jupiter:

> The sights with which thou torturest gird my soul
> With new endurance, till the hour arrives
> When they shall be no types of things which are.

The regenerate Los and the regenerate Prometheus are both equivalent to Christ, who in Blake's myth put on Luvah's robes of blood in order that the state called Luvah might not cease.

Man can proceed to a Last Judgment—he can put off Satan in "mental fires"—when, to follow Blake's use of the Pauline classification, the Redeemed shall free themselves from the power of the Elect and make common cause with the Reprobate; when, in short, his emotional life shall respond to the Christ within him, not to Satan. In Blake's symbolism this means that a Last Judgment becomes possible when the Emanation refuses longer to be driven into vengeance by an insistent Spectre of doubt and returns to the human and masculine ideal of forgiveness.

The Last Judgment [will be] when all those are cast away who trouble religion with questions concerning good and evil or eating of the tree of those knowledges or reasonings which hinder the vision of God, turning all into a consuming fire.

In the *Four Zoas* the immediate impulse to the Last Judgment comes from Los, who, unable to endure longer that vision of nonexistence which is Deism, reaches up and pulls down the sun and moon, symbols of the temporal vision which has replaced the Divine Vision of Eternity. Both of these Los has himself created—the one to replace the intelligence of Urizen, the other to replace the forgiveness of Luvah. Both have done their work and both are now inadequate.

For Blake his own age seemed ripe for such a wholesale destruction of error. Man, it seems, does not give himself to a Last Judgment until error has become intolerable. "When imagination, art and science and all intellectual gifts, all the gifts of the Holy Ghost are looked upon as of no use and only contention remains to man, then the Last Judgment begins."

It is not necessary to describe the Last Judgment in detail. It should be said, however, that the activities which characterize it are of two sorts. Error is first burned away in the fires of the freed Orc. Then the labors of reconstruction begin. Over this part of the Judgment the regenerated Urizen exercises a directing force. The final labor—the writing of the "bitter words of stern philosophy" and the kneading of the "bread of knowledge" —is left to Urthona. The recovered heaven is obviously intended to rest upon the secure foundation of six thousand years of ex-

perience gained in an attempt to create a heaven by selfish and rational means. With the Last Judgment man's disorganized powers

> . . . resume the image of the human,
> Co-operating in the bliss of Man, obeying his Will,
> Servants to the infinite & Eternal of the Human form.

The "dark religions" depart and "sweet science reigns."

To this picture of felicity one exception must be made. Albion, rising from his couch of death, finds to his distress that he cannot put off his mortal body in the flames of Orc. His inability is apparently due to the opacity of the Elect. They cannot be regenerated because they cannot recognize and put off their own error. They cannot go through the flames of a Last Judgment. For that reason Albion's "created" body (the Christian Church) has been redeemed to be permanent through mercy. For that same reason Vala must again go down through the "gates of dark Urthona"; some form of religious illusion must be retained for the Elect, who are unable to do without it. However, this new religion, as Enitharmon's weaving suggests, is a merciful illusion, unlike the cruel illusions of the dark religions.

Are we then to assume that Los's labors have been only partially successful—that the Last Judgment is itself a failure? That does not seem to be Blake's meaning. He has himself told us that the purpose of a Last Judgment is not to make bad men better, but to prevent them from hindering good men. The most that can be accomplished, so far as the Elect are concerned, is to destroy their power over others. Mortal life and a Last Judgment exist that the Redeemed may be freed from error's power as it is constantly exercised by the Elect. The restless rational mind will never be stilled. Doubt will always arise, the principle of self will remain; but the Redeemed, who live largely by their emotions, will have freed themselves from the Elect, who live by rational doubts and fears. They will have learned to disregard the rationalists who harass them and to live by the translucence in their own hearts, the Christ himself.

The whole interpretation has a close affinity with Gnostic teaching. There, too, are three classes of men; the pneumatic, the psychic, the hylic. The pneumatic do not fall from grace. The psychic stand between the pneumatic and the hylic, capable, like the Redeemed, of ascending into heaven or of descending into hell. The hylic, who are of the earth, are lost. Blake's teaching is more merciful. The Elect cannot take on the likeness of Christ, but they can, by the mercy of the Reprobate, be restored to a religion of Beulah. The regenerated Job, it will be remembered, prays for his friends, in whom are incarnated the Elect of that story.

In the Gnostic myth Christ, by descending into matter, encompasses all life, taking upon himself the three classes of men. In Blake's allegory, also, the descending Christ takes upon himself three classes of men, and is an equally inclusive figure. In both allegories the descent is for the purpose of turning the current of existence, which has been away from God, once again toward its eternal source.

The Seven Eyes

. . . Then they Elected Seven, called the Seven
Eyes of God & the Seven lamps of the Almighty.
The Seven are one within the other; the Seventh is named Jesus,
The Lamb of God, blessed for ever: & he follow'd the Man,
Who wander'd in mount Ephraim, seeking a Sepulcher,
His inward eyes closing from the Divine vision, & all
His children wandering outside from his bosom, fleeing away.
 Four Zoas, Night I.

A CIRCULAR movement of the soul in its absence from God
is all but incumbent upon mystical religions. A wheel of birth,
a cycle of destiny, a ring of return—these conceptions, foreign
to Greek classical religion, came in through the Mysteries, and
were basic in the Gnostic systems. In this type of thinking the
soul has its origin in a supersensible world, incurs a fall, under-
goes expiation and purification, and returns at last to its primal
source. In the Gnostic systems, whatever may have been the case
in the Mystery religions, the cosmos follows the cycle along with
man. It, too, falls from its primal purity and oneness into mate-
riality and multiplicity, only to undergo renovation and return
to the One from which it fell. The reader is by this time well
aware that in Blake's system man and the universe swing round
the cycle of destiny together. It is a logical conclusion of the
story that the Last Judgment, as described in the ninth book of
the *Four Zoas*, should be nothing less than cosmic.

That the cosmic cycle should have seven stages was almost
inevitable. No other number—not even three, shall we say?—
has exercised such dominion over the mind of man. It was the
number of the planets, which direct our fate. By reason of that
association, which had numerous applications, and by reason of
qualities inherent in the number itself, it was thought to be

filled, as Cornelius Agrippa says, "with every kind of majesty."
Seven is the chariot of human life and the number of a com-
pleted sequence; it combines three, the number of the soul, with
four, the number of the body; and as the number of virginity
it is most appropriate to a cycle which begins and progresses in
a "chaste" ethics. An enumeration of the venerable sevens would
require a chapter in itself. Seven days are commanded for
cleansing the altar and freeing it from sin; the seventh year is
the year of release; seven times does the just man fall and rise
up again; seven times passed over Nebuchadnezzar when he was
driven from men and became a beast. Gold is tried in the fur-
nace seven times, there is a seven-runged Jacob's ladder in
Erigena, and a sevenfold wheel of change in Jacob Boehme.
Seven is, in general, the number of redemption. It may be the
number of redeeming forces, or the number of evil influences
which make redemption necessary. Mundane history is divided
by St. Augustine into seven stages, and the life of the soul into
seven degrees. Seven archons rule this world in the Gnostic sys-
tems and in Hermes. Isis is clothed in seven veils. Seven holy
angels are alluded to in the book of Tobit; there are seven
spirits of the Lord in Isaiah; and above all, there are seven
spirits of God in Revelations, which are seven eyes, and which
are sent forth into all the earth. In the *Kabbalah Denudata*,
seven emissaries go forth from the eye of Microposopus, and
these emissaries have the very Blakean purpose of "uncover-
ing the ways of sinners."

Blake's cycle, familiar to all students of the illustrations of
the Book of Job, is also sevenfold. There, a band of seven angelic
figures carries the wheel around the page, clockwise or counter-
clockwise, as the case may be. These are the seven Eyes of God,
otherwise called the seven Lamps of the Almighty and the seven
Angels of the Presence, appointed by the Eternals to follow
Albion (or Job or Milton) in his descent, guarding round him
and going with him even to Satan's seat. Downward they fall
and outward, turning upward with the fourth figure, but not in-
ward until the seventh, which is Christ. With Lucifer (the first
Eye) the soul falls in selfish pride away from God; with Christ

it is restored in self-annihilation. These seven figures represent the seven spiritual states possible to man. They are God descending in accordance with man's weakness. They are states of the inner translucence, burning red or dim, but never going out. They are a sequence of error so ordered as to bring man back to truth. The path which begins with Lucifer must be terminated, late or soon, in Christ.

As the wheel swings downward and outward—outward to self and sense, downward into darkness and discord—it swings, like the sun and the other planets in their journey through the zodiac, in a counter-clockwise movement from west to east. This motion, initiated by the selfish will of man placing itself in opposition to the Divine Vision, is that of the "wheel of religion," setting the heavens aflame with the fires of passion. It moves from the circumference, the united life of Eden, the region of Tharmas in the West, to the empty heart of Luvah in the East, the selfish centre, where the individual law is holy and invoked by the self-righteous against the transgressor. In biblical imagery this wheel of religion is the turning sword at the Tree of Life.

However, this anti-Christian wheel is not the only spiritual force at work. Were it so there could be no regeneration and no return. The wandering soul would be lost eternally. No mystic could tolerate such a picture. Evil must find a place in the divine scheme. There must therefore be another wheel, a wheel of regeneration, by means of which evil is turned to good.

Mystical literature is full of imagery that expresses the dual character of single forces. The astral light allies itself with both good and evil; light is generated out of darkness; even the serpent has a good aspect. A force that swings to the left and generates evil may swing to the right and generate good. Among the Gnostics we find that when the waters of the Jordan or of the ocean flow downward, there ensues a generation of men; but when they flow upward, there ensues a generation of gods. "The Devil is God as understood by the wicked," writes Eliphaz Levi. He also repeats the affirmation of the kabbalists, "that the secret and true name of the Devil is that of Jehovah written

backwards. . . . Jehovah is he who dominates nature, but Chavajoh . . . is an unbridled horse which overthrows its rider and precipitates him into the abyss." This kabbalistic source, whatever it was, Blake knew, since he drew the rebellious horse in the *Marriage of Heaven and Hell.* A dual aspect of what appears to be a single force is found also in the progression of the Eyes. The selfhood which carries man downward and outward generates its opposite and swings him upward and inward.

This spiritual use of unspiritual forces is everywhere emphasized in Blake's myth. Job sinks deeper and deeper into error until he sees it revealed in all its horror, whereupon he casts it off and enters into his salvation. In the *Four Zoas,* after Albion has suffered for ages under the moral law, Christ is born of that very law in order that it may be repudiated. In *Jerusalem* the Spectre is astonished and confounded when he learns that Los, not he, is the real lord of the furnaces. This double progression, appearing as a force moving in the direction of evil, yet terminating paradoxically in good, is represented in Blake's myth by two wheels, swinging in opposite directions. In the Job pictures the first succession of angels, swinging counter-clockwise, is supplemented by a second succession, swinging clockwise. Blake calls this second movement the "current of creation."

The current of creation flows from the forgiving heart in the East to the spiritual body in the West, that is to say, toward Eden, which gets its character from the acceptance of every minute particular and the forgiveness of sin. Yet in true mystical fashion the two wheels are one. Their identity is suggested in the fifth illustration of the Job series by the two cycles of six angels moving in opposite directions, but united in the middle by a single figure (Satan) which completes each cycle. The identity is again suggested in the thirteenth illustration by the God in the whirlwind, in whose garments of storm the two movements are plainly discernible. It is likely that Blake found the idea substantiated in the very heavens, where the sevenfold planetary spheres revolve, of their own motion, in a direction contrary to

that of the eighth sphere of the fixed stars; and yet the motion of the eighth sphere—a diurnal motion from east to west—prevails, and subdues the wandering planet cycles to its own course.

Blake tells us very little about the seven Eyes who make up the seven divisions of his wheel. The following passage, containing their names and the reasons for their failure, is as helpful as any:

Lucifer refus'd to die for Satan, & in pride he forsook his charge.
Then they sent Molech. Molech was impatient. They Sent—
Molech impatient—They Sent Elohim, who created Adam
To die for Satan. Adam refus'd, but was compell'd to die
By Satan's arts. Then the Eternals Sent Shaddai.
Shaddai was angry. Pachad descended. Pachad was terrified,
And then they Sent Jehovah who, leprous, stretch'd his hand to
 Eternity.
Then Jesus Came, & Died willing beneath Tirzah & Rahab.

Since the Eyes collectively make up the cycle of mortal life, it ought to be possible to assign to each his special segment. The fact that Elohim comes with the Flood and shapes the world which rises after it makes the assignment of Lucifer and Molech certain. They divide the antediluvian world between them. On this world, in its beginning, rests the glory of the primitive. Man was nearer to God. He thought intuitively. He had not fallen into vengeance. His law was pity. If he sinned, sin at least was not imputed. His giant stature was an outward sign of his inward greatness. He ranked with the highest hierarchy of the angels. He possessed the wisdom of the ancient Druids. This period may be ascribed to Lucifer, before he was undone by pride.

As Lucifer yielded to pride, Molech, who followed him, yielded to impatience. By this feeble word Blake designated the violence into which man's self-righteous pride led him. During this period intuition weakened. The symbol was taken for the reality and the blood of sacrifice reddened the earth. Druid temples and Druid oaks flourished. Urizen himself succumbed to the "impatience" by which Molech is undone and cast out Ahania. Vengeance for sins was loosed. The earth was filled

with violence. The patriarchal world (the world of the New Atlantis) was overwhelmed by a flood of angry waters.

These waters are the five senses whelming "in deluge o'er the earth-born man." For it is at this point in Blake's myth, as in much theological tradition, that the world of time and space definitely begins, and man becomes a child of earth, a diminished creature, physically and spiritually, subject to sin and death. Having fallen a prey to vengeance, he bursts the boundary of what Blake calls existence, and plunges into the abyss. But the abyss into which he falls is "the void outside of existence, which if entered into becomes a womb." Out of death and chaos a new world must be generated. The ruins of the eternal world and eternal man must be reshaped in temporal and finite forms. This is the work of the third Eye, the triple Elohim. The important thing about the Elohim is that they "swore vengeance for sin." In vengeance they form a world for man, who has himself fallen a prey to vengeance. This done, they are said to grow weary and faint, just as Los faints in the myth, he being "of the Elohim." We may take this to mean that their anger gives way to pity, in analogy with the pity which succeeded to God's anger when he set the rainbow in the sky as a token that he would never again destroy the world in a flood of waters.

Shaddai comes in tempered mood to carry on. He is the God (El Shaddai) who made the covenant with Abraham, assuring a prosperous issue to this new world. He is the pardoner of the *Zohar*, the "benefactor after temptation" of Swedenborg. But in the course of time Shaddai grows angry. His people are rebellious, for the emotions cannot endure the limitations which the Elohim placed upon them. The moral law has to be created in order to restrain them. Orc is bound upon Mt. Sinai.

When Shaddai fails the succession is carried on by Pachad. The word Pachad occurs in the second chapter of Isaiah, in connection with the name Adonai, the phrase being translated, in the King James version, "fear of the Lord." The word is found again in the *Kabbalah* as the name of the seventh *Sephira*, where also it signifies fear or terror. Pachad comes at the nadir of the

cycle. "O wretched man that I am," cried St. Paul, in fear and despair over the law, "who shall deliver me out of the body of this death?" Historically this period of fear has its climax in the Babylonian captivity. It is symbolized astrologically by the descent of the sun into the depths of winter. But deliverance is at hand. In Blake's philosophy, "Fear and hope are vision." During those three dark days at the end of December, when the sun turns back upon its course and Saviours are born, Urizen takes his globe of fire, a tragically confined and diminished luminary, and explores the dark caves of his ruined world. This journey is described, in the sixth book of the *Four Zoas*, in imagery as terrifying as the human terror which is its theme.

The searching of soul which goes on in this period should bring deliverance. But Jehovah, who follows Pachad, is not yet the Saviour. He grows "leprous," so that his deliverance from the bondage of the law is into the labyrinth of Mystery. It is only Christ, the seventh and last Eye, who delivers from the bondage of corruption into the liberty of the glory of the children of God.

It is none too certain, however, that the world will take the path of deliverance. An outward and feminine religion of Mystery challenges the inward and masculine gospel of Christ. But when Mystery is at last stripped of its trappings, and the grinning skeleton of Deism stands revealed, it is time for the Last Judgment. With Deism the wheel of Natural Religion, which began its circuit centuries ago, has swung full circle, and must now submit itself to Christ or swing round once again. Which will it do? Will the world today, having come to the edge of the abyss over the path of mutual fear, renounce that policy and enter into the ways of peace? Are we purged and pure— true gold—or must we be cast, as dross, once more into the furnaces of affliction? The question haunted Blake, as it haunted Shelley. The prophet in him, especially around the year 1790, filled him with hope of the great renunciation. The Spectre in him pointed out the power of error to renew itself. Where Babylon ends Babylon might begin again. Generation might not be swallowed up in regeneration. This fear is never absent from

Los's mind, or Blake's. Los's Herculean efforts are necessary, that the "wheel of religion" may presently disappear in the "current of creation." He dare not relinquish his activities, lest the creation itself (the egg-shaped world of Los, and Blake's symbol for what has already been accomplished in a regenerative way) be destroyed. But, though Blake's fear was great, his will to believe was greater. He persuaded himself that man would take the path Job takes in the Illustrations. He would cast his pride and selfhood (which betrayed him into the cruelty of Natural Religion) into the lake of fire, and be transformed into the likeness of Christ.

It should be noted in closing that the progression toward Christ is not the only movement of the Eyes. In the thirteenth illustration of the Book of Job, the Eyes are drawn facing alternately inward and outward. This would seem to be an alternation of masculine and feminine in the Blakean usage of these terms; for there is reason to think that Blake believed that history proceeded in accordance with such a pattern. The law of contraries, without which "is no progression," would seem to require it. A predominantly masculine period has its reaction in a predominantly feminine period, and *vice versa.* Let us review the sequence of the Eyes. The pride of Lucifer (Luvah's pride in Vala) passes into the impatience of Molech; the impatience of Molech into the faintness of Elohim; the faintness of Elohim into the anger of Shaddai; the anger of Shaddai into the terror of Pachad; the terror of Pachad into the leprosy of Jehovah. In Christ the warring contraries are again brought together. This sequence can surely be read, without undue forcing, as a sequence of active and passive, inner and outer, masculine and feminine. If this is the pattern of the cosmic cycle, it ought to be reproduced in the microcosmic cycle of the individual. Is it too much to assume that such a pattern is implied in the succession of the contraries of which Blake speaks with reference to regeneration? "Man," he asserts, "is born a Spectre or Satan, and is altogether an Evil, and requires a new selfhood continually, and must continually be changed into his direct contrary."

If Blake saw the cycle of progression, individual and cosmic,

moving from contrary to contrary, as has been suggested, he no doubt found a striking confirmation of his theory in the masculine and feminine alternations which the astrologers had for centuries ascribed to the signs of the zodiac. Thus all the aspects of his cycle—the opposing wheels and the succession of the contraries—were registered in the heavens.

XIII

Nature (the Vegetable Glass)

All that we saw was owing to your metaphysics.
Marriage of Heaven and Hell.

. . . What seems to Be, Is, To those to whom
It seems to Be.

Jerusalem, p. 36.

Error, or Creation, will be Burned up; and then, and not till
Then, Truth, or Eternity, will appear. It is Burnt up the Moment
Men cease to behold it.

Descriptive Catalogue.

IT WOULD be a platitude to say that the panorama of the natural world provides an inexhaustible fund of illustration for states of the mind and soul. A cloudless sky, an autumn field, a winter wind, renders an inner state far more subtly than mere words. The animal world vies with the natural world in heightening man's consciousness of his own qualities. Who does not know himself and his neighbors better after reading La Fontaine? Possibly these affinities and correspondences go deeper than is commonly supposed. The supposition that they do—that man and nature are animated by a single spirit, that there is a presence

> Whose dwelling is the light of setting suns,
> And the round ocean and the living air,
> And the blue sky, and in the mind of man,

is a conception which Wordsworth made familiar to readers of poetry in the nineteenth century.

The conception of nature as a manifestation of mind is a familiar philosophical position even now, being an element of subjective idealism. The conception is fundamental in Blake's system. "Mental things," he declares, "are alone real." Conversely, reality is denied to natural things.

And every Natural Effect has a Spiritual Cause, and Not
A Natural; for a Natural Cause only seems; it is a Delusion
Of Ulro.

But this is not the full extent of the Blakean idea. A moral
element enters in. A fall and a return, in which nature as well
as man participates, are presupposed. Thus nature and man be-
come the manifestation of a single spirit, and natural appear-
ances are the visible register of that spirit as it traverses the re-
generative cycle. Nature, says Fourier, is "an immense museum
of allegorical pictures in which are depicted the crimes and vir-
tues of humanity." Blake's attitude to nature remains unintel-
ligible without the realization that for him also nature was such
a storehouse of pictures, not casual, but actual, revelations of
the spiritual state of man.

This view of nature is one of Blake's most important debts
to Swedenborg. The enthusiasm, the sense of divine revelation,
which the Swedenborgian interpretation of nature aroused in
the elder Henry James must have been aroused in Blake. In
that view nature is, James says, "a pure spiritual apparition."
It is not, he continues,

in the least what it sensibly purports to be, namely, absolute and
independent; but, on the contrary . . . a pure phenomenon or
effect of spiritual causes as deep, as contrasted, and yet as united, as
God's infinite love and man's unfathomable want. . . . The lion
and the lamb, for example, both exist in nature, but has either lion
or lamb the least title to be esteemed the objective or spiritual crea-
ture of God? What nonsense to think of such a thing! If then the
lion and the lamb, the serpent and the dove, the leopard and the
kid, the bear and the calf, naturally exist or appear to be to my in-
telligence, what is the inference? Not that such things spiritually
exist or have absolute being in God, but that they pertain exclu-
sively to the created consciousness, having no other function than
outwardly to image or represent the things of human affection and
thought, which alone make up the spiritual creation, or are alone
objective to the divine mind.

In this conception is the explanation of Blake's cryptic sentence
that "Nature is a vision of the science of the Elohim." When
that triple god took command, at the time of the Flood, swear-

ing "vengeance for sin," and making the world over in forms of "death and decay," the "science" which they possessed, their knowledge, their insight, their cruelty tempered by an almost unconscious regenerative purpose, were all mirrored in the world which they created. Blake's famous tiger is precisely such a creation, seen both in its destroying and its redemptive aspects. On the whole, the world which they created was the tiger's world, not the lamb's. It mirrors the cruelty of the Elohim, and at the same time their belief in corporeality, for which feminine self-seeking is responsible. It is the outward image of man in a state of absence from God. Therefore Blake could say to Crabb Robinson: "Nature is the work of the Devil. The Devil is in us, so far as we are Nature."

As the "vegetable glass" of the soul, nature images the progress of the Fall. When Albion first creates a feminine ethics, he believes in a feminine or natural monism; when he subscribes to a belief in good and evil, he believes in a dual world. This evolution in nature's history is indicated by successive episodes in the myth. When the Fall begins, the physical world ceases to be thought of as human, and takes on an identity of its own. The result is a natural monism, though still animated by spirit, as the immurement of Tharmas in the web of Enion suggests. This is the condition of nature in the first period of mundane history, the period of the Mundane Shell. When the Shell crashes, the Elohim create out of its ruins a dual world, in which nature is divided into two antithetical principles, matter and spirit. This succession of events renders the facts of the early history of thought as Blake saw them, even as we may see them now. The early philosophers had proposed one or another of the four elements as the first principle. If Blake read Origen he found the Persians condemned for worshipping the creature instead of the Creator, and the Egyptian myths interpreted as inculcating the worship of earth and water (Isis and Osiris). If he read Philo on the *Migration of Abraham*, he found the Chaldeans condemned because they "imagined that this visible universe was the only thing in existence, either being itself God or containing God in itself as the soul of the whole. And they

made Fate and Necessity divine, thus filling human life with much impiety, by teaching that apart from phenomena there is no originating cause of anything whatever." To this effect Blake could have read in still other ancient authors; to this effect we may read today. Of the early Greek philosophy Professor Burnet says that "in the days of Thales, and even far later, the distinction between matter and spirit had not been felt, still less formulated in such a way that it could be denied. The uncreated, indestructible reality of which these early thinkers tell us was a body, or even matter, if we choose to call it so; but it was not matter in the sense in which matter is opposed to spirit." Of Parmenides the same authority says that he "held that the reality which underlies the illusory world presented to us by the senses was a corporeal, spherical, continuous, eternal and immovable *plenum*"—an apt description, surely, of Tharmas imprisoned in Enion's "filmy woof," when her Circle of Destiny was complete, and "round roll'd the sea, englobing in a wat'ry globe, self-balanced." In Egypt the various deities were personifications of natural forces. The same may be said of most of the Vedic gods in India, where, of course, pantheism took an early hold. In brief, this can be said today: that "in Indo-European antiquity, the most important part of religion consisted in adoring the great objects of living nature: the sky, the earth, the sun, the moon, water, wind and fire. This may be deduced from Aryan, Greek, Germanic and Baltic traditions." The picture is one of animism developing into pantheism or a material monism. Even in Persia, the home of dualism, "pure dualism took shape but slowly."

Nevertheless, in all these countries an ethical dualism was taking shape. The idea of good and evil was splitting the inner life, and was bound in time to split the outer life. Ahriman, the spirit of darkness, rose from the abyss and rushed to destroy the light and the creatures of Ormazd. In the same way, Tharmas, who had caused Urizen so many anxious hours in the "porches," rose up from the abyss and destroyed the Mundane Shell, the natural monism which Urizen had created. The world which the Elohim create out of its ruins is a dual world, one in

which body and soul, matter and spirit, good and evil in all
their aspects fight for supremacy.

These two stages through which nature runs—an apparent
monism prior to the Flood, and an open dualism thereafter,
often reverting to a monism—constitute the mundane cycle.
At no point in that cycle does man see nature in her perfection.
The outward as well as the inward life is under a spiritual curse.
Only in Eternity is the glorified body, personal and cosmic, to
be seen. The nature we now see and the body we now have re-
sulted from the Fall. This idea did not originate with Blake,
nor even with Swedenborg. It had its inception, probably, in
the Orphic mysteries. It was nourished by certain passages in
Plato. The *Timaeus* brings the visible world into correspond-
ence with the spiritual world. It "accustomed the mind," says
M. de Faye, "to regard the cosmos entirely in a metaphysical
aspect. Is it not a powerful attempt to prove that the cosmos is
the product of the spirit? Such is the outstanding concern of the
author. The cosmos is a reflection of the higher world, and it
is there that we must look for its rationale and for the secret of
its destiny." When to metaphysics there is added ethics, the
Swedenborgian point of view has been created. This point of
view was held in common by Christians and Gnostics. Origen,
on the Christian side, made the cosmos consequent upon the
Fall.

Along with the cosmos [M. de Faye continues] there appear what
Origen calls "the corporeal natures." These are men and animals,
beings possessed of a body. Nevertheless, says our theologian, bodies
are not all the same. . . . Corporeity differs in beings. In one, it is
opaque and dark; in another, it is more ethereal and luminous.
The reason for this diversity is a moral one. The corporeity of a
being varies according to the degree of its culpability. All supra-
sensible beings that have fallen are clothed in bodies. But in the
case of the heavenly beings, whose fault was but slight, the matter
of their bodies is tenuous, diaphanous, luminous. The archangels
have a little more of matter. Mankind has the body with which we
are all acquainted. The daimons have a dense and tenebrous body.

So it is also in Milton, where the bodies of the fallen angels lose
their ethereal brightness and become corporeal and dark in a

degree corresponding to their depth of fall. There is a similar ladder of matter in Blake, with the body of nature as well as the body of man submitting to the descent. Bodies of every kind became more dense and tenebrous with the moral darkness of the Flood. The natural body hardens and darkens in the Job illustrations in correspondence with Job's descent into the pit. Albion shrinks and darkens and withers in the opening pages of *Jerusalem*, as the Fall begins. When Satan's pride and selfhood increased upon him "his bosom grew opaque against the Divine Vision," and a world of deeper Ulro opened within him. The Spectre is called an "opaque blackening fiend."

Among the Gnostics a moral and metaphysical explanation of the cosmos was invariable. Valentine, for example, makes the fall of Sophia responsible for the creation, the cosmic drama, and the redemption. The passions of Sophia become the four elements, which reminds us that the Zoas, in falling, become the elements. There is another Blakean parallel with both Valentine and Origen, in that they make evil and the Fall originate in the mind or soul, not in matter. Matter is the "final consequence of evil. In matter evil becomes, so to speak, concrete, arrested and fixed."

There is no need to carry this idea of a moral and metaphysical core to the cosmos farther, except to bridge the gap between antiquity and Swedenborg. Midway between stands Erigena. Speaking of the human body he has this to say:

But the body as we know it, material and corruptible, came into existence after man's sin and because of it. It was man, after he had transgressed, who made to himself this fragile and mortal body. . . . But where, then, is that spiritual and incorruptible body? . . . It is hidden in the secret recesses of our nature, and it will reappear in the future, when this mortal shall put on immortality.

We shall find later that Blake looks upon the mortal body of death as an incrustation upon the spiritual body beneath.

The nature of the body which lies beneath the incrustation, or hidden in the secret recesses of our nature, has been the subject of some speculation. It has been thought of as light and diaphanous, not subject to pain and decay and death. Boehme

took the sea of glass in the Book of Revelations as the type of matter in the eternal world. Some such ethereal quality Blake must have ascribed to bodily substance in its eternal form, for in his philosophy, as in Swedenborg's, heaven is in continual correspondence with the "interiors" of the angels, that is to say, with their "affections and consequent thoughts." Blake's conception is substantially the same; the outer world corresponds to the creative imagination. Swedenborg had a vision of Sir Hans Sloan examining a bird which he knew to be no other than an "affection" of a certain angel. He found that it differed not in the least from a similar bird on earth, except that it vanished with the vanishing of the angel's affection. Had the bird been filled in every part with earthly matter and so fixed, it would have been durable, like an earthly bird. The difference, then, between the heavenly and the earthly bird would seem to lie in the responsiveness of matter. The recurrence of the word "fixed" in the writings of the Gnostics, Swedenborg, and Blake is interesting. Los is forever "making permanent" and "fixing" such "affections" as his world provides him—creating a tangible world, mental and physical, to serve as a transition between the dark chaos of Ulro and the bright visions of Eden. Earthly matter no doubt serves a spiritual purpose in fixing, as Swedenborg says, the spiritual influx; but it is a hindrance to a superior imagination.

II

The basic idea behind such thinking about the physical world is this: There are two co-operating principles, one formative and intellectual, the other recipient and material. The metaphysics of the ancient world called the one "form," the other "matter." It is logical that the two should be in correspondence. This theory of form is developed in Blake and in Plotinus also, with considerable complexity. Blake's system, which lurks beneath what has proved to be a very obscure myth, can best be analyzed in the light of its clearer analogue in Plotinus.

At the summit of existence in Plotinus stands the One, an undifferentiated unity, motionless, indefinable, ineffable—tran-

scending Being. It is a world into which Blake can hardly be said to follow, although in some respects his dark Urthona is a counterpart.

Emanating from this, as its utterance and act, is the world of the Intellectual Principle, the Divine Mind. In this world multiplicity has declared itself, but it is still a multiplicity within unity, a One-that-is-Many. This world is timeless; it holds authentic eternity; it knows not death and decay. It is also real. Each particular enjoys authentic existence, and the sum of the particulars is authentic existence entire. Its knowledge is intuitive, and there is identity between the seer and the thing seen. Matter in this world is "divine." It has "a life defined and intellectual." It enjoys true Being. It responds completely and perfectly to Form, which is also pure and authentic. Form and Matter unite into a single "illuminated reality." This world is a reposeful version of Blake's Eden.

Emanating from this world in turn, as its utterance and act, is the world of Soul; and Soul is the animating principle of the world of sense. This world hasn't the beauty of its superior; it is but an image, and an imperfect image. The shaping power— the Form—and the Matter upon which it works are both but images. Matter in this world "is not living or intellective, but a dead thing decorated; any shape it takes is an image, exactly as the Base is an image." Life here is temporal, and subject to change and decay and death. And multiplicity has been dispersed into separate and even mutually opposed exsitences. It is a very extensive world, reaching from the level of Being that Blake calls Beulah to the level that he calls Ulro. Its peculiar character is in its middle region, but it reaches upward toward the authentic existence of the Divine Mind and downward into darkness and nonentity. In its declension Soul begets an image of itself—a still less authentic existence—which extends down into the vegetable world, ever diminishing as it descends until it comes upon a residuum which cannot be brought under determination—abstract matter; not matter visible and tangible, but the substratum supposed to lie behind or beneath all forms, only to be grasped by a mental process, a substratum without

form or quality, utterly without light, utterly without reason, outside reality.

This is the procession downward and outward—from mind to matter, from light to darkness, from reason to unreason, from the One to the Many. The return procession—upward and inward—recovers, step by step, what has been lost. It may have been observed that all the stages of the outward movement contain all things in different modes of being. These different modes of being correspond to different modes of perception. Perception, therefore, is the "gnosis" of the return. In those lowest reaches of the Soul, in which "the lower Soul is entangled in the illusions of bodily existence," perception is bodily sensation. This is what Blake calls "the vegetated mortal eye's perverted and single vision." It is his world of Ulro. But Plotinus, who hated nature less than Blake, did not find it necessary to separate off this region of existence into a local habitation with a name. The characteristic region of the Soul, as has been said, is in its mid extent, where perception is by means of the discursive reason. This is an outward reason which has to enquire; it is not inward and intuitive. However, it has some standards of value inherited from the Divine Mind, its begetter. By looking thither in contemplation, the Soul "takes fulness," and turning in upon itself it attains to the next degree of vision which is inward and intuitive. "Truth is within ourselves," the mystics say; and this inward truth "knows by right of its own being." "Its knowing is not by search but by possession, its blessedness inherent not acquired." Under this vision the multiplicity of the world is brought into perfect unity, each particular, nevertheless, retaining its individual existence; and the grossness and indeterminateness of matter are purged away. Beyond this there is the transcendent ineffable One, to be experienced only in a state of ecstasy. This journey inward, reversing the movement outward, can be made—need it be said?—without change of place. It is purely a matter of perception. "Likeness knows its like."

There is a similar cycle in Swedenborg, with a characteristic

difference. He conceived of nature as a progression from God, countered by history as the return.

Nature is a centrifugal movement of the creative providence, whereby the creature becomes projected or set off to his own consciousness from the creator, by all the breadth of mineral, vegetable and animal existence. History is an answering centripetal movement of the same providence, whereby the creature becomes gradually lifted out of his mineral, vegetable and animal thraldom, into properly human proportions, or endowed with conscience.

In the outward progression, nature provides the mind with a "living inventory" an "exquisite picture-language" of conditions and qualities of soul. In the inward progression, history—spiritual history, the history of the Church—gradually creates a true society or brotherhood upon the earth.

Blake's cycle unites these two conceptions, the Swedenborgian and the Plotinian. Return is effected by means of spiritual history, an evolutionary experience, ending in the return to unity and social brotherhood and accomplished by a continual enlargement of perception.

The correspondence between the perceptive power and the thing perceived is a fundamental principle of mysticism, and has an important place in Blake.

The Visions of Eternity, by reason of narrowed perceptions,
Are become weak Visions of Time and Space fix'd into furrows of
death.

The reader will probably remember the statement of this principle in the *Marriage of Heaven and Hell* and its amusing application:

If the doors of perception were cleansed, every thing would appear to man as it is, infinite.
For man has clos'd himself up, till he sees all things thro' narrow chinks of his cavern.

Now an angel—a creature of "confident insolence sprouting from systematic reasoning"—came along and displayed to the poet a vision in which his insolence became so terrifying that he himself took refuge, whereupon the poet, left to his own imagination, beheld a romantic scene with music and moon-

light. "As a man is, so he sees." This theory is worked into the
metaphysics of the later prophetic books; it becomes, in fact,
their very basis. In Eternity the senses are as comprehensive as
the universe itself.

Let the Human Organs be kept in their perfect Integrity,
At will Contracting into Worms or Expanding into Gods,
And then, behold! what are these Ulro Visions of Chastity?
Then as the moss upon the tree, or dust upon the plow,
Or as the sweat upon the labouring shoulder, or as the chaff
Of the wheat-floor or as the dregs of the sweet wine-press.
Such are these Ulro Visions: for tho' we sit down within
The plowed furrow, list'ning to the weeping clods till we
Contract or Expand Space at will; or if we raise ourselves
Upon the chariots of the morning, Contracting or Expanding Time,
Every one knows, we are One Family, One Man blessed forever.

Los and Enitharmon, before their senses became fixed, had the
power

At will to murmur in the flowers, small as the honey bee;
At will to stretch across the heavens and step from star to star.

But with the Fall the senses become shrunk and fixed, and re-
veal or create a world of time and space, a world of forms
mortal as the body personal has become mortal. In its fallen
form, perceived by the organic senses, the cosmos shrinks and
hardens and darkens. The once spiritual body appears as the
body of death. We read in *Jerusalem* of

. . . the outside surface of the Earth,
An outside shadowy Surface superadded to the real Surface,
Which is unchangeable for ever & ever.

This incrustation over the earth parallels a similar incrustation
over the spirit of man. Milton, speaking under inspiration, says
of the negations imposed through the ages by the spectrous
mind:

This is a false body, an Incrustation over my Immortal
Spirit, a Selfhood which must be put off & annihilated away.

The idea of a temporal and unreal incrustation upon the
immortal spirit, superinduced by the Fall, was entertained,

among many others, by Plotinus. On the one hand he imagined a "lovely soul," a soul which "is all Idea and Reason, wholly free of body," a soul which enjoys "a graciousness native to it and not foreign," and upon which rests "this grace, this splendour as of light"; while on the other hand he portrayed an "ugly soul," one which had deserted what it ought to contemplate, a soul dissolute, unrighteous, devoted to things base and perishable. This fallen soul has gathered about it an ugly and alien incrustation.

What must we think [Plotinus asks] but that all this shame is something that has gathered about the Soul, some foreign bane outraging it, soiling it, so that, encumbered with all manner of turpitude, it has no longer a clean activity or a clean sensation, but commands only a life smouldering dully under the crust of evil; that, sunk in manifold death, it no longer sees what a Soul should see, may no longer rest in its own being, dragged ever as it is towards the outer, the lower, the dark?

An unclean thing, I dare to say; flickering hither and thither at the call of objects of sense, deeply infected with the taint of body, occupied always in Matter, and absorbing Matter into itself; in its commerce with the Ignoble it has trafficked away for an alien nature its own essential Idea.

If a man has been immersed in filth or daubed with mud, his native comeliness disappears and all that is seen is the foul stuff besmearing him; his ugly condition is due to alien matter that has encrusted him, and if he is to win back his grace it must be his business to scour and purify himself and make himself what he was.

So, we may justly say, a Soul becomes ugly—by something foisted upon it, by sinking itself into the alien, by a fall, a descent into body, into Matter.

Blake differs from Plotinus only in believing that nature, as well as the individual, would cast off the unreal incrustation which had been "foisted upon it." At the time of the birth of Christ the impulse toward regeneration and release has gathered such momentum that Los can say:

. . . Even I already feel a World within
Opening its gates, & in it all the real substances
Of which these in the outward World are shadows which pass away.

But the consummation of this vision must wait upon a Last Judgment.

Metaphysics come alive in drama when we find that this husk and covering—this body of death—is woven by the Daughters of Albion. That the Daughters should have this function is entirely logical, since the feminine powers which weave the spiritual body in response to thought are also the regents of sense. What man believes he sees. Sitting within the Mundane Shell the Daughters of Albion weave the senses into narrow forms, and as they weave the senses, "so shall they fold the world."

> And sometimes the Earth shall roll in the Abyss & sometimes
> Stand in the Center & sometimes stretch flat in the Expanse,
> According to the will of the lovely Daughters of Albion.
> Sometimes it shall assimilate with mighty Golgonooza,
> Touching its summits; & sometimes divided roll apart.
> As a beautiful Veil: so these Females shall fold & unfold
> According to their will the outside surface of the Earth,
> An outside shadowy Surface superadded to the real Surface,
> Which is unchangeable for ever & ever.

This manipulation of the world in accordance with perceptions raises a number of interesting problems. Is this incrustation merely a mental vision or is it really there? Was the world actually made over in inferior physical forms at the time of the Flood, or was it only the perceptions that degenerated? And if the incrustation—the "serpent bulk of Nature's dross"—is there, how can that false world which is Satan's empire be called "the empire of nothing"?

III

Let us look at the problem in Plotinus. In his world of the Divine Mind—the world of reality—the reality perceived is "neither thought nor thing, but the indissoluble union of thought and thing, which reciprocally imply each other." This fact of reciprocation holds also in the world of sense, but in that world, where there are clouded apprehensions, there are clouded objects. "A feeble contemplation creates a feeble object of contemplation." The illusions of matter intervene. If these illusions

were known to be illusions, and kept their place, there would be little trouble. "Now it may be observed," says Plotinus, "that we cannot hold utterly cheap either the indeterminate, or even a kind whose very idea implies absence of form, provided only that it offer itself to its Priors and (through them) to the Highest Beings." Generation, as Blake says, may rise into regeneration.

The half-blinded spiritual faculty [says Dean Inge], the clouded perception, and the shapeless indeterminate object all "desire" to rise together into a clearer light, where all three will be transformed. From this it might be inferred that matter, as an object of thought, is nothing more than a delusive appearance, which vanishes, as such, when the Soul is "awake." Plotinus would accept this statement; matter has no reality; but the activity of the irrational soul which produces these phantasms is none the less a fact. In denying reality to matter, we do not affirm that it is absolutely non-existent.

This, I believe, is precisely the Blakean position.

In the passage just quoted from Dean Inge, the source of these delusive natural appearances is traced to the activity of the irrational soul. Soul is a term of which Blake makes little use. He would say, with no real change in meaning, the activity of the irrational mind. If, sometimes, we find the responsibility for the material illusion placed upon the perceptions (the Daughters), and sometimes upon the mind (Urizen), there is no real inconsistency. For in Blake's system mind and perceptions are always in correspondence; the perceptions are, indeed, begotten by the mind. As a man thinks, so does he see. In Plotinus, says Dean Inge, "the difference between sensations and spiritual perceptions is one of degree; sensations are dim spiritual perceptions, spiritual perceptions are clear sensations." The parallel with Blake is exact. The final cause, then, of the material illusion is in mind, not matter. The soul wrestles with itself, not with some foreign foe. There was nothing about which Blake was more concerned than this. From the beginning he absolved matter. As an epigraph to the *Four Zoas* he inscribed a verse from the Epistle to the Corinthians: "For our contention is not with the blood and the flesh, but with dominion, with authority, with the blind world-rulers of this life, with the

spirit of evil in things heavenly." As for the bugbear of matter—
"what is called corporeal, nobody knows of its dwelling place;
it is in fallacy, and its existence an imposture. Where is the
existence out of mind or thought? Where is it but in the mind
of a fool?"

Matter began its spurious existence in the mind as Albion
began to fall. He moved from the inward into the outward,
the feminine, and the natural; he believed in it; he even set
up the passive feminine, in its various aspects, as his ideal of
good. In doing so he moved into darkness and doubt, for, as
Plotinus says, "The unbelieving element is sense; it is the other,
the Intellectual Principle, that sees." At the same time he con-
ferred upon the feminine a spurious life and independence.
Enion found, when she first wove the web of nature, that it
was "perverse and wayward," with a will of its own. Out of this
feminine self-assertion come the Daughters of Albion, who weave
the perceptions as narrowly as possible, and fold the world ac-
cording to their will. But that will or power—an irrational thing
—was conferred upon them by the irrational mind. A falsity it-
self, it was created by a falsity. The unlit matter which the
Daughters fold is the product of an unlit soul. It would vanish
if the soul were "awake."

Meantime, while the soul remains asleep, the corporeal body
"exists" as a falsity, an illusion. It has no metaphysical reality.
It is the equivalent in the physical realm, of evil in the moral
realm. Evil too is a fact of experience, but it is not real. It does
not participate in the only good. Evil and matter—both of
them—will be consumed when men cease to behold them.

Though the temporal and natural body is unreal, there is
and was and always will be the eternal body of Albion, com-
pounded of some heavenly or ethereal matter, and hidden under
the hard incrustation apparent to the "vegetable eye." This in-
crustation is no mere illusion of the organic senses. It is a hard-
ening and darkening of the cosmic body comparable to the
hardening and darkening of the personal body. The constric-
tion of the one is no less literal than that of the other. Both
are the result of a hard, constricting force ever at work, "fixing"
the temporal forms which we know. Did not the cosmos share

in a blighting negation, it need not share with man in a Last Judgment. Yet Blake submits it to one, most thoroughgoing. After all, logic demands that the cosmos share in the fate of man. There is in Blake's scheme no external God to fashion a universe in accordance with his will. There are only the incomprehensible Zoas, at present in a state of contrariety. As the Zoas fall, the physical world undergoes changes correspondent to those in the spiritual world. The Fall is so allegorized. The Divine Vision is replaced by the "dark religions"; the eternal world by the mortal world. Enion in her temporal state is the mortal body that "originated with the Fall and was called Death and cannot be removed but by a Last Judgment." As Albion sinks into doubt and unbelief, she descends, as a mental concept, from her spiritual and immortal state as far as nonentity itself, that blank, invisible, intangible, basic matter of ancient metaphysics. Actually nature never reaches this level. Yet the possibility remains as a terrifying vision. To prevent it Urizen hastens to build the Mundane Shell. When that fails, the Elohim take up their work and Los begins his task of "fixing" in nature the diminished influx from the spiritual world. Enion is formed into imperfect bodies under the impact of imperfect vision—bodies born only to die. In this rôle she becomes the "dark consumer," an "eternal consummation," the purveyor of Los's "vegetable fires." But as all things are redeemed in Christ, his advent brings to Enion the hope of release. With the success of Los's regenerative efforts, she looks forward to deliverance from the "bondage of corruption." She takes heart from the voice of the furrowed field speaking to her in the grave:

> Behold the time approaches fast, that thou shalt be as a thing Forgotten: when one speaks of thee, he will not be believ'd.

The activities of the masculine and feminine contraries which create the material illusion and drive Enion into Death come out dramatically in the relationship between Urizen and Vala. Since Vala is the personification of the "selfish virtues of the natural heart," she is the spiritual fact behind temporal nature, the self-righteous state of the soul without which nature would

never have lost its eternal and spiritual aspect. She is in this
respect the Goddess Nature, the veritable empress of the fallen
world, even of Urizen, its God, whose secret holiness she per-
sonifies. It is because of Vala's selfish dominion over the mind
that temporal nature is engendered; it is for her deification that
it continues to exist. But nature, in the sense sometimes attrib-
uted to her, she most emphatically is not. The rôle of the phys-
ical universe as it is organically perceived must go to Enion.
Seen as a whole, nature is Blake's "maternal humanity." In it
every one of the four feminine Zoas has a part. They bear to
each other the same mystical relationship of head, heart, loins,
and body as do the masculine Zoas. In this relationship Enion
is the physical body, the apparent universe; Vala, the hidden
heart, the selfish feminine virtues of the natural man.

But Vala's cruel ethics and Enion's cruel Nature, which
emerges from those cruel ethics, would be consumed if they
were not sustained by the mind of Urizen. He is the primal
fact in the situation. For that reason the fortunes of nature
follow the fortunes of Urizen. At the height of Urizen's illumi-
nation, nature is the unified body of man. When, no longer the
"servant . . . of inspiration," he begins his great period of
rational activity and the pursuit of a rational good, the physical
cosmos is set off from man, and takes on a separate existence
as nature, retaining, however, something of its former glory.
When his activities lead him into a belief in good and evil and
vengeance for sin, nature takes on the death and decay of mat-
ter. When, by denying intuition and depending upon the senses,
Urizen sets the temper of Blake's own age, nature achieves her
triumph. The ancient spiritual universe appears as a material
monism.

On the subject of death and decay, which characterize the
"unlit" matter of the vegetable world, Plotinus has an inter-
esting observation. Decay, he says, is "a process implying a com-
pound object; where there is decay there is a distinction between
matter and form." This very conception must, I think, have
been entertained by Blake. It is not until a dual universe has
been achieved that death and decay make their appearance.

They come into being with Los's Generative world, in which the sexes are separate, in which good and evil struggle with one another, and Tharmas and Enion are known as distinct and antithetical principles. In the world as it is reshaped after the Flood, not only are form and matter regarded as distinct, but the one is felt to be living, the other dead. Yet both contribute their characteristics to the physical world. Mortality is the logical outcome of their union.

IV

In the mirror of nature, therefore, man may see the very image of his own soul. There also he may discern the entire temporal cycle. As a "vision of the science of the Elohim," nature mirrors the selfhood which pulled man and the cosmos down, and since Los, the redemptive agent, is "of the Elohim," it mirrors also the gradual renunciation of self which will pull it up. It must be admitted that Blake's eye was more sensitive to the downward than to the upward swing. Plotinus quarreled with the Gnostics on account of their disparagement of nature's beauty, and he would have quarreled with Blake. Plotinus inherited the Greek tradition, Blake the Christian and the Gnostic. Looking into the mirror of nature, he often found that the need for release outweighed the early prospect for release. The pace of regeneration irked and chafed his ardent spirit. The drawings render the redemptive elements more often than the poems do; but in both, the selfish and downward cycle seems to preponderate. Enion foretells the end, but her mind soon reverts to the suffering present:

As the seed waits, Eagerly watching for its flower & fruit, . . .
So Man looks out in tree & herb & fish & bird & beast,
Collecting up the scatter'd portions of his immortal body
Into the Elemental forms of every thing that grows. . . .
In pain he sighs, in pain he labours in his universe,
Sorrowing in birds over the deep, & howling in the wolf
Over the slain, & moaning in the cattle & in the winds,
And weeping over Orc & Urizen in clouds & flaming fires:
And in the cries of birth & in the groans of death his voice
Is heard throughout the Universe. Wherever a grass grows,

Or a leaf buds, The Eternal Man is seen, is heard, is felt,
And all his sorrows, till he reassumes his ancient bliss.

Since the whole cosmos fell, and is swinging round the cycle
in the agonies of generation and regeneration, the spectacle of
nature is as complicated to the inner eye as to the outer one.
The chain of being has often been conceived as rising from the
mineral, vegetable, and animal realms through man and various
supramundane existences to God. Blake's vision was less elab-
orate and categorical, but some such vision, nevertheless, he en-
tertained. The Eternals, looking down upon the world of time
and space, exclaim in *Milton*:

> . . . How are the Wars of Man, which in Great Eternity
> Appear around in the External Spheres of Visionary Life,
> Here render'd Deadly within the Life & Interior Vision!
> How are the Beasts & Birds & Fishes & Plants & Minerals
> Here fix'd into a frozen bulk, subject to decay & death!

The various elements of the cosmos have fallen in just grada-
tion and degree to form a chain of being that ranges from stars
to stones. Plotinus has a passage that must have delighted Blake
if he came across it. "In the case of a soul," he says, "entering
some vegetal form, what is there is one phase, the more rebel-
lious and less intellectual, outgone to that extreme." The "more
rebellious" is a most suggestive phrase. Is not the extreme of
rebelliousness—of selfishness and pride—to be seen in the dark
rocks which dominate the landscape in some of the Job illus-
trations?

> Furious in pride of Selfhood the terrible Spectres of Albion
> Rear their dark Rocks among the Stars of God.

Swedenborg made the mineral, vegetable, and animal kingdoms
correspond to the three faculties of man. Blake does not go so
far as that, but some particular phase and degree of fall may
be associated with rock and sand, thorns and briars, moles and
spiders, some particular phase of regeneration with the cater-
pillar and the lark. Such associations are made in the *Auguries
of Innocence*:

> The Bat that flits at close of Eve
> Has left the Brain that won't Believe.
> The Owl that calls upon the Night
> Speaks the Unbeliever's fright.

The two contending forces which operate within the cosmos
—the one which carries it down and the one which would lift
it again to its pristine state—are personified in Urizen and Los.
Theirs is the never-ending world war, a spiritual war which
cannot cease until it is settled right. As long as that war goes
on, there can be no lasting corporeal peace. There can only be
the terrors of Leviathan and Behemoth—"the war by sea enor-
mous and the war by land astounding." That these terrors are
themselves the creation of the mind which fears them subtracts
nothing from their power to confound. Readers familiar with
the Job illustrations will remember how these monstrous ap-
paritions are the subject of a lesson in spiritual vision on the
part of a kindly Jehovah (the God of Beulah) to Job and his
wife. They may also have remarked the sly humor of Behemoth
and Leviathan. Though illusions, Blake has made them sharers
in the colossal joke of their success as realities. This fifteenth
illustration is perhaps the finest of all Blake's comments on the
philosophy of materialism. In it we have not only his ironic
criticism of a belief in corporeality but also his deeper convic-
tion that in the scheme of salvation all such erroneous beliefs
become by their very embodiment instruments of their own
destruction; for, to quote from the marginal texts, "Behemoth
is chief of the ways of God." It is a belief which Blake repeats
in many forms, but never more clearly than when he writes
that Los labors in the hope

> That he who will not defend Truth may be compell'd to defend
> A Lie, that he may be snared and caught and snared and taken.

In a fine passage in *Jerusalem*, Behemoth and Leviathan are
called the pillars and pyramids of the Spectre's pride. As the
pyramids and pillars are broken by the blows of Los's hammer,
the Spectre's eyes and ears are unbound. The destruction of his

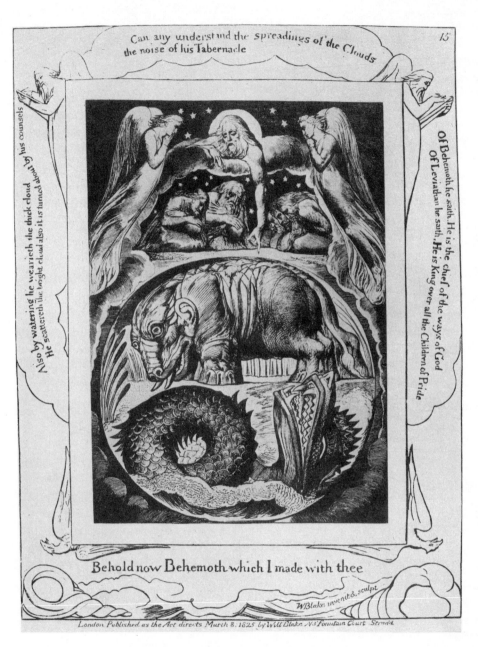

ILLUSTRATIONS OF THE BOOK OF JOB, PLATE XV

colossal labors (for Behemoth and Leviathan are the work of the Spectre) exposes their falsity, and so leaves the Spectre a disillusioned figure, ready now to hear and to see. "Go, put off holiness and put on intellect," thunders Los, as he hammers the pillars to dust. It is Blake's familiar indictment of the Satan "who exalteth himself above all that is called God or is worshipped." Back of these false systems of thought he sees the self-righteousness which he attributes alike to the Druids, the Greeks, and the Deists, an arrogance of the rational mind essentially blasphemous, for it is founded on doubt, and it exalts the self and not God.

Yet it would be unfair to Blake not to say that his own mental arrogance is tempered by sympathy for the Spectre. That worthy must be subdued, but Blake had wrestled with him too long not to respect him as an antagonist. There are not many finer passages in the prophetic books than that in which Blake, pitying the Spectre's intellectual humiliation, expresses his understanding of the woe engendered somewhere in the breast of man whenever a cherished cause is lost. The Spectre, watching his work fall under the blows of Los's mighty hammer, saw that

> . . . all his pyramids were grains
> Of sand & his pillars dust on the fly's wing, & his starry
> Heavens a moth of gold & silver mocking his anxious grasp.

His universe is that illusory empire of nothing over which Satan is king. It cannot stand before truth because it is based upon the mistaken conception of good and evil. But tremendous energy has gone into its making, and that vast outpouring of energy, misused though it has been, Blake respects. The lines just quoted are his salute to the enemy he hopes he has vanquished.

v

The complete cycle embraces the four degrees of vision. These have been mentioned from another point of view, but it is with relation to nature that Blake speaks of them, and in this relationship they must not be overlooked. Blake enumerates them in a poem to Mr. Butts:

> Now I a fourfold vision see
> And a fourfold vision is given to me;
> 'Tis fourfold in my supreme delight,
> And threefold in soft Beulah's night,
> And twofold Always. May God us keep
> From Single vision, & Newton's sleep!

Single vision is of the outward, feminine, corporeal world, and of that alone. The inner spirit is asleep. Perception is passive, as upon a white sheet of paper. One of the Hermetic writings, lamenting the deterioration of the eyes and the loss of "real sight," exclaims: "Windows they are, not eyes!" Single vision is window vision. It sees the body which is nature (Tharmas and Enion) and sees it falsely. Seen rightly, with fourfold vision, this body is spiritual; under single vision Tharmas "the angel of the tongue" becomes "the devouring tongue." The corporeal body is the abode of corporeal morality, and the tongue therefore demands "its sacrifices and its offerings,"

> . . . even till Jesus, the image of the Invisible God
> Became its prey.

Twofold vision brings spiritual perception into play. The object is now seen within and without. It is both itself and a symbol. " 'Twas outward a sun, inward Los in his might." The symbol need not be rationally deduced, as it tends to be in Swedenborg; it may be merely the product of the poet's fancy. A frowning thistle, for example,

> With my inward Eye 'tis an old Man grey;
> With my outward, a Thistle across my way.

Swedenborg wrote an account, too long to quote, of nature as a picture of regeneration. He saw the process in the flowers of spring and the fruits of summer, in showers of rain, in the colors of the morning before sunrise, in the continual renovation within the body. This is double vision, a correlative of the sexual world of Generation. The object, outward and corporeal, is feminine; the imaginative image is masculine. Both assert themselves, each challenging the other's right. The world of Generation might indeed be thought of as a training school in

vision. It may slip back into Ulro, or ascend to Beulah. This is Los's world, the world of the loins, twofold and sexual; corporeal, yet struggling to be spiritual.

Since there is no chasm, in Blake's system, between man and nature, the struggle toward regeneration in the natural world must be thought of, equally with the struggle in the spiritual world, as the work of Los. Los with his hammer vehemently constricting, hardening and fixing, eternally creating only to destroy the false work he has created, is Blake's dramatization of the process as he saw it constantly at work. For destruction is as essential as creation. For this reason the natural world is cast in mortal form. Death and decay are its attributes. Its vegetable life, like Los's systems, is "continually building and continually decaying." The invisible fires in which these vegetable forms consume are the fires of vegetation or generation which also light the furnaces of Los. Just as the soul of man is purified in the "furnaces of affliction," so is the physical world destroyed and renewed in the fires of "generation or vegetation." The necessary change is in both cases accomplished by death in fire.

When the struggle is over, and the world and all that is therein can be seen, calmly and assuredly, as the manifestation of spirit—then the soul has arrived at threefold vision and soft Beulah's night. This is the level which corresponds to the higher region of Plotinus's world of Soul, which is close to the Divine Mind, where the Soul "takes fulness by looking to its source." The transmutation of nature in terms of spirit is a well-known mystical experience which has often been vividly described. There is a passage in *Milton* in which Blake attempts to portray in natural imagery the character of Beulah, but he never expressed the vision in words as well as Plotinus did in a passage which I will quote.

Quiet must the imprisoning body be for her, and the wave of the body's passion: let all things likewise be quiet that lie about her. Quiet let the earth be, quiet the sea and air, and the heaven itself pausing the while. Then into that unmoving firmament let her conceive Soul flowing in, poured in like a tide from without, from all sides invading it and filling it with light. As the rays of the sun

enlightening a dark cloud give it the look of gold and set it all agleam, so did the Soul, entering into the body of the heaven, awaken it from its supineness and give it life and immortality. And thus the heaven, taking from the rational guidance of Soul its everlasting movement, became a blessed living thing. It gained worth when Soul became its guest: before Soul came it was no more than a body without life, no more than earth and water; nay, in strictness, it was but the darkness of Matter, the Unreal, "that which the gods abhor," as a poet has said.

In this way, time after time in the history of the mystical experience, has a world, which to the eyes of sense is unintelligible, been transmuted before

> . . . an eye made quiet by the power
> Of harmony, and the deep power of joy,

an eye that sees "into the life of things."

The supreme delight of fourfold vision transcends the Beulah level, at which I have placed Wordsworth's experience. But the third step—the one which transmutes sense to soul—is the decisive one. "The soul once seen to be thus precious, thus divine, you may hold the faith that by its possession you are already nearing God; in the strength of this power make upwards towards him; at no great distance you must attain; there is not much between." In Blake's imagery Beulah is in sight of Jerusalem, for, as Messrs. Sloss and Wallis have pointed out, Beulah, in addition to being "marriage," is also in the *Pilgrim's Progress* a

sweet and pleasant country beyond the valley of the Shadow of Death, and also out of reach of the Giant Despair; neither could they from this place so much as see Doubting Castle. Here they were within sight of the City they were going to; also here met them some of the inhabitants thereof; for in this land the Shining Ones commonly walked, because it was upon the borders of heaven.

In fourfold vision the eye sees as it sees in Eden. Corporeality has been utterly consumed in mental fires. Blake's visionary hours were frequent. Visionary seeing became almost habitual. He could say, with a little exaggeration:

I assert for myself that I do not behold the outward creation, and

that to me it is hindrance and not action; . . . "What," it will be questioned, "when the sun rises, do you not see a round disk of fire somewhat like a guinea?" O no, no, I see an innumerable company of the heavenly host crying, 'Holy, Holy, Holy, is the Lord God Almighty.' I question not my corporeal or vegetative eye any more than I would question a window concerning a sight. I look thro' it and not with it.

The ecstatic fourfold vision of the universe sees it as a man. Blake had such a vision one morning by the sea at Felpham.

> . . . Each grain of Sand,
> Every Stone on the Land,
> Each rock and each hill,
> Each fountain & rill,
> Each herb & each tree,
> Mountain, hill, earth & sea,
> Cloud, Meteor, & Star
> Are Men seen Afar.

When the ecstatic vision falls across a naturally energetic nature, like William Blake's, it orders and multiplies that energy. There is no longer the frustration of doubt, no longer the sense of futility. The tortures of repentance are "on account of our leaving the Divine Harvest to the enemy." The one satisfaction is in the building of Jerusalem. Every destruction of error, every revelation of truth, like every stroke of Los's hammer, advances the Judgment Day. In Blake's opinion, as in St. Paul's, the Creation waiteth for the revealing of the Sons of God. When that revelation shall have been made the Creation also will be delivered from the bondage of corruption. No wonder that Blake felt the making of a set of handscreens to be incompatible with his duty to the Eternals. As one commanded from heaven, he was himself a shaper on a cosmic scale.

VI

As a conclusion to this chapter a few words may be said about Blake in his relation to Wordsworth. James defends Swedenborg against the charge of either idealism or pantheism. Dean Inge defends Plotinus against the charge of pantheism. Blake's position is a little more difficult. One's conclusion would rest,

as I see it, on the interpretation of the dark world of Urthona. But one thing is certain. A natural monism, or any world that would have seemed to him a natural monism, however it might be denominated, was anathema to Blake. To see this ruined world, this gross natural body of death and decay which confines the immortal spirit in man and nature, this incrustation upon the true body of nature—a "shadowy surface" which is no less than a living tomb, where life lives upon death—to see all this as the expression of the Divine Vision was a tragic mistake. To see it with "single vision," as complete and satisfying in itself, and not with the symbolic value of "double vision" was to make the position of doubt and self-righteousness well-nigh impregnable. For nature does not live by imagination any more than man does. Gleams of it she has, as man has; but the life of both is predominantly dark and selfish. Beauty nature has, as Blake well knew; but his favorite epithet for beauty is "delusive"—delusive because of its power to seduce the beholder into complacency, even rapture, about nature as she is. It might fold wings that needed to expand. It is for this reason that Los dares not approach the lovely Daughters of Albion. He remembers, no doubt, that the delusive beauty of Vala and of the web of nature which Enion spun were incentives to the Fall.

It is from considerations of this sort that Blake's doubts of Wordsworth arise. Certain of Wordsworth's poems, it is true, seemed to him "the work of divine inspiration," and the author of them "the greatest poet of the age." But there is a strain in Wordsworth which arouses Blake's distrust. The idea of "natural piety" suggests Natural Religion, the basic error in Blake's system. Is Wordsworth a Christian, Blake asks Crabb Robinson, or no better than a pagan? In the margin of his Wordsworth he writes: "I see in Wordsworth the natural man rising up against the spiritual man continually, and then he is no poet, but a heathen philosopher at enmity against all true poetry or inspiration." Even when the two poets are most nearly in agreement there are important differences between them. The one tends to ignore the cruelty of nature, the other to exag-

gerate it. In theory, Blake's vision of nature should be rounded and complete, a mirror of the Devil, who pulled man and the cosmos down, and of Christ, who swings the cycle up. In practice he was more conscious of confinement than of release. Wordsworth's nature approximates a nature that in Blake's view has been and will be again, but is not now. To suppose that nature has not fallen along with man, and to make no distinction between temporal nature and eternal nature, was in Blake's opinion to support the continuance of all things temporal. I pass no judgment on the matter; I merely state the case.

XIV

Conclusion

Listen to your Watchman's voice: sleep not before the Furnaces.
Eternal Death stands at the door.

Jerusalem, p. 83.

Will you keep a flock of wolves & lead them? . . .
Will you erect a lasting habitation in the mouldering Church yard?

Four Zoas, Night VIII.

THE foregoing chapters have analyzed the thinking that lies
behind Blake's symbols, and have stressed the ancient tradition
in which it had its source. While this analysis has brought a
high degree of coherence out of apparent chaos, it has related
the thinking to the ancient rather than to the modern world.
Such an emphasis is unfortunate, for once the ideas are seen
apart from symbol and tradition, their significance for the pres-
ent time becomes apparent. It is beyond the capacities of the
present writer and beyond the scope of the present work to
undertake any evaluation of these ideas. Description must suf-
fice, and must at the same time be rapid and selective.

Under analysis certain essentials of Blake's thought are found
to be the familiar tenets of idealism: the conviction that appear-
ances are not reality; that the findings of the rational mind alone
are not sufficient, and that intuition is a prime source of knowl-
edge; that mind informs the natural universe, interpreting or
creating it in its own likeness; that the cosmic mind is in cor-
respondence with the mind of the individual; that reality is
mental. But Blake does not leave the matter there. He carries
idealism to the point of mysticism. The individual mind and
the universal mind are identical in nature, the supreme experi-
ence is ecstasy, the good life is unitive. The life of union, how-
ever, is not passive; it does not consist, or at least but partially,

in contemplation. Its main concern is in helping to build the New Jerusalem.

What, then, is this life, individual and collective, in which the New Jerusalem finds embodiment? First, it is a life lived from within. There alone are the vision, the faith, the energy, the capacity for self-sacrifice, by means of which Jerusalem can be built. It cannot be built by the virtues which reside in the outward principle, in distrust or denial of these inward virtues. Reason divorced from faith and intuition; emotions, well-intentioned, perhaps, but ungrounded in the higher intelligence which alone can render them effective; the selfishness of the natural man not broken and transmuted by the divine vision of all men as brothers—these faculties will not suffice. This is the essence of the Blakean message. It is a commonplace among the prophets, but it is prophetic folly to a world bent upon wandering in the wilderness.

In his earlier years Blake shared the vision of perfectibility which dazzled the eyes of the idealists of that idealistic generation. But he saw their dream of an earthly paradise come to grief upon the rock of an unregenerate will. "Tyrants rushed in and did divide the spoil." Even had the ideal been sounder than it was, the world was not yet ready; defeat was inevitable in the reaction of the natural man. For the earthly paradise cannot come—or last—unless it is freely willed. It cannot be imposed upon a recalcitrant spirit. A world living in the outward principle, yet seeking, as it ever must, inner and spiritual values, seeks them in vain by the means at its command. The natural and selfish reason relies mainly upon force, supplemented by secrecy, pretense, and expediency. The natural and selfish emotions, falling an easy prey to false idealism, generate the will to power instead of the will to serve. The Kingdom of Heaven has ever been sought by violence.

> And mutual fear brings peace,
> Till the selfish loves increase;
> Then Cruelty knits a snare
> And spreads his baits with care.

Presently, as the *Human Abstract* goes on to say, the shadow of the Tree of Mystery darkens the earth.

Blake analyzes the situation with some subtlety. He sees in the efforts of the outward and natural man toward inward and spiritual ends a condition which he calls hermaphroditic. The term denotes a checkmate and consequent sterility by reason of mutually contending forces. In the ethical world, for example, it is a condition of "love and jealousy immingled." The Christian Church is sometimes called hermaphroditic because it preaches, but hardly dares to practice, the forgiveness of sin; and again because it proclaims peace yet surrenders to war. The League of Nations would furnish an apt example. It, too, seeks peace, but by means of "mutual fear," its ideal of "love" and federation belied by "jealousy" and national ambitions.

The trouble is twofold. The mind and the emotions are both at fault. The mind which is operative in this world is mainly that lower reach of intellect, that "dweller in outward chambers," which, having little contact with the inner essential and imaginative man and having therefore little or no sense of man's infinite consanguinity, builds its world around the individual, or at least around a class. Even if this reason has gleams enough of imagination to desire enlightened ends, it is self-inhibited from employing enlightened means. Blake's quarrel with reason is purely with this selfish, constricting reason. His good life is founded upon "thought," which is the higher, or imaginative, reason. Allied with imagination, reason's function would be to give form and substance to the dream. Allied with self, it finds reasons for believing the dream impossible.

In the mortal world of Blake's system the emotional life is always in correspondence with the self-seeking reason. The emotions therefore come under as much criticism as the mind. Blake is no sentimentalist, shutting his eyes to inconvenient facts, deluding himself that all is well when right reason insists that it is not. He had a remarkable ability to face the facts and to apply to himself, as well as to others, his own uncompromising judgments. Nowhere is there greater insistence that even well-intentioned emotions may be of no avail—may even be an

active menace. A "polypus of soft affections without thought or vision" is Blake's abhorrence. Grounded in right thinking the emotions would be the motive force in building the New Jerusalem. Grounded in wrong thinking they create Babylon—a life of passion and prejudice, at once blind and cruel, enslaving even the mind which originally begot them.

If the selfish mind and the selfish emotions had their way, they would arrive at a static coercion which in Blake's view would be a state of eternal death, since it would be a negation of the divine energies. But man is so constituted that he cannot endure that state. Enlightened thinking and enlightened feeling continually reassert themselves, and these forces of enlightenment are joined in times of stress, as Blake points out, by unenlightened forces—the dark, rebellious passions. For no social form can offer peace unless it is grown organically, from within outward, like flower from stem. The attempt to impose a rationally and selfishly begotten form, like a bed of Procrustes, upon an unwilling spirit, mangles the victim. Strife and violence, crime and warfare, are the inevitable consequences of a life in which the immortal energies are diverted from creative ends into the impasse of negation.

Such is the outward way of life, the way of a world shut up in corporeal desires, possessed by fear and dominated by the selfhood. In contrast to this is the inward way, relying upon imagination and resulting in social brotherhood.

It should be observed that brotherhood is Blake's word, not love. Love, like pity, is often spoken of in terms of criticism and distrust. For it is likely to become a mere "polypus of soft affections," a soft network of entanglement, extinguishing the life which it so tenderly embraces. It is even likely, in the pursuit of its delusive ends, to turn to hate and cruelty. Brotherhood, on the other hand, is rendered safe because it is informed by intellect. The basic principles of the informing intellect are these: There is no other God than he who is immanent in his creatures. Every man, therefore, is or may be a temple of the Holy Ghost. This Holy Ghost within him is his genius, his individuality; it is the essential One becoming Many. It is there-

fore to be honored equally in oneself and others; there is to be perfect toleration. Even more. This indwelling spirit is not pure and holy, incapable of sin; error and mistake are inevitable, both in ourselves and others, and selfhood—the potential devil in us —is an ever present danger. These faults, when they arise, must be forgiven. The strong man must recognize in the weakness of his fellows qualities potential in his own nature and accept the burden of sin, as Christ did, forgiving it.

The skeptic might object that the liberty of Blake's ideal world is anarchy. But no one who has accepted the postulates of the system would hesitate here. The principle of unity in that world is as strong as the principle of separation. It is in this respect an exact analogue of Plotinus's world of the Divine Mind, in which the Many are at the same time One. Every man reverences another's genius equally with his own, since all genius is "the Holy Ghost in man." No other form of equality would seem to be acknowledged or demanded. At the same time, the selfish will, which is a source of strife in our world, is wanting there. Nor is there any dispute about an abstract scale of values. Nothing is self-righteously condemned because it does not conform to one's own identity. Every "minute particular" is holy. The symbol of this world is a human being—Albion— a vastly complex yet marvelously harmonious organism.

Doubtless there are many problems, social and economic, which Blake does not answer, and of which he had, indeed, no conception. His is the spiritual point of view. His faith would be that the illuminated mind of the regenerate man, free to work upon our social and economic problems unselfishly and imaginatively, could master them. And the poet may see a basic factor in the situation to which the economist is blind. Certain it is that contemporary economic Utopias are totally un-Blakean in character. They do not confer upon the individual that spirit- ual dignity which alone can bring salvation, individual or social. They do not permit the individual to manifest the universal im- agination in whichever of the infinite ways it may have chosen in his case. Men must be set marching; their faces must all point one way. They are social and economic units to be ordered and

directed to certain ends, ordered and directed with benevolent purpose, if you like, but this benevolence is precisely that kind which Blake called a pretense of love to destroy love. It is the path which Albion took as he began to fall. For an abstract benevolence, operating from without, soon turns, in the fury of its inevitable defeat, to vengeance. Men march—to the firing squad.

We may pass now to the individual, about whom Blake has more to say than he does about society. The point of view is, of course, the same. Strength and peace come from within. The Stoic wins these virtues, at heavy cost. The mystic wins them, often at still greater cost; the tradition of St. Simeon is a sorry chapter in the history of Christian mysticism. The revenges taken by desires not perfectly suppressed or sublimated often make the mystical strength a "strength girt round with weakness." But the Blakean strength is not based upon the suppression of desire. The good life is not ascetic. There is no denial of the sensuous life, no retreat, no immurement. On the contrary, the "doors of perception" are to be opened wide. The sexual instinct is not inhibited. Energy is the "only life."

In presenting a way of life that preserves the well-known mystical values, yet is at the same time manly, robust, and joyous, Blake makes a decided contribution to designs for living. And since its distinction lies in the liberation of the energies, some attention must be given to the problem of repression.

Blake's concern in the earlier writings with the sexual aspect of repression is well known. He is one of those who have sought to redeem and ennoble the sexual instinct. Defiance is hurled against the network of inhibition and prohibition. The demand is for perfect freedom. The mere insistence upon freedom does not carry us far toward the solution of the problem, and it is to Blake's credit as a thinker that his conception of the problem and its solution widens and deepens in the later writings. Even in the earlier work he was concerned about the repression of other than sexual desires. In the *Poison Tree* there is a powerful and rapid delineation of the progress of concealment.

> I was angry with my friend;
> I told my wrath, my wrath did end.
> I was angry with my foe;
> I told it not, my wrath did grow.

Concealment breeds malevolence and hypocrisy, and these soon deal spiritual death to protagonist and antagonist alike. In the later writings, where psychology and metaphysics have become more subtle and complicated, the problem of repression includes the whole range of desire. When Ahania (desire) is cast out by Urizen (the repressive mind), the effect is felt throughout the whole of man's fourfold life. Urizen, who had thought to strengthen himself by casting out desire, which he had come to look upon as subversive of his own dominion, is, ironically, rendered impotent. Thenceforth his activity is an exemplification of Blake's proverb that "the weak in courage is strong in cunning." It consists of negation—supported by pretense and hypocrisy and every kind of selfish machination. If this is the effect of suppressed desire upon the intellect, the effect upon the emotions is no less terrifying. Under an ethics of freedom and forgiveness, such as Blake believed had once obtained, the emotions corrected their excesses and mistakes in a natural and healthy way. But with the failure of love and forgiveness, and the consequent emergence of good and evil, the emotional life is divided against itself. The portion considered evil undergoes repression, but reappears as the demon Orc, the anarchist, the antichrist. The creative principle also shares in the general degradation. For the fires of the imagination require the fuel of experience—sense experience, emotional experience, and intellectual experience. When a portion of this sustenance is denied, the imagination is to that extent impoverished. The fourth principle, the body, also suffers from Urizen's condemnation of desire. For the struggle of good and evil within the mind results in the warfare of body and soul. In this warfare the body suffers under metaphysical contempt and physical asceticism. Thus the attempt to suppress desire breeds more evil than it cures. It is, in fact, one phase of the original sin itself.

Nevertheless, there is one restraint upon the Blakean liberty,

one sacrifice to be laid upon the altar. The selfhood must be "put off and annihilated alway." The selfhood doesn't really "belong"; it is a hindrance to the divine influx, a negation of every good endeavor. Death to self is proclaimed by all mystics as the price of entrance into the good life. But the energies need not die; having been sublimated at the source, they may be released for all kinds of imaginative ends. In fact, the energies are increased and multiplied by their emergence out of self into the bright and boundless world of the collective imagination.

The rationalist will object that this is a counsel of perfection, visionary and impractical because the nature of man is grounded in selfhood. As Urizen declares, at the outset of his decline, "The Spectre is the man; the rest is only delusion and fancy." This is the crux of the whole matter. If the nature of man is really grounded in selfhood beyond hope of regeneration, there is no real solution of our problems. Man must continue to muddle along, forever trying feverishly with the selfish rational arts at his command to save himself from impending chaos. Civilization must continue to be—what it has been described as being— a dance upon a tight rope drawn over an abyss. But that rope itself is an effect of imagination. The selfhood, as such, in Blake's myth, is negation. Its world is Ulro, chaotic and unlighted. Any rope or net or form is the result of some sense, however dim, of higher ends and a common good. These principles of cohesion deliver man out of Ulro into the world of Generation, which is an "image of regeneration." Is this as far as man can go? Does his basic selfishness restrict him to weaving nets to catch the wind? Or is the idea, of which the world of Generation is but an image, capable of realization? Blake's faith as a mystic tells him that it is. A similar conviction is the motive of Los's titanic labors. But Blake and Los were both haunted by a Spectre of doubt and fear. The round of error seems to be endlessly repeated, never broken. There is a note of apparent acquiescence in plain prose. "Many persons, such as Paine and Voltaire, with some of the ancient Greeks, say: 'We will not converse concerning good and evil; we will live in paradise and liberty.' You may do so in the spirit, but not in the mortal body, as you pretend,

till after the Last Judgment. . . . While we are in the world of mortality we must suffer. . . . You cannot have liberty in this world without what you call moral virtue, and you cannot have moral virtue without the slavery of that half of the human race who hate what you call moral virtue." That is to say: So long as society is a jungle of selfishness, the only possible liberty is within the moral law, but that kind and degree of liberty galls the idealist. This is the condition of the mortal world. When will this mortal world put on immortality? Only when the self-hood puts on imagination.

Meanwhile, the world being what it is, Blake adopted a way of life which many seekers of the good life in a bad world have adopted—the life of art. In this field of activity there is less selfish interference with another, more indulgence of the creative impulse and of individuality than in any other. And in this way of life what Blake called "mortal contingencies" can be disregarded, as Mrs. Blake well knew. In the *Laocoön* inscriptions art is put forward as the one and only good way of life; all other ways and all hindrances to that way are disparaged. But the term "art" is used in an esoteric sense, for Blake declares that Christ and his disciples were all artists. The logical justification of this assertion, if there is one, is that they directed their energies to imaginative ends. But it will not do to overemphasize a group of aphorisms inscribed upon a single plate. Blake is not an esthete. Los, the hero of the prophetic books, who is the real Blake, is not an artist except in the esoteric Blakean sense. He is at the very centre of the fray, hammering upon his anvil with the energy of Thor himself, breaking down the sterile forms which represent every phase of human activity, breaking them down in the hope of bringing the separated principles together again in a fruitful union. He is Blake's dramatization of the good life, lived from within, lived energetically, devoted in all its variety to imaginative ends.

But not even Los's energy is without pause. Times were frequent, even in Blake's life, when the visions did not come. Energy recedes, and has to be renewed in periods of repose. Blake's ideal life has therefore two levels, an upper and a lower

paradise; the one a world of energy and vision, the other a world of appearance and repose. Life alternates between them. This is the alternation which Professor Hocking has pointed out as essential to the mystical way of life. It has various aspects. "God becomes as we are," Blake said, "that we may be as he is." He might also have said that imagination becomes reason that reason may be lifted again to imagination; that the infinite becomes the finite that the infinite may be restored; that mind becomes phenomena that phenomena may become mind; that the One becomes the Many that multiplicity may be restored to unity. The level upon which one lives predominantly depends upon one's particular degree of strength. Blake's system does not make heroic demands of everyone. It permits a normal concern with the world and its affairs. It only requires that these be seen *sub specie aeternitatis*. It requires continual discipline of the selfhood. It requires that one make the mystical identification of oneself with others and of all with God; and that one should have faith in this identification when the immediate perception fades. He who is trying to live the good life after the Blakean pattern will have faith in the higher values, though he experience them but seldom, and when the vision comes he will cherish it as a precious moment. The good life must be built, by faith or experience, upon the qualities of imagination. To attempt to build it on the qualities of reason and sense is to reduce god-like man to a handful of dust.

In Los's continual destruction of human forms and formulations we find Blake's attitude toward the question of change, which vexes the contemporary world. In the good life—in Eternity—existent forms never become entangled with selfish interests. When a given form ceases to fulfill the purpose for which it was created, it dies a willing death in order that a new form may take its place. The ideal world is therefore a world of constant change, permanent only in the ceaseless activity of the imagination.

Only the imagination could conceive of or tolerate such a world. When reason takes command it allies itself, in Blake's metaphysics as in human experience, with outward forms and

selfish interests. When a Zion has been created which places
us at ease, we resist change and thank God that we are not as
other men. When a literary form shows signs of decay, we cling
to it desperately and decry innovation because the form was
significant to us when we were young, regardless of the fact that
it may not be significant to the younger generation now. Only
the imagination can accept a basic change. Reason seeks its
satisfaction in a static perfection. This was Urizen's ambition
when, possessed by a rising selfhood and a falling rationality, he
set out to find a "joy without pain, a solid without fluctuation."
The irony of this ambition is that it delivers the world into
hands of the enemy. This too, too solid world of rationality was
promptly challenged by Orc, the spirit of revolution.

Revolution is a terrifying thing, even to Blake; but he re-
gards it as a symptom which demands a careful diagnosis and
a cure. Repression only fans its flames. The portent of revolu-
tion is an indication that conservatism has been too long in-
trenched. "Drive your cart and your plow over the bones of
the dead" is Blakean political philosophy. Violence and despair
are the harvest of its disregard. The early prophetic books sug-
gest that Blake at first looked upon revolution as itself a cure.
This would seem to be the hope of *A Song to Liberty*. But with
the failure of the French Revolution he came to see that with-
out regeneration revolution must prove ineffectual. It only
establishes another form of selfish error, which will in turn re-
quire another revolution. Confronted with the fact that man
is not yet ready for liberation, Blake did not turn conservative;
instead, he developed a political philosophy in which revolu-
tion serves the purpose of the prophet in keeping alive the
vision until man is ready to receive it. Until regeneration shall
be accomplished, discontent must be kept alive. Orc's fires must
rage; Los's hammer must destroy and re-create and again de-
stroy.

The final purpose of the dreary round of error is the return
to truth. While error continues to repeat itself, the world is
engaged in an evolutionary drama, in which the forces of change
and ultimate salvation are in the hands of Orc and Los—the

passions and the imagination—while the resisting force is symbolized by Urizen. It is Blake's faith as a mystic that Los must eventually triumph. It is not man's destiny to remain forever as he is. Out of almost endless folly, wisdom must at last be born. Out of a long succession of generative forms, regeneration must at last emerge. So impregnable is this faith on the part of Blake that Los is specifically told that if he fails, a substitute must be created to take his place. But one need not be a mystic to believe that wisdom is in change. Professor Whitehead has recently told us that "no static maintenance of perfection is possible . . . advance or decadence is the only choice offered to mankind . . . the pure conservative is fighting against the essence of the universe." This political philosophy is sheer Blake, whose celestial paradise is always advancing or receding, never static, and has the zest, the adventure, the endless change of a world founded in imagination. To such a world man must return, and change—even violent change—may be necessary to regain it. So long as a world of error and a vision of perfection exist together, change must continue. Even blind experiment is preferable to blind acquiescence. It is better to wake and change beds in the dark than remain comfortably asleep.

Blake's system also bears upon the religious problem, which vexes the contemporary world less than it ought. Christ is the Saviour, but the saving quality of Christ is not to be found in the Christianity of the churches, which in Blake's opinion has become perverted and restored in greater or less degree to the Pharisaic legalism which it was intended to destroy. Morality will not serve, nor the moral law; these do not reach the core of the problem, which consists of the proud, self-righteous heart. The Christian is accustomed to remind God that he is the worst of sinners, but how often is that confession more than a verbal formula? In the Job series Job suffers more under the well-intentioned pity of his friends than under his physical sufferings. But he learns his lesson; he comes to see in the quality of their pity the quality of his own. Seeing this, he casts his self-righteous heart into the lake of fire. This is the one

thing necessary: the crucifixion of the selfhood—a little death in the divine image. Dying to self, Job rises to new life in the likeness of Christ. History shows how difficult a thing this sacrifice is. It requires the rare courage and the rare intelligence to indict oneself, to see in one's own selfish instincts the evil from which the whole world is suffering, to assume in one's own person a share of the universal burden, and to extend real forgiveness to the trespasses of others, even as one prays that his own may be forgiven. This is the spirit of brotherhood, and nothing less can save. Urizen tried to build a paradise—the Mundane Shell—in which the selfish instincts should be controlled by the moral law, but it fell to pieces. It must always be so. The reorganization of society on a basis of spiritual planning is better than the moral jungle of unmitigated selfhood, but it cannot provide the paradise of which Blake dreamed. The quality of mercy is not strained; if it does not fall like the gentle dew from heaven it has little revivifying power. This truth separates Blake's Utopia from those of his and our time, and makes its realization theoretically possible and practically improbable. Though his superior faith looks forward to social regeneration, Blake is under no illusion concerning the magnitude of the task. Changes in the external situation are stopgaps at the best. The Kingdom of Heaven is the sum of its Christ-like individuals. It grows in exact proportion as they multiply.

The hopefulness in an apparently hopeless situation lies in Blake's classification of mankind into three divisions. Setting aside Blake's own nomenclature, one may say that at the two extremes are the prophets and the priests, between whom lie the majority of people, who are indeterminate and might go either way. The priestly class—the Elect of Blake's system— are incapable of regeneration. Their pride and selfishness are incorrigible. Hope lies in the indeterminate middle. As things stand and long have stood, this class of people observe the little private paradise which their selfish neighbors build, and think to build one for themselves by the same means. That is to say, they ally themselves, out of ignorance rather than incorrigible

selfishness, with the priests, but they might be persuaded to join the prophets and help build the New Jerusalem. Ignorance, as well as selfishness, is a barrier to progress. That is why Los cries: "I care not whether a man is good or evil; all I care is whether he is a wise man or a fool." If the eye is opened, the heart is more easily subdued. Under some great prophetic movement this indeterminate class of people might have their blind eyes opened and their obdurate hearts broken. The crying need is for more prophets crying in the wilderness.

To an age in which the older conceptions of God are becoming increasingly difficult to entertain, but in which the need of God is as great as ever, Blake offers a conception which is beyond the reach of science to destroy. This God is simply the Christ within the human breast. He is not a God afar off, remote and inaccessible; nor is he a pale abstraction, affording little help or solace to human needs. He is alive and human within the breast, intimately and convincingly there. He is the vision, the imagination, the capacity to think nobly of oneself and one's fellow men, the capacity to forgive their mistakes and weaknesses, the determination, in spite of all, to build the New Jerusalem. He is that something within man which makes him more than a physico-chemical machine, that something within nature which makes it groan to be delivered. In this sense, and in this sense only, is he supernatural. And because God is within us only because he is within all things, he is more than we are. His relationship to us is in this sense objective. We are one with God, but we are not God. We know him intimately because he is within us. We worship him because he is the source of our being and the goal of our return. The conception retains for us the reverence without which life tends to become a dreary round with neither dignity nor meaning.

Finally, this God is inescapable. He is within the breast, however much obscured. Into whatever abysses of ignorance and selfishness and despair man may fall, this God falls with him, becoming as we are that we may be as he is. He is ever struggling to become manifest. Wherever Los lifts a hammer, there God is. He is the living God whom one may serve without hope of

heaven as a reward or fear of hell as a punishment, but because to serve him is to participate in God.

This is not the whole of Blake's teaching, but it is the heart of it. Nothing has been said of his esthetics, and little of his psychology, so surprisingly modern in its understanding of the subconscious. Moreover, it has been outside the purpose of this work to appraise the poetic quality of the prophetic writings. Yet I must digress from my purpose to pay tribute to the vitality of Blake's gigantic personifications. So perfect is their realization that they cease to be puppets of the history they are set to unroll and become its creators. If one can lend himself to a belief in human qualities operative throughout the universe, he must believe in the Zoas and their Emanations. They are the creatures of authentic myth. They should be common cultural possessions. They would be but for the obscurities of the myth and the misconceptions concerning it. A patient study of the prophetic books will be amply rewarded. Under a veil of esoteric symbol the reader will discover a view of life both wise and courageous. And he will come away humble before the indomitable spirit of Blake, whose vision of the world he will have seen through the eyes of a poet with an imagination as grandiose and intense as that of a Hebrew prophet.

Notes

THE abbreviations of Blake's titles will probably be self-explanatory. The principal ones are: *J.* for *Jersusalem*; *M.* for *Milton*; *F.Z.* for *Four Zoas*; *B.U.* for *Book of Urizen*; *B.A.* for *Book of Ahania*; *B.L.* for *Book of Los*; *M.H.H.* for *Marriage of Heaven and Hell*. The references are to *William Blake's Prophetic Writings*, edited by Sloss and Wallis, Oxford, 1926, for the writings contained therein. Other Blake references are to the *Poetry and Prose of William Blake*, edited by Geoffrey Keynes, London, The Nonesuch Press; New York, Random House. This volume is referred to simply as "Keynes." Each note refers to page number, line number, and catchword in the text.

CHAPTER I

1,6. odds: T. S. Eliot, *Selected Essays* (1932), p. 279.

1,7. framework: *Ibid.*

1,24. Bible: *M.H.H.* (24).

2,5. mental: Keynes, p. 819.

2,26. Time: *M.*, p. 23, l. 72.

3,8. fatal: *J.*, p. 52.

3,33. I turn: *J.*, p. 15, ll. 14-17.

4,1. I see: *J.*, p. 15, l. 8.

4,17. Everything: E. Morley, *Blake, Coleridge* . . . (1922), p. 12.

4,24. sublime: Warburton's *Divine Legation*, Bk. III, sec. 3.

6,18. No: Plotinus *Enneads* v. 3. 2.

8,2. the selfish: *J.*, p. 52.

8,6. the human: *M.*, extra p. 32, l. 32.

8,13. tree of life: The figure is imaginary, although it may be implied in the Preludium to *Europe*, whence the quotations come.

8,23. a tripartite: "We must observe, then, that our soul is threefold, and has one part that is the seat of reason, another that is the seat of high spirit, and another that is the seat of desire. And we discover that the head is the place and abode of the reasonable part, the breast of the passionate part, the abdomen of the lustful part."—Philo, *Allegorical Interpretation*, "Loeb Classics," Vol. I, p. 193. The source of this passage is in Plato's *Phaedrus* 246-57. Cf. E. Bevan: "The figure of Reason as

the charioteer controlling, or failing to control, the irrational parts of the soul—that figure, suggested by Plato, is the one that sums up the psychology and ethics to which the bulk of the educated world subscribed at the time of the Christian era."—*Stoics and Sceptics* (1913), p. 103.

8,26. *Kabbalah:* "Let us not lose sight of the great kabbalistical idea, that the trinity is always completed by and finds its realization in the quaternary."—*Kabbalah denudata,* ed. Mathers (1926), p. 35. "The Kingdom, the tenth Sephira, represents the harmony of the whole archetypal man."—C. D. Ginsburg, *The Kabbalah* (1925), p. 98.

Philo: "The fourth river," he says, "is Euphrates. Euphrates means fruitfulness, and is a figurative name for the fourth virtue, justice . . . When, then, does it appear? When the three parts of the soul are in harmony."—*Allegorical Interpretation,* "Loeb Classics," Vol. I, p. 195.

Boehme: "The seventh property is the substance, that is, the *subjectum* or house of the other six, in which they are all substantially, as the soul in the body."—*The Clavis,* sec. 122. Cf. *Threefold Life,* ch. iv, sec. 5; ch. v, sec. 15.

The idea of "body" might also have been suggested by Plato. A. E. Taylor says: "Cf. the famous myth in the *Phaedrus,* also obviously of Pythagorean inspiration, where the soul is figured as a charioteer driving a car drawn by a pair of horses of different strain . . . There, however, our attention is demanded only for the charioteer and the horses, which represent the 'tripartite' soul . . . and nothing is said of the 'car' itself. Here it is the body which is the 'car' of the 'immortal soul.' "—*Commentary on Plato's Timaeus* (1928), p. 496.

9,27. is no progression: *M.H.H.* (3).

10,2. brandished: *Europe,* Preludium, l. 8.

10,25. necessity: On necessity cf. J. Kroll, *Die Lehren des Hermes Trismegistos* (1928), ch. iv; W. Scott, *Hermetica,* Vol. III (1926), pp. 246-48; 277-78.

10,28. Plato: *Statesman* 268-74.

10,32. Eternals: *B.U.,* ch. v.

10,36. Proclus: T. Whittaker, *The Neo-Platonists* (2d ed., 1928), p. 291.

11,7. Empedocles: *The Writings of Hippolytus,* "Ante-Nicene Library," Vol. I, p. 295.

11,16. as we are: Keynes, p. 148.

11,30. return is easy: The idea of an "amphibious" life alternating between the inner and outer contraries but without involving a "fall," is in Plotinus. "Individual souls, as if desiring a more independent life than the blessed community of the spiritual world, separate themselves partially from this close intercommunication, and animate particular bodies. They live an 'amphibious' life, passing from the spiritual to the sensuous and back again . . . It is impossible for souls always to remain in the spiritual world; all souls must trace the circle again and again. Clearly there is no question of sin here in the soul's incarnation; its wanderings and returns are the pulsation of unending life."—W. R. Inge, *The Philosophy of Plotinus* (1929), pp. 257, 263. The *Four Zoas* makes it clear that the fall which is then taking place is far deeper than the normal pulsa-

tion of unending life. The Daughters of Beulah, who preside over the outward and lower level, are terrified at the "Spectre of Tharmas," which they call "eternal death."

11,32. downwards: *F.Z.*, Night I, l. 263.

12,11. Circle of Destiny: *F.Z.*, Night I, l. 93.

12,13. the sensual: Coleridge, *France, an Ode.*

CHAPTER II

13,1. Albion: On the primal man and primal bisexuality cf. W. Bousset, *Hauptprobleme der Gnosis* (1907), ch. iv; W. Scott, *Hermetica*, Vol. III (1926), pp. 135-45; Vol. II (1925), pp. 4-5; E. Bréhier, *Les Idées philosophiques et religieuses de Philo d'Alexandrie* (2d ed., 1925), pp. 121-26; T. Whittaker, *The Neo-Platonists* (2d ed., 1928), pp. 221-23; F. W. Bussell, *Religious Thought and Heresy in the Middle Ages* (1918), pp. 554-55, 575-76; R. Reitzenstein, *Poimandres*, (1904), and *Die Hellenistische Mysterienreligionen* (1927), Index, s. v. "anthropos"; S. Karppe, *Etude sur les origines et la nature du Zohar* (1901), p. 392 and pp. 455-57; *Jewish Encyclopaedia*, art. "Adam Kadmon."

13,13. St. Paul: I Cor. xv. 45.

14,3. living being: The Stoics regarded the cosmos as a gigantic animal. So also did Origen, *De prin.* Bk. II, ch. iii. Plato calls the world a "living creature."—*Timaeus*, 30b; *Statesman*, 269d. Hermes, Libellus X, says: "The kosmos is first among all living creatures; man, as a living creature, ranks next after the kosmos, and first among those that are mortal." W. Scott, *Hermetica*, Vol. II, p. 195.

14,7. In particles: Keynes, pp. 1051-52.

14,28. anciently: *J.*, p. 27.

14,33. identifies: *J.*, p. 27.

15,1. London: *J.*, p. 79, ll. 22-23.

15,5. parent: *J.*, p. 27.

15,8. the fields: *J.*, p. 27, ll. 1-4.

15,12. all things: *J.*, p. 27.

15,23. cardinal points: Cf. *J.*, p. 97, ll. 7-11; p. 12, l. 45—p. 13, l. 33.

15,31. eastern cave: Shelley, *To Night.*

15,36. cosmic man: That south, east, and north are the head, heart, and loins will not, I suppose, be questioned. The evidence is explicit. The evidence for the west being the Body may be briefly summarized. The west is "outwards every way." As the Fall begins, Tharmas and Enion (the dual regent of the west) are said to constitute Nature (the cosmic body). At this point also Enion weaves a "filmy woof" containing Tharmas; this is a new conception of the physical universe. As the Fall progresses, it is "the world of Tharmas" which troubles Urizen (the Mind). At the time of the Flood Tharmas appears as the "rough demon of the waters," an overwhelming multiple and material universe. It is he who commands the universe to be rebuilt in forms of "death and decay." The Fall drags Enion into the indefinite of matter—into the Grave, whence she speaks with a comprehensive knowledge of the sufferings of nature. As regeneration begins and the unity of Eden be-

gins to be restored, Albion is said to gather together "the scattered portions of his immortal *body*." The unity of Eden, which is placed in Tharmas's western region, is suggested by the fact that the Eternals live there "in perfect harmony," meeting together as "One Man."

16,23. ten: For the signification of this number cf. A. E. Taylor, *Commentary on Plato's Timaeus* (1928), p. 138 n. One of the Hermetic documents says that "the decad is the number by which the soul is generated."—W. Scott, *Hermetica*, Vol. I, (1924), p. 249.

16,15. Ptolemy: Cf. H. Leisegang, *Die Gnosis* (1924), p. 309.

16,29. upside-down: Cf. *Europe*, l. 100.

16,31. Swedenborg: *Heaven and Hell*, Nos. 548, 558; *Angelic Wisdom*, No. 275; *Apocalypse Explained*, No. 1143. On the legend that Peter insisted on being crucified head downward and the reasons therefor cf. G. R. S. Mead, *Fragments of a Faith Forgotten* (1906), pp. 446-48.

16,35. Aristotle: Cf. A. E. Taylor, *Commentary on Plato's Timaeus* (1928), p. 150.

17,3. stretch'd: *F.Z.*, Night VIII, ll. 4-6.

17,8. contained: *J.*, p. 27.

17,13. Andrew Ramsay: *Travels of Cyrus* (4th ed., 1730), p. 134. Blake must also have had in mind Milton's interpretation of this story in the *Areopagitica*, where the body of Osiris is the body of Truth, hewn into a thousand pieces and scattered to the four winds, but destined to be reassembled "into an immortal feature of loveliness and perfection." But Blake saw more in the story than either Ramsay or Milton. He saw what a modern scholar, Professor E. R. Goodenough, sees: "At the same time her [Isis's] longing for Osiris, her gathering of his fragments together, is a symbol of the whole spirit of mystic ascent, the desire to find the whole of God in place of fragments, and the intense longing for union."—E. R. Goodenough, *By Light, Light* (1935), p. 15.

17,27. is designated: *J.*, p. 99, l. 5; *M.*, p. 42, l. 15; Keynes, p. 829; *J.*, p. 54, l. 4.

17,31. Liberty: *J.*, p. 54, l. 5.

17,33. I know: *J.*, p. 77.

18,4. In Great Eternity: *J.*, p. 54, ll. 1-3.

18,8. She comes: *F.Z.*, Night II, l. 255.

18,11. Vala: *J.*, p. 44, l. 40.

18,13. holy reasoning: *J.*, p. 10, l. 15.

18,18. Satanic wheels: *J.*, p. 12, l. 44; p. 13, l. 37.

18,19. harlot: One may compare what is said of the harlotry of Jerusalem in the sixteenth chapter of Ezekiel, though there is only a slight phrasal influence.

18,21. mother: *J.*, p. 18, l. 12; p. 31, l. 58.

18,33. eternal senses: Keynes, p. 1021; H. Leisegang, *Die Gnosis* (1924), p. 77.

19,3. contracting: *J.*, p. 38, ll. 17-18.

19,13. what are: *F.Z.*, Night I, ll. 7-8.

19,21. natural symbolism: *J.*, p. 36, ll. 31-32.

19,28. Boehme: *Threefold Life*, ch. v, secs. 120, 122.

20,30. south: *Europe,* ll. 94-101; *F.Z.,* Night I, ll. 180-202.

21,14. outward: *F.Z.,* Night II, l. 212.

21,17. Urizen: *B.U.,* ch. iva, l. 19; *F.Z.,* Night IV, l. 208; Night III, l. 18; Night IX, ll. 309-10, l. 290; *B.A.,* ch. v, ll. 60-61; *F.Z.,* Night II, l. 315.

21,26. Pope: *Essay on Man,* Bk. I, ll. 121-22.

21,32. beholding: *F.Z.,* Night II, ll. 229-35.

21,35. radiance: *F.Z.,* Night II, l. 179.

22,4. Now I: *F.Z.,* Night II, l. 61.

22,16. Basilides: Hippolytus, *Refutation,* Bk. VII, chs. x-xiv; H. Leisegang, *Die Gnosis* (1924), pp. 213-29.

22,19. crashes: *F.Z.,* Night III, ll. 129-53.

22,33. Kabbalah: *Kabbalah denudata* (1926), p. 270.

———— cave: *B.U.,* ch. iva, ll. 33-34.

22,35. Plato: *Republic,* 514-17.

22,36. skull: The skull, or head, is associated with the cosmos in Plato's *Timaeus,* 44-45, and in Hermes, Libellus X. Cf. W. Scott, *Hermetica,* Vol. I, p. 195; Vol. II, p. 249.

23,7. *Paradise Lost:* Bk. I, ll. 645-47.

23,12. allegorical: *Europe,* l. 39.

23,16. drag: *F.Z.,* Night VI, ll. 314-22.

23,19. Urizen: Keynes, pp. 93, 103, 134; *V.D.A.,* l. 187; *F.Z.,* Night IX, l. 130; Keynes, p. 1030.

23,33. web: *B.U.,* ch. viii, ll. 47-54; *F.Z.,* Night VI, ll. 314-22.

23,34. idiot: *M.,* p. 43, l. 12.

24,7. But still: *F.Z.,* Night VI, ll. 164-70.

24,31. Tho' thou: Keynes, p. 763.

25,5. repose: Cf. *Zohar,* ed. by De Pauly, Vol. II, p. 340, "Car c'est la femme qui constitue le repos de l'homme."

25,9. reposed and renewed: *M.,* p. 10, ll. 49-50.

25,14. She is: *F.Z.,* Night III, ll. 108-10, l. 118.

25,18. science: *B.A.,* ch. v, l. 61.

25,21. cornfield: *F.Z.,* Night VIII, l. 531.

25,32. *Book of Ahania:* chs. i, ii.

26,1. one within: Cf. *J.,* p. 12, l. 48; *M.,* p. 32, drawing.

26,9. wise: Wordsworth, *Expostulation and Reply.*

26,12. dim: *F.Z.,* Night III, ll. 115-16.

26,25. Plato: *Phaedrus* 246.

26,37. sacrifice: *F.Z.,* Night II, l. 404.

27,5. labyrinthine: *F.Z.,* Night II, ll. 395-97.

27,9. scheming: *F.Z.,* Night II, ll. 446-47; 591-92.

27,14. and never: *F.Z.,* Night II, l. 632.

27,18. vision: *F.Z.,* Night III, ll. 38-98.

27,25. Sin: *B.A.,* ch. i, l. 34.

27,31. Shall the: *F.Z.,* Night III, ll. 108-24.

28,8. selfish: Keynes, p. 70.

28,12. Philo: *Allegorical Interpretation,* "Loeb Classics," Vol. I, pp. 269-77, 311.

28,23. mother: *B.A.,* ch. i, l. 43.

29,6. Luvah: *F.Z.*, Night V, l. 232; *J.*, p. 82, l. 79.

29,9. Mutual: Keynes, p. 753.

29,14. eternal: *M.H.H.* (4).

29,20. cupbearer: *F.Z.*, Night V, ll. 266-69; Night IX, ll. 586, 617-18.

29,27. weaver: *J.*, p. 95, l. 17.

30,13. Luvah: *F.Z.*, Night I, ll. 176-207; Night III, l. 85.

30,22. Ovid: *Metamorphoses* ii. 173-75.

30,25. serpent: *F.Z.*, Night III, ll. 89-96.

30,29. mercy: Keynes, p. 88.

31,1. Blasphemous: *America*, ll. 56-57.

31,4. red Orc: *F.Z.*, Night V, l. 66.

———— war: *F.Z.*, Night IX, l. 151.

31,14. feeding: *F.Z.*, Night VII, ll. 61-62.

31,22. beneath: *B.U.*, ch. vii, l. 20.

31,37. allegorical: *Europe*, l. 39.

32,1. Orc accepts: *F.Z.*, Night VII, ll. 28-41, 135-56; Night VIIa, ll. 212-16.

32,10. Later: *F.Z.*, Night VIII, ll. 586-89; Night IX, ll. 69-89.

32,18. Laocoön: Keynes, p. 764.

32,28. shadow: *J.*, p. 44, l. 40.

33,3. nature: *J.*, p. 34, l. 9.

33,5. She is not: The temptation to identify Vala with outward nature arises from the fact that we are not accustomed to think of nature as an *anima mundi*, a hidden creative force which gives form to matter. Yet this was a familiar Neoplatonic concept. Plotinus's World Soul, in its lower phase, creates, in conjunction with matter, the forms of the world of sense. In the Neoplatonism of the Renaissance the World Soul was conceived of as Venus, and this identification was adopted by Spenser. It is possible that Spenser's Venus-Nature contributed something to Blake's conception of Vala. For Spenser cf. Josephine W. Bennett, *Studies in Philology*, Vol. XXX, pp. 160-92; *P.M.L.A.*, Vol. XLVII, pp. 46-80.

33,10. dark: *B.U.*, ch. ii, l. 35.

33,12. sleeping: *F.Z.*, Night II, ll. 15-16.

———— lily: *J.*, p. 19, l. 42.

33,22. die: *F.Z.*, Night III, l. 80.

33,35. nature's: *M.*, p. 36, l. 25.

33,36. the selfish: *J.*, p. 52.

34,15. allegorical: *Europe*, l. 39.

34,23. I am not: *J.*, p. 4, ll. 16-18.

35,1. the nameless: *Europe*, Preludium, l. 1.

35,2. unutterable: *M.*, p. 9, l. 14.

35,3. under: *J.*, p. 52.

35,12. harlot: *F.Z.*, Night VIIa, l. 135.

35,13. Babylon: *J.*, p. 75, l. 19.

35,16. sinless: *F.Z.*, Night IX, l. 456.

———— Albion's: *J.*, p. 33, l. 39.

35,26. O cruel: *F.Z.*, Night III, l. 73.

35,33. female will: Keynes, p. 840; *J.*, p. 34, l. 39.

35,35. only life: *M.H.H.* (4).

35,6. loins: Some of the evidence for identifying Urthona with the loins is as follows: Urthona, Los's eternal form, is assigned to the North (*M.*, p. 32, drawing), which is the place of the loins (cf. p. 15). Los, the temporal form of Urthona, is arbiter of the Generative world; he builds Golgonooza, and he initiates the Last Judgment, which is placed in the loins (*J.*, p. 30, l. 38). It should be understood that the loins represent the creative principle, and that in Eternity this principle is intimately associated with the mind. It is only with the Fall that man's organization becomes "sexual."

36,17. Los was: *F.Z.*, Night I, ll. 9-17.

36,23. kept: *J.*, p. 95, l. 20.

37,1. Dionysus: On the relationship of Dionysus and Apollo, cf. A. B. Cook, *Zeus*, Vol. II (1925), pp. 243-67; Edna Kenton, *Book of Earths* (1928), pp. 117-18; T. Whittaker, *Macrobius* (1932), p. 24. The plate in Robert Fludd's *Philosophia moysaica*, a book which Blake probably read in its Latin or in its English form, represents Dionysus and Apollo in this relationship. Cf. also C. D. Ginsburg, *The Kabbalah* (1925), pp. 107-8.

37,5. torment: *M.H.H.* (6).

37,13. separation: *B.U.*, chs. iii, iva; *B.L.*, entire.

37,23. *Four Zoas:* Night II, ll. 44-45.

38,1. Deity: Cf. *M.*, p. 12, ll. 1-3.

38,8. reasoning: *M.*, extra p. 5, l. 14.

38,32. prophecy: *M.*, p. 23, l. 71.

38,33. Time: *M.*, p. 23, l. 68.

38,35. Time: *M.*, p. 23, l. 72.

39,21. sun: *B.L.*, ch. iv, ll. 18-35.

39,23. two suns: The idea of two suns has its source in Plato's *Republic*, where the Idea of Good is the illumination of the Ideal world, while the sun is the illumination of the material world. This idea was widely adopted and elaborated, so that "the sun henceforth becomes a subordinate power, a reflexion or sensible expression of a superior divinity. But in order to avoid breaking with tradition, from the luminary which gives us light was detached that universal 'Reason,' of which the sun had hitherto been the focus, and the existence of another purely spiritual sun was postulated, which shone and reigned in the world of intelligence, and to this were transferred the qualities which henceforth appeared incompatible with matter. We can follow this doctrinal evolution in the works of the neo-Platonists, and discern its termination in the speculations of Julian the Apostate. The 'intelligent' sun becomes the intermediary between the 'intelligible' God and the visible universe." —Cumont, *Astrology and Religion among the Greeks and Romans*, p. 134.

39,28. Damon: *William Blake* (1924), p. 69.

39,34. dark religions: *F.Z.*, Night IX, l. 853; Night VIIa, l. 167.

40,1. Golgonooza: *F.Z.*, Night V, ll. 76-77.

40,12. binds: *F.Z.*, Night V, ll. 79-170.

40,13. modulates: *F.Z.*, Night VII, l. 453.
———— peace: *F.Z.*, Night VII, l. 365.
40,18. epilogue: St. Paul has a similar interval (I Cor. xv. 22-28).
40,21. lethargy: *F.Z.*, Night VIII, l. 459-64.
40,34. struggle: *F.Z.*, Night II, *passim.*
41,7. space: *F.Z.*, Night I, l. 152.
41,16. obdurate heart: *F.Z.*, Night VIII, l. 29; Night VII, l. 319.
41,20. web: Keynes, p. 762.
41,21. Cathedron: *F.Z.*, Night VIII, l. 30; ll. 175-86, 193-208, 218-26. *J.*, p. 83, l. 72; p. 86, l. 38.
41,26. sleep: *Europe*, l. 55.
42,2. iron: *F.Z.*, Night VI, l. 296.
———— parent: *F.Z.*, Night V, *passism.*
42,10. parent power: *F.Z.*, Night I, l. 18.
———— angel: *J.*, p. 63, l. 5.
42,17. everything: *Song of Liberty*, p. 3.
———— looks: *F.Z.*, Night VIII, l. 549.
42,22. shepherd: *J.*, p. 95, l. 16; *F.Z.*, Night IX, l. 774.
42,23. mildest: *F.Z.*, Night IV, l. 81.
42,26. West: Evidence for the association of Eden with the West and with Tharmas:

 (1) O Albion . . . clos'd is thy Western Gate!—*J.*, p. 45, l. 3.
 (2) For the Sanctuary of Eden is in the Camp, in the Outline, in the Circumference: & every Minute Particular is Holy.—*J.*, p. 69, ll. 41-42.

42,31. victim: *F.Z.*, Night I, ll. 18-85.
42,33. eternal four: Cf. p. 127, l. 2.
43,3. multiple: Cf. p. 183.
43,10. Urizen: Cf. Urizen's anxiety in the "porches" in *F.Z.*, Night II, and Tharmas's destruction of him in *F.Z.*, Night III. Cf. also *F.Z.*, Night VIII, l. 26.
43,15. end: Cf. pp. 246, 254.
43,17. arrested: *F.Z.*, Night IV, ll. 34-35.
43,20. adopted son: *F.Z.*, Night VI, l. 43.
43,23. Golgonooza: *F.Z.*, Night V, l. 78.
43,27. Nature: *F.Z.*, Night I, ll. 63-85.
43,28. bright: *F.Z.*, Night I, ll. 110-11.
43,32. Circle: *F.Z.*, Night I, ll. 68, 93.
43,35. Los: *F.Z.*, Night I, l. 116.
44,3. nonexistence: *F.Z.*, Night II, l. 591.
44,12. What is: *F.Z.*, Night II, ll. 605-9.
44,26. time: *F.Z.*, Night VIII, ll. 526-71.
44,33. dark: *F.Z.*, Night VIII, l. 532.
45,24. St. Paul: Galatians iv, 22-26.
45,30. Eternals as One Man: *F.Z.*, Night I, ll. 158-64; Night II, l. 105. This image of the Eternals meeting together as One Man who is Christ has a striking parallel in Eckhart: "Men differ according to flesh and according to birth; but according to thought they are one man, and

this man is Christ."—W. R. Inge, *The Philosophy of Plotinus* (1929), Vol. II, p. 84 n. I fancy that the conception of divine "watchers," mentioned in Daniel and the Book of Enoch, had something to do with Blake's conception of the Eternals and the Council of God.

CHAPTER III

47,10. Plotinus: *Enneads* iv, 8, 1.

48,4. gentle falls: Cf. note on p. 11, l. 30. Blake's two paradises, the heavenly and the earthly, probably have some connection with Swedenborg's assertion that the internal man [Eden] is called heaven, the external man [Beulah] is called earth.—*Arcana coelestia*, No. 477. This is the more likely since Blake calls Beulah "the earth of Eden."—*F.Z.*, Night I, ll. 9-13.

48,6. renewal: Cf. *M.*, p. 30, ll. 21-31; *F.Z.*, Night I, ll. 86-92.

48,8. Flood: Keynes, p. 837.

48,37. Plotinus: Cf. note on p. 48, l. 4.

49,2. Proclus: *Elements of Theology*, tr. by Taylor, No. 77.

49,10. continually fed: Cf., for example, *M.*, p. 31, ll. 1-7; p. 30, ll. 7-14; *J.*, p. 17, ll. 27-28.

49,28. That thing there: The oneness of Eden may be illustrated by an eloquent passage from Plotinus: "They see themselves in others. For all things are transparent, and there is nothing dark or resisting, but every one is manifest to every one internally and all things are manifest; for light is manifest to light. For every one has all things in himself and again sees in another all things, so that all things are everywhere and all is all and each is all, and the splendour is infinite."—T. Whittaker, *The Neo-Platonists* (1928), p. 62.

49,33. Dean Inge: *Philosophy of Plotinus* (1929), Vol. I, p. 215.

50,4. General: *J.*, p. 91, ll. 29-30.

50,26. In selfhood: *J.*, p. 45, l. 13.

50,35. Thomas Taylor: *Five Books of Plotinus* (1794), p. iii.

51,1. hunting: *J.*, p. 43, l. 31.

——— warfare: Cf. *J.*, p. 38, ll. 14-15; p. 97, l. 14.

——— fury: *M.*, p. 30, ll. 19-20.

51,3. Albion: *J.*, p. 38, ll. 14-17.

51,12. calls: *J.*, p. 43, l. 41.

51,14. talking: Keynes, p. 839.

51,20. West: For Eden in the West, cf. *F.Z.*, Night I, ll. 163-64; *J.*, p. 45, l. 3; p. 69, ll. 41-42.

51,26. all is: Keynes, p. 765.

51,30. in this: Keynes, p. 830.

52,1. Swedenborg: *Angelic Wisdom*, No. 322.

52,9. giant: *J.*, p. 48, l. 15.

52,12. Kill: *J.*, p. 48, l. 16.

52,16. not a primal: *M.*, p. 30, ll. 21-27.

52,17. eternally: *F.Z.*, Night I, l. 89.

52,18. those who sleep: *F.Z.*, Night I, l. 88; *M.*, p. 30, l. 3.

52,24. feminine . . . life: The *Zohar* says, "Carr c'est la femme qui con-

stitue le repos de l'homme." *Zohar,* ed. by De Pauly, Vol. II, p. 340. I
have no doubt that Michelangelo's "Pieta" also contributed to Blake's
conception of Beulah.

52,27. But: *M.,* p. 30, ll. 21-31.

53,1. Marcus: G. R. S. Mead, *Fragments of a Faith Forgotten* (1906), p.
363. The Chevalier Ramsay, reporting Plato, presents the same idea:
"These spirits are qualified to enjoy a double felicity: the one consist-
ing in the contemplation of the divine Essence, the other in admiring
his works . . . If souls could without intermission contemplate the
divine Essence by a direct view, they would be impeccable, the sight
of the supreme Good necessarily engaging all the love of the will. To
explain, therefore, the fall of spirits, they are forced to suppose an
interval, when the soul withdraws from the divine Presence, and quits
the supercelestial abode, in order to admire the beauties of nature,
and entertain herself with ambrosia, as a food less delicate, and more
suitable to a finite being." It is from this level, as it is from Beulah,
that the deeper fall occurs. For, says Ramsay, "'Tis in these intervals
that she [the soul] becomes false to her duty."—A. Ramsay, *Travels of
Cyrus* 4th ed., (1730), "Discourse," p. 68.

53,10. Beulah all around: *F.Z.,* Night I, ll. 89-90; *M.,* p. 30, ll. 8-9.

53,11. South: *J.,* p. 72, l. 50.

53,20. false: *F.Z.,* Night II, l. 25.

53,22. faith in . . . spirit: Cf. Boehme, "And the outward spirit . . . and
the whole outward principle . . . did cleave to the inward."—*Forty
Questions,* qu. 4.

53,24. shadow: *M.,* p. 30, l. 25. Cf. Psalms xvii. 8: "Hide me under the
shadow of thy wings."

53,32. pure: *F.Z.,* Night IX, l. 628.

54,6. moon and sun: If it be remembered that the words "sun" and
"moon" are used metaphorically, the following passage from the *Zohar*
expresses the relationship between Eden and Beulah: "Now the moon
never shines except from the reflection of the sun, and when the sun
is aloft the moon does not appear, but only when the sun is gathered
in does the moon rule the heavens, and the moon is of no account
save when the sun is gathered in."—*Zohar,* tr. by Sperling and Simon,
Vol. II (1932), p. 354.

54,10. vengeful: The *Zohar* again illustrates Blake: ". . . means the time
when the moon is invisible. For at that time the evil serpent is in
power and is able to do hurt to the world. But when mercy is aroused,
the moon ascends and is removed from that place, and so the evil
serpent is confounded, loses his power and is unable to approach there."
—*Zohar,* tr. by Sperling and Simon, Vol. I (1931), p. 359.

—— outward: *J.,* p. 92, l. 17.

54,14. Spaces: *J.,* p. 69, ll. 20-22.

54,23. corse of death: *F.Z.,* Night IV, ll. 268-69.

54,25. knows: The relation of belief to knowledge is commented upon
by E. Allison Peers: "This explains the simile by which the Dark Night
is likened to Faith, a figure which the reader whose theological ideas

are shaped by popular hymns and conventional books of devotion often fails to understand. Night is the accepted metaphor for Sin, Sorrow, Doubt, Death; but Faith—how can Faith be Night? St. John of the Cross explains that Faith is the Night of the Understanding . . ."— *Studies of the Spanish Mystics,* Vol. I (1927), p. 258.

54,29. veil: Cf. *J.,* p. 20, ll. 22-35.

54,30. gates: *F.Z.,* Night V, l. 232; *J.,* p. 82, l. 79.

54,37. from: *M.,* p. 30, l. 14.

55,5. imaginative: Keynes, p. 829.

55,9. equally: *M.,* p. 30, l. 1.

55,10. no dispute: *M.,* p. 30, l. 3; *J.,* p. 48, l. 20.

55,24. sexes: *J.,* p. 30, l. 33.

55,29. marriage: Isaiah lxii. 4.

55,33. handmaidens: *J.,* p. 69, l. 15.

55,34. hide: *M.,* p. 22, ll. 39-42.

56,12. Males: *F.Z.,* Night I, l. 60.

56,32. Swedenborg: *Angelic Wisdom,* No. 108.

57,10. Dante: *Purgatorio,* Canto VIII.

57,24. Faith, Hope, Charity: Urizen before the Fall was Faith (*F.Z.,* Night II, l. 315), and Ahania would share this quality. The word Hope is used in connection with Enion. (*F.Z.,* Night VII, l. 474; Night VIIa, l. 226). The Tarot also associates the corporeal with Hope. (Papus, *The Tarot of the Bohemians,* 1929, p. 214). Pity and Love (Charity) are Vala's characteristic virtues.

58,7. caves of sleep: *F.Z.,* Night IX, ll. 625-29.

—— beneath it: *F.Z.,* Night II, l. 281.

58,10. *Kabbalah: Kabbalah denudata* (1926), pp. 41, 45, 177. Cf. note on p. 22, l. 36.

58,17. Man: *F.Z.,* Night IX, ll. 625-29.

58,22. repose: Cf. *M.,* p. 10, l. 49.

58,32. void: *M.,* p. 43, l. 37.

58,37. womb: Cf. *M.,* p. 43, l. 37—p. 44, l. 1; *B.U.,* ch. ii, l. 26. Bishop Burnet says that the womb of earth was "that subterraneous capacity in which the abyss lay."—*Sacred Theory of the Earth* (1759), Vol. I, p. 110. Ramsay reports a similar conception.—*Travels of Cyrus,* 4th ed. (1730), "Discourse," p. 84.

59,10. No more: *F.Z.,* Night II, ll. 224-35.

59,20. *Paradise Lost:* Bk. VII, ll. 216-42.

59,28. Basilides: Hippolytus, *Refutation,* Bk. VII, chs. x-xiv.

60,11. Stern: *F.Z.,* Night II, ll. 284-86.

60,19. Now I: *F.Z.,* Night II, l. 61.

60,21. level of the stars: With the Mundane Shell, built by reason at the level of the stars, cf. Boehme: "For in the will of reason we are children of the stars and elements."—*Threefold Life,* ch. vi.

60,23. St. Paul: I Cor. xv. 41.

61,10. blood: *F.Z.,* Night II, ll. 88, 259, 105-6, 282.

61,14. golden: *F.Z.,* Night II, l. 449.

61,15. created: *F.Z.,* Night II, ll. 474-75.

61,23. Divine: *F.Z.*, Night II, ll. 469-70.
61,31. Orc: *F.Z.*, Night V, ll. 79-170.
62,3. Time: *F.Z.*, Night IV, ll. 179-81.
62,7. Feast: *F.Z.*, Night II, ll. 97-100; Night IX, ll. 163-64.
62,12. Plato: *Phaedrus* 250c.
62,15. roll: *F.Z.*, Night II, l. 264.
62,16. what: *F.Z.*, Night II, l. 265.
62,20. Jerusalem: *F.Z.*, Night II, l. 255; *J.*, p. 27, l. 41.
62,22. The sun: *F.Z.*, Night II, ll. 252-54.
62,32. rivers: *F.Z.*, Night II, ll. 458-60.
63,1. pyramids: *F.Z.*, Night II, ll. 346-50.
63,5. wondrous: *F.Z.*, Night II, l. 448.
63,6. eternal: *F.Z.*, Night II, l. 450.
63,12. looms: *F.Z.*, Night II, l. 355.
63,19. Beneath: *F.Z.*, Night II, ll. 358-59.
63,23. many: *F.Z.*, Night II, ll. 368-71.
63,29. frozen: Cf. Keynes, p. 762: "Freezing her veil, the Mundane Shell."
63,35. Egypt: Cf. *B.U.*, ch. ix, ll. 44-46; Song of Los (Africa), l. 3.
63,37. Hermes: G. R. S. Mead, *Thrice Greatest Hermes* (1906), Vol. II, pp. 351-56.
64,10. Druidism: *J.*, p. 27; *J.*, p. 89, l. 32. Cf. Keynes, p. 797: "The antiquities of every nation under Heaven is no less sacred than that of the Jews. They are the same thing, as Jacob Bryant and all antiquaries have proved. . . . All had originally one language and one religion; this was the religion of Jesus, the everlasting Gospel." Similarly Mallet, *Northern Antiquities,* ch. iv: "A few plain and easy doctrines seem to have comprised the whole of religion known to the first inhabitants of Europe. The farther back we ascend to the era of the creation, the more plainly we discover traces of this conformity among the several nations of the earth . . ."
64,19. Bishop Burnet: *Sacred Theory of the Earth* (1759), Vol. II, pp. 83-88.
64,28. stars: *M.*, p. 10, ll. 24-26.
64,35. extent: *M.*, p. 9, ll. 4-5; p. 16, ll. 21-27; p. 37, ll. 15-18; p. 24, l. 45; *J.*, p. 75, l. 4.
65,3. till: Keynes, p. 69.
65,20. *Poimandres:* G. R. S. Mead, *Thrice Greatest Hermes* (1906), Vol. II, p. 4.
65,27. Plato: *Timaeus* 35c.
66,6. withering: *J.*, p. 49, l. 25; p. 83, ll. 33-48; p. 64, ll. 2-5; *M.*, p. 34, ll. 24-31.
66,14. empires: *M.*, p. 37, l. 49.
66,15. polypus: *M.*, p. 34, ll. 24-26.
66,19. Los: *J.*, p. 91, ll. 36-37.
66,21. Newtonian: *M.*, p. 38, l. 46.
66,30. is said: *J.*, p. 73, ll. 38-40.
67,2. twenty-seven: Cf. *M.*, p. 34, l. 26.
67,3. the place: *J.*, p. 59, l. 9.
67,12. what are: *J.*, p. 77.

67,26. whatever: *J.*, p. 13, ll. 44-45.

67,31. There is: *J.*, p. 13, ll. 38-50.

68,8. Sources: One more source would be Mallet's *Northern Antiquities* (1770), Vol. II, p. 178 n.

68,9. not of: *F.Z.*, Night VIII, ll. 216-17.

68,11. Thomas Taylor: *Dissertation on the Eleusinian and Bacchic Mysteries* (1790), p. 22.

68,16. Circle: *F.Z.*, Night I, ll. 93-94.

68,19. lake of fire: *Blake's Prophetic Writings*, ed. by Sloss and Wallis (1926), Vol. I, p. 519, quatrain in notes. Cf. *Illustrations to the Book of Job*, Plate XVI. Cf. also *M.*, p. 40, ll. 11-12.

68,20. rainbow: *J.*, p. 48, l. 35.

69,6. Webs: *F.Z.*, Night VIII, ll. 211-13.

69,13. self-righteousness: *J.*, p. 13, l. 52.

69,15. abstract: *J.*, p. 5, l. 58.

69,22. God: Keynes, p. 134.

69,28. scattered: *J.*, p. 5, l. 13.

69,32. iron laws: *B.U.*, ch. viii, l. 31.

69,33. mills: *F.Z.*, Night VIII, ll. 214-18.

70,2. man is: *J.*, p. 49, l. 69.

70,14. death to: *J.*, p. 35, l. 12.

70,16. Cerberus: National Gallery.

70,19. triple Hecate: The serpentine character of the book is not apparent without the color.

70,25. incoherent: *J.*, p. 43, l. 68.

70,26. polypus: *M.*, p. 23, l. 38.

71,5. O holy: *J.*, p. 7, l. 65.

71,16. Error: Keynes, p. 844.

71,20. Generation and Ulro: *J.*, p. 58, ll. 50-51.

71,26. Differences: The two worlds of Ulro and Generation are similar to Plotinus's one world of Soul which, however, has two aspects; it may look downward and generate a corporeal world, or it may look upward to its source, and thereby "take fulness."

72,1. giving: *J.*, p. 12, l. 13.

72,6. *Milton*: *M.*, p. 32.

72,17. a hope: The foundation of the Generative world is laid immediately after the Flood with the founding of Golgonooza, but the purpose of that world is not accomplished until Christ is born. With the enlargement of spiritual perception which that event signifies, generation as the image of regeneration is in effect. Until that time it awaits Jesus, "who is the God and Lord to whom the Ancients look'd, and saw his day afar off with trembling and amazement."—*J.*, p. 3.

72,33. mentally preconceived: Hippolytus, *Refutation*, Bk. VII, ch. xv. Redemption was really begun, however, with the beginning of the Fall. Cf. *F.Z.*, Night VII, ll. 234-35.

73,1. the spiritual: *J.*, p. 53, ll. 17-18.

73,21. Los raged: *J.*, p. 6, ll. 8-11.

73,29. If the Sun: Keynes, pp. 120-21.

73,35. sun, moon: *B.L.*, ch. iv; *J.*, p. 36, ll. 3-4. Cf. note on p. 54, l. 10.

74,6. alternation: The correspondence between the two unfallen and the two fallen worlds might be stated in this way: Eden is a land of eternal life and mental warfare, relieved by occasional rest and repose in Beulah. Ulro is a land of eternal death, with passivity as its ideal, but it is stirred into warfare by the activities of Generation. For the relationship between Ulro and Generation cf. Plutarch (*Of Isis and Osiris*, sec. lxiii), ". . . showing that when Corruption had tied fast and brought it to a standstill, Generation again unlooses and restores Nature by means of Motion."

74,21. Erigena: H. Bett, *Erigena* (1925), p. 50.

75,16. world maps: Cf. J. L. Lowes, *Chaucer* (1934), pp. 40-42. Cf. also the Book of Numbers xxxiv. 6: "And as for the western border, ye shall even have the great sea for a border; this shall be your west border."

75,23. Egypt: *B.U.*, ch. ix, ll. 33-35, 44-47.

CHAPTER IV

77,13. In Eternity: Keynes, p. 765.

77,14. Swedenborg: *Angelic Wisdom*, Nos. 321-22.

77,24. there exists: Keynes, p. 830.

78,5. hindrance: Keynes, p. 844.

———— Natural objects: Keynes, p. 1024.

78,12. are told: Gilchrist, *Life of Blake*, ch. xxxiii.

78,18. Thomas Taylor: *Five Books of Plotinus* (1794), p. v.

78,21. all law: Keynes, p. 1141.

78,36. weak visions: *J.*, p. 49, l. 22.

78,37. unexpansive bulk: Cf. *F.Z.*, Night V, l. 2.

79,8. How do: Keynes, p. 806.

79,18. Vision: Keynes, p. 986.

79,19. The painter: Keynes, p. 795.

79,23. Nature: Keynes, p. 769.

79,24. The definite: Cf. Plotinus: "Now . . . if Matter must characteristically be undetermined, void of shape, while in that sphere of the Highest there can be nothing that lacks determination, nothing shapeless . . ."—*Enneads* ii. 4. 2. Milton describes chaos in very Plotinian language,

> . . . a dark
> Illimitable ocean, without bound,
> Without dimension; where length, breadth, and highth,
> And time, and place, are lost.
>
> *P.L.*, Bk. II, ll. 891-94

In *Europe* Blake says that "man fled . . . and hid in the forests of night." These forests of Blake's are akin to Dante's "dark wood."

79,33. The clearer: Keynes, p. 795.

80,5. determinate: Keynes, p. 986.

80,12. perceptive organs: Cf. Wordsworth:

> . . . of all the mighty world
> Of eye and ear—both what they half create
> And what perceive.
>
> *Tintern Abbey.*

Cf. J. Kroll, *Die Lehren des Hermes Trismegistos* (1928), pp. 289-94.

80,24. idiot questioner: *M.*, p. 43, l. 12.

80,28. Spectre of Albion: *J.*, p. 56, l. 17.

80,34. internal light: *M.*, extra p. 8, l. 16. Cf. *J.*, p. 54, ll. 1-3.

80,37. Take away: W. R. Inge, *Philosophy of Plotinus* (1929), Vol. I, p. 147.

81,5. Thomas Taylor: *Five Books of Plotinus* (1794), p. 71.

81,12. Proclus: *Institutes of Theology*, Nos. 89, 50.

81,33. Spectre: *J.*, p. 8, ll. 6-12.

82,9. determinate: Keynes, p. 986.

82,12. identity: *J.*, p. 91, ll. 20-21; Keynes, p. 980.

82,17. *Kabbalah denudata:* (1926), p. 270.

82,20. science to faith: Cf. note on p. 54, l. 25.

82,32. Swedenborg: Cf. passage on p. 56.

83,1. caves, skull: *F.Z.*, Night IX, ll. 625-29; *Europe*, ll. 94-101.

83,14. follow: *F.Z.*, Night I, ll. 91-92.

83,32. Swedenborg: *Divine Providence*, No. 50.

84,2. an appearance: Swedenborg, *Ibid.*

84,7. Enitharmon: *M.*, p. 11, ll. 11-12.

84,15. contracting: *J.*, p. 38, ll. 17-18.

84,34. And every: *M.*, p. 28, ll. 5-7.

85,1. God: Keynes, p. 930.

85,8. chaos: Origen says that matter, the lowest of all the creatures, was created immediately after the Fall to prevent the world from being dissolved. See *De prin.* Bk. II, ch. iii.

85,14. And the: *J.*, p. 69, ll. 23-24.

85,32. The Nature: *M.*, extra p. 8, ll. 6-7.

86,1. Satanic: *M.*, p. 36, l. 20.

86,10. Swedenborg: *Angelic Wisdom*, No. 108.

86,21. perturbed: *F.Z.*, Night VIII, l. 217.

87,7. idiot: *M.*, p. 43, l. 12.

87,8. imagination: *M.*, extra p. 32, l. 32.

87,9. eternal: *J.*, p. 4, epigraph.

87,10. abstract: *J.*, p. 13, l. 37.

87,11. non-entity: *J.*, p. 56, l. 16.

87,12. perturbed: *F.Z.*, Night VIII, l. 217.

87,13. without: *M.*, extra p. 8, l. 20.

87,14. neither: *M.*, p. 26, l. 27.

87,15. opaque: *M.*, p. 7, l. 39.

87,16. destroyer: *J.*, p. 56, l. 17.

87,17. polypus: *M.*, p. 23, l. 38.

87,29. egg-formed: *M.*, p. 34, l. 33.

87,32. bounds: *M.*, p. 27, l. 4.
87,33. circumscribing: *J.*, p. 98, l. 18.
88,6. the spirit: Keynes, p. 277 n.
88,8. all mortal: *F.Z.*, Night VIII, ll. 470-71.
88,12. Truth: *B.L.*, ch. ii, l. 20.
88,15. Error: Keynes, p. 844.
88,18. created: *M.*, extra p. 5, ll. 11-12; p. 9, l. 20. The Elect of these passages are equivalent to the Spectre.
88,26. vegetated: *F.Z.*, Night VIII, l. 256.
89,5. whatever: *J.*, p. 13, ll. 44-45.

<h3 style="text-align:center">CHAPTER V</h3>

90,4. One thing: A.E., *Collected Poems* (1919), p. 294.
91,3. Swedenborg: *Arcana coelestia*, No. 160.
—— Boehme: "These two essences, viz., the inward heavenly and the outward heavenly, were mutually espoused to each other, and formed into one body, wherein was the most holy tincture of the divine fire and light, viz., the great joyful love-desire, which did inflame the essence, so that both essences did very earnestly and ardently desire each other in the love-desire, and loved one another; the inward loved the outward as its manifestation and sensation, and the outward loved the inward as its greatest sweetness and joyfulness, as.its precious pearl and most beloved spouse and consort. And yet they were not two bodies, but only one; but of a twofold essence, viz., one inward, heavenly, holy; and one from the essence of time."—*Mysterium magnum*, Vol. I, ch. xviii, sec. 8.
—— Philo: "Each of the seven faculties shows itself in one way as male, in another way as female; for since it is either in restraint or in motion, in restraint when at rest in sleep, in motion when now awake and active,—when regarded under the aspect of restraint and inaction, it is called female owing to its having been reduced to passivity; when looked at under the aspect of movement and employment of force, being thought of as in action, it is described as male."—*The Worse Attacks the Better*, "Loeb Classics," Vol. II, p. 315.
91,4. *Kabbalah:* "Without destroying the antithesis established as the general condition of existence, they, nevertheless, cause often the female or passive principle to spring forth from the male principle."—A. Franck, *The Kabbalah* (N. Y., 1926), p. 160. "The sephiroth are feminine in their receptive aspect, masculine in their transmissive aspect."—*Kabbalah denudata* (1926), pp. 26-27. Cf. also the doctrine of the Tarot in Papus, *The Tarot of the Bohemians* (1929), pp. 193-94.
91,24. Franz Hartmann: *Paracelsus*, 2d ed., pp. 76-77. I suspect that Hartmann has mingled Boehme and perhaps others with Paracelsus, but it is of no importance so far as this chapter is concerned.
92,15. However: R. Wilhelm, *The Secret of the Golden Flower* (1931), p. 13.
92,22. Hippolytus: *Refutation*, Bk. VI, ch. iv.
92,26. Boehme: *Forty Questions*, qu. i, sec. 277.

92,33. its own: *Forty Questions*, qu. i, secs. 100, 107.

92,35. For all: G. R. S. Mead, *Thrice Greatest Hermes* (1902), Vol. II, p. 260.

93,2. Swedenborg: *Apocalypse Explained*, No. 1.

93,25. St. Paul: The observation is from G. Murray, *Five Stages of Greek Religion* (1925), p. 38. Cf. Romans i. 25; viii. 20-23.

93,27. Erigena: H. Bett, *Erigena* (1925), p. 66. Cf. Boehme: ". . . therefore the man must rule her."—*Threefold Life*, ch. ix, sec. 112. Also: ". . . for the inward is lord of the outward, the outward must be obedient to it."—*Forty Questions*, qu. vi.

94,7. eternal . . . only: *M. H. H.* (4).

94,15. uncurbed: Keynes, p. 842.

94,17. they provide: What is said here of the feminine emotions is characteristic of the feminine world of Beulah.

94,31. Philo: *Allegorical Interpretation*, "Loeb Classics," Vol. I, pp. 255-57.

95,8. woman's world: *J.*, p. 88, l. 16. Cf. *J.*, p. 34, ll. 27-28.

95,20. sundered contraries: Cf. *M.*, p. 34, l. 23: "To where the Contraries of Beulah War beneath Negation's Banner."

96,8. Paint: These "voices" are, of course, imaginary.

96,25. *Zohar:* tr. by Sperling and Simon, Vol. I (1931), p. 177. Cf. Swedenborg, who says that Man (*homo*) is the union of the male (*vir*) and female. See *Arcana coelestia*, No. 476.

96,29. The Feminine: *J.*, p. 90, ll. 1-2.

97,6. Entering: *J.*, p. 74, ll. 7-8.

97,14. pure negation: Cf. *M.*, p. 30: "A Negation is not a Contrary."—*Blake's Prophetic Writings*, ed. by Sloss and Wallis (1926), Vol. I, p. 406 n.

97,25. This is: *J.*, p. 10, ll. 15-16.

97,28. is described: Keynes, p. 141; *M.*, p. 40, l. 18.

98,5. spiritual: *Writings of Irenaeus*, "Ante-Nicene Library," Vol. I, p. 9 n.

98,7. loves: *M.*, p. 22, l. 40.

98,12. concentering: *F.Z.*, Night VII, l. 398.

98,26. Swedenborg: *Angelic Wisdom*, No. 4.

98,34. No: *J.*, p. 90, ll. 28-33.

99,9. The Spectre: *J.*, p. 10, ll. 37-39.

99,13. loves: *J.*, p. 8, l. 44.

99,14. buried: *J.*, p. 9, l. 15.

99,24. Shame: *J.*, p. 21, ll. 6-10.

99,36. miseries: Keynes, p. 88.

100,14. stolen: *J.*, p. 7, l. 14. Cf. *J.*, p. 65, l. 59.

100,17. Keats: Letter of Feb. 27, 1818.

100,27. He hunts: *M.*, extra p. 32, l. 5.

100,34. scorn: Keynes, p. 105.

100,35. indefinite: *F.Z.*, Night VIII, l. 454.

100,36. frost: Keynes, p. 105.

101,6. drink: *J.*, p. 65, l. 58.

101,16. psychology: The psychology is characteristic of the tradition to which Blake belongs. Cf. Count Villiers de L'Isle Adam: "If you cease to

limit a thing in yourself, in other words to wish for it; if, so doing, you withdraw from it, then woman-like it will come to you, as water comes and fills the place you offer it in the hollow of your hand."—*Axel*, Pt. III.

101,33. female will: Keynes, p. 840.

102,3. a worm: Cf. *J.*, p. 33, l. 6; p. 34, l. 57.

102,14. elevated: *J.*, p. 34, l. 10.

———— throne . . . man: *J.*, p. 34, ll. 27-28.

102,25. And every: *M.*, p. 26, ll. 44-46.

102,28. Mental: Keynes, p. 844.

102,36. Boehme: *Treatise of the Incarnation*, Pt. I, ch. ii.

103,9. Plotinus: *Enneads* v. 2.1.

103,20. I care: *J.*, p. 91, ll. 54-56.

103,34. Los: *J.*, p. 78, ll. 3-9.

104,15. reincarnation: Cf. *M.*, extra p. 5, ll. 11-12; *J.*, p. 58, ll. 13-20.

104,17. Thomas Taylor: *Proclus's Elements of Theology*, No. 50.

104,29. mercy: Keynes, p. 58.

105,12. Los creates: Cf. *J.*, p. 12, ll. 10-15; p. 11, l. 5.

105,16. St. Paul: I Cor. xii. 27.

105,28. created: *M.*, extra p. 5, ll. 11-12. The Elect of this passage are equivalent to the Spectre.

106,1. Generative: Cf. *F.Z.*, Night VIII, ll. 180-83; 36-39; Night VII, ll. 364-65; Night VIII, ll. 250-326.

106,19. release: *J.*, p. 11, l. 5.

106,24. Christ: *M.*, p. 3, ll. 7-10.

CHAPTER VI

107,12. sundered: Cf. H. Leisegang, *Die Gnosis* (1924), pp. 29, 164-65.

107,21. And render: Keynes, p. 140.

108,14. torments: Title page to *Four Zoas*.

108,35. woman born: *J.*, p. 64, ll. 16-17.

110,1. In Eden: *J.*, p. 87, ll. 17-18.

110,14. after: Boehme, *Threefold Life*, ch. xi, secs. 21-23; *et passim*.

110,20. what: *J.*, p. 34, ll. 25-28.

111,2. Humanity: *J.*, p. 79, ll. 73-74.

111,9. men: Keynes, p. 1052.

111,12. contracting: Cf. *J.*, p. 38, ll. 17-18.

111,35. sit: *J.*, p. 83, ll. 33-37.

112,12. sexes: *J.*, p. 30, l. 33.

112,33. Embraces: *J.*, p. 69, l. 43.

112,37. pompous: *J.*, p. 69, l. 44.

113,2. woman's: Keynes, p. 932.

113,5. veil: *J.*, p. 55, l. 11.

113,10. man: *J.*, p. 44, l. 38.

113,14. How: *J.*, p. 88, ll. 12-13.

113,25. handmaidens: *J.*, p. 69, l. 15.

113,27. gems: *J.*, p. 69, l. 18.

114,6. Beulah: *F.Z.*, Night I, ll. 86-92; *M.*, p. 30, ll. 1-14.

114,13. In Beulah: *M.*, p. 32, ll. 17-18; *J.*, p. 69, ll. 14-22.

114,15. Boehme: *Mysterium magnum*, ch. **xix**, sec. **3.**

114,26. veil: *J.*, p. 20, ll. 31-32. Cf. the plate in *Jerusalem* entitled, "Vala and Jerusalem 'assimilating in one' in the cup of a lily."—*The Engraved Designs of William Blake*, ed. by Binyon (1926), Plate LXVIII.

115,4. Aristotle: *Met.*, Bk. I, ch. iii.

115,18. classes: *M.H.H.* (17).

115,29. St. Augustine: *City of God*, ch. xxii, sec. 30.

115,30. interpretation: *J.*, p. 75, ll. 10-18.

116,20. Origen: *Against Celsus*, Bk. V, ch. 55.

116,22. Nephilim: *J.*, p. 27; Keynes, p. 796.

117,9. stem: *F.Z.*, Night I, l. 31.

117,14. Job: *Illustrations to the Book of Job*, Plate VII, marginal text.

117,28. If once: *J.*, p. 80, ll. 14-15.

117,30. disobedient: *J.*, p. 69, l. 38.

118,3. Have you: *J.*, p. 36, ll. 43-46.

119,14. Apostle: Galatians ii. 19.

119,25. Swedenborg: *Arcana coelestia*, No. 1034.

119,31. But when: *J.*, p. 42, ll. 32-34.

120,1. is made: *J.*, p. 53, ll. 27-28.

120,4. opens: *J.*, p. 73, ll. 25-26.

120,8. image: *J.*, p. 7, l. 65.

120,10. womb: Cf. *M.*, p. 43, l. 37—p. 44, l. 1; *B. U.*, ch. ii, l. 26.

120,20. spiritual: *J.*, p. 54, l. 12.

120,27. Jealousy: Cf. the *Zohar*: "The left side is without pity in the state of separation."—A. E. Waite, *The Holy Kabbalah* (1929), p. 128. Again: "It is further said that the side of severity emanates from her, though she is not herself severity; and we know that the pillar of severity is on the left side of the Tree."—*Op. cit.*, p. 348.

121,23. a male: *J.*, p. 75, l. 15.

121,33. Antichrist: *America*, l. 56.

122,4. harlot: *J.*, p. 18, l. 30; p. 21, ll. 5-6.

122,9. commerce: *J.*, p. 69, ll. 34-35.

122,12. Terah: *J.*, p. 75, l. 14.

122,21. chain: *B.U.*, ch. vii, l. 19; *F.Z.*, Night V, ll. 95, 157.

122,30. the female: *J.*, p. 75, l. 18.

123,9. Poetic Genius: *F.Z.*, Night VII, ll. 311-96.

123,11. obdurate heart: *F.Z.*, Night VII, l. 319.

123,13. I will: *F.Z.*, Night VII, ll. 364-65.

123,25. Swedenborg: *True Christian Religion*, No. 102.

123,33. scoffs: Keynes, p. 142; *J.*, p. 61, ll. 3-27.

123,36. lest: *J.*, p. 90, l. 37.

123,37. sexual: *M.*, p. 43, l. 25.

124,7. childbirth: *J.*, p. 34, l. 23.

124,11. Apostle: Galatians iv. 4-5.

124,20. dragon: *J.*, p. 75, l. 20.

124,33. Isaiah: li, 21; lii. 3.

124,35. Lift: *F.Z.*, Night VIIa, ll. 189-93.

125,6. to scatter: *J.*, p. 65, l. 45.

125,15. his members: *J.*, p. 21, ll. 3-49; *M.*, p. 22, ll. 40-42.

125,19. little grovelling: *J.*, p. 17, l. 32.

125,20. By Laws: *J.*, p. 49, ll. 26-28.

125,31. And: *M.*, p. 16, l. 14.

125,32. Come: *J.*, p. 90, l. 38.

125,33. Assume: *F.Z.*, Night VIII, ll. 232-33.

125,35. by his: *J.*, p. 90, ll. 35-37.

126,3. Boehme: Cf. *Three Principles*, ch. xii: "But you must clearly understand that when the Fiat to the Creating (of the woman) was in Adam, in his sleep, his body had not then such hard Grisles and Bones; O no; that came to pass first when Mother Eve did bite the apple . . ." Cf. also *Paradise Lost,* Bk. I, ll. 424-28:

> . . . so soft
> And uncompounded is their essence pure,
> Not tied or manacled with joint or limb,
> Nor founded on the brittle strength of bones,
> Like cumbrous flesh.

In Cicero's *De natura deorum*, a similar composition of the body of the gods is asserted by the Epicurean speaker, and ridiculed by the Academic and Stoic speakers.

126,10. a solid: *B.U.*, ch. ii, l. 20.

126,11. great: *F.Z.*, Night IX, l. 130.

126,18. globe: *B.U.*, ch. v, l. 53.

126,32. inward: *B.U.*, ch. ix, l. 7.

126,33. streaky: *B.U.*, ch. ix, ll. 11-13.

127,1. Agrippa: *Philosophie occulte,* Liv. i, ch. lxi.

127,8. Ah: *J.*, p. 49, ll. 32-41.

127,19. disobedient: *J.*, p. 69, l. 38.

127,24. weaving: Keynes, p. 762.

CHAPTER VII

128,14. He is: E. Morley, *Blake, Coleridge* . . . (1922), p. 3.

128,20. Thou art: Keynes, p. 138.

128,26. According: *M.*, p. 12, ll. 1-3.

129,3. As all: Keynes, p. 149.

129,22. Christ: *J.*, p. 77.

129,23. intellectual: *J.*, p. 99, l. 10.

129,24. Divine: *F.Z.*, Night II, l. 469.

———— Human: *M.*, extra p. 32, l. 32.

129,25. Universal: *F.Z.*, Night VIII, l. 223.

———— One: *F.Z.*, Night I, ll. 158-64.

129,31. men: Keynes, p. 1052.

129,35. in the: Keynes, p. 938.

130,1. Henry James: *Society the Redeemed Form of Man* (1879), pp. 41-42.

130,12. crucifies: Keynes, p. 842.

130,17. But still: *J.*, p. 90, l. 67—p. 91, l. 20.

130,31. the real: *J.*, p. 77.

130,35. human: *M.*, extra p. 32, l. 32.

131,1. Divine: *J.*, p. 5, l. 59.

131,4. All are: *J.*, p. 71, l. 15.

131,13. spirit: Keynes, p. 277 n.

131,21. both good: Cf. Boehme: "And thus there is good and evil in each life, and yet there is no evil in anything, unless the good, viz., the love-oil, famishes in its own lubet."—*Signatura rerum,* ch. vi.

131,24. Robinson: E. Morley, *op. cit.*, p. 13.

131,29. little death: *J.*, p. 96, l. 27.

131,32. It is: Keynes, p. 844.

131,27. Robinson: E. Morley, *op. cit.*, p. 4.

132,6. To be: Keynes, p. 139.

132,10. The spirit: *J.*, p. 3.

132,20. if he: Keynes, p. 933.

132,24. intellect: With Blake's insistence upon intellect cf. Hermes: "And the soul's vice is ignorance."—G. R. S. Mead, *Thrice Greatest Hermes* (1906), Vol. II, p. 146. This is, of course, the Platonic doctrine and tradition.

132,25. I care: *J.*, p. 91, ll. 54-56.

133,5. bursting: Mrs. Piozzi, *Anecdotes of Dr. Johnson.*

133,7. severe: Boswell, *Life of Johnson, sub anno* 1776.

133,8. the glory: *J.*, p. 52.

133,14. at the judgment: Keynes, p. 843.

133,18. not in: Keynes, p. 842.

——— You cannot: Keynes, p. 843.

134,5. to those: *J.*, p. 36, ll. 50-51.

134,9. eternal: *M.H.H.* (4).

134,11. human: *M.*, extra p. 32, l. 32.

134,12. evil: Since Lytton Strachey, failing to understand Blake's metaphysics, accused him of glaring inconsistency in his doctrine of good and evil, it may be worth while to quote Bett's remarks on the similar doctrine in Erigena. "Erigena's doctrine," he says, "of the negativity of evil must not blind us to the fact that he recognizes evil as a real positive, and militant power. There are many passages which illustrate this. It is easy to regard this as a mere inconsistency. Perhaps it is finally inconsistent in a logical sense, but that is arguable, for the two positions are not on the same plane. An ultimate metaphysical doctrine is not to be regarded as an immediate conclusion for practical life. We may deny the doctrine of the older natural philosophy, as to the extension and solidity of matter, and hold that these attributes may be resolved into an arrangement of electrical force, but that does not mean that you will not break your head if you collide with a stone wall. Erigena never dreamt of denying the present phenomenal reality of evil. He was only concerned to deny that it is an ultimate constituent of the universe, one of those essential and eternal realities that are, in his view of experience, the only realities."—H. Bett, *Erigena* (1925), p. 131.

134,14. Erigena: quoted in W. R. Inge, *Christian Mysticism* (1918), p. 137.

134,30. Thou sealest: Ezekiel xxviii. 12-18.

135,4. Satan in His Glory: *The Paintings of William Blake*, ed. by Figgis (1925), Plate VIII.

135,26. spring: *M.H.H.* (3).

135,27. and they: *M.H.H.* (17).

135,32. from his: *M.*, p. 9, l. 10.

136,30. Plotinus: *Enneads* v. i. 3.

137,10. If you: Keynes, p. 131.

137,15. hidden: *J.*, p. 28, l. 16.

137,28. the eternal: *F.Z.*, Night IX, p. 170.

137,36. Jerusalem: p. 96, l. 7.

138,8. when Los: *B.L.*, ch. ii, ll. 29-35.

138,10. Elsewhere: Keynes, p. 829.

138,27. Jehovah-Elohim: It is the doctrine of the *Zohar* that Jehovah and Elohim are one, or as it is sometimes said, Jehovah is Elohim. This unity combines masculine and feminine, mercy and severity.

139,4. The Spectre: *F.Z.*, Night II, l. 84.

139,12. Though he: *Illustrations to the Book of Job*, Plate X.

139,30. is acquired: Keynes, p. 933.

140,2. He who: Keynes, p. 148.

140,13. For God: *M.*, extra p. 32, ll. 40-43.

141,2. the image: *M.*, p. 3, l. 12.

141,3. dark: *F.Z.*, Night VIII, l. 232.

141,4. God becomes: Keynes, p. 148. Irenaeus, Athanasius, and others have almost the same phraseology. It is important to remember, in connection with Blake, that the Incarnation was not an isolated historical event to satisfy justice, but a continuous process emanating from mercy. Cf. Milton: "The Christian doctrine is that divine revelation disclosed in various ages by Christ (though he was not known under that name in the beginning) concerning the nature and worship of the Deity, for the promotion of the glory of God, and the salvation of mankind."—*Christian Doctrine*, Bk. I, ch. i.

141,7. weeping infant: *J.*, p. 63, l. 17.

141,23. stems: *J.*, p. 83, l. 13.

141,24. dark: *F.Z.*, Night IX, l. 853.

141,32. Los: *J.*, p. 30, l. 15; p. 95, l. 20. Cf. *J.*, p. 39, l. 12.

142,35. Mental: Keynes, p. 844.

143,3. as in: *J.*, p. 71, ll. 18-20.

143,21. permanent: Keynes, p. 830.

144,9. All things: *J.*, p. 16, ll. 61-67.

144,24. passages: *J.*, p. 40, ll. 25-47; *M.*, p. 26, ll. 18-20.

CHAPTER VIII

145,5. *Divine Love:* No. 126.

146,16. Eliphas Lévi: *History of Magic*, tr. by A. E. Waite (1922), p. 27.

146,33. young man: *F.Z.*, Night II, ll. 262, 217.

147,7. two movements: Cf. note on p. 245, l. 36.

147,9. current . . . wheel: *J.*, p. 77, ll. 4, 13.

147,15. into being: *F.Z.*, Night V, ll. 27-28.

147,17. I stood: *J.*, p. 77, ll. 1-15.

148,17. planets: *F.Z.*, Night V, ll. 27-28. Cf. *J.*, p. 99, l. 3.

148,18. Los creates: *B.L.*, ch. iv, ll. 20-38; *J.*, p. 36, l. 4.

148,23. from falling: *F.Z.*, Night II, ll. 474-75.

149,4. till break: Keynes, p. 65.

149,9. mathematic: *F.Z.*, Night II, l. 482.

149,12. Thomas Taylor: *Commentaries of Proclus on Euclid,* Vol. II, p. 302.

149,21. If: Keynes, p. 120.

149,32. Reversing: A. Koyré, *La Philosophie de Jacob Boehme* (1929), p. 71 and n.

149,35. compacted: Boehme, *Aurora,* ch. xxiv.

150,27. *Descriptive:* Keynes, p. 837.

150,30. Burnet: *Sacred Theory of the Earth* (1759), Vol. I, p. 222.

150,36. Summer: *F.Z.*, Night II, ll. 514, 528.

152,10. look on futurity: The passage from Mallet is quoted from the Bohn edition of the *Northern Antiquities,* 1859. The passage as it stands in the edition of 1770 (Vol. II, p. 61) is a little less close to Blake. It reads: "Senseless Loke, why wilt thou pry into the fates? Frigga alone knoweth what is to come, but she never discloseth it to any person." On "futurity," cf. *F.Z.*, Night III, ll. 10, 27; Night VI, l. 230; Night VII, l. 86; Night IX, ll. 179-80.

152,27. bulls: Cf. *F.Z.*, Night II, l. 330. That the plow drawn by Luvah's bulls is a celestial plow is shown by the following passage:

> Nor all Urthona's strength, nor all the power of Luvah's Bulls,
> Tho' they each morning drag the unwilling Sun out of the deep . . .

F.Z., Night V, ll. 164-65. Cf. *M.*, p. 19, ll. 20-21.

152,32. Arthur: Keynes, p. 797.

152,34. O woman born: *J.*, p. 64, ll. 16-17.

155,15. Macrobius: Bk. I, ch. xii.

156,1. strong scales: *F.Z.*, Night II, ll. 352-53.

156,13. materialism: Cf. note on p. 182, l. 9.

156,28. sun and moon: *B.L.*, ch. iv; *J.*, p. 36, l. 4.

156,36. twenty-seven . . . Orc: *M.*, p. 16, l. 24; p. 28, l. 31.

157,19. primal serpent: *J.*, p. 29, ll. 76-80; *F.Z.*, Night III, l. 92.

157,24. Tyburn: *M.*, p. 9, ll. 4-5.

158,9. stars: *M.*, p. 10, l. 26.

158,11. Revelations: xii. 4.

158,32. *Europe:* Preludium, l. 2.

158,35. rears: *Europe,* l. 207.

159,4. Scorpio: R. H. Allen, *Star Names and Their Meanings* (1899), p. 363.

159,27. Gate: For the source literature of the two "gates," cf. H. Leisegang, *Die Gnosis* (1924), p. 363 n.

159,29. reborn: For the dying and reborn sun, cf. H. F. Dunbar, *Symbolism in Medieval Thought* (1929), pp. 412-16.

160,13. better: *F.Z.*, Night VI, l. 228.

160,17. obdurate: *F.Z.*, Night VIII, l. 29.

160,22. Volney: *Ruins* (2d ed., 1795), pp. 165-67.

161,7. The Sun: *F.Z.*, Night IX, ll. 823-24.

CHAPTER IX

162,4. foul: *Paradise Lost*, Bk. IX, ll. 6-8.

162,11. And when: W. R. Inge, *Light, Life, Love* (1904), p. 198.

163,3. I will: Isaiah xiv. 12.

163,9. Empedocles: W. R. Inge, *Philosophy of Plotinus* (1929), Vol. I, p. 201.

163,15. Against: *Paradise Lost*, Bk. IX, ll. 998-99.

163,22. and it: Boehme, *Threefold Life*, ch. v, sec. 140.

—— And that: Boehme, *op. cit.*, ch. v, sec. 120.

163,27. Plotinus: *Enneads* i. 6. 8; v. 8. 2. Cf. J. A. Stewart, *Myths of Plato* (1905), pp. 239-40.

163,33. Plotinus: *Enneads* v. 8. 2.

164,3. Swedenborg: *Arcana coelestia*, Nos. 126-28.

164,7. Erigena: H. Bett, *Erigena* (1925), pp. 66-67.

164,9. *Zohar:* A. E. Waite, *The Holy Kabbalah* (1929), p. 280.

164,36. Both: Keynes, p. 133.

165,7. Many suppose: Keynes, p. 840. Cf. Milton: ". . . for that Angels were long before this visible creation was the opinion of many ancient Fathers."—Argument to *Paradise Lost*, Bk. I.

165,19. states: Keynes, p. 841.

165,29. Good: *M.H.H.* (3). Cf. *J.*, p. 10, ll. 8-16.

166,29. Urthona: *F.Z.*, Night I, ll. 220-21.

166,32. the image: Boehme, *Threefold Life*, ch. vi, sec. 58.

166,37. dark and sulphureous: *B.U.*, chs. ii-v; *B.L.*, chs. i, ii.

167,12. would engender: Boehme says again: "Let none climb above the cross, or if he do, he will fall into hell to the devil."— *Forty Questions*, qu. i, sec. 348.

167,13. angry elements: Cf. Boehme: "The four elements are the habitation of our external humanity."—*Mysterium magnum*, ch. viii, sec. 18.

167,21. his tincture: Boehme, *Three Principles*, ch. xiii.

167,30. I offer the following partial list of references for the motive of pity and its relation to the Fall: *F.Z.*, Night I, ll. 21-28; Night II, l. 73; Night III, l. 85; Night V, ll. 42-53; 236-37; Night VIIa, l. 132; *J.*, p. 10, l. 47; p. 12, l. 29; p. 20, l. 35; p. 29, ll. 47-60; p. 65, l. 47; p. 80, ll. 55-56, 70; *M.*, p. 6, ll. 19-20; p. 7, ll. 46-47; p. 10, l. 28; p. 24, ll. 35-42; p. 25, ll. 31-32; p. 43, ll. 19-20; extra p. 3, l. 16; extra p. 17, ll. 34-35; *B.U.*, ch. ii, ll. 43-44; ch. v, ll. 32-34, 69; ch. viii, l. 35; *America*, ll. 124-29; *Europe*, l. 110.

168,24. selfhood: *F.Z.*, Night I, ll. 193-202, 228-29, 253-54; Night II, l. 217; Night III, ll. 73-74.

168,33. Lawrence: *Last Poems*, p. 218.

169,3. Pity: Keynes, p. 76.

169,8. selfish: *J.*, p. 52. Cf. *M.*, p. 32, ll. 2-9.

169,11. sinless: *F.Z.*, Night IX, l. 453.

169,12. Albion's bride: *J.*, p. 33, l. 39.

169,14. dragon: *J.*, p. 75, l. 20.

169,21. in Jerusalem: p. 81, l. 6.

169,23. pity: *F.Z.*, Night VIIa, l. 132.

169,36. pity divides: *M.*, p. 6, ll. 19-20.

170,5. Without: *J.*, p. 64, l. 24.

170,9. veil: *J.*, p. 20, ll. 30-35. Cf. note on p. 114, l. 26.

170,25. Swedenborg: *Heaven and Hell*, No. 123.

170,32. Go forth: *F.Z.*, Night V, ll. 222-23.

171,2. Luvah seizes: *F.Z.*, Night I, ll. 181-85; Night III, l. 29; Night V, l. 235.

171,5. Luvah gives: *F.Z.*, Night V, ll. 234-37.

171,9. Laws: *B.U.*, ch. ii, ll. 43-44.

171,17. Jerusalem: *J.*, p. 4, l. 14; p. 19, l. 29.

171,18. shame: *J.*, p. 21, ll. 3-5.

171,22. God: *F.Z.*, Night II, l. 61.

171,35. cannot: *F.Z.*, Night I, l. 28.

172,4. why: *F.Z.*, Night I, ll. 41-45.

172,15. The sin: *F.Z.*, Night I, ll. 39-42.

172,18. stern: *F.Z.*, Night I, l. 31.

172,20. both feel: *F.Z.*, Night I, l. 22.

172,24. a labyrinth: *F.Z.*, Night I, l. 22.

172,31. Jerusalem: *F.Z.*, Night I, l. 21.

172,34. I am: *F.Z.*, Night I, ll. 34-37.

173,7. shadow: *F.Z.*, Night IV, l. 259.

173,8. vine: *F.Z.*, Night I, l. 80.

173,9. But on: *F.Z.*, Night I, ll. 81-85.

173,29. Bacon: Keynes, p. 985.

173,32. comments: Keynes, p. 1010.

174,1. man is: *J.*, p. 52.

174,3. by nature good: Cf. E. Bevan: "Chrysippus and the orthodox Stoics maintained that there was no root of evil in human nature, and they explained moral evil in each individual, somewhat naïvely, as due to the bad influences of society."—*Stoics and Sceptics* (1913), p. 104.

174,18. oath: *F.Z.*, Night II, l. 596. It is just possible that Philo contributed something to the conception of the "false oath." Certainly the oath has something to do with the natural or cosmic law of which Philo speaks, and upon which Blake would have placed his own evaluation. Cf. E. R. Goodenough, *By Light, Light* (1935), p. 68.

174,21. Why: *F.Z.*, Night I, l. 23.

174,36. Time and Space: *F.Z.*, Night I, ll. 115-16.

175,7. all that: *Prophetic Writings*, ed. by Sloss and Wallis (1926), Vol. I, p. 151, canceled passage.

175,19. I am made: *F.Z.*, Night II, ll. 595-609.

175,37. sceptre: *F.Z.*, Night II, l. 215.

173,6. Pale: *F.Z.*, Night II, ll. 225-31.

176,13. Thus: *F.Z.*, Night II, ll. 474-75.

176,32. Bailly: J. S. Bailly, *Histoire de l'astronomie ancienne* (1775), Avertissement. Also: *Lettres sur l'origine des sciences* (1777).

176,37. John Smith: *Gaelic Antiquities* (Edinburgh, 1780), p. 3.

177,7. all religions: *J.*, p. 27.

177,13. Boehme: *Threefold Life*, ch. vi, secs. 62, 21; ch. vii, sec. 73; ch. x, sec. 35.

177,21. a finite: Boehme, *Aurora*, Introduction, sec. 25.

177,22. a partition: Boehme, *op. cit.*, ch. xx, sec. 41.

177,24. gulf: *Mysterium magnum*, ch. xxiv, sec. 31.

177,30. Behold: *Aurora*, ch. xxiv, sec. 31.

178,6. western: *F.Z.*, Night II, ll. 389-91.

178,18. into: *F.Z.*, Night II, l. 373.

178,19. sacrifice: *F.Z.*, Night II, ll. 398-410.

178,26. porches: *F.Z.*, Night II, ll. 395, 411.

178,30. For many: *F.Z.*, Night II, ll. 463-65. Urizen's meditations upon the world of sense were probably very much like Philo's: ". . . for in us mind corresponds to man, the senses to woman; and pleasure encounters and holds parley with the senses first, and through them cheats with her quackeries the sovereign mind itself . . . Reason is forthwith ensnared and becomes a subject instead of a ruler, a slave instead of a master, an alien instead of a citizen, and a mortal instead of an immortal."—Philo, *On Creation*, "Loeb Classics," Vol. I, p. 131. Blake, on the other hand, believed in an "improvement of sensual enjoyment."—*M.H.H.* (14).

179,6. Why didst: *F.Z.*, Night III, ll. 28-37.

179,16. vision: *F.Z.*, Night III, ll. 26-98.

180,1. His visage: *F.Z.*, Night III, ll. 104-7.

180,5. A crash: *F.Z.*, Night III, ll. 129-32.

180,6. a world: *F.Z.*, Night III, l. 138.

180,10. The bounds: *F.Z.*, Night III, ll. 129-32.

180,30. showed: G. R. S. Mead, *Thrice Greatest Hermes* (1906), Vol. II, p. 9.

181,3. Thomas Burnet: *Sacred Theory of the Earth* (1726), Vol. I, chs. vi, vii, and p. 85.

181,10. toward: *M.*, p. 34, l. 39.

181,15. Is this: *M.*, p. 43, l. 37—p. 44, l. 1.

181,27. upside down: Swedenborg, *Arcana coelestia*, No. 920; *Divine Providence*, No. 328.

181,29. Aristotle: Cf. A. E. Taylor, *Commentary on Plato's Timaeus* (1928), p. 150.

181,36. sunk: *Europe*, ll. 100-101.

182,9. flood: In addition to the analogues mentioned, it should be observed that Thomas Taylor interpreted the flood in Plato's *Timaeus* myth as a flood of matter, and that Swedenborg interpreted the biblical flood as an inundation of evil and falsity.

182,11. Boehme: *Threefold Life,* ch. vii; *Mysterium magnum,* ch. viii, sec. 18.

182,16. It is: Philo, *The Worse Attacks the Better,* "Loeb Classics," Vol. II, p. 269.

182,22. dashed: *F.Z.,* Night III, l. 153.

———— stonied: *F.Z.,* Night IV, l. 170.

182,25. visage: *F.Z.,* Night III, l. 104.

182,29. Prophetic: *F.Z.,* Night III, l. 17.

182,36. But Mercy: Keynes, p. 80.

183,5. Swedenborg: *Arcana coelestia,* No. 1034.

183,13. Boehme: *Aurora,* ch. xi, sec. 115.

183,21. death: *F.Z.,* Night IV, l. 28.

183,25. struggling: *F.Z.,* Night III, ll. 150-52.

183,32. she believes: *F.Z.,* Night III, ll. 177-81.

183,36. blames Enion: *F.Z.,* Night III, ll. 164-69.

184,12. immortal: *F.Z.,* Night IV, l. 20.

184,16. death: *F.Z.,* Night IV, l. 28.

184,17. some little: *F.Z.,* Night IV, l. 32.

184,23. If the world: *Zohar,* tr. by De Pauly, Vol. I, p. 337. The *Zohar* says further (De Pauly, Vol. I, p. 378) that at the time of the Deluge God was hidden and Elohim alone manifested himself. This is Blakean as well as Zoharic wisdom. In both the Elohim is feminine and ought to be in union with the masculine Jehovah; in both the feminine apart from the masculine is cruel.

184,31. binding of Urizen: *F.Z.,* Night IV, ll. 199-245.

184,33. two types of demiurge: "Thus we can understand how a Neoplatonist like Amelius came to distinguish two demiurgi, a 'prior' and a 'posterior,' and how Proclus was led to still more subtle refinements."— A. E. Taylor, *Commentary on Plato's Timaeus* (1928), p. 83. Cf. J. Kroll, *Die Lehren des Hermes Trismegistos* (1928), p. 126 and n; p. 149 and n. Cf. also Bouillet's edition of Plotinus, Vol. I, p. 193 n; p. 533 n; Vol. III, p. 135.

185,3. furnaces of affliction: *F.Z.,* Night II, l. 282; *J.,* p. 7, l. 30. Cf. Isaiah xlviii. 10.

185,4. thundering: *F.Z.,* Night IV, l. 178.

185,6. under: *F.Z.,* Night IV, ll. 179-82.

185,16. narrow: *M.H.H.* (14).

185,35. became what he beheld: This is characteristic mystical teaching. Thus Plotinus asserts that "souls, while they contemplate diverse objects, are and become that which they contemplate" (whereas he who contemplates the eternal verities is one with the object of his contemplation).—W. R. Inge, *Philosophy of Plotinus* (1929), Vol. II, p. 187. The Chevalier Ramsay, reporting ancient wisdom, has a passage which is Blakean from beginning to end: "He would needs dispute about truth and falsehood, and these disputes banished the eternal Reason. He then fixed his looks on terrestrial objects, and loved them to excess; hence arose the passions; he became gradually transformed

into the objects he loved, and the celestial reason entirely abandoned him."—A. Ramsay, *Travels of Cyrus*, 4th ed. (1730), *Discourse*, p. 85.

186,3. Los felt: *F.Z.*, Night IV, ll. 275-77.

186,10. rebuild: *F.Z.*, Night IV, ll. 27, 149.

186,11. Death: *F.Z.*, Night IV, l. 152.

186,30. it brake: Job xxxviii. 8, 11.

186,32. Hitherto: *F.Z.*, Night IV, l. 35.

187,3. Plato: *Statesman* 269 (tr. by Jowett).

187,11. wheel of religion: *J.*, p. 77, l. 13.

187,16. parallel: *B.U.*, ch. v, l. 70.

187,18. Plutarch: *On Isis and Osiris*, secs. 48-49.

187,23. always present: *F.Z.*, Night IX, l. 170.

188,18. Plotinus: *Enneads* v. i. 2.

188,24. God wants: Keynes, p. 135.

188,28. If thou: Keynes, p. 136.

188,35. furnaces: Cf. note on p. 185, l. 3.

189,14. Pity: *B.U.*, ch. v, l. 69.

189,19. globe: *B.U.*, ch. v, l. 53.

189,25. The red: *M.*, p. 28, ll. 23-24.

190,1. Antichrist . . . hater: *America*, l. 56. Orc is born as Antichrist to the orthodox. To the unorthodox the whole "sexual religion" is Antichrist.

190,2. endure: *F.Z.*, Night II, l. 171.

190,3. bursts forth: *F.Z.*, Night V, l. 37.

190,12. Faint: *F.Z.*, Night V, ll. 27-38.

191,2. incestuous: *F.Z.*, Night V, ll. 79-91.

191,11. beneath: *B.U.*, ch. vii. l. 20.

191,18. not Enitharmon's: *F.Z.*, Night V, ll. 161-70.

191,36. stirs Urizen: *F.Z.*, Night VI, l. 289; Night VII, ll. 5-89.

192,14. stonied: *F.Z.*, Night IV, l. 170.

192,16. deep: *F.Z.*, Night V, ll. 238-39.

192,24. journey: *F.Z.*, Night VI, l. 172.

192,34. another world: *F.Z.*, Night VI, ll. 228-30.

193,20. iron laws: *B.A.*, ch. iii, ll. 10-29.

193,29. allegorical: Cf. *Europe*, l. 39.

193,35. Tree: *F.Z.*, Night VIII, l. 163.

193,37. worm: *F.Z.*, Night VII, l. 139.

194,15. whatever: *J.*, p. 83, ll. 38-39.

194,24. Is this: *J.*, p. 34, ll. 39-40.

194,36. They mock: *J.*, p. 30, ll. 28-32.

195,7. calling: *J.*, p. 17, l. 30.

195,9. dragon: *J.*, p. 75, l. 20.

195,13. if once: *J.*, p. 80, l. 14.

195,24. Jesus: *J.*, p. 77, l. 21.

195,33. There is: *J.*, p. 34, ll. 27-28.

196,4. dens: *F.Z.*, Night V, l. 189.

196,22. But when: Keynes, p. 762.

196,26. in Mystery's: *F.Z.*, Night VIII, l. 254.

CHAPTER X

198,29. cyclic change: For the details of this transformation, as well as for the whole subject of the origin of alchemy, see the great work of E. O. von Lippmann, *Die Entstehung und Ausbreitung der Alchemie* (1919).

198,33. *A New Pearl of Great Price:* 1894 reprint, p. 250.

199,14. Aristotle: *De. gen. et corrupt.,* 336b. Cf. also Dante's assertion at the beginning of the *Convivio,* that "everything, being impelled by foresight belonging to its own nature, tends to seek its own perfection."

200,1. the one: Shelley, *Adonais,* stanza xliii.

200,19. Sendivogius: "The New Chemical Light," in *Hermetic Museum,* ed. by Waite, Vol. II, p. 81.

200,29. *Sum of Perfection: The Works of Geber,* tr. by Russell (1928), p. 40.

202,5. All things: *A Golden and Blessed Casket,* by B. Figulus (new ed., 1893), p. 334.

202,10. Sendivogius: *Hermetic Museum,* ed. by Waite (1894), Vol. II, p. 143.

202,16. Thomas Vaughan: *Works,* ed. by Waite (1919), p. 270.

202,35. Geber: *Works,* tr. by Russell (1928), p. 17.

203,6. Hence: *Hermetic Museum,* ed. by Waite (1894), Vol. II, p. 177.

203,20. Paracelsus: *Of the Chymical Transmutation* (1657), ch. iv.

204,6. Vulcan: *Triumphal Chariot of Antinomy,* ed. by Waite (1893), pp. 83, 88.

204,32. Swedenborg: *Arcana coelestia,* No. 1034.

204,36. mercy: Keynes, p. 80.

205,31. lord: *J.,* p. 8, l. 26.

205,32. tells us: *J.,* p. 52.

205,34. Life: *J.,* p. 10, ll. 55-57.

206,21. it showeth: *Of the Supreme Mysteries of Nature* (1655), ch. v.

206,31. I behold: *J.,* p. 96, ll. 11-13.

206,34. St. Clement: *Stromata,* Bk. VI. But Philo had offered the same interpretation and more elaborately. In sum, the priestly dress is "a likeness and imitation of the cosmos, its details are likenesses and imitations of the cosmos." Cf. E. R. Goodenough, *By Light, Light* (1935), pp. 99-100.

206,36. Wisdom of Solomon: xviii. 24.

207,9. the serpent: *M.,* p. 10, ll. 28-30.

208,2. Waite: *The Secret Tradition in Alchemy* (1926); pp. 254-57.

208,6. *Water Stone:* Pt. IV.

208,12. Boehme: *Threefold Life,* chs. ii, iii; *Forty Questions,* qu. i; *Mysterium magnum,* ch. vi.

208,29. cast God: A. von Harless, *Jacob Boehme und die Alchemisten* (1870), p. 66.

209,4. naked: Keynes, p. 834.

209,29. consuming fire: *F.Z.,* Night VII, p. 147.

——— Job pictures: Plate III.

209,32. *Book of Urizen:* chs. i, iii.

209,34. hell: Cf. William Law, interpreting Boehme: "The wrath which shuts us off from God is the dark fire of our own fallen natures."—*Works,* Vol. V, p. 156.

210,26. harlot robes: *F.Z.,* Night VIII, l. 589.

211,20. mortal: *J.,* p. 27, l. 55.

211,22. translucent: *J.,* p. 27, l. 54.

211,36. I will: *F.Z.,* Night VII, ll. 364-65.

212,4. Loud roar: *J.,* p. 9, ll. 25-26.

212,25. Los with: *J.,* p. 78, ll. 3-9.

213,3. For lo: *J.,* p. 97, ll. 3-4.

213,6. universal: *J.,* p. 96, l. 5.

213,7. likeness: *J.,* p. 96, l. 7.

213,8. as man: *J.,* p. 96, l. 6.

213,10. deadly: *J.,* p. 96, l. 11.

213,11. threw himself: *J.,* p. 96, ll. 35-37.

213,19. Of this: *Hermetic Museum,* ed. by Waite (1894), Vol. II, p. 269.

213,24. sweet: *Aurora,* ch. xii, sec. 163.

213,26. Bernard: *Hermetic Museum,* ed. by Waite (1894), Vol. II, p. 252.

213,29. fountain: T. Vaughan, *Works,* ed. by Waite (1919), p. 270 n.

214,5. serpent bulk: Keynes, p. 134.

214,6. serpent reasonings: Keynes, p. 761.

214,18. Thought: *Europe,* l. 86.

214,22. Then: *Europe,* ll. 91-92.

214,26. weeping: Keynes, p. 762.

CHAPTER XI

216,12. looks out: *F.Z.,* Night VIII, ll. 549-50.

217,5. nothing: Keynes, p. 842.

217,9. sweet: *F.Z.,* Night IX, l. 853.

217,14. Job pictures: Plate XVIII.

217,20. St. Paul: II Thess. ii. 3.

217,21. Albion: *J.,* p. 29, ll. 11-12.

217,31. imagery: Keynes, p. 839.

218,4. sat: *J.,* p. 70, l. 18.

218,7. *Milton:* p. 11, ll. 48-51.

218,11. I have: Letter to Hayley, 4 Dec. 1804 (Keynes, p. 1111).

218,21. To be: Keynes, p. 839.

218,24. Plotinus: *Enneads* iv. 8. 7.

219,3. And he: *J.,* p. 27, ll. 83-84.

219,7. learn: *F.Z.,* Night III, l. 85.

———— remote: *F.Z.,* Night IX, ll. 169-70; *J.,* p. 4, ll. 16-29.

219,25. within: *F.Z.,* Night II, l. 265.

219,27. a little: *J.,* p. 17, l. 32.

219,30. sexual mandrake: *Gates of Paradise,* Plate II, and l. 4. (Keynes, pp. 753, 761).

220,8. war: *F.Z.,* Night IX, l. 852.

———— form: *F.Z.,* Night IX, l. 851.

220,11. demonstrative: *J.,* p. 12, l. 14.

220,24. a cradle: *J.*, p. 56, l. 8.
220,31. Plotinus: W. R. Inge, *Philosophy of Plotinus* (1929), Vol. I, pp. 172, 173.
221,5. Erigena: H. Bett, *Erigena* (1925), p. 50.
221,11. Time is: *M.*, p. 23, ll. 72-73.
221,16. All that: *M.*, p. 42, l. 30.
221,21. *Milton:* p. 17, ll. 10-14.
221,34. Circumscribing: *J.*, p. 98, ll. 18-20.
222,29. the prophet: Cf. *Illustrations to the Book of Job*, Plate XII.
222,34. furnaces: *F.Z.*, Night II, l. 282; *J.*, p. 73, l. 25.
223,12. a cradle: *J.*, p. 56, l. 8.
223,13. the terrors: *J.*, p. 92, l. 20.
223,33. created: *M.*, extra p. 3, ll. 11-12.
224,20. he who: *M.*, p. 6, ll. 47-48. Cf. *J.*, p. 9, ll. 29-30.
224,35. Swedenborg: *Angelic Wisdom*, No. 344.
225,8. Fixing: *J.*, p. 12, ll. 12-14.
225,20. continually: *J.*, p. 88, l. 40.
226,8. It is: *M.*, p. 16, l. 14; *J.*, p. 90, l. 38; *F.Z.*, Night VIII, ll. 232-33.
226,12. put it off: Keynes, p. 135.
226,23. where: II Cor. iii. 17.
226,24. ministration: II Cor. iii. 7.
226,33. He hopes: *M.*, p. 43, ll. 2-28.
227,10. *Four Zoas:* Night VIII, l. 29; Night VII, ll. 319-23.
227,17. For Los: *F.Z.*, Night VIII, ll. 28-29.
228,1. *Kabbalah denudata:* ed. by Mathers (1926), p. 22.
228,4. Swedenborg: *Arcana coelestia*, No. 1034.
228,11. But when: *J.*, p. 42, ll. 32-34.
228,27. Job's wife: *Illustrations to the Book of Job*, Plate IX.
228,32. fear: Keynes, p. 759.
229,2. is made: *J.*, p. 53, l. 27.
229,4. Christ: *F.Z.*, Night VIII, l. 254.
229,16. image: *J.*, p. 7, l. 65.
229,20. looms of Cathedron: *F.Z.*, Night VIII, ll. 30-52.
229,25. vegetation: *F.Z.*, Night VIII, l. 32.
229,37. modulate: *F.Z.*, Night VII, l. 453.
230,2. the immortal: *F.Z.*, Night VII, l. 466.
230,20. Luvah's robes: *F.Z.*, Night II, ll. 105-6; 309-11.
230,25. lest: *F.Z.*, Night II, l. 472.
230,30. emotions: *F.Z.*, Night VIII, ll. 198-99; 200-204.
231,1. forms: *F.Z.*, Night VIII, ll. 221-22.
231,4. Daughters: *J.*, p. 67, l. 3.
231,19. beast-formed: *F.Z.*, Night IX, l. 149.
231,30. Clothed: *F.Z.*, Night VIII, ll. 52-53; *M.*, p. 25, ll. 32-39; p. 27, ll. 35-39; *F.Z.*, Night VIII, ll. 205-8. Sloss and Wallis say that the "division of men into the Elect, the Redeemed, and the Reprobate is confined to *Milton.*"— *Prophetic Writings*, Vol. I, p. 358 n. But the division, in the *Four Zoas*, into head, heart, and loins is equivalent.
232,8. fixing: Cf. *F.Z.*, Night VIII, ll. 598-600.

233,9. Voltaire: *J.*, p. 73, ll. 29-30.

233,17. dark: *F.Z.*, Night VIII, l. 222.

233,19. But: *F.Z.*, Night VIII, ll. 223-24.

233,27. Give: *F.Z.*, Night VIII, ll. 256-57.

233,29. sin: Keynes, p. 135.

233,36. God: Keynes, p. 148.

234,4. But: Keynes, p. 762. The secret the traveler sees in the grave is the worm:

> The Door of Death I open found
> And the Worm Weaving in the Ground:
> Thou'rt my Mother from the Womb,
> Wife, Sister, Daughter, to the Tomb,
> Weaving to Dreams the Sexual strife
> And weeping over the Web of Life.

This is a picture of the feminine corporeal world, the feminine by which man fell, and the feminine by which he is redeemed. The dreams woven by the female are at once man's bondage and the means of his release. They are the cosmic process of "conversion." The worm of the soul that dies not is a frequent image in mystical writings. Some mystics have conceived of the worm as central in the universe. Cf. H. F. Dunbar, *Symbolism in Medieval Thought* (1929), Index, s. v. "worm."

234,24. weaving: Keynes, p. 762.

234,31. Thus: *F.Z.*, Night VIII, l. 469.

235,1. moral: *J.*, p. 27, l. 23.

235,4. drawn: *F.Z.*, Night VIII, l. 270.

235,9. that they: *F.Z.*, Night VIII, ll. 470-72.

235,24. states: *J.*, p. 25, ll. 12-16.

235,33. It ought: Keynes, p. 832.

236,7. Descend: *J.*, p. 25, ll. 12-13; *F.Z.*, Night VIII, ll. 368-72.

236,16. been said: Aldous Huxley, *Texts and Pretexts* (1933), p. 354.

236,37. without destroying: *F.Z.*, Night VIII, l. 225.

237,3. Rahab: *F.Z.*, Night VIII, ll. 224-26.

237,14. It was: *F.Z.*, Night VIII, ll. 275-76.

237,19. The Synagogue: *F.Z.*, Night VIII, ll. 594-97.

238,1. The Ashes: *F.Z.*, Night VIII, ll. 598-600.

238,27. peace: *F.Z.*, Night VII, l. 365.

238,32. The sights: *Prometheus Unbound*, Act I, ll. 643-45.

239,11. The Last: Keynes, p. 828.

239,16. Los: *F.Z.*, Night IX, ll. 6-9.

239,25. When: Keynes, p. 828.

239,34. bitter: *F.Z.*, Night IX, ll. 817-18.

240,4. resume: *F.Z.*, Night IX, ll. 370-72.

240,7. dark: *F.Z.*, Night IX, l. 853.

240,9. Albion: *F.Z.*, Night IX, ll. 284-89.

240,11. Elect: *M.*, p. 31, ll. 21-22.

240,17. gates: *F.Z.*, Night IX, l. 373. The Gnostic sects differed as to

whether the third class of men could be saved. Valentine, for example, said that the "hylic" could not be saved. *Pistis Sophia* is eager to save all. Cf. E. de Faye, *Gnostiques et gnosticisme* (1925), pp. 67-90. Among the Christians Origen provided for universal salvation by means of a plurality of worlds. Erigena saves the devil himself. As the text says, Blake provides for only a partial salvation of the Elect. He probably knew the Vulgate version of I Cor. xv. 51: "Omnes quidem resurgemus, sed non omnes inmutabimur."

240,27. The most. Cf. Keynes, p. 838.

241,9. regenerated Job: *Illustrations to the Book of Job,* Plate XVIII.

CHAPTER XII

242,1. A circular: Cf. A. Diès, *Le Cycle mystique* (1909); H. Leisegang, *Die Gnosis* (1924), and *Der Apostel Paulus als Denker.*

243,1. Cornelius Agrippa: *Philosophie occulte,* Liv. II, ch. xii. Philo writes at length on the number seven in his *On the Creation,* "Loeb Classics," Vol. I, pp. 73-101. It should have been observed that Philo divides the irrational part of the soul into seven parts, since the cycle of the Fall and of the Seven Eyes is equivalent to the irrational part of the soul. Blake also writes:

> . . . & the seven diseases of the Soul
> Settled around Albion and around Luvah.
>
> *J.,* p. 19, ll. 26-27

243,25. uncovering: *Kabbalah denudata* (1926), p. 187.

243,31. Lamps: *F.Z.,* Night I, l. 243.

243,34. Satan's seat: *M.,* p. 35, l. 64.

243,11. counter-clockwise: For clockwise and counter-clockwise cf. H. Leisegang, *Die Gnosis* (1924), p. 363.

244,13. wheel: *J.,* p. 77, l. 13.

244,36. Eliphas Lévi: *Transcendental Magic,* tr. by Waite (1923), p. 122.

244,37. the Devil: *Ibid.,* note.

245,3. horse: The origin of this image is doubtless in Plato's *Phaedrus,* but I think some intervening source must be supposed.

245,15. the Spectre: *J.,* p. 8, l. 26.

245,24. current: *J.,* p. 77, l. 4.

245,36. sevenfold planetary spheres: The Blakean astronomy is clearly stated by Philo, who, of course, derived it from Plato. Philo says: "For the movements assigned to the heavenly spheres are of two opposite kinds, in the one case an unvarying course, embodying the principle of sameness, to the right, in the other a variable course, embodying the principle of otherness, to the left. The outermost sphere, which contains what are called the fixed stars, is a single one and always makes the same revolution from east to west. But the inner spheres, seven in number, contain the planets and each has two motions of opposite nature, one voluntary, the other under a compelling force. Their involuntary motion is similar to that of the fixed stars, for we see them pass every day from east to west, but their own proper motion

is from west to east."—*On the Cherubim*, "Loeb Classics," Vol. II, p. 21. However, Blake seems to have a ninth sphere. Cf. *F.Z.*, Night II, l. 556.

246,8. Lucifer: *F.Z.*, Night VIII, ll. 388-95. Cf. *M.*, p. 11, ll. 17-28.

247,3. in deluge: *Europe*, l. 81.

247,10. the void: *M.*, p. 43, l. 37—p. 44, l. 1.

247,16. swore: *Ghost of Abel*, l. 46.

247,19. Elohim: *J.*, p. 73, l. 24.

247,26. the pardoner: *Zohar*, tr. by De Pauly, Vol. I, p. 543.

247,27. benefactor: Swedenborg, *Arcana coelestia*, No. 1992.

248,1. St. Paul: Romans vii. 24.

248,6. Fear: Keynes, p. 759.

249,34. Man: *J.*, p. 52.

CHAPTER XIII

251,21. Mental: Keynes, p. 844.

252,1. And every: *M.*, p. 26, ll. 44-46.

252,9. Fourier: A. Warren, *The Elder Henry James* (1934), p. 92.

252,19. apparition: *The Secret of Swedenborg* (1869), p. 29.

252,20. he continues: *Op. cit.*, pp. 15, 35.

252,36. Nature: *M.*, p. 28, l. 65.

253,1. vengeance: *Ghost of Abel*, l. 46.

253,2. death: *F.Z.*, Night IV, l. 28.

253,12. Nature: E. Morley, *Blake, Coleridge* . . . (1922), p. 10.

253,30. Origen: *Against Celsus*, Bk. VII, ch. lxv; Bk. V, ch. xxxviii.

253,34. Philo: *Migration of Abraham*, "Loeb Classics," Vol. IV, p. 237.

254,5. Burnet: *Early Greek Philosophy* (2d ed., 1908), pp. 15-16, 262.

254,16. filmy: *F.Z.*, Night I, l. 71. W. J. Perry says, "The Great Mother was the first 'deity' that man thought of."—*Origin of Magic and Religion* (1923), p. 25. Cf. also: G. Murray, *Five Stages of Greek Religion* (1925), p. 45; J. Kroll, *Die Lehren des Hermes Trismegistos* (1928), p. 236 and n.

254,17. round: *F.Z.*, Night I, l. 82.

254,21. Indo-European: Clemen, *Religions du monde* (1930), p. 277.

254,27. dualism: *Op. cit.*, p. 163.

255,15. M. de Faye: *Origen and His Work* (1929), p. 79.

255,25. Along with: *Op. cit.*, pp. 86-87.

256,9. his bosom: *M.*, p. 7, ll. 30-31.

256,10. opaque: *J.*, p. 7, l. 8.

256,16. the Zoas: *J.*, p. 36, ll. 31-32.

256,20. final consequence: E. de Faye, *Gnostiques et gnosticisme* (1925), p. 104.

256,25. Erigena: H. Bett, *Erigena* (1925), p. 56.

256,37. Boehme: *Mysterium magnum*, ch. xvi, sec. 27; *Threefold Life*, ch. v.

257,4. Swedenborg: *Angelic Wisdom*, No. 322.

257,6. Blake: Keynes, p. 148.

257,8. Swedenborg: *Angelic Wisdom*, No. 344.

257,23. a hindrance: So also says Plotinus: "This is the fall of the soul, this entry into Matter; thence its weakness; not all the faculties of its

being retain free play, for Matter hinders their manifestation; it encroaches upon the Soul's territory, and, as it were, crushes the Soul back . . ."—*Enneads* i. 8. 11.

258,12. a life: *Enneads* ii. 4. 5.

258,22. is not living: *Ibid.*

259,11. the lower Soul: W. R. Inge, *Philosophy of Plotinus* (1929), Vol. I, p. 236.

259,23. takes fulness: *Enneads* v. 2, 1.

259,26. knows: *Enneads* v. 3. 6.

259,27. Its knowing: *Enneads* v. 1. 4.

259,35. Likeness: *Enneads* ii. 4. 10.

259,37. Swedenborg: H. James, *The Secret of Swedenborg* (1869), p. 54.

260,23. The Visions: *J.*, p. 49, ll. 21-22.

261,1. As: Keynes, p. 1039.

261,5. Let: *J.*, p. 55, ll. 36-46.

261,18. At will: *F.Z.*, Night II, ll. 505-6.

261,26. the outside: *J.*, p. 83, ll. 46-48. The "real surface" of the earth is discussed in Plato's *Phaedo* 109-12.

261,33. This is: *M.*, p. 42, ll. 35-36.

261,36. temporal and unreal incrustation: Cf. the following three analogues.

(1) Hermes: "But first you must tear off this garment [the body] which you wear,—this cloak of darkness, this web of ignorance, this prop of evil, this bond of corruption,—this living death, this conscious corpse, this tomb you carry about with you,—this robber in the house, this enemy who hates the things you seek after, and grudges you the things which you desire. Such is the garment in which you have clothed yourself; and it grips you to itself and holds you down, that you may not look upward and behold the beauty of the Truth, and the Good that abides above . . ."—W. Scott, *Hermetica*, Vol. I (1924), p. 173.

(2) Erigena: "The spiritual form is, in fact, the spiritual body, which was made in the first creation . . . The material body is superadded because of sin, and it is not so much a true body, as a kind of changeable and corruptible vestment of the spiritual body."—H. Bett, *Erigena* (1925), p. 64.

(3) Boehme: "The old Adamical flesh of death cometh not to be heavenly flesh: No, it belongeth to the earth, to death; but the eternal flesh is hidden in the old earthly man, and it is in the old man, as the fire is in the iron, or as the gold in the (dark) stone."—Boehme, *Threefold Life*, ch. vi, sec. 97.

262,1. Plotinus: *Enneads* i. 6. 5.

262,36. Even I: *F.Z.*, Night VII, ll. 360-6½.

263,12. And sometimes: *J.*, p. 83, ll. 40-48.

263,26. serpent bulk: Keynes, p. 134.

263,28. empire: E. Morley, *Blake, Coleridge* . . . (1922), p. 9.

263,31. neither: W. R. Inge, *Philosophy of Plotinus* (1929), Vol. II, p. 39.

263,35. A feeble: W. R. Inge, *op. cit.*, Vol. I, p. 151.

264,2. Now: *Enneads* ii. 4. 3.

264,8. The half-blinded: W. R. Inge, *op. cit.*, Vol I, p. 139.

264,28. Dean Inge: *Op. cit.*, Vol. I, p. 222. With regard to declining perceptions, Plotinus makes an observation which is important to the understanding of Blake: "When a man moves from the active to the passive his perceptions undergo a decline."

264,35. For our: Keynes, p. 277 n.

265,2. what is: Keynes, p. 844. On the subject of matter and evil Thomas Taylor wrote a passage which I shall quote because it was assuredly read by Blake: "From all that has been said, therefore, we must conclude, in opposition to Plotinus, that matter is not the first evil, and evil itself; for matter is the offspring of deity, and consequently must be, in a certain respect, good. Matter, indeed, is the first indefinite, and is neither good nor evil, but a thing necessary to the universe, and the most distant of all things from the good itself. Nor is the soul's debility owing to her lapse into matter; for as this lapse is voluntary, the soul must have sinned prior to her descent."—*Five Books of Plotinus* (1794), p. xix. Cf. Boehme, "The original of the Fall was within the creature and not without the creature; and so it was in Adam also."—*Mysterium magnum*, ch. ix, sec. 9.

265,11. The unbelieving: *Enneads* v. 8. 11.

265,14. Enion: *F.Z.*, Night I, l. 79.

266,9. dark: *F.Z.*, Night IX, l. 853.

266,11. originated: Keynes, p. 843.

266,23. dark . . . eternal: *F.Z.*, Night VIII, ll. 530, 532.

266,24. vegetable: Cf. Keynes, p. 834.

266,29. Behold: *F.Z.*, Night VIII, ll. 537-38.

266,35. selfish: *J.*, p. 52.

267,9. maternal: *J.*, p. 90, ll. 65-66.

267,21. servant: Keynes, p. 789.

267,32. Plotinus: *Enneads* ii. 4. 6.

268,11. vision: *M.*, p. 28, l. 65.

268,13. Elohim: *J.*, p. 73, l. 24.

268,27. As the: *F.Z.*, Night VIII, ll. 546-71.

269,12. How are: *M.*, p. 34, ll. 50-54.

269,19. Plotinus: *Enneads* v. 2. 2.

269,27. Furious: *J.*, p. 58, ll. 48-49.

269,29. Swedenborg: *Angelic Wisdom*, No. 52.

270,1. The Bat: Keynes, pp. 118-19.

270,11. the war: *J.*, p. 91, ll. 39-50.

270,32. That he: *J.*, p. 9, ll. 29-30.

270,34. Behemoth: *J.*, p. 91, ll. 40-43.

271,3. Go: *J.*, p. 91, ll. 55-56.

271,5. Satan: *Illustrations to the Book of Job*, Plate XI. Cf. *M.*, p. 9, l. 12.

271,21. all his: *J.*, p. 91, ll. 47-49.

272,1. Now: Keynes, p. 1068.

272,11. Windows: G. R. S. Mead, *Thrice Greatest Hermes* (1906), Vol. III, p. 109. Cf. Boehme: "The inward man, viz., the inward eye, saw through the outward; as we in the other world shall need no

sun, for we [shall] see in the divine sight . . ."—*Mysterium magnum,* Vol. I, ch. xviii, sec. 13. In the Hermetic writings, the "nous" is the organ of gnosis, in the same sense that the eye is the organ of sight. Cf. W. Scott, *Hermetica,* Vol. II, p. 247.

272,14. angel: *J.,* p. 63, l. 5.

272,15. devouring: *J.,* p. 14, l. 4.

272,16. its sacrifices: *M.,* p. 3, ll. 11-12.

272,17. even till: *M.,* p. 3, ll. 12-13.

272,21. 'Twas outward: Keynes, p. 1067.

272,25. With my: *Ibid.*

272,27. Swedenborg: *True Christian Religion,* No. 687.

273,13. continually: *J.,* p. 53, l. 19. Cf. *J.,* p. 88, l. 40.

273,17. furnaces: *J.,* p. 73, l. 25.

273,18. generation: Keynes, p. 834.

273,25. takes fulness: *Enneads* v. 2. 1.

273,28. *Milton:* p. 31, ll. 28-63.

273,32. Quiet: *Enneads* v. 1. 2.

274,13. an eye: Wordsworth, *Tintern Abbey.*

274,19. The soul: *Enneads* v. 1. 3.

274,24. Sloss and Wallis: *Prophetic Writings of William Blake* (1926), Vol. II, p. 134.

274,37. I assert: Keynes, p. 844.

275,10. Each grain: Keynes, p. 1052.

275,21. on account of: *J.,* p. 77.

275,29. handscreens: Gilchrist, *Life of Blake,* ch. xvii.

276,20. Los: *J.,* p. 17, l. 7.

276,24. Blake's doubts: E. Morley, *Blake, Coleridge* . . . (1922), pp. 4, 5, 6, 15, 24.

CHAPTER XIV

280,8. love: *J.,* p. 64, ll. 28-29.

281,1. polypus: *M.,* p. 23, l. 38.

283,15. strength: Shelley, *Adonais,* stanza xxxii.

282,2. put off: *M.,* p. 42, l. 36.

285,13. Spectre: *F.Z.,* Night II, l. 84.

285,34. Many persons: Keynes, p. 842.

286,16. mortal: Keynes, p. 842.

287,3. Hocking: *Meaning of God in Human Experience* (1912), ch. xxviii.

287,5. God: Keynes, p. 148.

288,10. joy: *B.U.,* ch. ii, ll. 19-20.

288,18. Drive: *M.H.H.* (7).

289,9. Whitehead: *Adventures of Ideas* (1933), p. 354.

291,4. Los cries: *J.,* p. 91, ll. 54-55.

Index